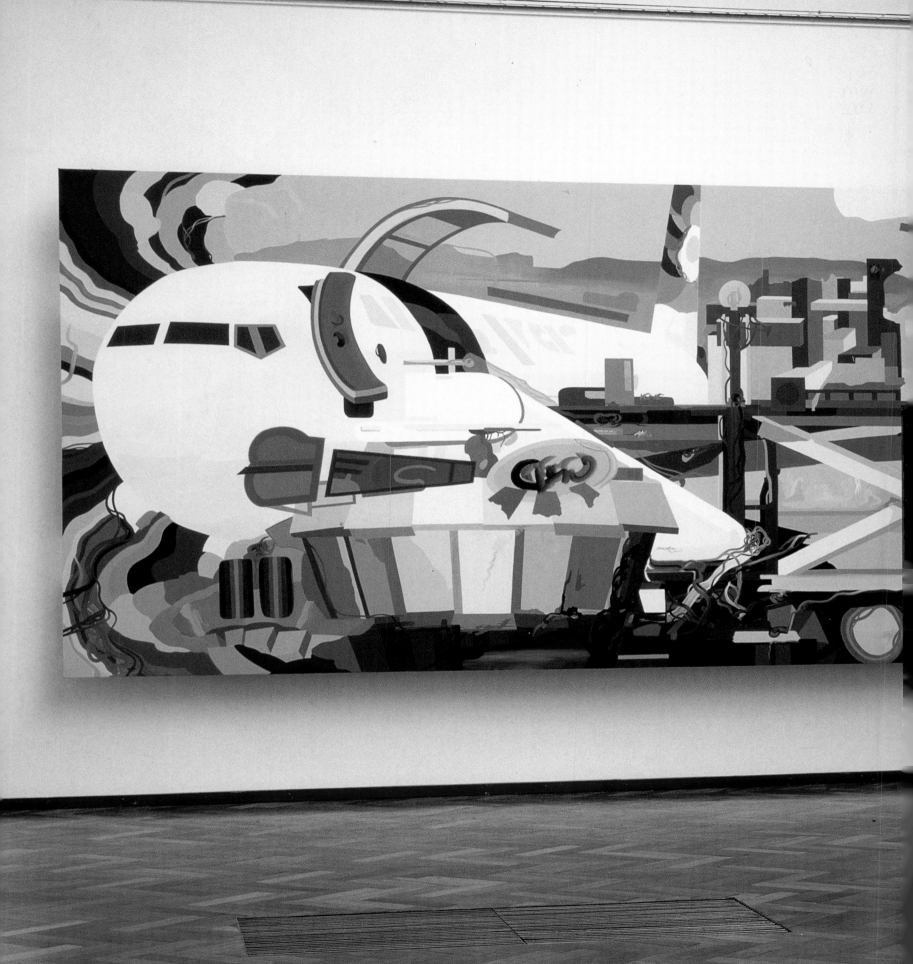

◀ FRANZ
ACKERMANN
Born in Neumarkt St. Veit, Germany, 1963/Lives in Berlin and Karlsruhe

Boarding. 2002
Mixed media and oil paint on canvas
280 x 540 cm/110 1/4 x 212 1/2 in.

◀ FRANZ
ACKERMANN
Born in Neumarkt St. Veit, Germany, 1963/Lives in Berlin and Karlsruhe

Where Is Love. 1999
24 Cibachrome prints
61 x 76 cm/24 x 29 7/8 in. each

AMY ▶
ADLER
Born in New York, 1966/Lives in Los Angeles

Monument to Now

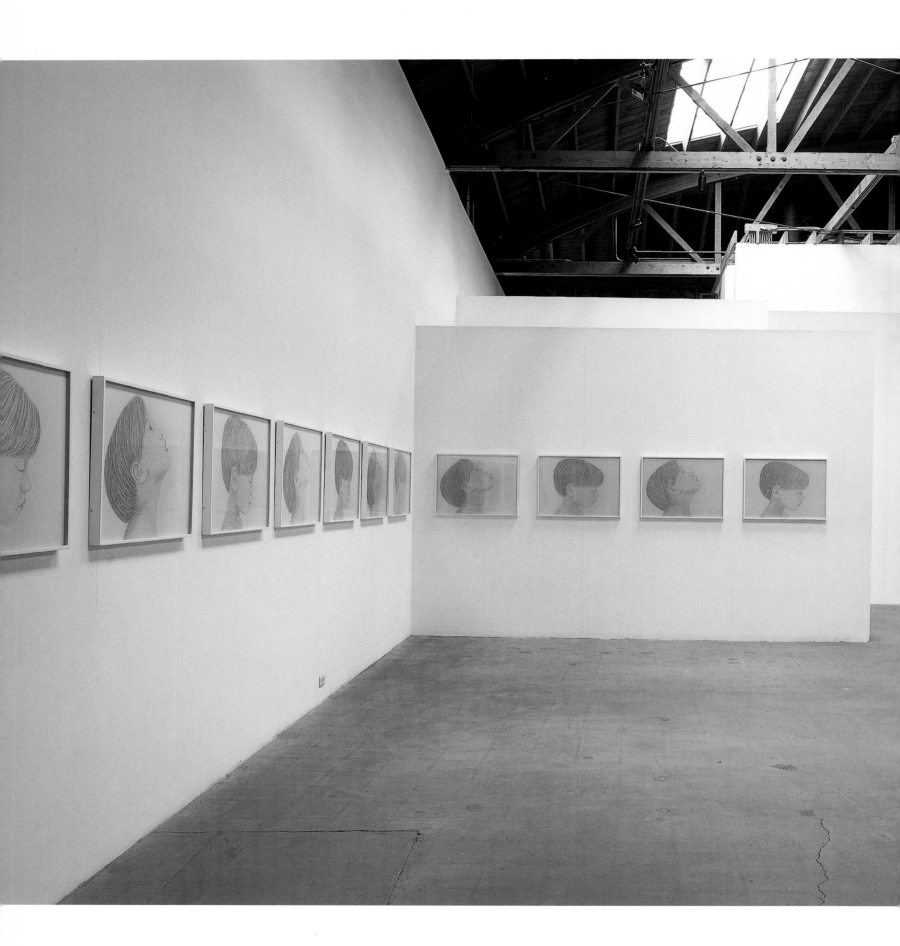

 GHADA
AMER
Born in Cairo, 1963/Lives in New York

Untitled. 1996
Embroidery and gel medium on canvas
167,6 x 182,8 cm/66 x 72 in.

monument

Numbers Runners. 1979
Wood, telephone, audiotape, and artificial grass
240 x 116 x 116 cm/94 1/2 x 45 5/8 x 45 5/8 in.

ro now

The
Dakis Joannou
Collection

Essays by
Dan Cameron, Jeffrey Deitch,
Alison M. Gingeras, Massimiliano Gioni,
and Nancy Spector

Edited by Jeffrey Deitch

Designed by Sagmeister Inc., New York

DESTE Foundation for Contemporary Art

NUMBERS RUNNERS 1978

An altered phone booth.
The listener picks up the phone and responds
to a series of questions and stories.
Gaps were left for the listener's responses,
which were on time delay.

You know that ad—that ad for the phone company—there's
a mother and her little daughter and they're sitting
around and the phone rings.
The mother picks it up and talks for a moment.
Then she holds the receiver out to the daughter and says,
"Talk to Grandma! Here's Grandma!"
And she's holding a piece of plastic.
So, of course, the question is:
Is the phone alive? What's alive and what doesn't have life?

And I answered the phone and
I heard a voice and the voice said:
Please don't hang up.
We know who you are.
Please do not hang up.
We know what you have to say.
Please do not hang up.
We know what you want.
Please do not hang up.
We've got your number:
One...two...three...four
We are tapping your line

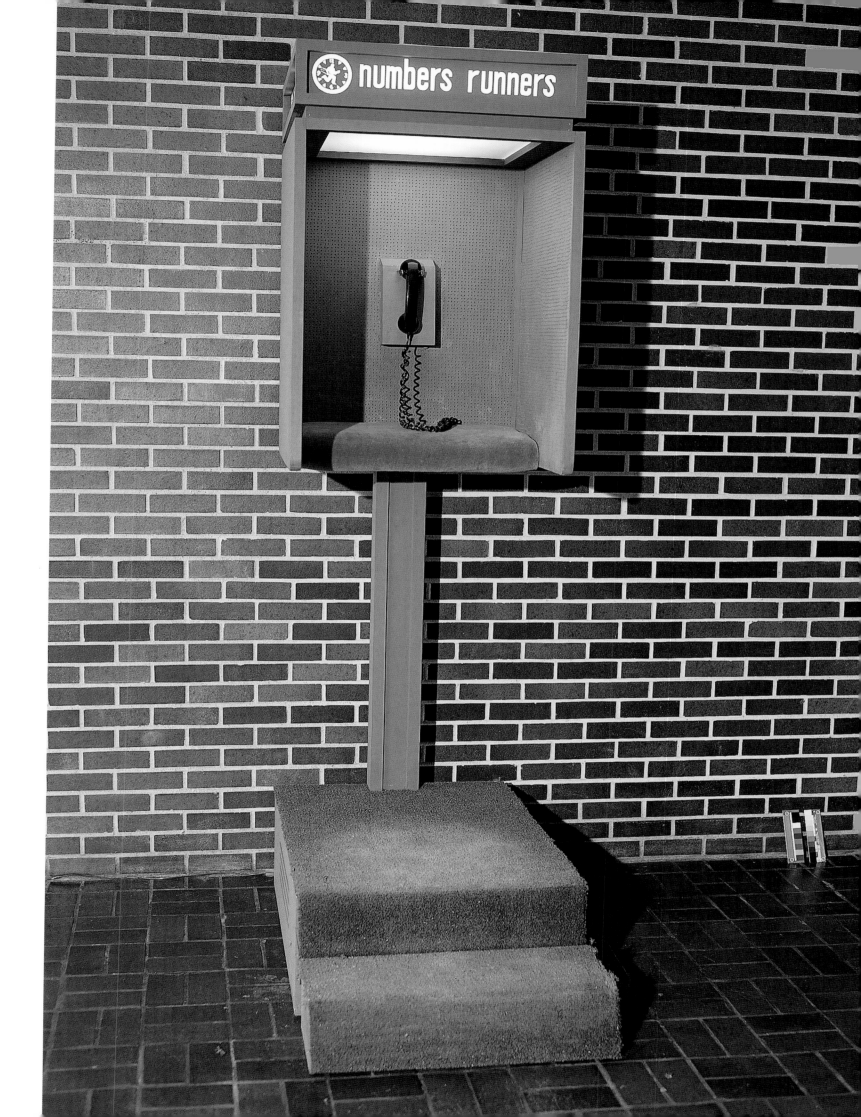

This book is published on the occasion of the exhibition
Monument to Now: The Dakis Joannou Collection,
presented at the DESTE Foundation
for Contemporary Art, Athens, Greece,
22 June–31 December 2004

Published by DESTE Foundation for Contemporary Art,
Athens, Greece

Project manager: Jeffrey Deitch
Curators: Dan Cameron, Jeffrey Deitch,
Massimiliano Gioni, Alison M. Gingeras, Nancy Spector
Installation design: Dakis Joannou with the
curatorial team
Project coordinator/Curator of special projects:
Marina Fokidis

Designer: Sagmeister Inc., New York
Editor: Diana Murphy
Photo and collection research: Natasha Polymeropoulos
Photo research: Ali Subotnick, Marie Bonnet

Distribution in North/South America and Asia:
D.A.P./Distributed Art Publishers, Inc.
155 Sixth Avenue, 2nd floor
New York, N.Y. 10013
Tel 212 627 1999 Fax 212 627 9484
www.artbook.com

Distribution outside North/South America and Asia:
Thames and Hudson Distributors Ltd.
44 Clockhouse Road
Farnborough
Hampshire GU14 7QZ United Kingdom
Tel 00 44 (0) 1252 541602 Fax 00 44 (0) 1252 377380
E-mail customerservices@thameshudson.co.uk
www.thamesandhudson.com

ISBN 0-9648530-7-8 (hardcover)
ISBN 0-9648530-8-6 (paperback)

Library of Congress Control Number 2004100497

Printed and bound in Hong Kong

Slumber. 1994
Maple loom, wool yarn, bed, nightgown, blanket,
artist's REM reading on computer paper, and REM decoder
Dimensions vary

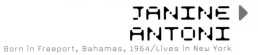

JANINE ▶
ANTONI

Born in Freeport, Bahamas, 1964/Lives in New York

Contents

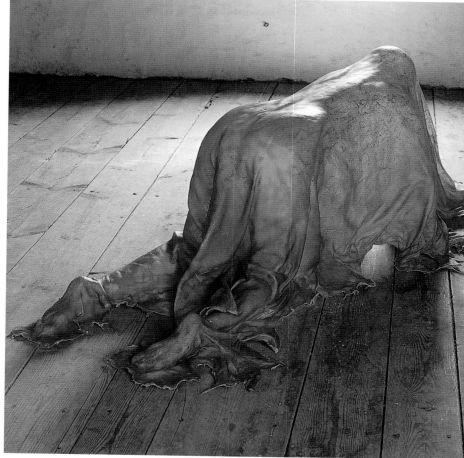

Saddle. 2000
Full rawhide
64,7 x 82,5 x 199,3 cm/25 1/2 x 32 1/2 x 78 1/2 in.

Saddle. 2000
Full rawhide
64,7 x 82,5 x 199,3 cm/25 1/2 x 32 1/2 x 78 1/2 in.

Preface

Gianna Angelopoulos-Daskalaki

President, ATHENS 2004 Organizing Committee for the
Olympic Games

Dear Friends of Culture and Art,

At the start of every Olympic Games there is an explosion of energy and excitement,
anticipation of the unexpected, and curiosity about the special cultural events that nor-
mally accompany this great celebration of sports. This is especially true in the case of
the ATHENS 2004 Olympic Games because of the unique fusion of the rich cultural history
of Greece and the country's dynamic Olympic present. The world expects the homecom-
ing of the Olympic Games to be a joyful celebration that combines the Olympic spirit with
the multidimensional reality of the twenty-first century.

 Monument to Now, as a part of the ATHENS 2004 Cultural Program, rises per-
fectly to this challenge. It is a global forum highlighting the message that the Olympic
spirit, like contemporary art, can be a vibrant expression of universality, creativity, and
human measure. It embraces the idea of a global culture based on diversity, and makes
a clear statement about the power of the moment. This exhibition is an invitation to
now: exciting, provocative, colorful, interactive.

 On behalf of the ATHENS 2004 Organizing Committee for the Olympic Games,
I would like to extend our warmest thanks to the DESTE Foundation for Contemporary Art
for this generous invitation and for organizing the exhibition, and to Heineken, one of
our Grand National Sponsors, for its dedication and support. I would also like to express
our deep appreciation to Mr. Dakis Joannou for his cooperation, passion, and, above all,
for the contribution of his priceless collection to the ATHENS 2004 Cultural Program. Last
but not least, congratulations are due to the distinguished group of curators and artists
for their inspiring participation and invaluable assistance.

 We hope that all of you who have the opportunity to visit this unique exhibi-
tion will have an enriching and unforgettable experience, and that *Monument to Now*,
as part of a global celebration of the Olympic spirit and culture, captures for you the
energy, magic, depth, and meaning of the moment.

Installation with Chair, Bookcase, and Painting. 1985
Chair, bookcase, and acrylic paint on canvas
Chair, 91,4 x 49,5 x 53,3 cm/36 x 19 1/2 x 21 in.;

bookcase, 86,3 x 101,6 x 35,5 cm/34 x 40 x 14 in.;
painting, 76,2 x 76,2 cm/30 x 30 in.

Sponsor's Statement

Minas Tanes

CEO, Heineken/Athenian Brewery

Sports are integral to the cultures of all nations. The city of Athens, as host of the 2004 Olympic Games, and the Greek government have made an important political decision: to bring together and inseparably connect the Games with art and culture. This is a decision that in itself renders the Athens Olympic Games unique among all those held previously—indeed, an unprecedented event in the history of modern Olympics.

Art and creative expression appear to be the perfect means of communicating the Olympic ideal. As Plato said, art succeeds where knowledge fails: in its ability to grasp the concepts of the ideal and the sublime. Works of art create an aesthetic emotional response; they become the means of communication between different sensibilities, because through art and intuition one may better understand the true spirit of the Olympic Games.

Heineken/Athenian Brewery, as one of the Grand National Sponsors of the Games, but also through its long tradition of supporting the arts, is happy and proud to have been given the chance to participate in and actively contribute to an event that rests upon and realizes these two great principles: the value of sports and of culture, of the Olympic ideal and of the fine arts. The exhibition *Monument to Now*, organized as part of the visual arts section of events of the ATHENS 2004 Cultural Program, is an opportune fusion of the ideals that promote culture and civilization.

As the philosopher Jules de Gaultier observed in his poem "Art," "for the artist the process of creation is a continuous effort, a struggle, a fascination." Let us, therefore, attempt to approach the physical and spiritual toil entailed in competitive sports through the efforts of artistic creation, and let us disseminate the meaning of the beautiful, the grand, and the real to every corner of the planet.

Heineken congratulates all those who have contributed to this effort, especially the DESTE Foundation for Contemporary Art, and is happy to participate as sponsor in this outstanding artistic event.

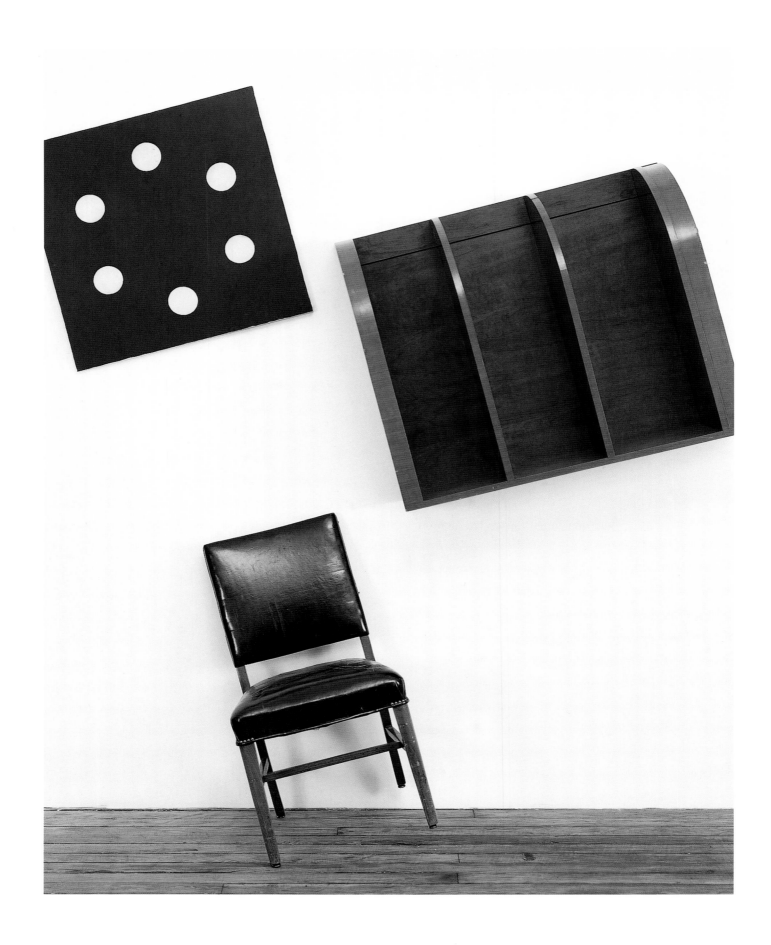

Furniture Sculpture. 1986
Acrylic paint, canvas, and wooden bed frame
194,9 x 220,3 x 76,5 cm/76 3/4 x 86 3/4 x 30 1/8 in.

◀ JOHN
ARMLEDER

Furniture Sculpture. 1986
Acrylic paint, canvas, and wooden bed frame
194,9 x 220,3 x 76,5 cm/76 3/4 x 86 3/4 x 30 1/8 in.

1+1=1. 2002
2 DVDs and 2-screen video installation
DVDs approx. 50 min. each
Dimensions vary

KUTLUG ▶
ATAMAN
Born in Istanbul, 1961/Lives in Barcelona and Istanbul

Introduction Dakis Joannou

I hope that these words will be looked upon not as an ordinary greeting but rather as an attempt to share a feeling.

Being a collector is a process of becoming. I have always been drawn to art, but in reality I became a collector by chance; it was a strange moment that lasted a few seconds and later developed into a necessity.

The first time I came across Jeff Koons's *One Ball Total Equilibrium Tank*, in 1985, I knew it was a work I simply could not resist. There was magnetism, an unsettling yet beautiful feeling that brought me into a totally different world. In a split second, art became part of not only my visual but also my psychic vocabulary. I have often been seduced by the energy of the new, but since then, as if Pandora's box had opened, I have identified a million new ways of looking at things through the process of collecting.

Collecting is, for me, an adventure, a set of different "lived" experiences—a constant flow of meeting, talking, listening, looking. It is an act of understanding and participating. And within this never-ending involvement with "what is happening," the moments when I see exciting works for the first time constitute some of the highlights of my life, for they have caused me to look at issues that I had never considered before.

Of course, my feelings are influenced by culture and perception. Collecting tends to be as much an emotional and instinctive process as it is a rational and methodical one, but surely it is not only about putting together an interesting group of works and making a strong statement. I have a deep trust in art and the discourses generated by and around it, but collecting could never be a "neutral calling" because, for me, almost every acquisition is by definition the beginning of a new relationship that is the result of a moment of inexplicable chemistry.

In organizing *Monument to Now*, the second major installation of my collection, I have been fortunate to be surrounded by a group of curators whom I trust to take what I knew until now in an unknown direction. Although they have been occupied with the important task of presenting art and ideas to us in creative ways, I hope that some of you may experience this moment when seeing a work for the first time clicks in a manner that words cannot express. It is a luxury you enjoy only once in a lifetime.

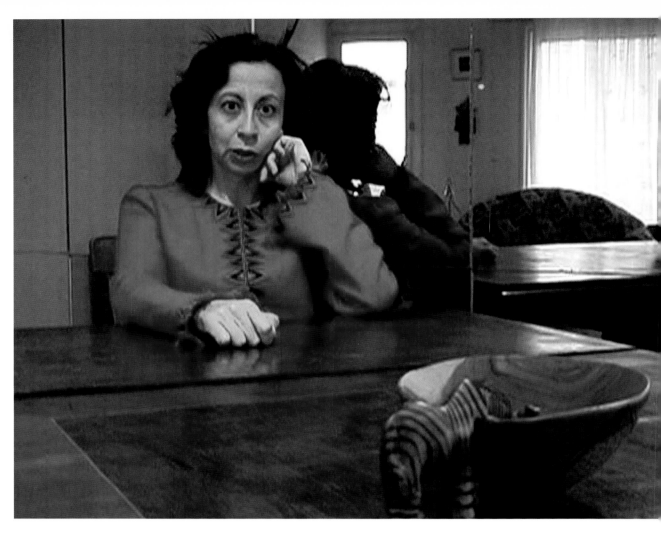

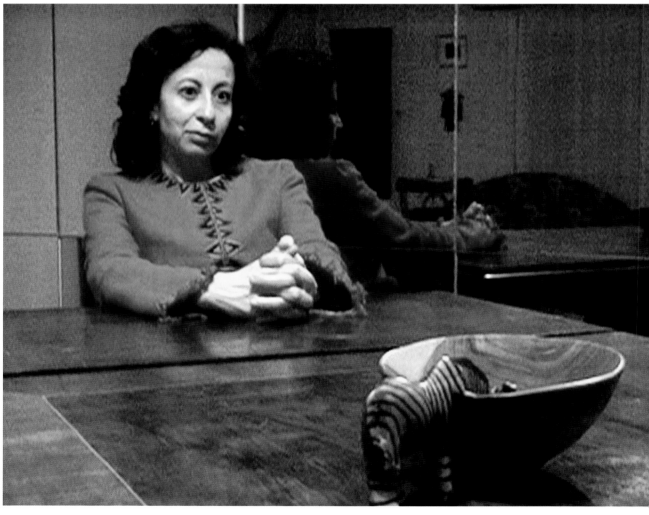

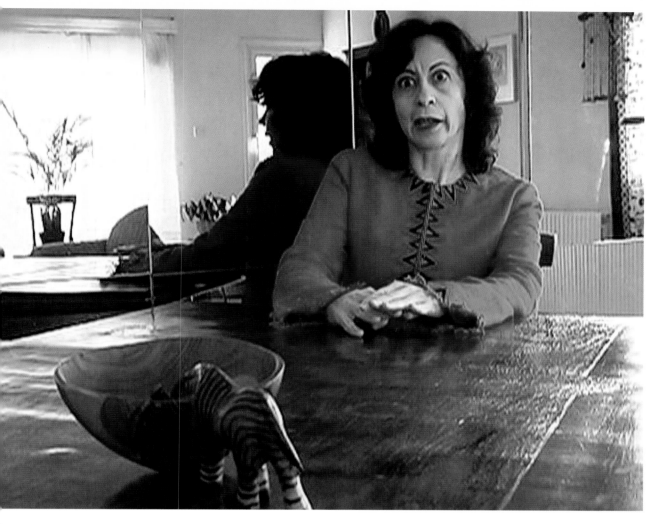

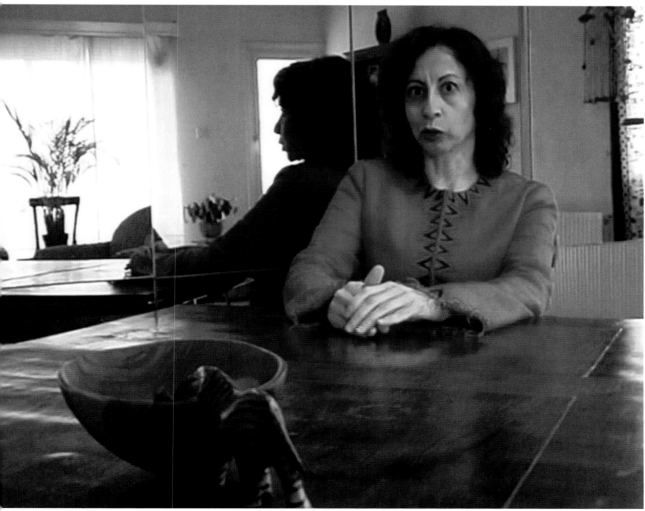

Jeffrey Deitch

A

On the new album by 2manydjs, *as heard on radio soulwax*, a Kylie Minogue hit is fused with an Emerson Lake and Palmer cover of Henry Mancini's theme to the TV show *Peter Gunn*. This is overlaid onto "Where's Your Head At" by Basement Jaxx, which flows into tracks by Peaches, the Velvet Underground, Polyester, Sly and the Family Stone, and forty other recording artists, whose songs are deconstructed, spliced, stretched, and remixed into a seamless composition. Described by the music critic of the *Evening Standard* as "a breathless concoction of 45 tracks that were never supposed to meet," it pushes the art of the dj to a new level of musical collage. Casey Spooner of Fischerspooner told me about a "white label" smash-up engineered by the dj John Selway on which Nirvana's "Smells Like Teen Spirit" is

Case Bolus. 1989–91
Cast petroleum jelly, wax, and sucrose,
45-pound Olympic weights, 8-pound dumbbells,
speculum, mouth guards, glass case,

foam and nylon pads, and binding belts
Dimensions vary

MATTHEW ▶
EARNEY
Born in San Francisco, 1967/Lives in New York

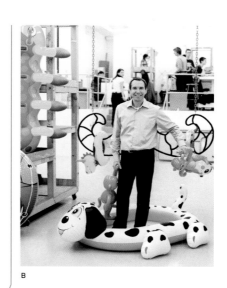

B

crossed with Fischerspooner's "Emerge" to create a hybrid en-
titled "Smells Like Emerge." Rather than being upset by this un-
authorized appropriation, Spooner was thrilled that his work had
been collaged into an unexpected mix that made the familiar new.

A new enthusiasm for collage is also found now in the
most exciting artists' studios. Jeff Koons's studio is a collage
factory. There are piles of inflatable swimming-pool toys, clip-
pings from supermarket advertising circulars, photographs from
modeling sessions, stacks of plastic chairs, aluminum ladders,
and all of the other visual raw material that is scanned, Photo-
shopped, cast, modeled, hand painted, inserted whole, or oth-
erwise transformed into his ambitious paintings and sculptures.
An inflatable caterpillar toy rams through a stepladder. A bright
red inflatable lobster is meticulously painted onto a flawless
double portrait of the St. Pauli girl, which is itself painted onto
a background appropriated from an H. C. Westermann painting.
Other sculptures incorporate ready-made elements like chain

A Dance music legends 2manydjs (aka Soulwax), 2003

B Jeff Koons in his studio, 2003

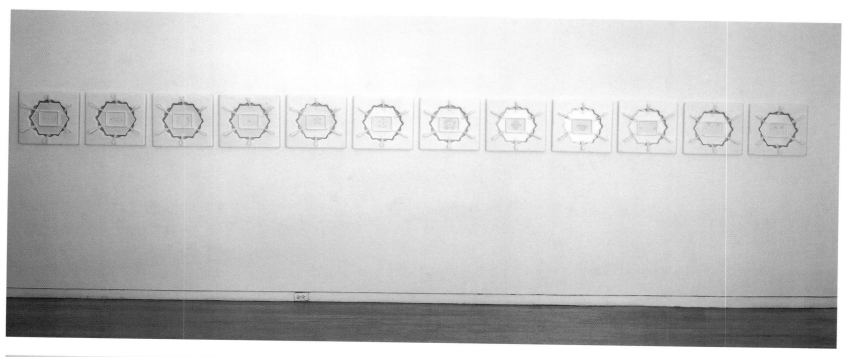

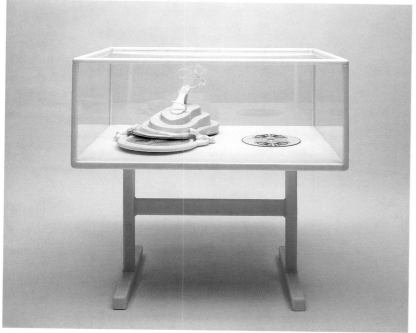

Cremaster 1: Choreographic Suite. 1996
Acrylic paint, Vaseline, and pencil on paper, vinyl floor tile, and patent vinyl in self-lubricating plastic frames
Set of 12 drawings
47,6 x 44,7 x 6,9 cm/18 3/4 x 17 5/8 x 2 3/4 in. each

Cremaster 1. 1995
Silkscreened video disk, cast polyester, self-lubricating
plastic, prosthetic plastic, and patent vinyl
40,6 x 60,9 x 54,6 cm/16 x 24 x 21 1/2 in.

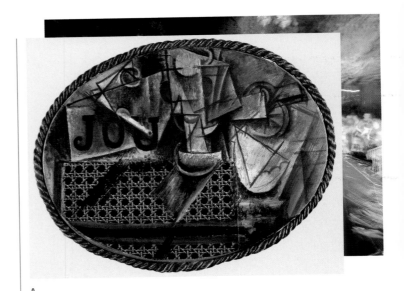

link and chair caning along with perfectly rendered and hand-painted sculptures of the found objects that were the source material. Realism, abstraction, the readymade, and collage are all intertwined. Koons's real straw chair caning has an uncanny connection with Pablo Picasso's *Still Life with Chair Caning* of 1912, the work that marked the invention of the modern concept of collage. Instead of hand painting an illusionistic rendering of chair caning, Picasso cut out a piece of oilcloth printed with a simulation of chair caning and pasted it on, creating an artistic revolution that rather than remaining enshrined in modern art history is now resonating more strongly than ever.

On my first visit to the London studio of Tim Noble and Sue Webster, unprepared for what I was to see, I was astonished to find a mound of garbage in the center of the room where one would normally expect to see a sculpture. The artists hovered around me, anxious to read my reaction as I tried to make sense of the seemingly random pile of carry-out food containers, discarded cleaning supplies, plastic garbage bags, and other debris. They then shined a spotlight on the garbage and

VB48, Palazzo Ducale, Genoa, Italy. 2001
Digital c-print
4 panels, 361 x 452 cm/142 x 178 in. total

VANESSA ▶
BEECROFT
Born in Genoa, 1969/Lives in New York

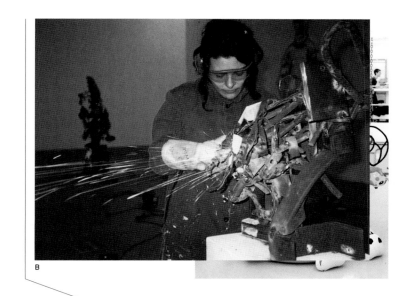

B

looked even more eagerly for my response. I was still so taken aback by the mess on the studio floor that it took me a while to notice that the spotlight on the mound of trash formed a perfect silhouette of the two artists on the wall behind. Noble and Webster had created a magical double self-portrait out of a collage of the discarded debris of their own life and work.

2manydjs, Koons, and Noble and Webster are among the surprisingly large number of influential artists, musicians, performers, writers, and filmmakers whose new work embraces a revitalization of collage. Franz Ackermann, Matthew Barney, Robert Gober, Johan Grimonprez, Barry McGee, Chris Ofili, and Tom Sachs are among the many artists in the Dakis Joannou collection for whom actual or conceptual collage is an essential element of their artistic approach. Collage was long considered to be a sideshow in the development of modern art, secondary to the invention of abstraction. Thirty years ago, it would have been

A Pablo Picasso
Still Life with Chair Caning. 1912
Oil on oilcloth on canvas edged with rope
29 x 37 cm/11 3/8 x 14 1/2 in.
Musée Picasso, Paris

B Sue Webster in her and partner Tim Noble's studio, London, 2003

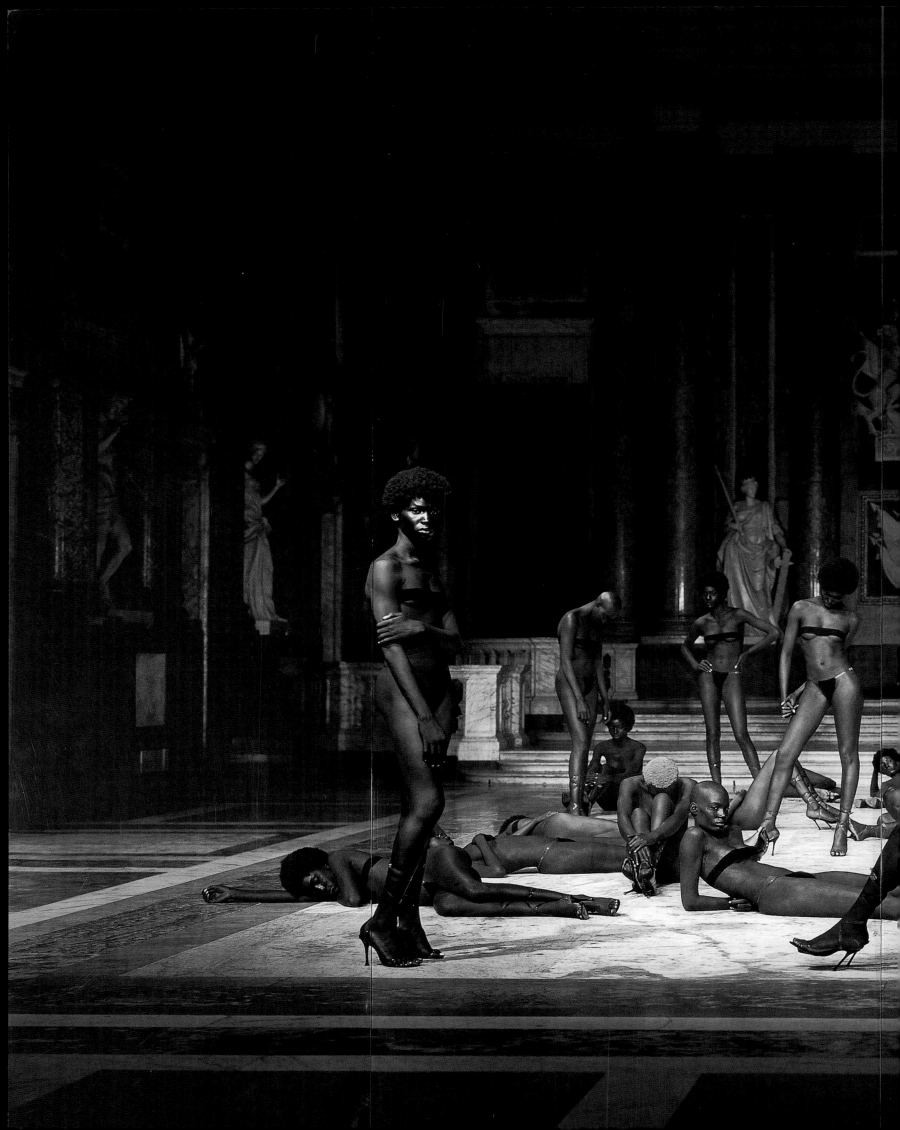

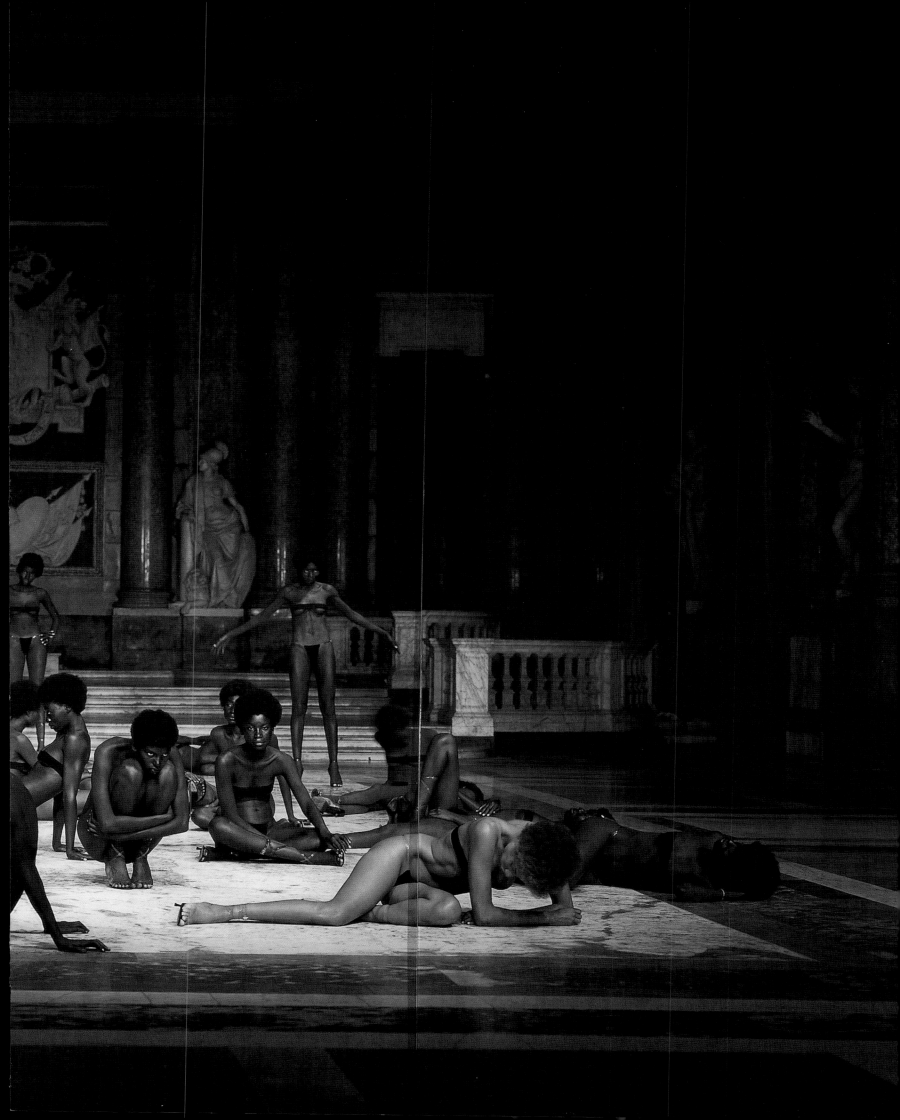

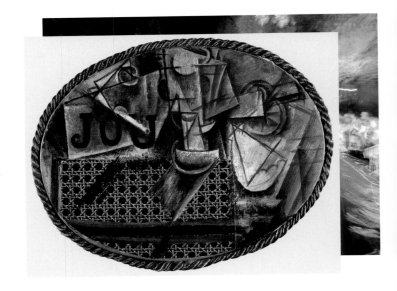

hard to imagine that the concept of collage would have more resonance today than the tradition of modernist abstraction.

As abstraction paralleled developments in science and social organization for much of the twentieth century, collage is now much closer to contemporary models of social and scientific thinking. People may live and work within large abstract structures such as corporate and government bureaucracies, but their daily experience is increasingly collaged. The multiple windows on computer screens create a virtual collage of a person's professional, personal, and financial interests. Internet links, satellite television, and mobile telephones provide a web of connections and juxtapositions that fit within Max Ernst's definition of collage as "a meeting of two distant realities on a plane foreign to them both."

VBGDW. 2000
Digital c-print
4 panels, 305 x 366 cm/120 x 144 in. total

VANESSA ▶
BEECROFT

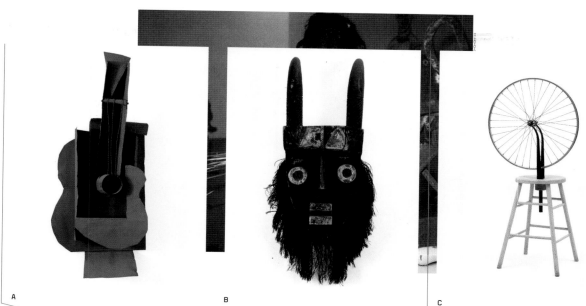

A B C

Four remarkable innovations revolutionized modern art in the years 1912 to 1914: Picasso's invention of the modern concept of collage with *Still Life with Chair Caning* in the spring of 1912; his creation of constructed sculpture with *Guitar* in 1912-13; the birth of abstraction around 1912 in a fusion of the analytical, experiential, mystical, and visionary approaches to painting; and Marcel Duchamp's invention of the readymade in 1913, which led to the development of conceptual art.

For most of the twentieth century, the emergence of abstraction was understood to be by far the most important development in modern art. Influential critics like Clement Greenberg argued that art should abstract its essential qualities, defining itself through its own form and structure. Greenberg and his followers criticized anecdotal and extraneous subject matter. In his 1958 essay "The Pasted-Paper Revolution," Greenberg saw collage not as a method to bring outside reality into art, but as a route to the achievement of the essential flatness of painting through the abstraction of the cutout form.

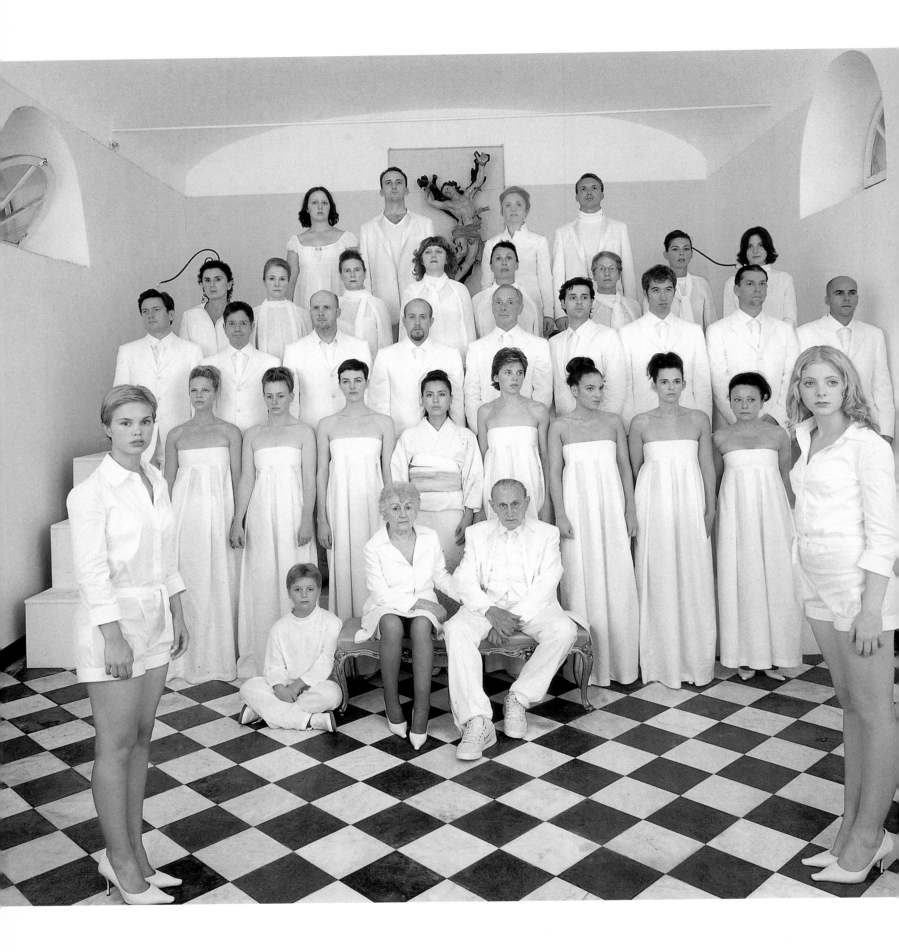

VANESSA BEECROFT

Ein Blonder Traum. 1994
Video
90 min.

Performance during the opening of *Everything That's Interesting Is New*, The Factory, National School of Fine Arts, Athens, 1996

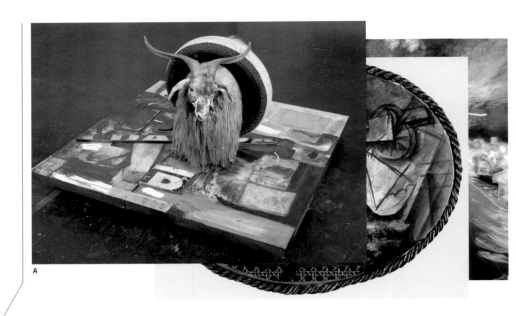

A

Although the mainstream of modernist criticism until the 1980s relegated collage and the related concept of the readymade to a secondary position, another reading of twentieth-century art traces a remarkable history of innovations developing out of collage, including essential aspects of Dada, Surrealism, and Abstract Expressionism. The music of John Cage and the work of Robert Rauschenberg and Jasper Johns also built on the collage tradition. By the 1980s, with the onset of postmodernism and revisionist criticism, collage began to be viewed as equal to or even more important than abstraction in providing the foundation for the most important developments in twentieth-century art. In "The Object of Post-Criticism," an influential essay of 1983 that explores the conceptual innovations of collage, Gregory L. Ulmer declares that "collage is the single most revolutionary formal innovation in artistic representation to occur in our century." He describes collage as "an unprecedented and significant step in bringing art and life closer to

A Robert Rauschenberg
Monogram. 1955–59
Freestanding combine
129 x 186 x 187 cm/42 x 64 x 64 1/2 in.
Moderna Museet, Stockholm
© Robert Rauschenberg/Licensed by VAGA, New York, NY

B Café Le Dôme, Paris, ca. 1930s

C Computer screen with multiple windows open

Shut Up, I'm Meditatin'. 1999
Acrylic paint on canvas
2 panels, 188 x 396,2 cm/74 x 156 in. total

MICHAEL ▶
BEVILACQUA
Born in Carmel, California, 1966/Lives in New York

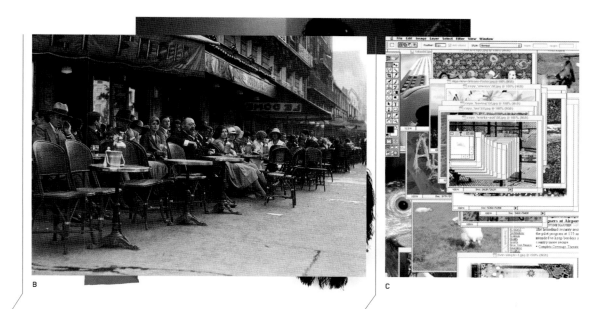

B

C

being a simultaneous experience." He interprets it as "a solu-
tion which finally provided an alternative to the 'illusionism' of
perspective," explaining that "by incorporating directly into the
work an actual fragment of the referent...it remains 'represen-
tational' while breaking completely with the *trompe l'oeil* illusion-
ism of traditional realism."

The Paris café, which figures prominently in many of Pi-
casso's early collages, was the center of artistic exchange, the
place where the artists went to interact with their community and
with the larger world. Like the collage, it was a platform for ran-
dom couplings and unexpected juxtapositions. Although there
are still cafés in Paris that are frequented by artists, and artists'
bars in cities like Berlin and New York, the kind of exchange that
happened in a Paris café in 1912 is perhaps more likely to take
place today on a computer screen. There is again a social struc-
ture through which to exchange images and opinions that artists
can access on a daily basis. Like the chance encounter in the
café, the online computer can also lead to unexpected connec-
tions. A Web surfer's computer screen regularly sends up the vir-

◀ MICHAEL
BEVILACQUA

Tomorrow Comes Today. 2002
Acrylic paint on linen
2 panels, 122 x 335,2 cm/48 x 132 in. total

Split Screen. 1998
Acrylic paint on canvas
2 panels, 121,9 x 304,8 cm/48 x 120 in. total

tual equivalent of the Comte de Lautréamont's "chance encounter of a sewing machine and an umbrella on a dissection table."

In a society where the real and the unreal and the high and the low are regularly juxtaposed, shuffled, and confused, collage has again become a model that artists use to interpret contemporary reality. The absolutes of pure abstraction have become less relevant as an artistic model of the world, where very little remains pure, if it ever was. The search for absolute truth, which was taken for granted as one of the principal artistic goals throughout much of modern art history, has been replaced by a relativistic approach. Philosophically, reality is now more likely to be defined through social and physical interaction, through a person or an object's connection with other people and other things. A monolithic understanding of the philosophical self seems no longer to be relevant. The artist's life experience today, like that of most people in the most international cities, is

A Man Ray
Marcel Duchamp Dressed as Rrose Sélavy. 1924
Gelatin silver print
21,6 x 17,3 cm/8 1/2 x 6 13/16 in.
Philadelphia Museum of Art. The Samuel S. White 3rd and
Vera White Collection (1957-49-1)

F.O.B. 1993
Fiberglass, enamel paint, and steel
208,2 x 78,7 x 73,6 cm/82 x 31 x 29 in.

ASHLEY ▶
BICKERTON
Born in Barbados, 1959/Lives in Bali

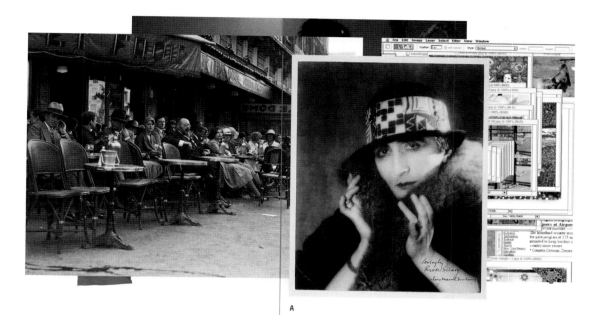

A

multicultural, multiethnic, and multimedia. Rather than trying to find a universal reality, artists, like other cosmopolitan people, are collaging multiple realities. It is interesting to note that Picasso's invention of constructed sculpture and his development of collage may have had a cross-cultural source. He is reported to have been fascinated by an African Grebo mask, which he may have acquired during the summer of 1912. Its protruding cylindrical eyes, which were attached to the face, are thought to have been part of the inspiration for Picasso's constructed *Guitar*.

Paris in 1912 was a crossroads of cultural exchange, with ambitious creative people converging from all corners of the world and new horizons opening through the colonial experience. Like New York today, Venice in the sixteenth century, and the great trading cities of antiquity, it was conducive to a cultural mix that encouraged hybrid artistic forms. The café culture of bohemian Paris also generated the context for the development of a new concept of self that was related to collage, that is, the collaged or fabricated persona. Sammy Rosenstock's transformation into Tristan Tzara and Duchamp's creation of Rrose Sélavy are

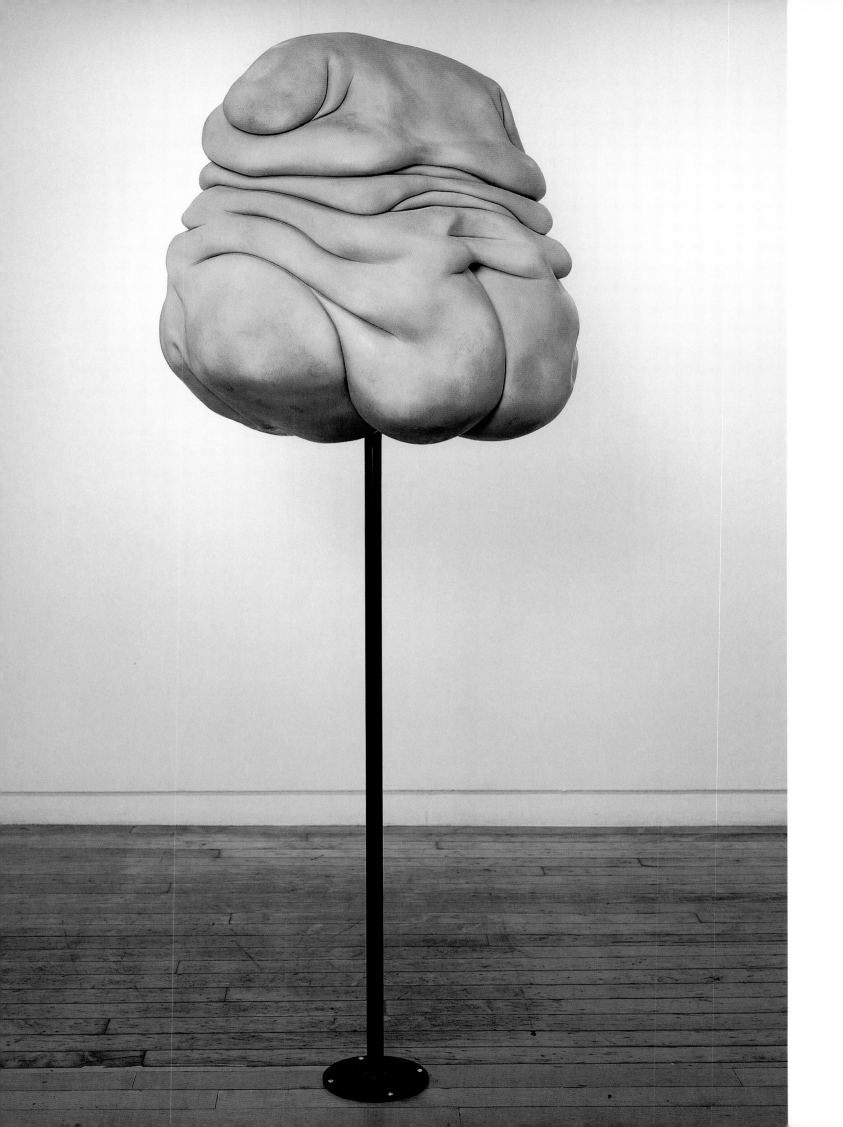

Abstract Painting for People No. 5. 1987
Silkscreen, acrylic aniline dye, and polyester resin
on plywood with anodized aluminum
172,7 x 121,9 x 38,1 cm/68 x 48 x 15 in.

Wall Wall 4. 1986
Plaster, polymer, plywood, aluminum, and silver paint
121,9 x 121,9 x 16,5 cm/48 x 48 x 6 1/2 in.

A

two of the most prominent examples of a trend that, as ex-
plained in the essay by Alison M. Gingeras that follows this one,
continues to influence the course of contemporary art. The new
freedom to re-create oneself rather than accepting the body
and the social situation into which one was born has resulted
in a new kind of collaged identity. Plastic surgery, hair and skin
treatments, and body sculpting allow people to collage a new
self-image. Whole social subcultures are now living examples
of collaged identity almost to the point of performance art. The
Japanese subculture of *ganguro* girls in Tokyo's Shibuya dis-
trict cultivates a collage of ghetto fabulous and Dallas Cowboys
cheerleader styles mixed with the highly choreographed manner-
isms of Japanese traditional theater.

Despite the continuing dynamism of the collage tradition
into the art of the early 1960s, collage had ceased to be an in-
spiration for the leading vanguard artists who emerged after the
Pop and assemblage movements. The next embrace of a col-
lage approach appeared not in the art galleries but in the play-
grounds of the South Bronx, in the illegal loft discos in down-

Formalist Painting with Red, Yellow, and Blue. 1988
Mixed-media construction with padded yellow canvas,
steel, and enamel paint
82,5 x 204,4 x 91,4 cm/32 1/2 x 80 1/2 x 36 in.

Seascape: Transporter for the
Waste of Its Own Construction, No. 1. 1989
Wood, aluminum, glass, fiberglass, plastic, leather, and rope
57,1 x 209,5 x 78,7 cm/22 1/2 x 82 1/2 x 31 in.

ASHLEY ▶
EICKERTON

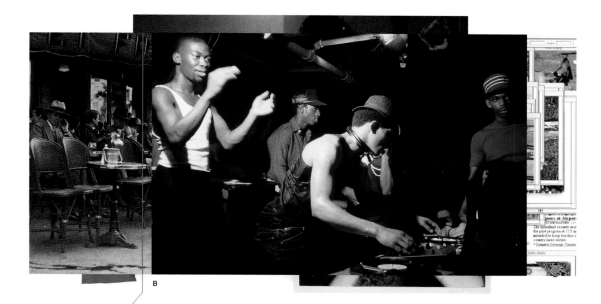

town Manhattan, and on the streets around the Bowery. This revitalization of collage developed in three underground music scenes that began to flourish in New York in the mid-1970s. The birth of hip hop, the development of gay dance club culture, and the attitude of punk rock took the concept of collage to a new level that continues to exert enormous influence on both vanguard and popular culture. These innovations in music led to the emergence of the dj as an artist and as the embodiment of the contemporary concept of collage.

The operators of sound systems like Kool Herc who set up in playgrounds and Police Athletic League gyms in the South Bronx did not have artistic pretensions. They were out to get a good party going and give people a good time. Kool Herc and several other hip-hop pioneers like the Cold Crush Brothers did not even record in the early days. They were just making party music and could not imagine that their innovations were the be-

A *Ganguro* girls in the Shibuya district of downtown Tokyo

B Dj Lovebug Starsky and Grand Master Caz at the Celebrity Club,
 Harlem, 1980

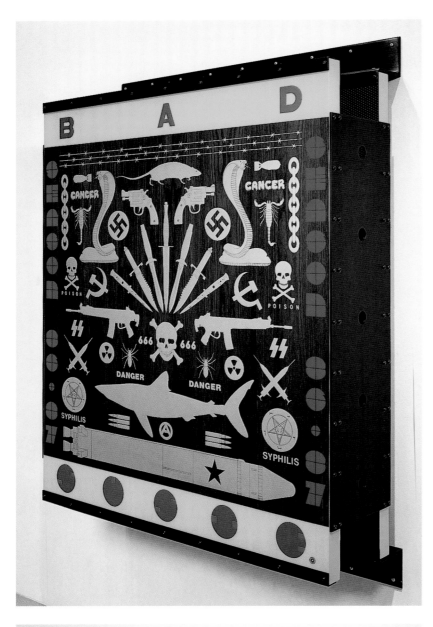

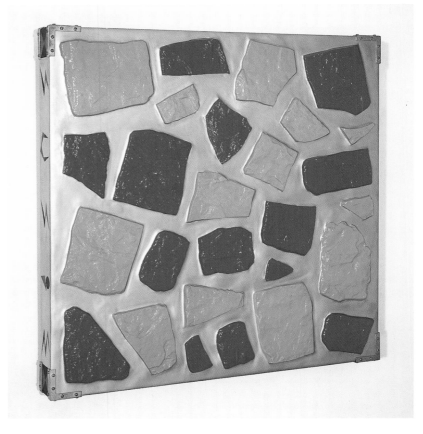

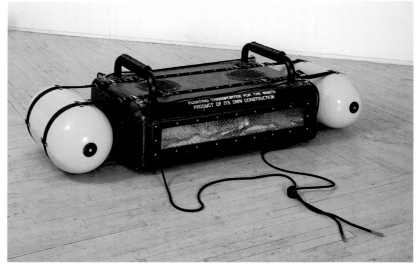

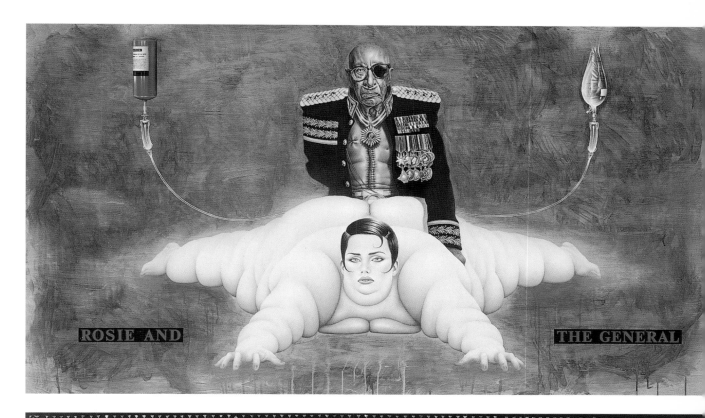

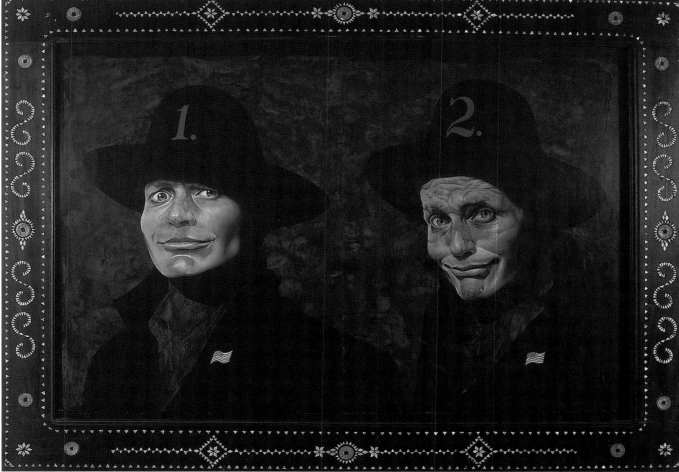

◀ ASHLEY
BICKERTON

Rosie and the General. 1996
Oil paint, acrylic paint, and pencil on wood
122,2 x 209,5 cm/48 1/8 x 82 1/2 in.

Double Self: The Patriots. 2002
Acrylic paint on paper with wood frame and
mother-of-pearl inlay
81,2 x 111,1 cm/32 x 43 3/4 in.

ginning of a new art form that would eventually transform popular culture. Kool Herc noticed that when he broke out the beats that made the b-boys dance and collaged them into a continuous dance number through manipulation of the turntables, the crowd went wild.

Legend has it that the first dj to perfect the use of two turntables to merge one dance song with another was an Italian American ex—go go dancer named Francis Grasso. Around 1969, Grasso perfected his technique at The Sanctuary in New York's Hell's Kitchen and at The Haven on Christopher Street. He was one of the first of a group of innovators whose obsession with creating an immersive dance club led to the creation of a new type of musical experience. Like the founders of hip hop, these dance club pioneers could never imagine that their passion would spawn a worldwide cultural phenomenon. The clubs like David Mancuso's The Loft on Broadway near SoHo were deliberately underground, catering to a dedicated gay, mostly black and Latino clientele. Although their musical legacy may include thousands of cheesy disco lounges in hotels around the world,

House of Hope. 1997
Wooden stools, strands of hanging herbal beads, herbs,
Chinese medicines, and other media
Dimensions vary

MONTIEN ▶
BOONMA
Born in Bangkok, 1953/Died in Bangkok, 2000

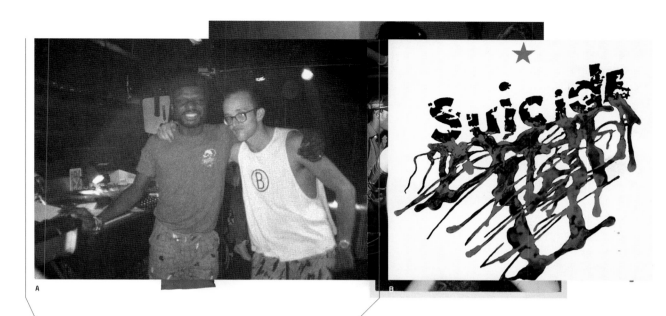

they also engendered a legendary group of underground dance
clubs like the Paradise Garage in New York and the Warehouse
in Chicago, where djs like Larry Levan and Frankie Knuckles con-
tinued to innovate and surprise, creating nights of musical col-
lage that are still remembered with reverence.

Unlike the pioneers of hip hop and dance club culture,
many of the punk and no wave bands that emerged in New York
in the mid- to late 1970s did have artistic pretensions. Many of
the band members were, in fact, artists and conceived of their
music as an extension of performance art. Punk rock ranged
from the Ramones' compressed, speeded-up versions of 1960s
rock to Suicide's collages of synthesized sound and beat poet-
ry. The collage element in punk was as much in its look and its
ethos as in its sound. The slash-and-burn fashion and cut-up
graphics favored by the bands and their circle made this exten-
sion of collage a central part of their image and their aesthetic

A Larry Levan and Keith Haring at the closing party of the Paradise Garage,
New York, September 26, 1987
Photo © Tina Paul 1987. All Rights Reserved

B The cover of Suicide's debut album, 1977. Illustration by
Timothy Jackson and Alan Vega

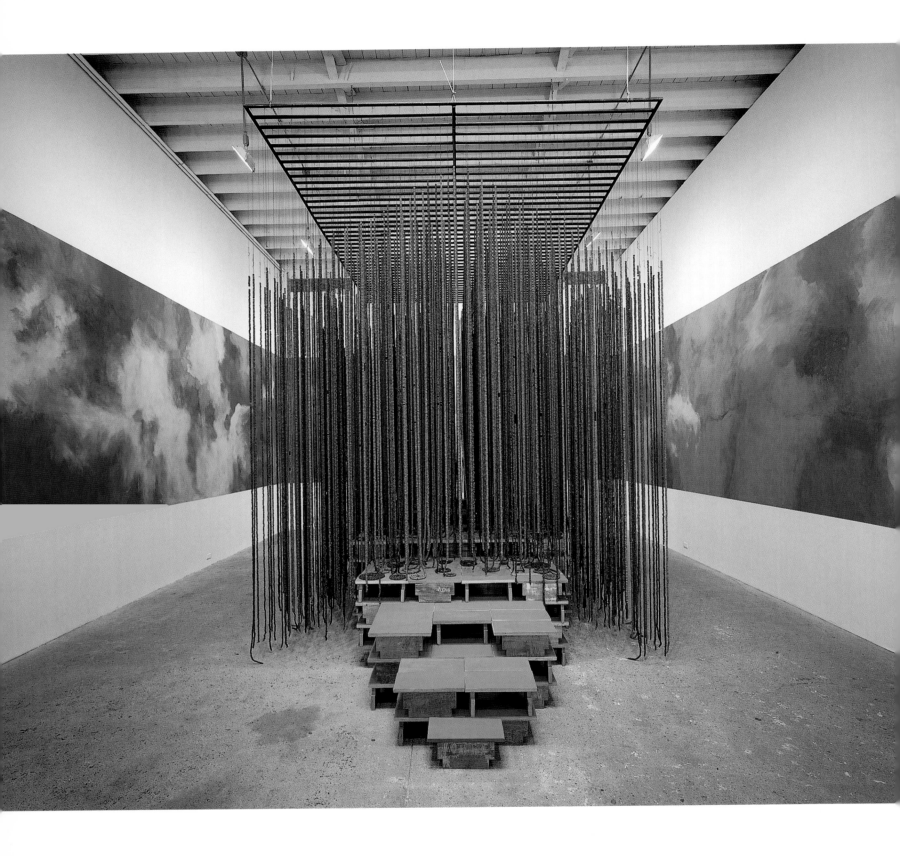

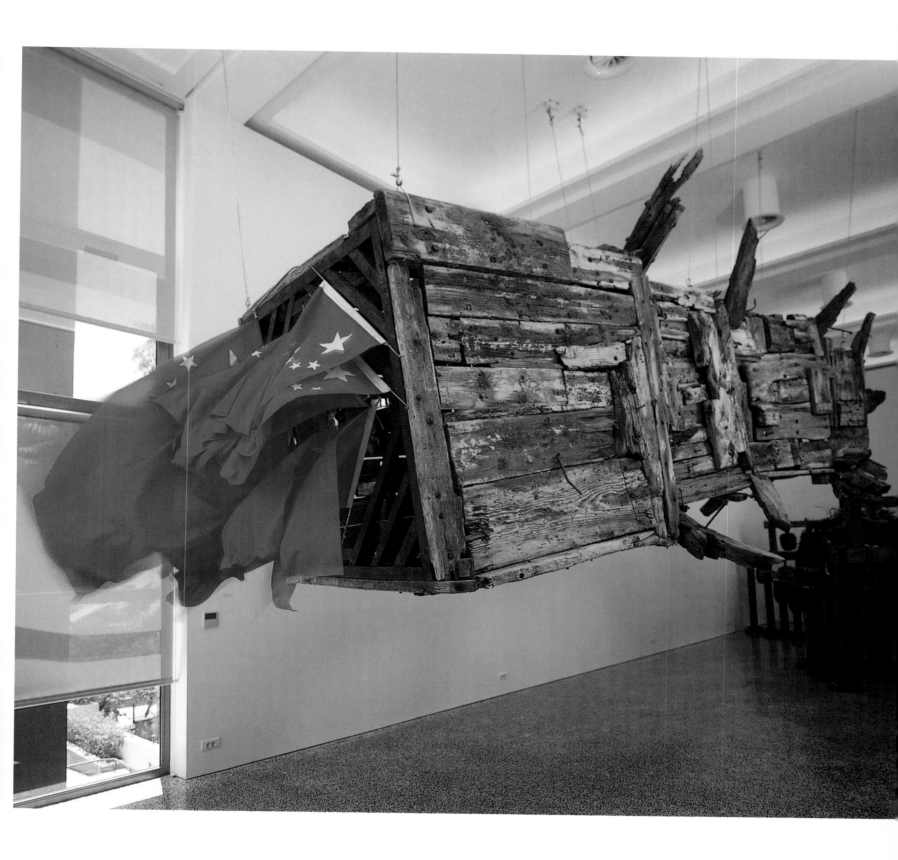

The Dragon Has Arrived. 1997
Wood, electric fans, flags (People's Republic
of China), and lights
Dimensions vary

message. The writer Kathy Acker, who was a central figure in the mid-1970s New York art and rock scenes, published novels like *Kathy Goes to Haiti* that were collages of texts appropriated from other writers.

Several influential figures, such as Charlie Ahearn, Fred Brathwaite, Diego Cortez, and Keith Haring, all artists, became links between these various scenes, mixing hip hop and graffiti from the South Bronx with the downtown art world, punk rock, and the gay dance club culture. It is partly through these talented connectors that the art and music emerged out of the subcultures that created them and entered the broader culture. The revitalization of collage in these three music-oriented scenes influenced the new art of the early 1980s, particularly the work of Jean-Michel Basquiat and Keith Haring, but the full influence of these developments seems to have skipped a generation. It is only now that the impact of these extensions of collage is being strongly felt in contemporary art. The artists in their twenties and early thirties who are currently shaping the artistic agenda are people who grew up listening to hip hop, going to

Frank & Jamie. 2002
Wax and clothes
Frank, 191,7 x 63,5 x 52,7 cm/75 1/2 x 25 x 20 3/4 in.;
Jamie, 182,2 x 62,8 x 45,7 cm/71 3/4 x 24 3/4 x 18 in.

MAURIZIO ▶
CATTELAN
Born in Padua, Italy, 1960/Lives in Milan and New York

dance clubs, and studying the music and style of punk rockers. This is part of the foundation of their artistic culture.

Rather than building on the influence of music subcultures of the mid-1970s, artists of the 1980s tended to look to earlier models of collage, referencing Dada and Surrealism and the work of Rauschenberg and Johns. The major exceptions were the artists who converged around the 1980 *Times Square Show*, which mixed artists from uptown and downtown. Basquiat made his art world debut as a painter in the *Times Square Show*, but he was already known for his conceptual street poetry written under the name of SAMO. He was also a member of a no wave band called Gray. Even Basquiat's earliest paintings display a mastery of collage, encompassing words, images, and found objects from his voracious study of art, music, history, and literature and his nightly adventures on the street. The work is multicultural and

A Jean-Michel Basquiat
Peter and the Wolf. 1985
Acrylic, oil stick, and Xerox collage on canvas
254 x 287 cm/100 x 113 in.
The Dakis Joannou Collection, Athens

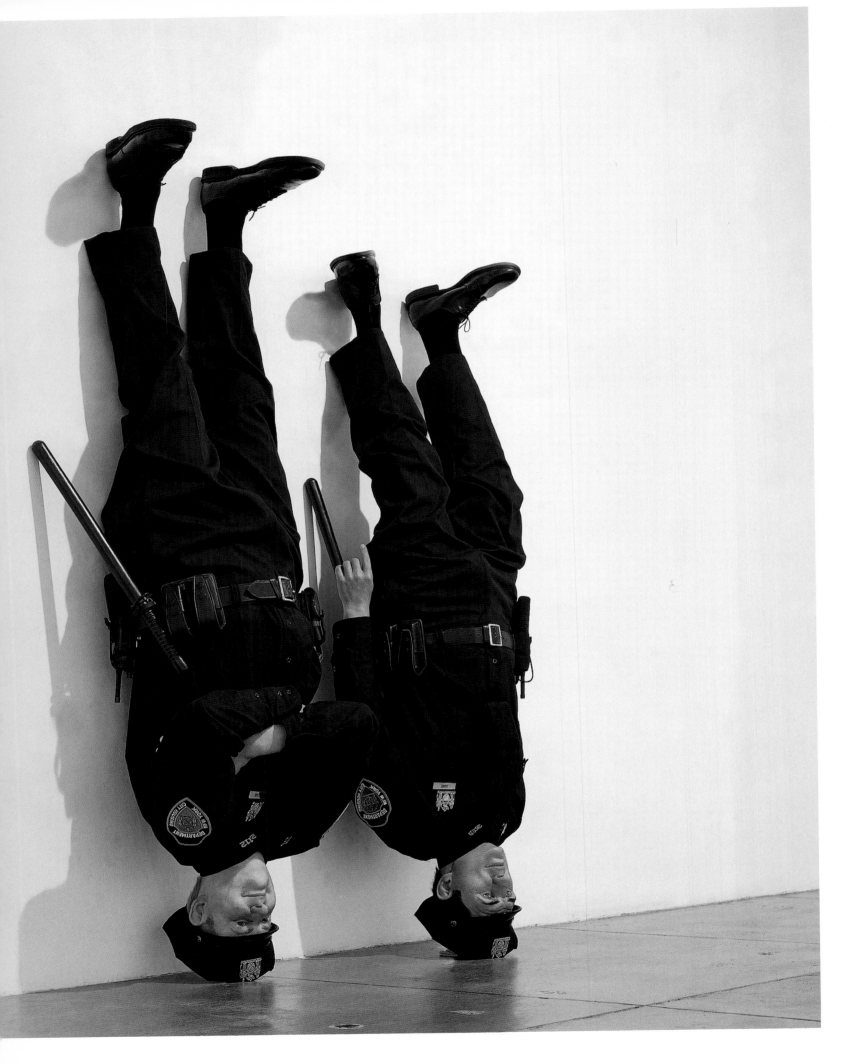

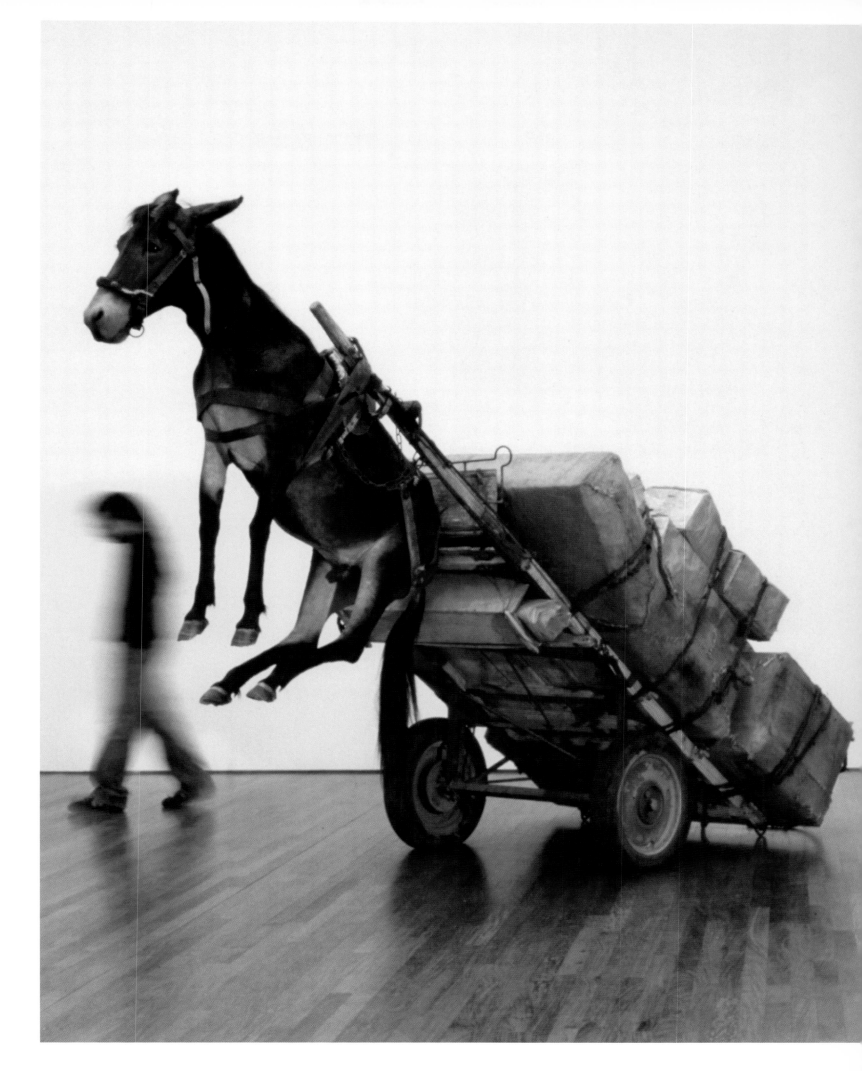

◀ MAURIZIO
CATTELAN

Untitled. 2002
Taxidermied donkey and cart
300 x 120 x 400 cm/118 x 47 1/4 x 157 1/2 in.

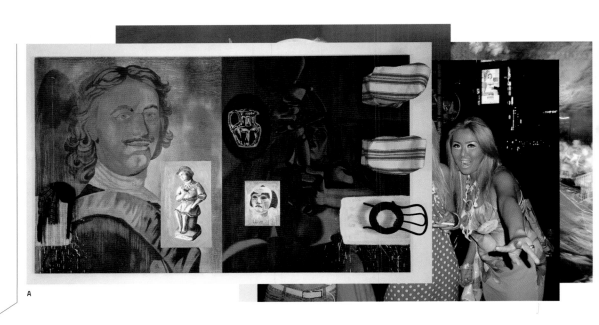

A

multilingual, fusing European, American, and Afro-Caribbean tra-
ditions and incorporating words in English, French, and Spanish.

David Salle's layered, dreamlike imagery and his practice of
attaching chairs and other found objects to his paintings reference
Dada and Surrealist artists like Francis Picabia as well as the work
of Rauschenberg and Johns. Gober also draws on Surrealist sources
like Hans Bellmer in his use of sculptural collage. Cindy Sherman
embraces Duchamp and the Dadists' invention of the fabricated
persona. Haim Steinbach's juxtapositions of strange objects and
minimalist shelves are contemporary versions of Lautréamont's
chance encounter. These artistic innovators of the 1980s brought
representation and interchange with the real world back into art af-
ter a twenty-year stretch when many of the leading artistic figures
focused on art's interior formal and conceptual structure.

A David Salle
 Théâtre des Amis. 1989
 Acrylic paint, oil paint, canvas, fabric, and 3 wood chairs
 288,2 x 478,1 x 101,6 cm/113 1/2 x 188 1/4 x 40 in.
 The Dakis Joannou Collection, Athens
 © David Salle/Licensed by VAGA, New York, NY

B Jeff Koons
 One Ball Total Equilibrium Tank. 1985
 Glass, iron, water, and basketball
 163,8 x 77,4 x 33,6 cm/64 1/2 x 30 1/2 x 13 1/4 in.
 The Dakis Joannou Collection, Athens

C Jeff Koons
 Ushering in Banality. 1988
 Polychromed wood
 96,5 x 157,4 x 76,2 cm/38 x 62 x 30 in.
 The Dakis Joannou Collection, Athens

Untitled. 2001
Wax and fabric
Figure, 150 cm/59 in. high; hole, 60 x 40 cm/23 5/8 x 15 3/4 in.
Installation at Museum Boijmans van Beuningen, Rotterdam, the Netherlands

MAURIZIO ▶
CATTELAN

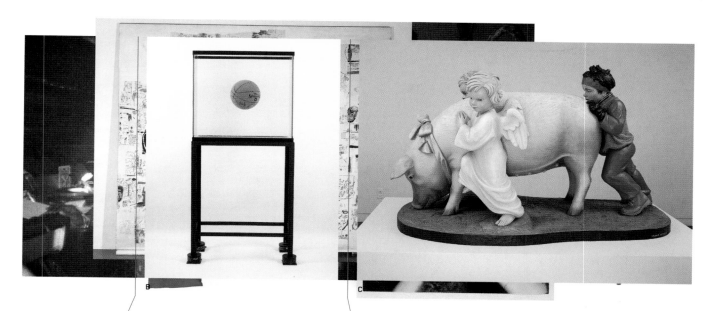

Outrageous juxtapositions of images, concepts, and emotions that were never meant to be combined in the same object contribute to the power of Koons's art. Opposite forces are fused, resulting in images that resonate in the memory. He excavates the deep structure of his forms to create works that communicate to the subconscious. Koons builds on the example of Duchamp's assisted readymades like the *Bicycle Wheel* (1913), producing emotionally charged pieces that collage objects connoting highbrow and lowbrow, illusion and reality, security and fear. In several of his well-known series, Koons pairs objects and materials like vacuum cleaners and the light from fluorescent tubes or basketballs floating in water. In other series, the elements are joined together into hybrids, as in *Ushering in Banality* (1988). In his recent paintings, his use of collage is seamless. The unlikely combinations of images are fused with an irrational but understandable logic into portraits of contemporary experience. Koons takes collage to a new level in creating objects that embody the contradictions of everyday life.

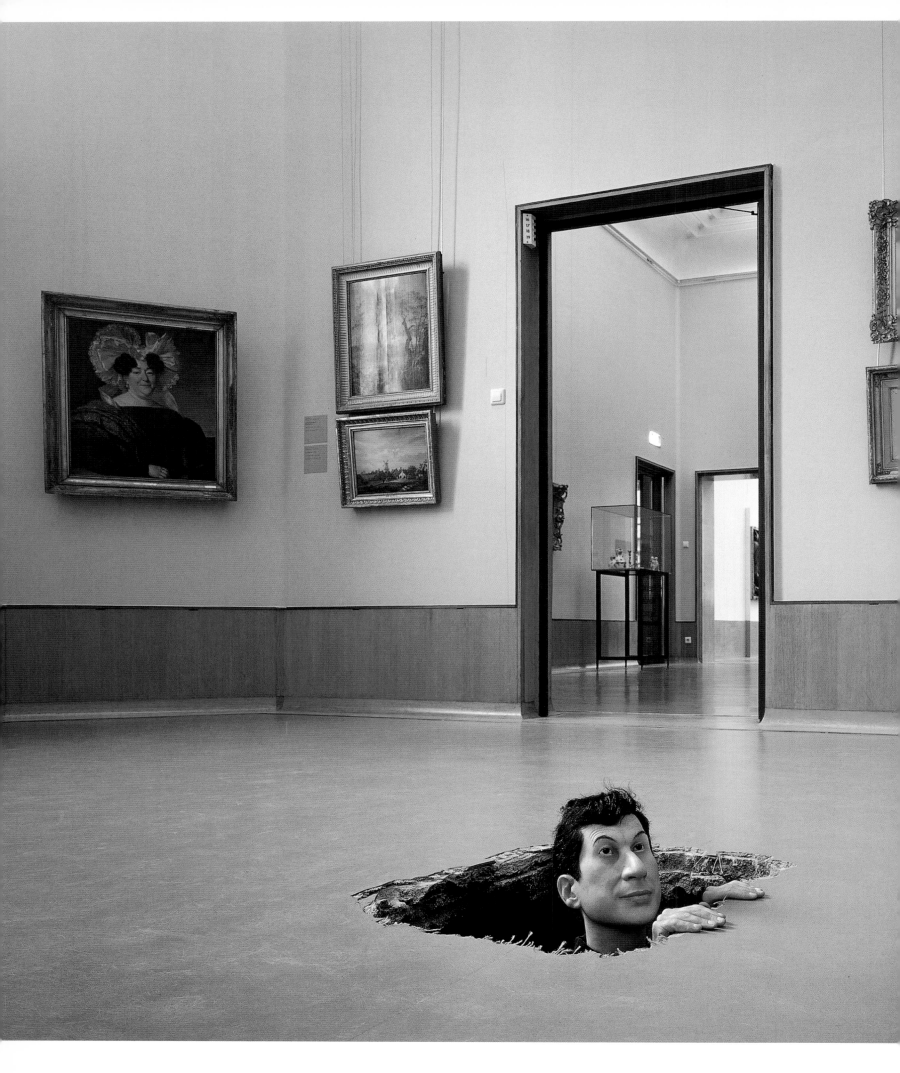

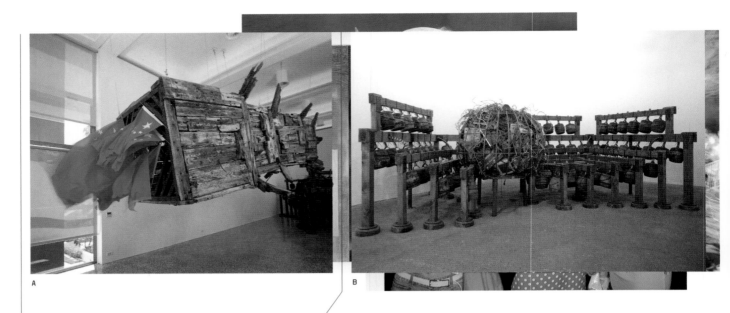

A

B

Contemporary life necessitates the integration of increasingly complex contradictions and juxtapositions, and many of the strongest artists who have emerged during the last decade reflect this new reality in their work. From performance art to geometric abstraction, contemporary art increasingly encompasses this fractured or collaged environment. Economic globalization has also led to a more globalized art community. Artists like Cai Guo-Qiang, Chen Zhen, and Shahzia Sikander have created hybrid approaches that fuse the art of traditional cultures with a contemporary artistic language. In Cai Guo-Qiang's sculpture *The Dragon Has Arrived* (1997), banners propelled by electric fans are attached to the bottom of a flying pagoda. In Chen Zhen's *Daily Incantations* (1996), an assemblage of discarded television sets and other electronic devices is nestled in-

A Cai Guo-Qiang
The Dragon Has Arrived. 1997
Wood, electric fans, flags (People's Republic of China), and lights
Dimensions vary
The Dakis Joannou Collection, Athens

B Chen Zhen
Daily Incantations. 1996
Wood, metal, chamber pots, electrical appliances, television sets, and cable
Dimensions vary
The Dakis Joannou Collection, Athens

C Mariko Mori
Pure Land. 1996–98
Glass with photograph interlayer
5 panels, 3,05 m x 6,1 m x 2 cm/10 ft. x 20 ft. x 7/8 in. total
The Dakis Joannou Collection, Athens

D *Form Follows Fiction*, 2001, book cover

Untitled (Gerard). 1999
Plastic dummy, clothes, shoes, and blanket
82 x 66 x 87 cm/32 1/4 x 26 x 34 1/4 in.

MAURIZIO ▶
CATTELAN

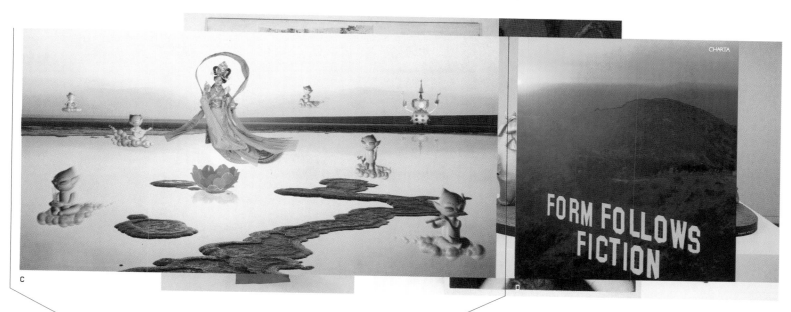

side a traditional Chinese musical instrument made out of used chamber pots. Mariko Mori's work mixes traditional Japanese aesthetics with the contradictions of contemporary Japanese culture and a dream of a new cybernetic age. Her work collapses time into a fusion of past, present, and future.

"Form Follows Fiction" is the title of an essay I wrote in 2001 that describes the most important artists of the 1990s as creators of fictional worlds. Barney, Gregory Crewdson, and Mori are examples of artists with this visionary approach. At the beginning of the 1990s, there was a tendency for artists to turn inward and create personal worlds that mixed fantasy and reality. The motivation behind this essay is to articulate, as in "Form Follows Fiction," an overriding theme or structural approach that explains the direction of the most influential contemporary art. One of the essential themes that links the work of Ackermann, Maurizio Cattelan, Koons, Noble and Webster, Ofili, and a number of the other most important artists working today is a reflection of the cultural collage that envelops us, and a reinvention of collage in their work.

Spermini. 1997
Painted cast rubber
50 elements, 17,5 x 9 x 10 cm/6 7/8 x 3 1/2 x 3 15/16 in. each

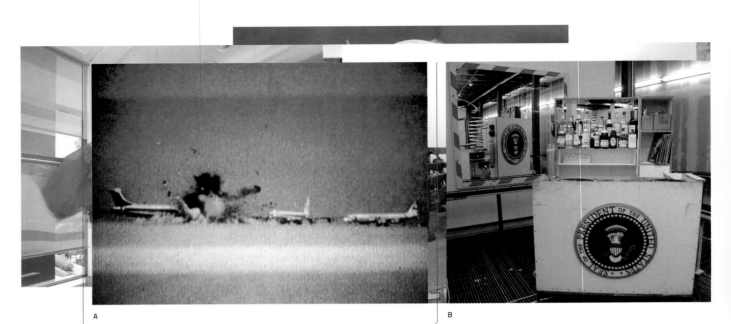

A B

Djs were among the first to articulate the new culture of
collage. Christian Marclay was one of the first to apply the con-
ceptual approach of dj culture to visual art. From his portraits
of hybrid rock stars collaged from record album covers to his
recent video-and-sound collages, his work has had a growing
influence on the structure of artistic thinking. Grimonprez's as-
tonishing video collage *Dial H-I-S-T-O-R-Y* (1997) compress-
es twenty years' worth of television clips chronicling the his-
tory of airplane hijacking, creating a disturbing parallel between
real events and these new artistic approaches. The work is en-
hanced with a riveting soundtrack by the dj David Shea.

In one of Sachs's new pieces, he collages the U.S. presi-
dential seal onto the front of a dj booth. It is an appropriate
commentary on both the practice of managed news and the
central importance of the dj in contemporary culture. Sachs
uses a collage structure to comment on the multiple sides of
the modern dream. In his recent *Nutsy's* project, he spent more
than a year hand-building scale models of two of Le Corbus-
ier's most famous buildings, which were realizations of what

Daily Incantations, 1996
Wood, metal, chamber pots, electrical appliances,
television sets, and cable
Dimensions vary

CHEN
ZHEN
Born in Shanghai, 1955/Died in Paris, 2000

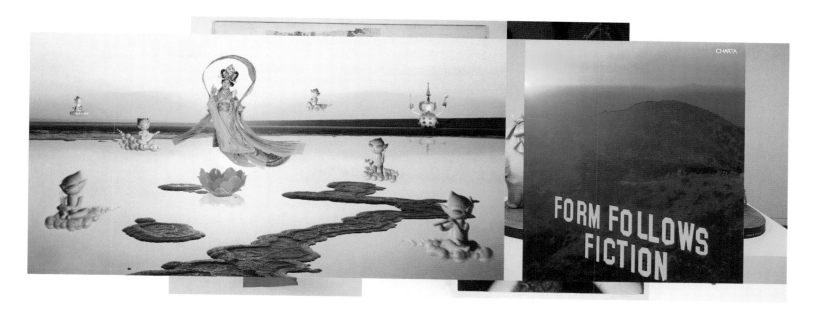

was conceived as a modern utopia. Sachs's hand-glued styrofoam models capture both the majesty of Le Corbusier's dream and the decay of the idealized concrete forms. These works are paired with a fully functioning hand-built scale model of a McDonald's restaurant, showing the reality of modernism's impact on daily life. Sachs's collaged approach honors the tradition of the *bricoleurs*, the craftsmen whose experiments with odd combinations of materials created many of our modern inventions. His work also embraces the other side of modernism, paying homage to Nutsy, the proprietor of a bicycle shop in Jamaica who specializes in keeping things rolling with an improvised collage of scavenged materials.

A Johan Grimonprez
Dial H-I-S-T-O-R-Y, 1997
Video
68 min.
The Dakis Joannou Collection, Athens

B Tom Sachs
Presidential Vampire Booth (Nutsy's DJ Booth), 2002
Metal, wood, hardware, stereo components, and bottles of alcohol
121,9 x 182,9 x 121,9 cm/48 x 72 x 48 in.

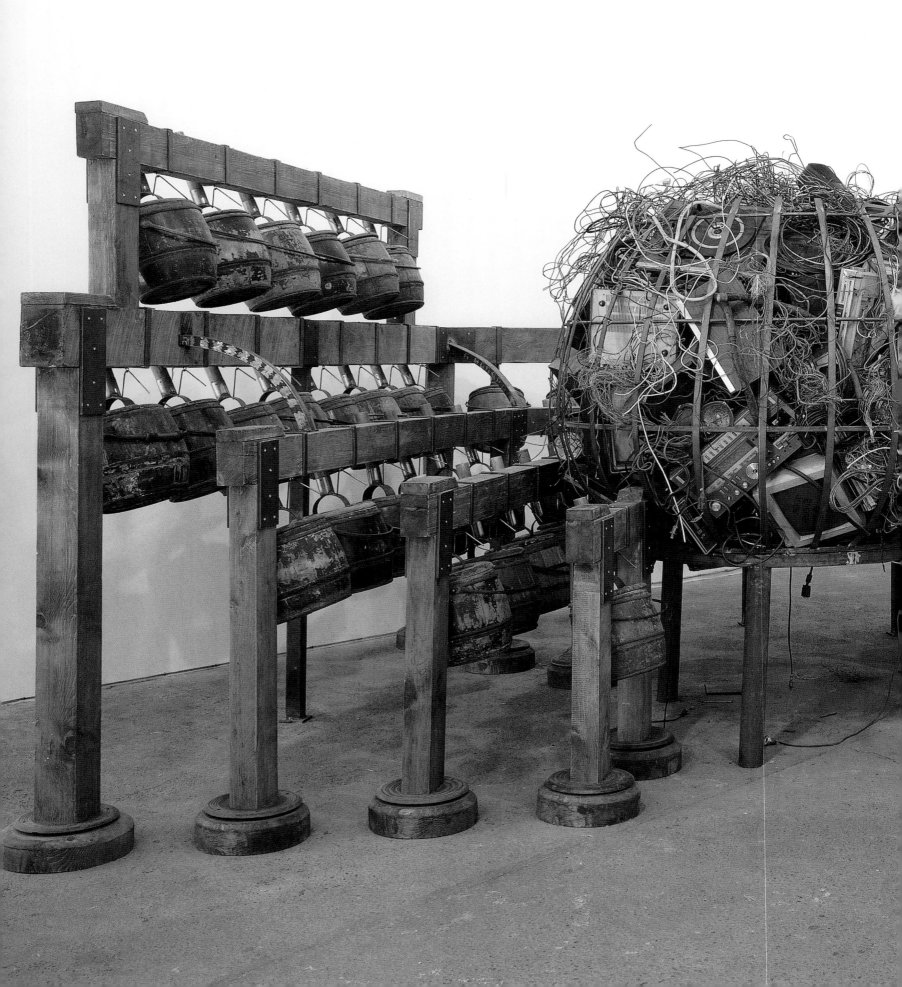

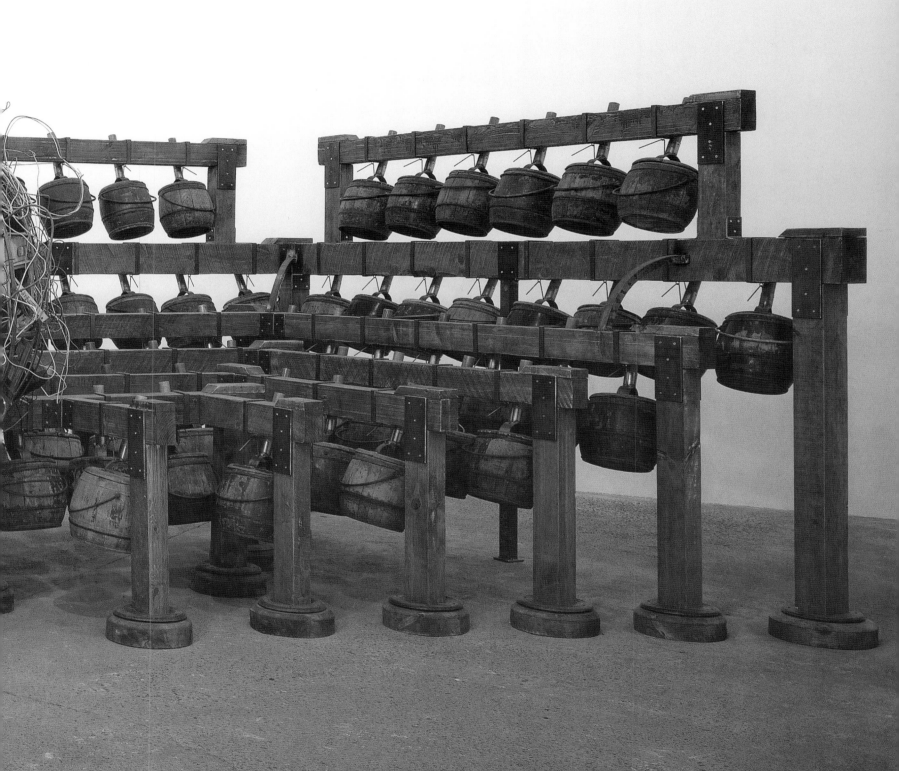

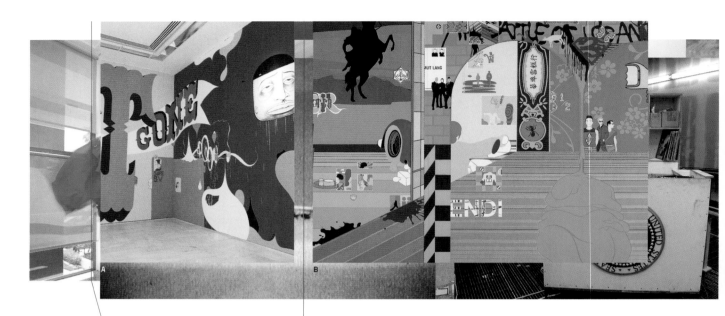

Art in the street is part of a natural collage, where the tags of graffiti writers are juxtaposed with posters, shop signs, and variations of the street art popularized by Haring and Basquiat in the early 1980s. McGee, revered as one the great street artists (writing under the street name of Twist), has recently taken some tentative steps up from the underground and begun showing his work in galleries and museums. His work is built from the same kind of collage of found images and signs that appears in the street, enhanced by his own masterful drawings of the lonely men left behind by the churning of the contemporary economy. These streets signs, along with some of McGee's own tags, are also often incorporated into the paintings of Michael Bevilacqua, which are constructed from collages of the signs and logos of youth culture, vanguard culture, and luxury brands. Bevilacqua's work extends the tradition of painterly collage as practiced by Johns into the logo landscape of the present.

A Barry McGee & Margaret Kilgallen
Holdfast. 1999–2000
Mixed-media installation
Dimensions vary
The Dakis Joannou Collection, Athens

B Michael Bevilacqua
Shut Up, I'm Meditatin'. 1999
Acrylic paint on canvas
2 panels, 188 x 396,2 cm/74 x 156 in. total
The Dakis Joannou Collection, Athens

Silver Morosa. 2003
Acrylic paint on canvas
183 × 244 cm/72 × 96 1/8 in.

Smokestack in the Sun's Eye. 2003
Oil paint on canvas
182,4 × 243,2 cm/6 × 8 ft.

NIGEL ▶
COOKE

Born in Manchester, England, 1973/Lives in London

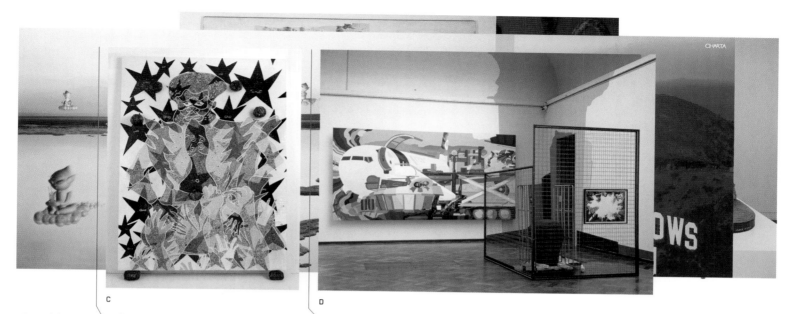

C D

Collage is also an essential element in the structure of some of the strongest new abstract painting. Artists like Ackermann, Ofili, Matthew Ritchie, and Fred Tomaselli have revitalized abstract painting by injecting pop culture imagery into the vocabulary of geometric abstraction. They are as influenced by the popularized versions of geometric abstraction found in 1960s textile designs, floor tiles, and supergraphics as they are by the "pure" abstraction of Vasily Kandinsky and Piet Mondrian. This new abstraction is deliberately impure. In Ackermann's work, geometric patterns unfold into maps, cityscapes, and swirling helicopter propeller blades. The urban experience is portrayed as abstract collage. Ofili's paintings are lush collages of vernacular imagery from the African diaspora, from middle- and lowbrow British culture, and highbrow European painting. His incorporation of elephant dung is perhaps the most outrageous

C
Chris Ofili
The Adoration of Captain Shit and the Legend of the Black Stars. 1997
Mixed media on canvas
244 × 183 × 13 cm/96 × 72 × 5 1/8 in
The Dakis Joannou Collection, Athens

D
Franz Ackermann
Boarding. 2002
Mixed media and oil paint on canvas
280 × 540 cm/110 1/4 × 212 1/2 in.
The Dakis Joannou Collection, Athens

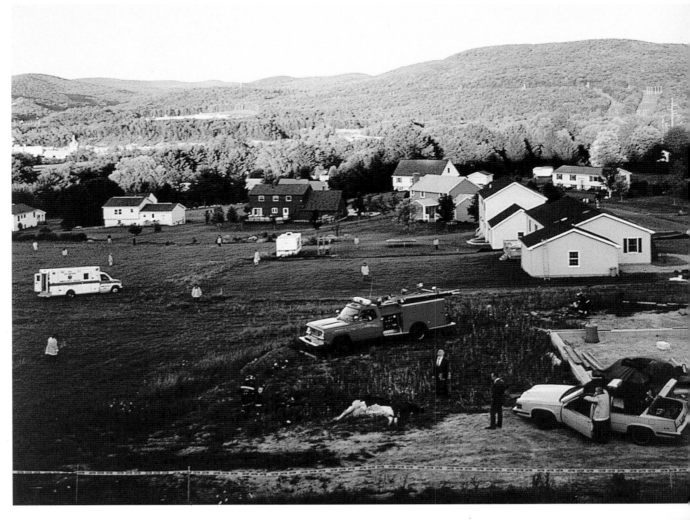

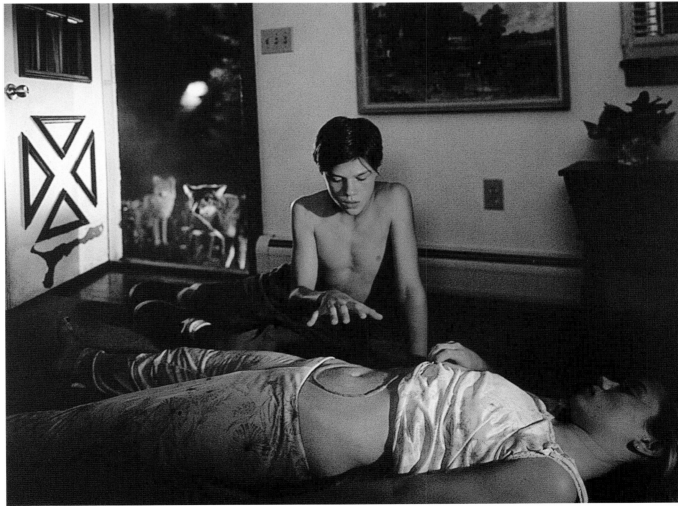

Untitled (Dead Cow Discovery). 1998
C-print
127 x 152,4 cm/50 x 60 in.

Untitled (Brother and Sister). 1998
C-print
127 x 152,4 cm/50 x 60 in.

use of collage in the history of art. Ritchie sometimes collages one wall painting on top of another. His work mixes the tradition of geometric abstraction with game theory and other conceptual abstract structures: the culture of Las Vegas meets the culture of Kandinsky. Tomaselli has invented a new approach to painting that fuses collage with abstract decorative patterns. His collage elements, which include "controlled substances," are almost as outrageous as Ofili's.

The new embrace of collage in music, literature, film, and visual art reflects the collage of opposing realities that characterizes contemporary life. The current reality television show *The Simple Life*, which features the young socialites Paris Hilton and Nicole Richie living on an Arkansas farm, is an example of how "reality collage" has also become one of the favorite new themes in popular entertainment. This juxtaposition

Massacre of the Little People by the Big People. 2002–3
Oil paint on canvas
208 × 254 cm/81 7/8 × 100 in.

VERNE ▶
DAWSON
Born in Meridianville, Ala., 1961/Lives in Pennsylvania

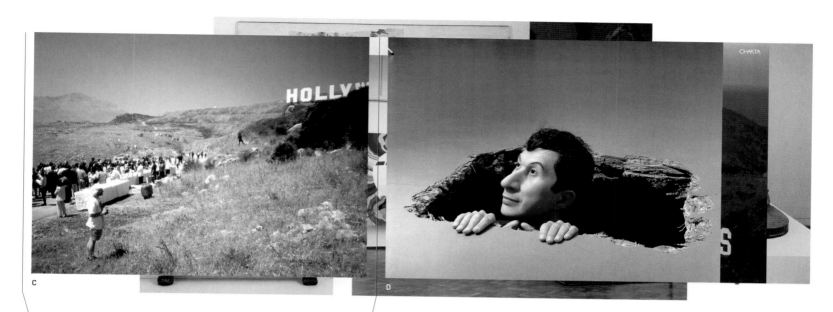

of parallel realities is the context for Cattelan's work, which deliberately confuses the boundaries between art and life. Cattelan is a great image-maker in the sculptural tradition, but his art also involves the manipulation of the social structure and the communications systems through which art is disseminated and interpreted. He delights in using the mass media and the institutions of the art world to create his subversive social sculpture and to construct his astonishing collages of incompatible realities. His manipulations of parallel realities include his portrayal of a ten-year-old version of himself peeking through the floor of a famous art collector's bedroom, and his notorious sculpture of the pope felled by a meteor. He used the world press as an element in his installation of a facsimile of the Hollywood sign above a garbage dump in Palermo, inducing the elite of the international art world to leave the opening of the 2001 Venice Biennale and travel there by pri-

A Paris Hilton and Nicole Richie in *The Simple Life*, 2003

B Matthew Ritchie
The Fast Set. 2000
Mixed-media installation
Dimensions vary
The Dakis Joannou Collection, Athens

C Reception for the opening of Maurizio Cattelan's *Hollywood* project for the 2001 Venice Biennale, Palermo, Sicily, 2001. Photo © Armin Linke

D Maurizio Cattelan
Untitled. 2001
Wax and fabric
Figure, 150 cm/59 in. high; hole, 60 × 40 cm/23 5/8 × 15 3/4 in.
Installation at Museum Boijmans van Beuningen,
Rotterdam, the Netherlands

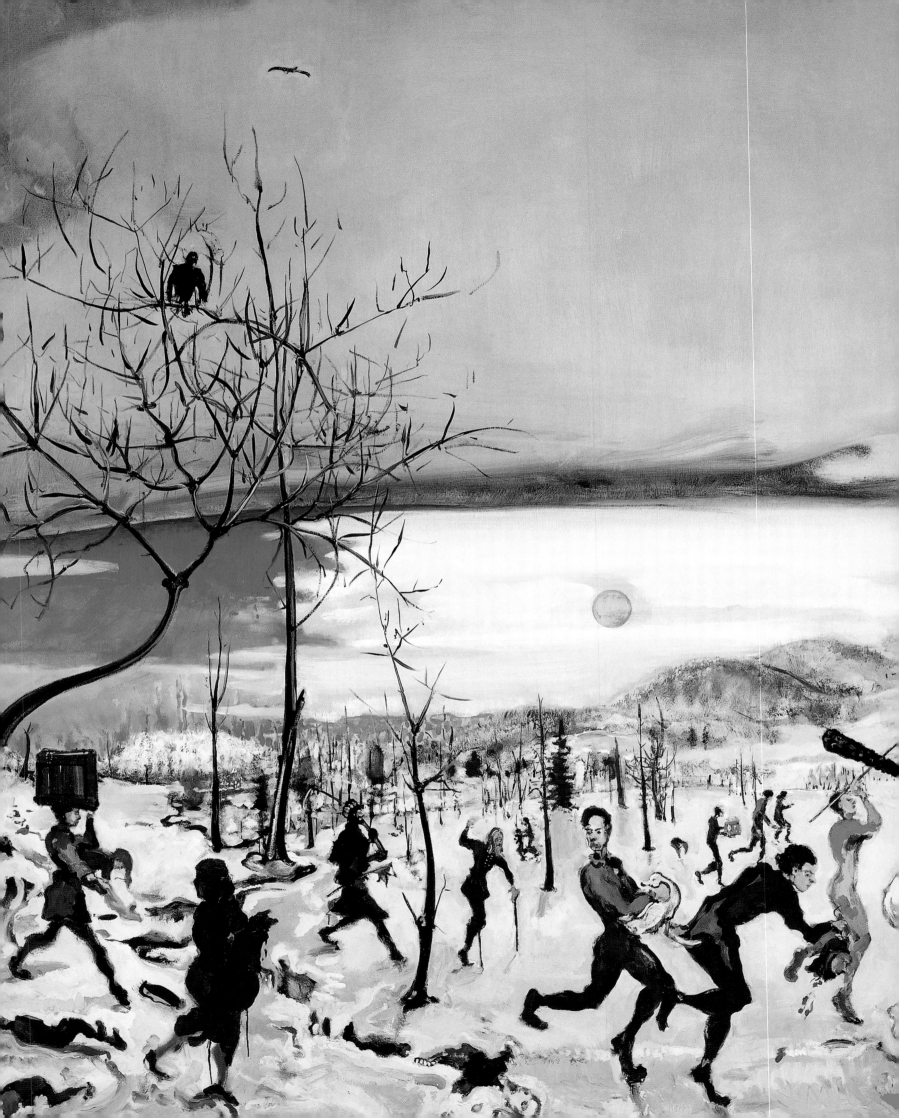

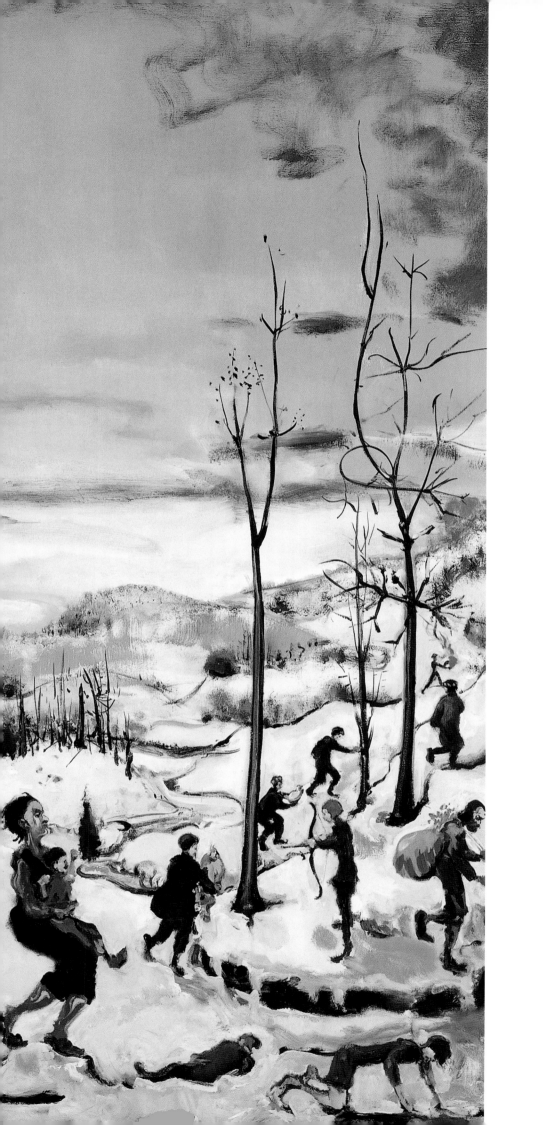

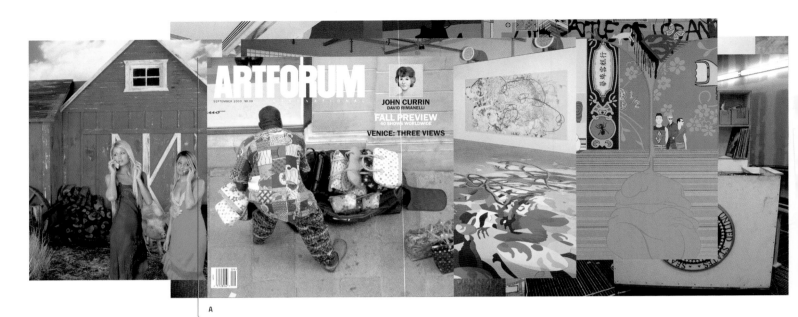

A

vate jet. Magazines featured images of fashionably dressed art collectors trudging through the dump to view Cattelan's work, probably unaware that they themselves were part of the piece.

At the opening of the 2003 Venice Biennale, another reality collage, this time a "found" reality collage, unplanned by an artist or curator, again upstaged the official program. Bootleg Louis Vuitton Murakami bags, hawked by African peddlers on the streets in front of the major tourist sites and luxury-goods stores, were the most noticeable and perhaps the most talked about "art objects" at the Biennale. A Venice street vendor's display of the knockoff bags was even featured on the cover of *Artforum*, becoming the image through which the 2003 Biennale will be remembered in contemporary art history. The Murakami bag itself

A *Artforum*, September 2003 cover

Panem et Circenses I. 1989
Stained glass, steel, lead, and enamel paint
207 x 314,9 x 109,2 cm/81 1/2 x 124 x 43 in.

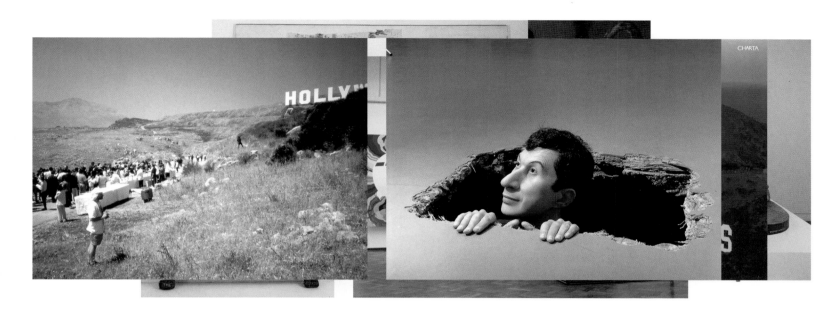

is a classic collage, juxtaposing the haute bourgeois symbolism of the Vuitton logo with the *otaku* subculture of Tokyo video arcades and basement comic-book shops. Layered on top of this is the collage of parallel worlds on the Venice streets: throngs of tourists, illegal African street peddlers, and the sophisticated art audience. Many members of the art community were fascinated by the irony of fake Murakamis being sold outside a museum featuring a real Murakami that, in the final analysis, was not as interesting as the fakes. This is the culture of collage.

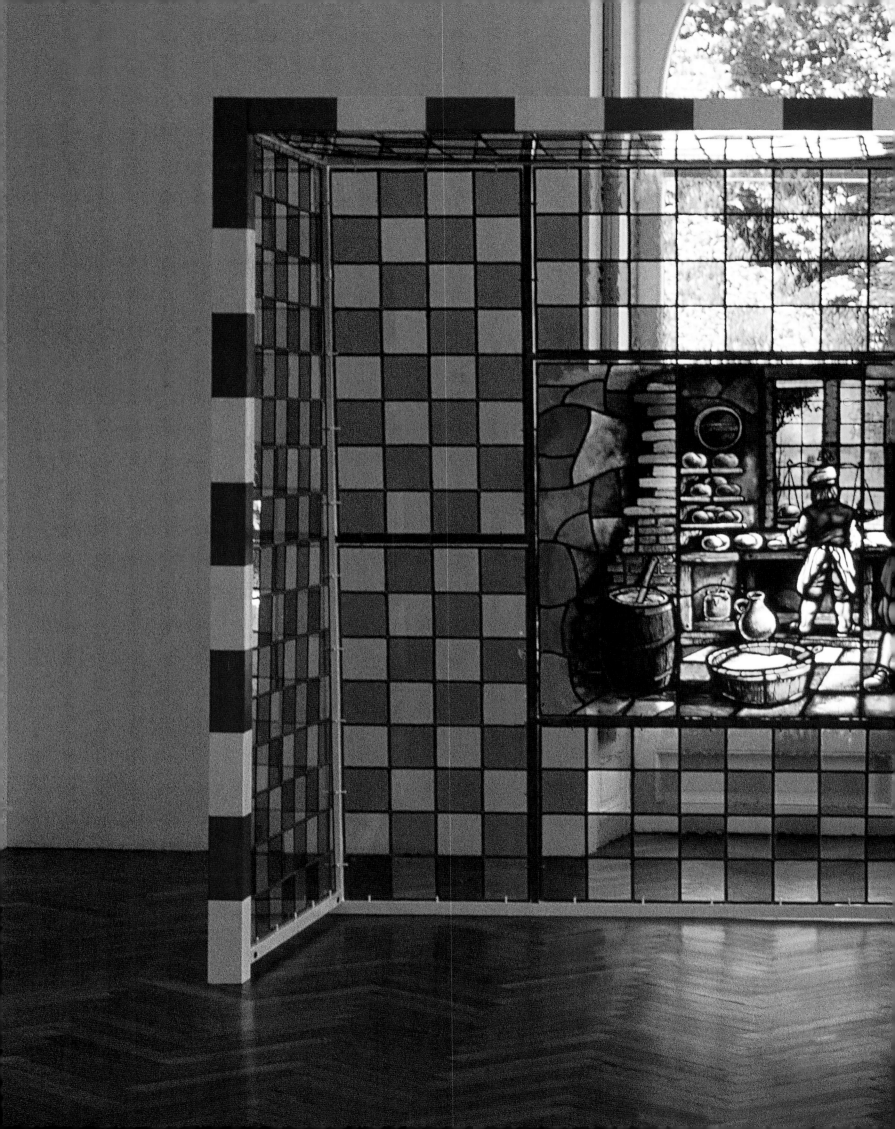

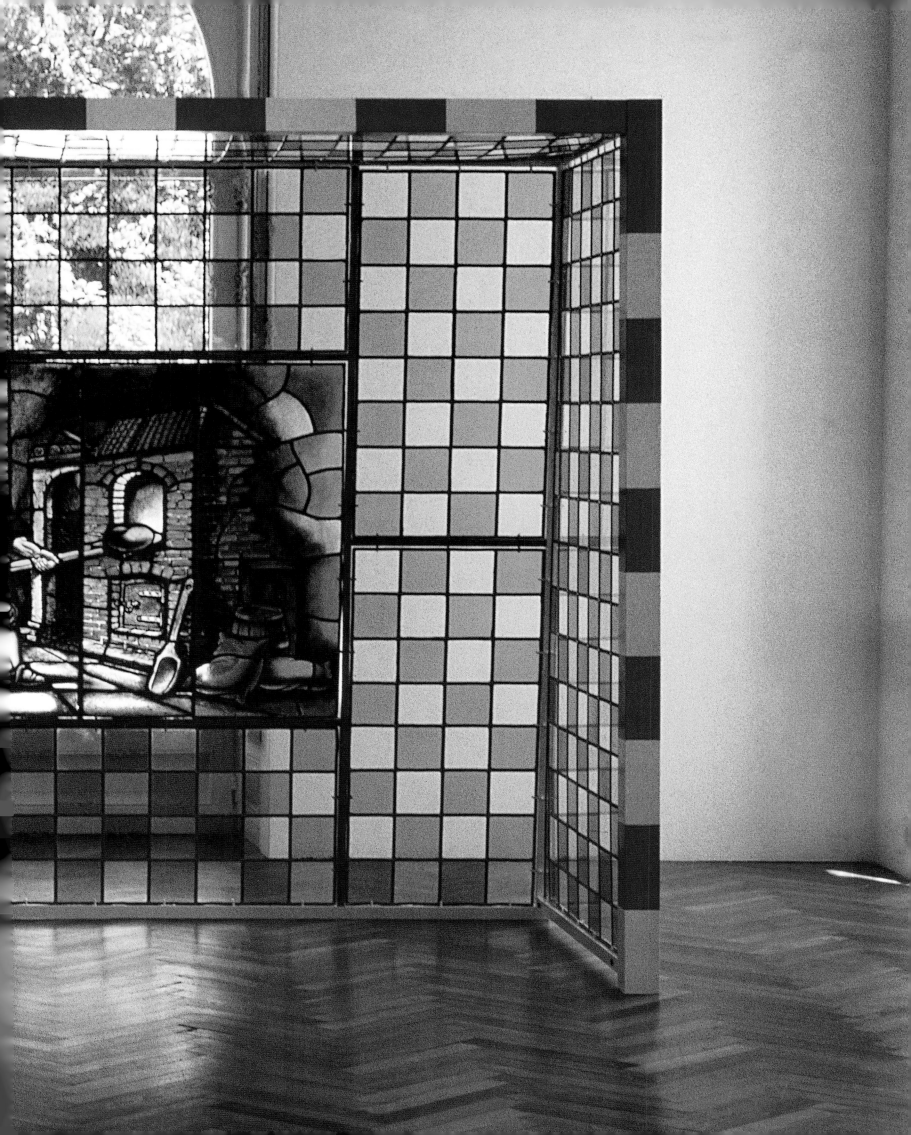

The Birth of Crass:
The Artist's Persona in the
Age of Advanced Capitalism Alison M. Gingeras

"When you consider what liberal capitalism has achieved over the past century and a half, not to mention the record of its rivals, the fact that its virtues and its very legitimacy remain so contested is surely remarkable....The culture that so reluctantly supports modern capitalism tends not merely to accentuate the negative but to obliterate the positive: otherwise, passive anti-capitalism of the kind just described could not have survived so well."

"Presumed Guilty: Capitalism and Democracy," *The Economist*, 26 June 2003

Tamir, Golani Brigade, Elyakim, Israel, May 26, 1999. 1999
Color photograph
181 × 153 cm/71 1/4 × 60 1/4 in.

RINEKE ▶
DIJKSTRA
Born in Sittard, the Netherlands, 1959/Lives in Amsterdam

"The Lives of the Artist": Purging Persona from Art History

How does one account for the persona of an artist? Outside the entertainment value of a good biography, what importance does persona play in the understanding of an artist's practice? Since the inception of their discipline, art historians have been troubled by the question of artistic persona. For many, the artist's persona is like the pesky shrew that is best chased away so as not to impede the historian's or critic's "serious" quest for facts and objective interpretation.

Yet this antagonistic shrew has been an integral part of art history beginning with its foundational texts. *Le vite de' più eccelenti architetti, pittori, et scultori italiani,* written in the sixteenth century by historian and artist Giorgio Vasari, is considered the first proper art historical treatise. Required reading for all students of art history, Vasari's *Lives of the Artists* densely interweaves detailed descriptions of the achievements of the great Renaissance artists (from Cimabue and Giotto to Leonardo da Vinci and Michelangelo) with biographical anecdotes intended to reveal their inner character and better illuminate their art.

◀ RINEKE
DIJKSTRA

Erez, Golani Brigade, Elyakim, Israel, May 26, 1999. 1999
Color photograph
181 x 153 cm/71 1/4 x 60 1/4 in.

To say that Vasari was a good storyteller is like saying Frank Sinatra could carry a tune. He was a "profoundly inventive fabulist"[1] who not only embellished tales about dead artists, but also incorporated the self-propagated myths told to him by his contemporaries. His collection of biographies freely blended aesthetic theory, sociological description, fact, and fiction. Five hundred years after Vasari's death, art history has become a much more astringent field of endeavor. By dismissing Vasari's factual errors and exaggerations, the current academic norm continues to discredit one of his main contributions to the field: the notion that legend and myth as generated by the artists themselves are inseparable from an understanding of art.

The Taming of the Shrew: Artists in Polite Society

"What is abnormal in Life stands in normal relations to Art. It is the only thing in Life that stands in normal relations to Art."

Oscar Wilde, "A Few Maxims for the Instruction of the Over-Educated," ca. 1894

The Buzzclub, 1996–97
Double video projection with
U-matic videotape and Betacam videotape 9
26 min. 40 sec.

RINEKE ▶
DIJKSTRA

This antagonism does not solely belong to art history. Society has often struggled with how to compartmentalize artists and their personas. As an inverted barometer for societal values, artists can safely act out fantasies, break the taboos, and enjoy the indulgences that are shunned by the moral consensus. Since the dawn of human civilization, artists have always been granted a different status than the rest of the populace. Artists could speak to the gods. They were accorded privileged positions, disregarding traditional class divisions. The figure of the artist possessed a unique duality, eliciting equal doses of fascination and contempt, envy and disdain.

Nineteenth-century French society invented an efficient means to prevent artists from contaminating the rest of normative society. The invention of bohemianism—a term derived from the name of a region in the Czech Republic known as Romany, which was inhabited by nomadic gypsies—designated a place where artists and disillusioned members of the bourgeoisie could intermingle with the poverty stricken, foreigners, racial minorities, homosexuals, and anyone else on the margins of society.

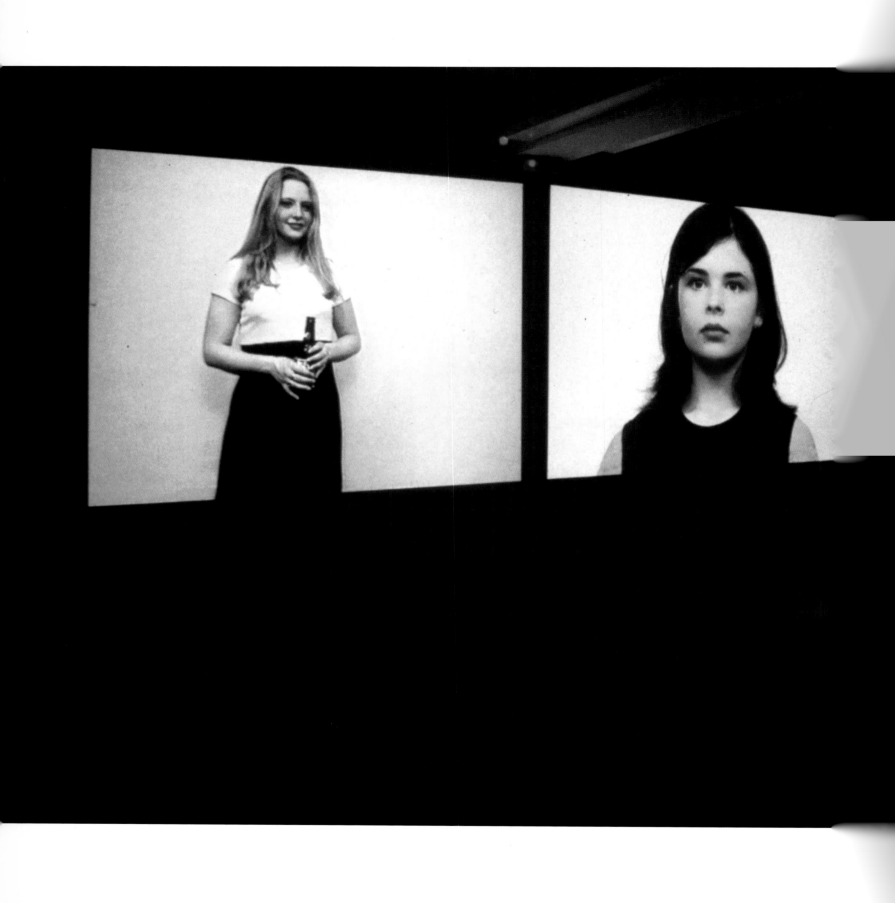

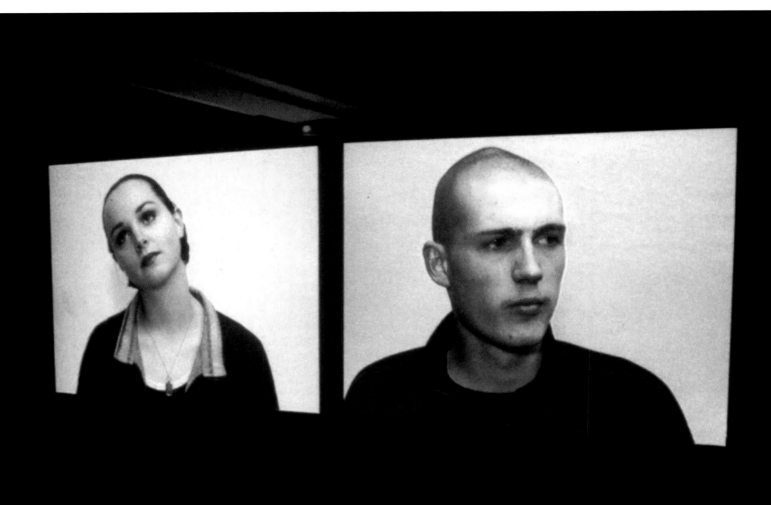

"Bohemia is a stage in artistic life; it is the preface to the Academy, the Hôtel Dieu, or the Morgue....Today, as of old, every man who enters on an artistic career, without any other means of livelihood than his art itself, will be forced to walk in the paths of Bohemia."

Henry Murger, *The Bohemians of the Latin Quarter (Scènes de la Vie de Bohème)*, 1915

As the historical epicenter of *la vie de bohème*, mid-nineteenth-century Montmartre provides the basis of most of the populist notions about how artists should live, behave, and look. From the image of the young struggling artist in an unheated Williamsburg loft to the dj-cum-painter spinning in an Electroclash club in former East Berlin, the bohemian imaginary persists in shaping the contemporary expectations of what role artists should play in society. Bohemia is like a zoo—it is a place that polite society can visit in order to be simultaneously repelled and dazzled by the less-civilized creatures, securely constrained in romanticized, golden cages.

Untitled (White Vinyl). 1986
Vinyl and rubber
76,2 x 76,2 x 20,3 cm/30 x 30 x 8 in. diameter

JOHN ▶
DOGG

The Birth of Crass: Beyond Bohemia

Not all artists continue to take refuge in bohemian or countercultural ideals. With the dissolution of oppositional regimes, contemporary Western society has been transformed by American-style capitalism. Extreme wealth and obsession with celebrity are the hallmarks of this hegemony—and artists are not immune to it. The absorption of avant-garde strategies into mainstream culture has made it virtually impossible to use these historical models as a means of resisting the "culture industry" and the "society of the spectacle" as they have been engendered by advanced capitalism. Art historian Benjamin H. D. Buchloh, a veteran opponent of the culture industry, explains the current state of affairs:

But it is not just the Saatchis and the Geffens of this world that have discovered that the greatest triumph is to own the supreme trophies of a culture of radical subjectivity that their industrial and corporate production is

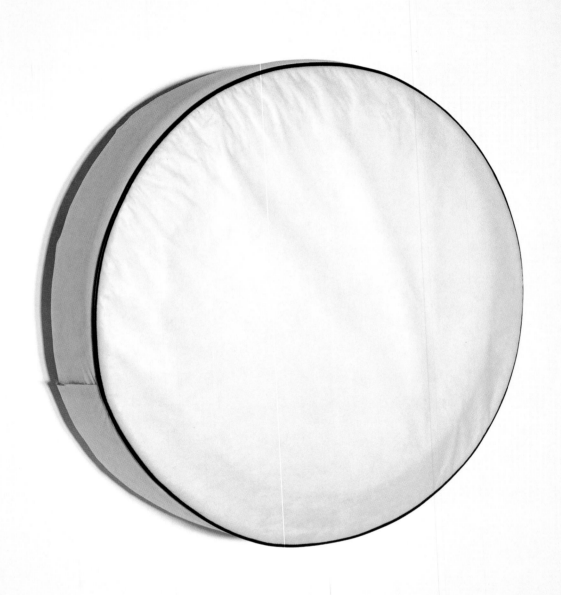

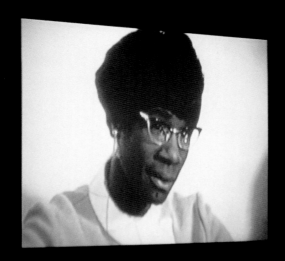
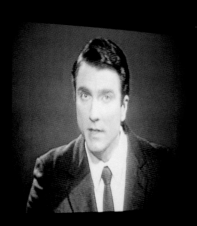

◀ STAN DOUGLAS.
Born in Vancouver, 1960/Lives in Vancouver

Evening. 1994
3 double-sided laser disks and 1 custom-made
synchronization device
Each rotation 14 min. 56 sec.

eliminating incessantly in everyday life....High cultural objects, in their hands, have become the emblems of the total triumph of spectacle: this controlling force can best be demonstrated by the fact that the tycoons of the culture industry can now apply the principle of total expenditure and ownership, even, or rather especially, to those objects that had been initially conceived to contest spectacle's universal validity.[2]

If the strategies of the avant-garde are obsolete, their great achievements for sale, and their meanings purged of their original critical intentions, what is left at the artist's disposal? How, then, can artists resist the culture industry? Should they resist? Are they passive victims or active proponents of this industry? What position should artists occupy in this kind of society?

More than just a collection of artists who have singular personalities or colorful biographies, this essay is an attempt to trace a hypothetical lineage of artists (most of whom figure prominently in the collection of Dakis Joannou) who have con-

Fountain. 1964
Ready-made porcelain urinal
35,5 x 48,2 x 60,9 cm/14 x 19 x 24 in.

sciously cultivated their public personas as a strategic, often antagonistic element in their art practice. Owing inspiration to Bice Curiger's seminal exhibition *The Birth of the Cool* (Kunsthaus Zurich, 1996), the notion of "The Crass" aptly summarizes our current era. Whereas "The Cool" was the perfect appellation for the mood of postwar America—its fear of communism, jazz as played by Miles Davis, and the quiet confidence of New York School artists—"The Crass" might capture today's temperament, which is colored by unparalleled profit stemming from the dominance of advanced capitalism, a buoyant, expansionist international art market, the triumph of spectacle through reality television, and so on.

"The Birth of Crass" is a slightly deceptive title. It does not single out one specific moment of origin when artists began to elevate their own personas into something more significant than simple biographical interest. Instead, what follows is an incomplete account of various "births" that have taken place across several generations and in very different geographic, social, and political contexts. The artists discussed have all found

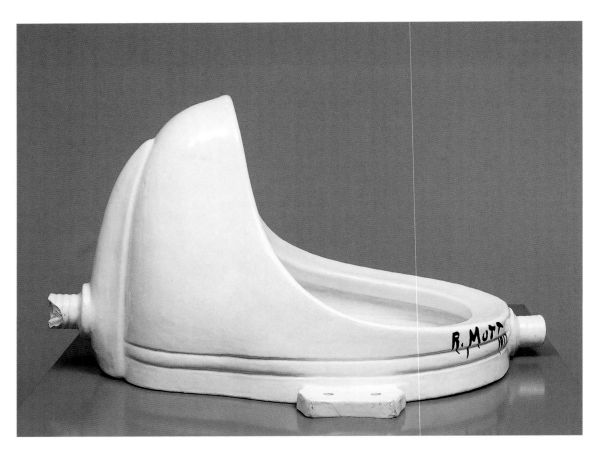

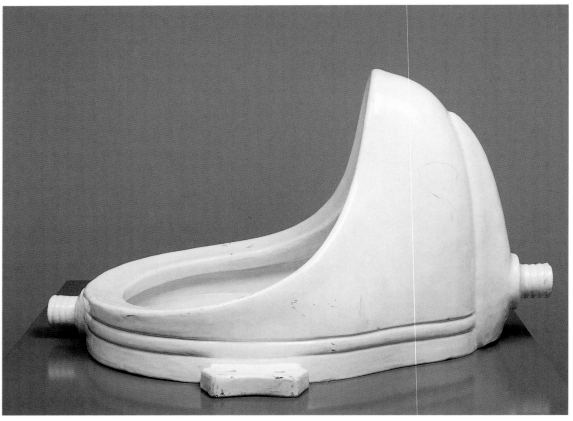

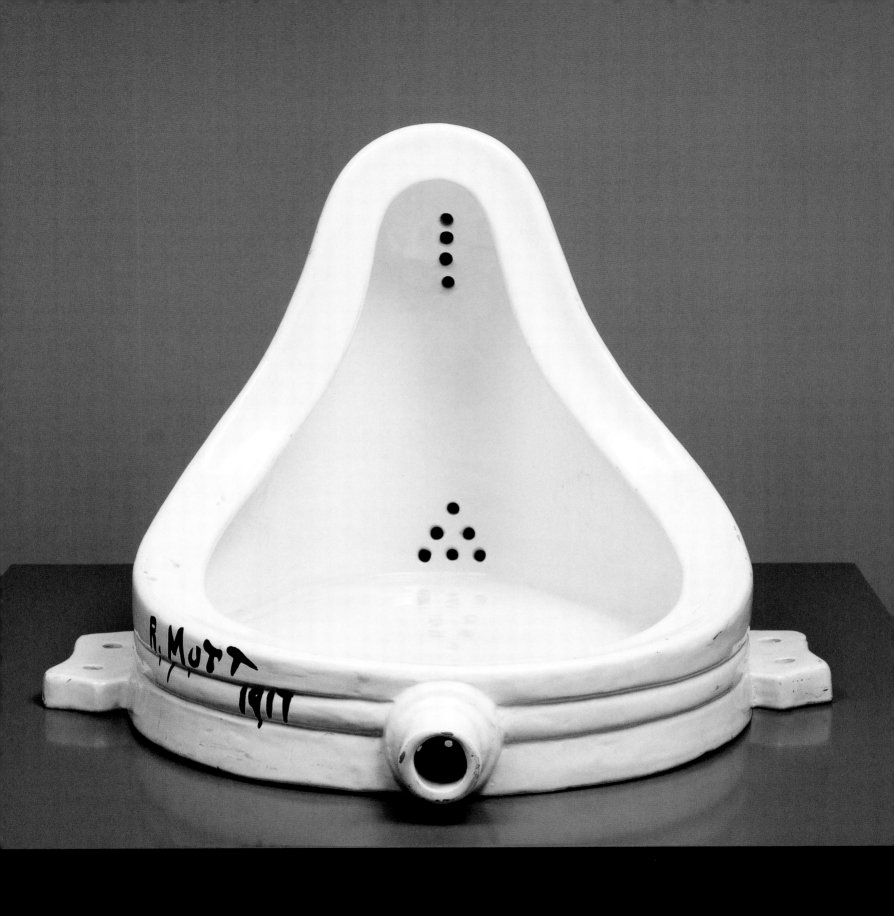

ways to challenge societal expectations as well as surpass ob-
solete models of criticism through the transformation of their
public personas into an artistic medium as such, equal to any of
the traditional forms of artistic expression.

Sea, Sex, and Sun?: Francis Picabia on the Côte d'Azur

"My idealism stops me from seeing society's morality.
The success of un-success is a success.
Life has neither goal nor result.
My painting is a woman who doesn't want to hear talk of her
husband when making love."

Francis Picabia's aphoristic response to an inquiry on "Socialist Realism," 1953

Your Strange Certainty Still Kept. 1996
Water, light, plexiglass, plastic,
recirculating pump, and wood
Dimensions vary

Sea, sex and sun
Le soleil au zénith
Vingt ans, dix-huit
Dix-sept ans à la limite
Je ressuscite
Sea, sex and sun
Toi petite
Tu es de la dynamite

Sea, sex and sun
Le soleil au zénith
Me surexcitent
Tes p'tits seins de la bakélite
Qui s'agitent
Sea, sex and sun
Toi petite
C'est sûr tu es un hit

Sea, sex and sun
Le soleil au zénith
Me surexcitent
Tes p'tits seins de la bakélite
Qui s'agitent
Sea, sex and sun
Toi petite
C'est sûr tu es un hit
Sea, sex and sun

Serge Gainsbourg, "Sea, Sex and Sun," 1978,
from the soundtrack of *Les Bronzés*

Dadaist conspirator, enfant terrible of the Surrealist revolution, friend and occasional collaborator of André Breton, Marcel Duchamp, Man Ray, Tristan Tzara. Francis Picabia has attained an indisputable place within the pantheon of the historical avant-garde. Yet intermittently throughout his avant-garde trajectory, he often deviated from the modernist track. His radical zigzags between different styles and subject matters during 1920s through the mid-1930s were sanctioned within the rules of high modernism—occasionally producing figurative paintings of Spanish women wearing traditional dress or images of "monsters" inspired by Catalonian Romantic frescoes. The practice of figurative representation was reconcilable when couched in a larger program of convention breaking—interwoven with experiments in Dadaist word play, abstract compositions, and "machinist" references.

But in the late 1930s, Picabia completely transgressed the alleged boundaries of modernism to create a series of figurative paintings that came to be known as his kitsch period. Categorized as hard-edge realism, these portraits of nude women de-

Skinny Afternoon. 2003
Sand-cast aluminum, mirror, and screws
200 x 120 x 160 cm/78 3/4 x 47 1/4 x 63 in.

UR·S·
FI·S·C·HER ▶
Born in Zurich, 1973/Lives in Los Angeles and Zurich

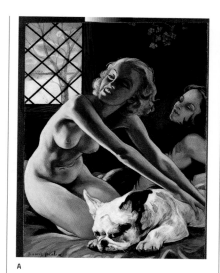

picted in decadent, erotic scenarios were characterized by their high tonal contrast, black-outline technique, and garish color palettes. These female nudes, such as *Nu de dos* (1940–42) and *Femmes au bull-dog* (1941–42), in fact drew on tawdry black-and-white photographs culled from soft-core pornography magazines such as *Mon Paris* and *Paris Magazine*.[3] Picabia's "kitsch years" (1939–44) were dismissed as an antimodernist black hole in the artist's otherwise prolific career, and were purged from most art historical accounts. Only in hindsight is a legitimizing reading of these paintings possible, with the recent discovery of the precise sources for the images coupled with a great deal of speculation about their meaning.

Many critics took this dismissal a step further by conflating Picabia's radical shift toward "realism" with his apolitical stance during World War II. Buchloh identified such artistic shifts as in Pablo Picasso's neoclassical period and Picabia's

A
Francis Picabia
Femmes au bull-dog. 1941–42
Oil on cardboard
106 x 76 cm/41 3/4 x 30 in.
Collection Musée National d'Art Moderne, Centre Pompidou, Paris

B
Francis Picabia
Nu de dos. 1940–42
Oil on cardboard
105 x 76 cm/41 3/8 x 30 in.
The Dakis Joannou Collection, Athens

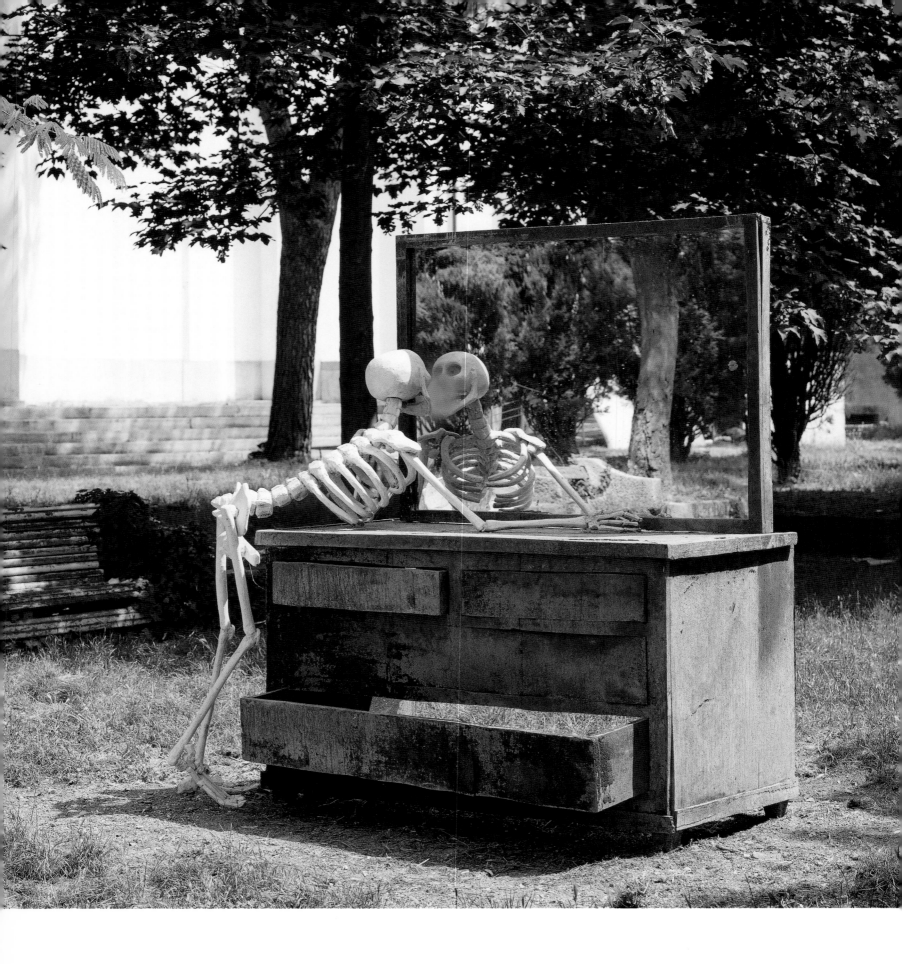

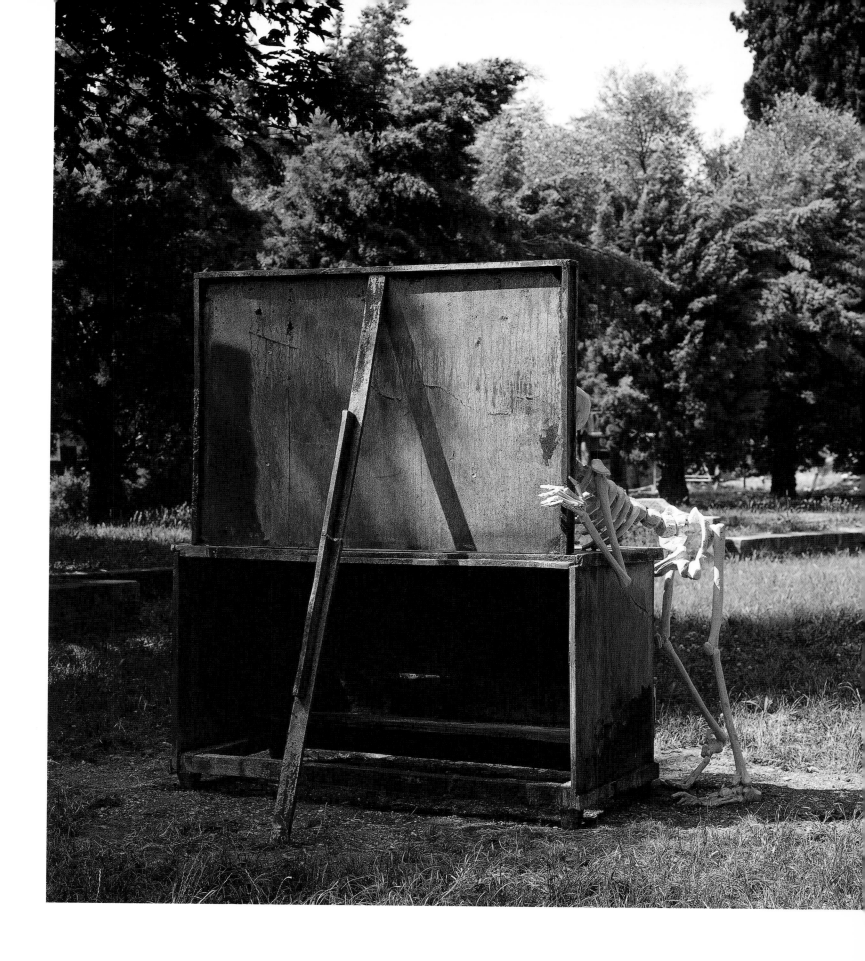

Chair for a Ghost: Thomas. 2003
Sand-cast aluminum, paint, lacquer, and wire
Upper part, 50 x 63 x 60 cm/19 3/4 x 24 3/4 x 23 5/8 in.; lower part, 50 x 50 x 60 cm/19 3/4 x 19 3/4 x 23 5/8 in.

kitsch nudes as a regressive attempt to reinstate the conventions of figuration. Without calling Picasso or Picabia outright fascists, he asks some rhetorical questions about the political climate of the time and the return to figuration: "Is there a simple causal connection, a mechanical reaction, by which growing political oppression [in Europe] necessarily and irreversibly generates traditional representation? Does the brutal increase of restrictions in socio-economic and political life unavoidably result in the bleak anonymity and passivity of the compulsively mimetic modes that we witness, for example, in European painting in the mid 1920s through the 1930s?"[4] In the eyes of the academic establishment, the answer is yes on all counts for Picabia. With his repeated reference to a "call to order" in the same article, Buchloh's questions have cast a long, negative shadow on Picabia's kitsch paintings, conflating them with the fascist rejection of "degenerate" avant-gardism and return to an official art of (national socialist) realism.

What if the phone rings. 2003
3 candles: wax, pigment, and wick
Blonde, 106 x 142 x 46 cm/41 3/4 x 55 7/8 x 18 1/8 in.; brunette, 200 x 54 x 46 cm/78 3/4 x 21 1/4 x 18 1/8 in.;
redhead, 94 x 99 x 54 cm/37 x 39 x 21 1/4 in.

URS ▶
FISCHER

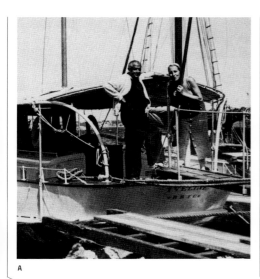

A

B

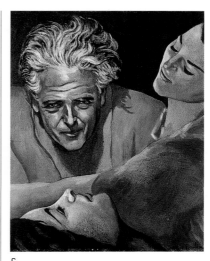

C

Such violently accusatory readings are further abetted by Picabia's ferociously unconventional persona. Echoing his fierce aesthetic independence, Picabia did not conform to the image or lifestyle of his avant-garde colleagues. Born to a cosmopolitan family, the son of a Cuban diplomat in Paris, Picabia never dabbled in bohemianism. He was rich and had no qualms about flaunting his wealth in public. More playboy than serious artist, Picabia lived with his wife, Olga, on a yacht in Cannes during the 1930s.[5] While many of his fellow artists split their time between the Côte d'Azur and Paris, Picabia steered clear of artistic circles when socializing in both cities. His relentless pursuit of pleasure was not only publicly acknowledged, but it surfaced in his work as well as in that of other artists. Picabia's love of fast cars (Man Ray made several images of him in the 1920s) was surpassed only by his insatiable taste for women. A self-portrait from 1941-42 depicting him with windswept hair and framed by two female temptresses painted in the same style

A Francis and Olga Picabia on their yacht, *L'Yveline*, Cannes, June 1938
 Collection Bibliothèque Kandinsky, Centre Pompidou, Paris

B "Francis Picabia at great speed, Cannes, 1924." Photo and handwritten
 inscription by Man Ray

C Francis Picabia
 Autoportrait. 1941–42
 Oil on cardboard
 57 x 45 cm/22 1/2 x 17 3/4 in.
 Private collection, Milan

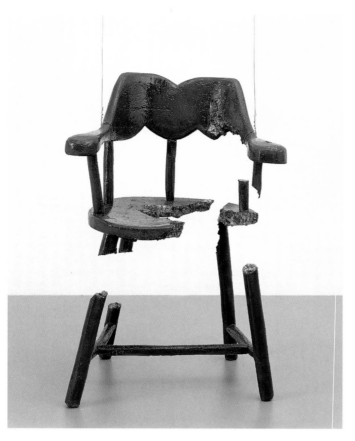

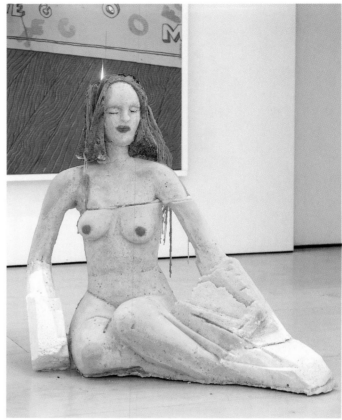

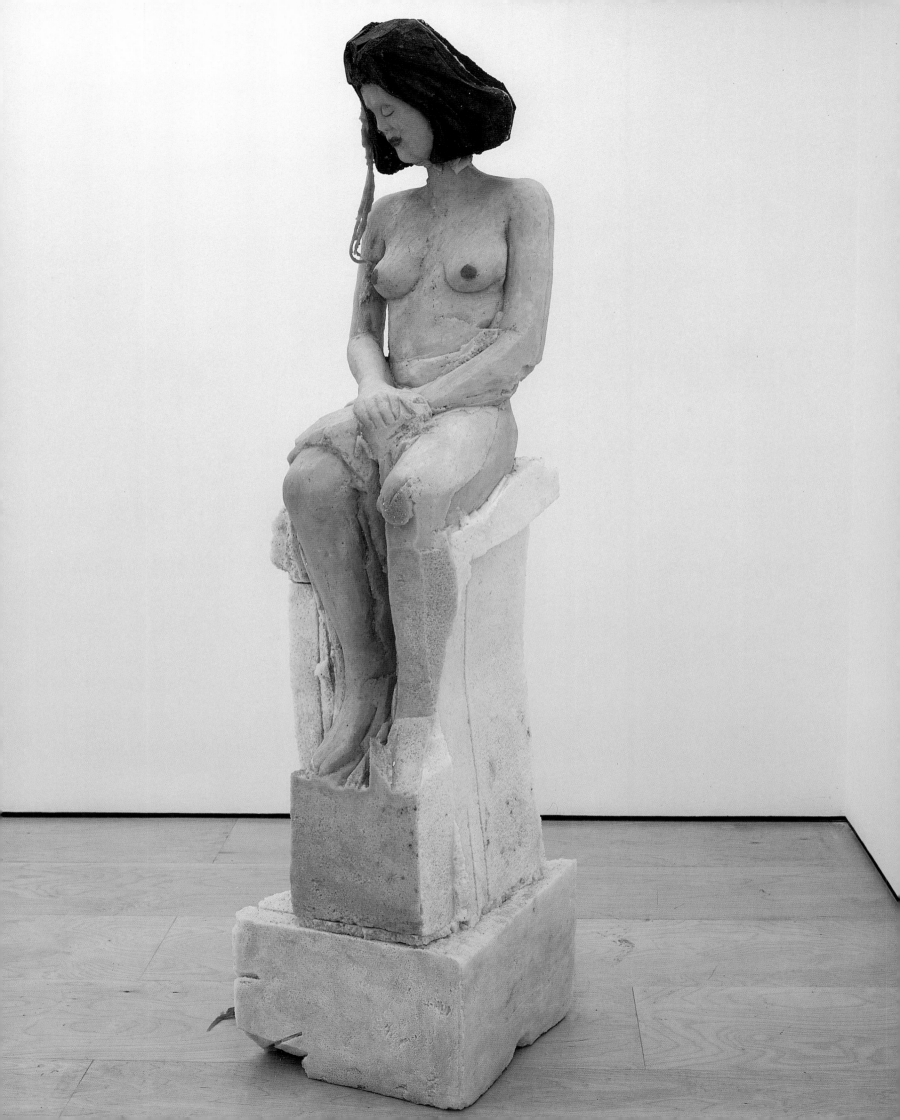

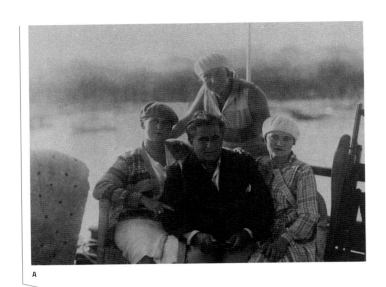

A

as the nudes suggests that Picabia took pleasure in portraying himself as an unapologetic womanizer (he often made aphoristic analogies between the pursuit of art and the love of women).

Picabia's male bravado and unabashed decadence takes on a more complex tone when read in parallel with his countless writings, letters, poems, and aphorisms. A devout Nietzschean since early adulthood, Picabia firmly believed that self-generated myth was one of the essential elements in his nihilistic program. When understood in these terms, his carefully groomed public persona was a part of his artistic strategy. Carole Boulbes, a leading scholar of Picabia's writings, explains his Nietzschean streak:

[Like Friedrich Nietzsche,] Picabia interwove his writings with numerous aphorisms about art, love, the family, glory and money....When Picabia opts for skepticism and insists

A Picabia with three unidentified women on the Côte d'Azur, ca. 1938
 Collection Bibliothèque Kandinsky, Centre Pompidou, Paris

Pick a Moment You Don't Pick. 2003
Paint marker, acrylic paint, glue, spray mount, screws,
wood, plexiglass, Perspex film, and varnish
231 x 311 x 8 cm/91 x 122 1/2 x 3 1/8 in.

URS ▶
FISCHER

that there is nothing to understand or when he prefers the critique of values to superfluous commentary on the works, this is in fact the expression of a philosophy. Throughout his literary and visual works he calls into question the founding oppositions of Western aesthetic categories (beautiful/ugly, pure/impure, good/evil).... Despite Picabia's apparent eclecticism, there are two things about Picabia that never change: the appropriation of photography, seen as a vehicle for pictorial pleasure, and the aesthetic appropriation of Nietzsche.[6]

The interpretation of Picabia's art, writings, and lifestyle are all subject to these Nietzschean principles of deformation and nihilism. When Picabia strays from the orthodoxy of the avant-garde or cultivates a nonconformist, decadent persona, his acknowledged affiliation with Nietzsche makes it hard to interpret his intensions only at face value. In this light, the superficial appearance of his "sea, sex, and sun" lifestyle on the Côte d'Azur in the early 1940s might be read as staking an antagonistic stance even if it is still interpreted as problematically

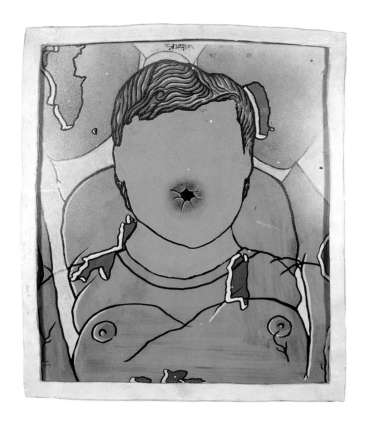

Face Hole Friend. 2003
Pastel, acrylic paint, and pigment marker on polyester foil in frame
of two-compound polyurethane, glass, and cardboard
46 x 38,3 cm/18 1/8 x 15 in.

Tasteless Tears. 2003
Pastel, acrylic paint, and pigment marker on polyester foil in frame
of two-compound polyurethane, glass, and cardboard
46 x 38,3 cm/18 1/8 x 15 in.

ambivalent in a time of war. Picabia provides a historical foundation for other artists' integration of their public personas as a strategic part of their practice. Picabia is the grandfather of "The Birth of Crass."

Andy Warhol: The Wrong Person for the Right Part

"If I ever have to cast an acting role, I want the wrong person for the part. I can never visualize the right person in a part. The right person for the right part would be too much. Besides, no person is ever completely right for any part, because a part is a role, is never real, so if you can't get someone who's perfectly right, it's more satisfying to get someone who's perfectly wrong. Then you know you've really got something."

Andy Warhol, "Fame," *The Philosophy of Andy Warhol (From A to B and Back Again)*, 1975

Andy Warhol wasn't merely famous. There were many visual artists before him who attained notoriety from the so-called general public. Picasso was a populist figure throughout his career. Jackson Pollock was featured in both *Life* and *Time* magazines, facetiously dubbed "Jack the Dripper." In postwar Europe,

Animal. 1986
Polyurethane, cheesecloth, and paint
55,8 x 96,5 x 58,4 cm/22 x 38 x 23 in.

FISCHLI
& WEISS

Peter Fischli: Born in Zurich, 1952/Lives in Zurich; David Weiss: Born in Zurich, 1946/Lives in Zurich

the taste for artists and decadence produced stars such as Bernard Buffet and his glamorous wife, Anabel, who were featured in countless pages of paparazzi pictures in *Paris Match*. Before Warhol penetrated the popular consciousness, an artist's popularity or adulation was primarily due to recognition of artistic talents or aesthetic innovation (e.g., the disruption of representation in Cubism, the invention of gestural abstraction). In these cases, fame was more of a passive consequence.

"In the future everyone will be world famous for fifteen minutes."[7] Warhol changed the nature of fame, and this impact was not limited to the world of art and artists. As the incarnation of Pop himself, he did not just surpass the level of celebrity of the handful of examples mentioned here. Instead Warhol founded his art practice on the careful choreography of his public persona. He harnessed the power of celebrity—his own, the celebrities he created, the culture's growing thirst for celebrity as such—elevating it to a different status. For Warhol, his persona was an artistic medium, no different from the more conventional forms (film, painting, sculpture, photography) he used in his art.

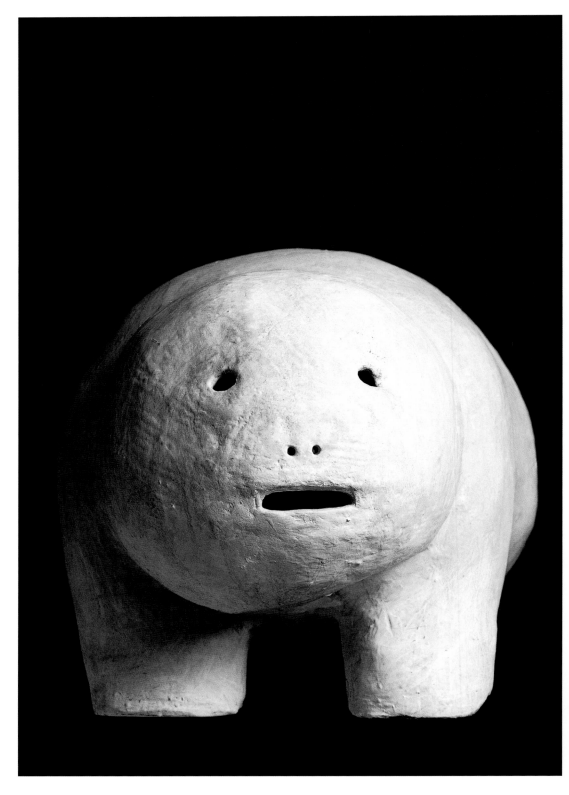

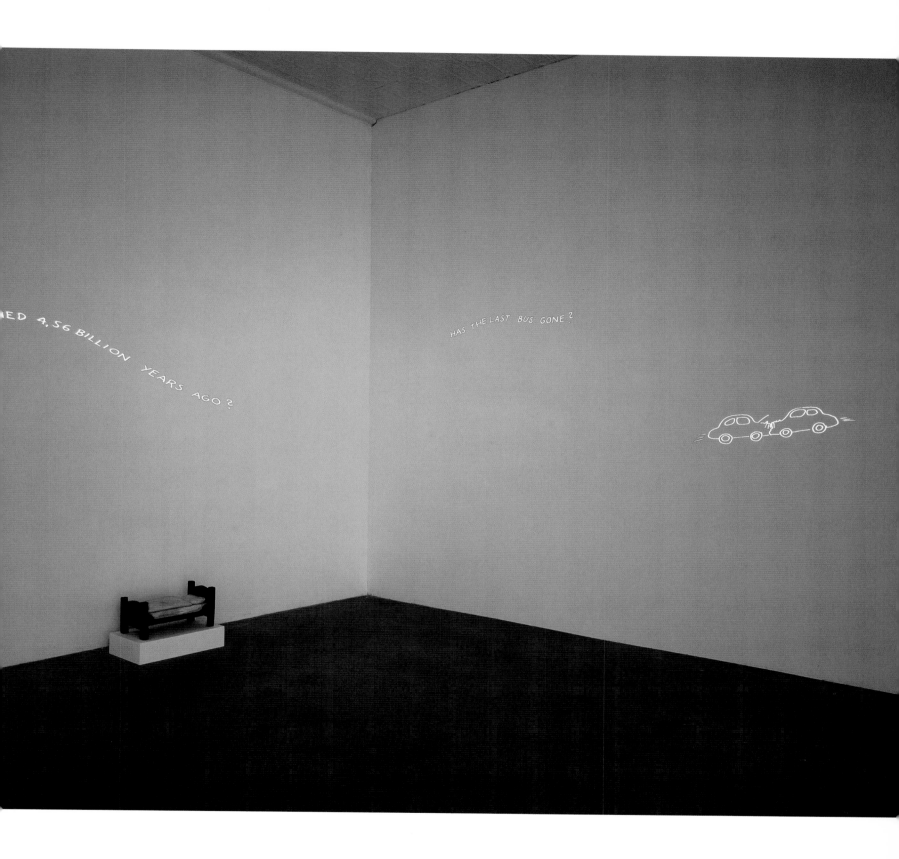

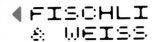

Questions. 1981–2002
405 slides, 5 projectors, 2 dissolve units, painted polyurethane,
black rubber, turntable, CD, and CD player
Dimensions vary

Despite our current facility to conflate the figure of Warhol with today's entertainment-obsessed society, there is no consensual interpretation of the relationship between Warhol's construction of his persona and its direct impact on his art. In the first serious account of Warhol's work, published by Peter Gidal in 1971, Warhol's persona was identified as the primary impediment to a serious assessment of his art. Gidal cautions in his introduction: "[Warhol's persona] should not concern us here unless we make the error of giving Warhol's social, public existence more weight than we know we should give any artist's. It's the work that counts. And since all artists in varying degrees manufacture their social existence, where should our collaboration with them end? Just because Warhol wanted to create the social aura of meaning from which his paintings and films would be inseparable, that is no reason for us to accept it."[8]

Regal mit acht Figuren/Panther. 1992
MDF, acrylic paint, 8 plaster madonnas, polyester resin, ivory black pigment
("Dr. Kremer"), Caparol, and latex
Regal mit acht Figuren, 245 x 100 x 100 cm/96 1/2 x 39 3/8 x 39 3/8 in.; *Panther,* 245 x 500 x 160 cm/96 1/2 x 196 3/4 x 63 in.

And while Gidal's preface can be explained as a valiant attempt to provide an anti-sensationalist reading of Warhol's films and paintings—something that was lacking at the time the book was published—Gidal cannot so easily disentangle the supposedly autonomous art production and the looming presence of Warhol as a highly constructed figure. He remarks, "Warhol was brilliant in not reconciling the irreconcilable: in thought, in philosophical statement, in ironic-cum-sarcastic speech, in self-consciousness, and in many of his best works of film and painting."[9] Gidal's account of the Factory years thus oscillates between the desire to celebrate Warhol's work as being objectively good while warning of the dangers of "the intentional fallacy"—giving too much importance to Warhol's persona/intentions as an integral element of his oeuvre. Yet within Gidal's best moments of formalist or iconographic analysis, he must always resort to accounts of Warhol's public persona to punctuate his point. For example, laconic Warholisms such as "I wanted to care but it was so hard" systematically fill out Gidal's structural analysis of his morbid-themed paintings of the 1960s.

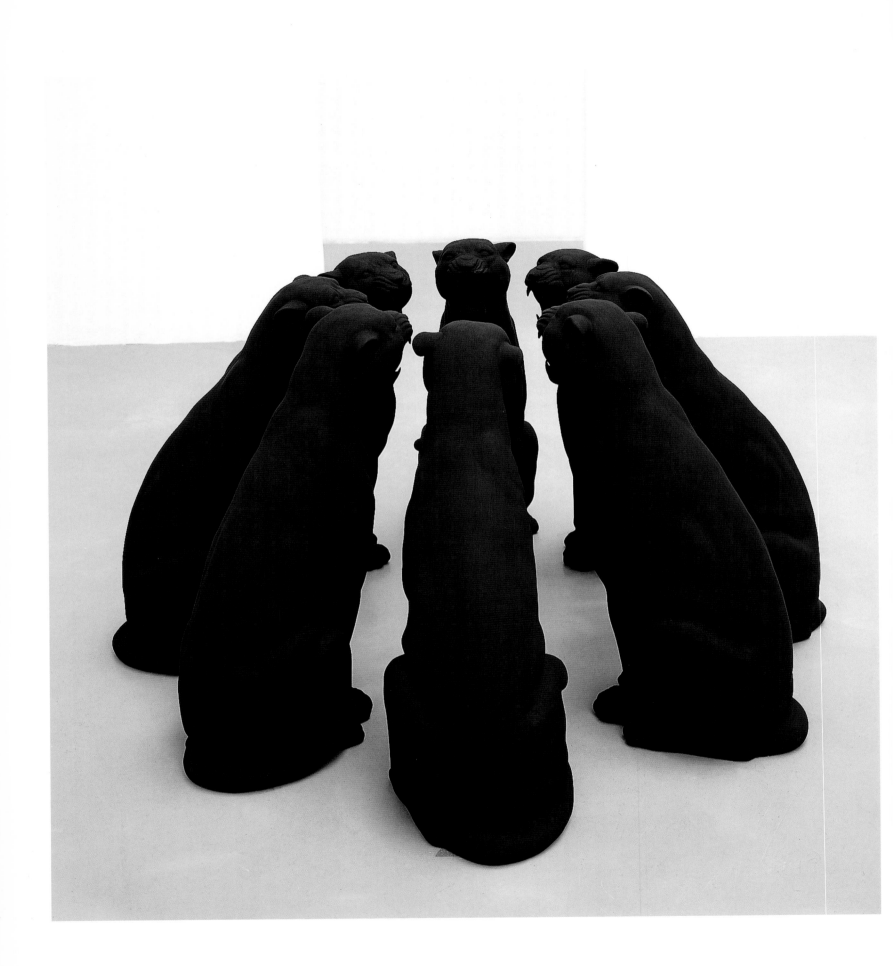

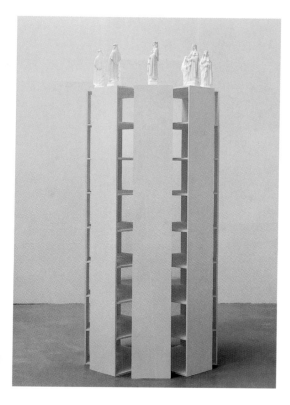

◄ KATHARINA
FRITSCH

Kerzenständer. 1985
Painted metal, brass, and candles
120 x 120 x 160 cm/47 1/4 x 47 1/4 x 63 in.

The campaign to isolate and dismiss the importance of Warhol's persona in terms of his overall artistic contribution is much more systematic in recent academic writing. Scholarly publications such as *October* attempt to "fix" the persona problem by historicizing Warhol into two distinct periods: the Early Factory Years (1960–68) and the Business Art Years (1969–87). Art historian and film theorist Annette Michelson has chosen the term "prelapsarian" to characterize the first period.[10] This biblical allusion perfectly sums up the "evil" that caused Warhol's expulsion from the Garden of Eden. "After 1968, Warhol assumed the role of grand couturier, whose signature sells or licenses perfumes....Warhol's 'Business art' found its apogee in the creation of a label that could be affixed."[11] Before his fall from grace, Michelson is able to account for the "eccentricities" or excesses of Warhol's behavior by framing them within certain theoretical models. She recasts the Factory as a cross between the *Gesamtkunstwerk* and Mikhail Bakhtin's concept of carnival—a place where discourse, behavior, and identity are detached from the normal rules of society, combining the sacred and the profane. While the pre-'68 Factory certainly flirted with celebrity

Untitled #91 (half life). 2002
C-print
156,2 x 190 cm/61 1/2 x 74 3/4 in.

Untitled (study for magicass). 1998
C-print
102 x 127 cm/40 1/8 x 50 in.

Untitled #60 (by proxy). 1999
C-print
152,4 x 177,8 cm/60 x 70 in.

Untitled #1. 1998
C-print
127 x 152 cm/50 x 59 7/8 in.

ANNA ▶
GASKELL

Born in Des Moines, Iowa, 1969/Lives in New York

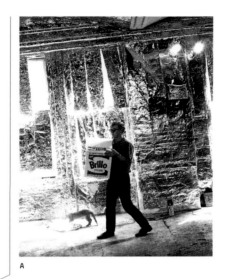

A

and the mainstream vehicles of fame, it did so under critical auspices. For Michelson, the prelapsarian Warhol reflected the ills of mainstream culture through irony-soaked parody. To push a metaphoric reading to excess, the Factory's silver walls were equivalent to a hall of distorted mirrors. Everything happened at the Factory, every gesture, word, or object "generated for our time the most trenchant articulation of the relation between cultures, high and low."[12]

The shot fired from Valerie Solanis's gun in 1968 marked the beginning of Warhol's "decline." It was the trauma that resulted from this assassination attempt that supposedly soured Warhol, driving him toward more cynical modes of art making. Worse yet, this event also marked a dramatic shift in Warhol's "use" of his celebrity, and this is what ultimately provoked his expulsion from Eden by the critical American intelligentsia.

A Andy Warhol carrying a *Brillo Box* at the first Factory, 1964

◀ ANNA
GASKELL

Untitled #31 (hide). 1998
C-print
178 x 152 cm/70 x 59 7/8 in.

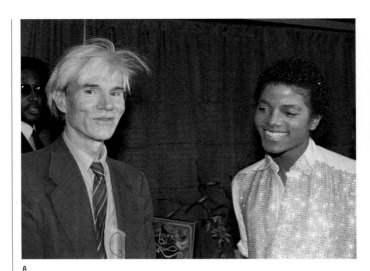

A

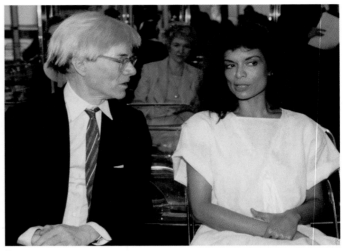

B

At least on the surface, Warhol's life and art in the "new" Factory carried on as before: he continued to make films, paintings, and sculptures as well as having a hand in various cultural enterprises. Yet as the delegation of Warhol's artistic production—whether to studio assistants or to the film director Paul Morrissey—slightly increased, Warhol made even more time for public appearances. During the 1970s and '80s, he continued to travel around the world, documenting his globetrotting through his *Time Capsules*. In New York, his social life epitomized the fashion of the time, and peaked with the decadence of such mythical clubs as Studio 54. Warhol behaved like any other star. His overactive social life was relentlessly photographed by the paparazzi, and he appeared regularly in the society and gossip pages. Michael Jackson, Bianca Jagger, Joan Collins, as well as countless other stars, royalty, and society women—the list of Warhol's companions on film was not only a barometer for who was hot in the '70s and '80s, but also reflected his rolodex of celebrity clients for his booming portrait business.

Flying Shit. 1994
Hand-tinted black-and-white photograph
253 x 639 cm/99 5/8 x 251 1/2 in.

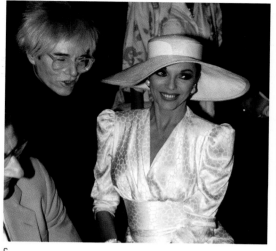

C

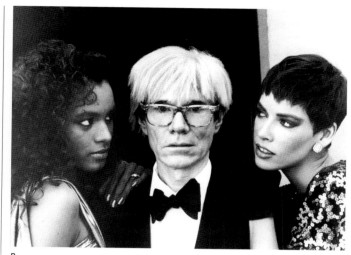

D

Working for the Zoli modeling agency (available for "special bookings only"), Warhol sold his celebrity to various companies for product endorsements in television and print, giving a sense of inevitability to his early Pop appropriations of such banal products as Brillo scrubbing pads and Campbell's soup. Whether he was modeling Levi's blue jeans, advertising TDK videotapes, l.a.Eyeworks, or the ill-fated Drexel Burnham Lambert junk bond trading firm, or guest starring on an episode of *The Love Boat*, these vulgar commercial activities were part of the logical culmination of Warhol's trajectory. "Business art is the step that comes after Art. I started as a commercial art-ist, and I want to finish as a business artist. After I did the thing called 'art' or whatever it's called, I wanted to be an art businessman or a Business Artist."[13]

A Andy Warhol and Michael Jackson, 1981

B Warhol and Bianca Jagger talking at Halston's fall-winter collection show, New York, 1983

C Warhol and Joan Collins, 1985

D Vera Perez, Warhol, and Laura Dean on *The Love Boat*, 1985

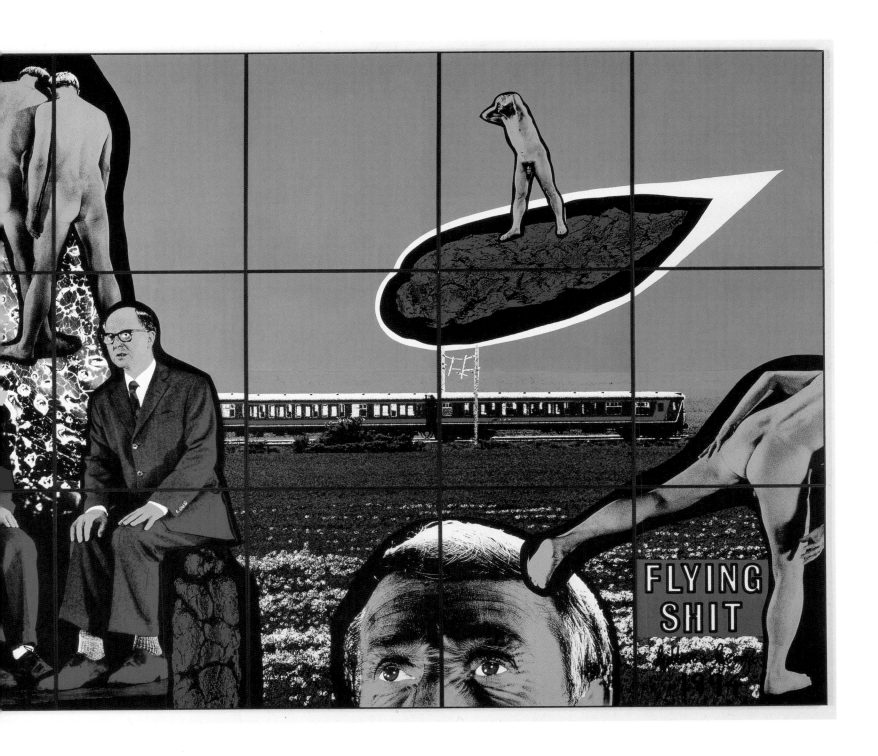

Warhol refused to differentiate between "right" and "wrong" appearances in the Business Art phase of his life. What counted was translating his persona into its most extreme commercial potential. Yet while Warhol was trying to maximize the impact of his public persona in the spheres of art, popular culture, and the market, he insisted on highlighting his imperfections, his personal neuroses, and his claim to be "Nothingness Himself."[14] While this paradoxical coupling of extreme public exposure and sense of invisibility might be chalked up to some manifestation of false modesty, as morally bankrupt as his indiscriminate activities, it could also be attributed to the fulfillment of one of his crypto-critical philosophic maxims. When he describes himself as "putting his Warhol on," he enumerates what he sees in the mirror: "Nothing is missing. It's all there. The affectless gaze. The diffracted grace....The bored languor, the wasted pallor...the chic freakiness, the basically passive astonishment, the chintzy joy, the revelatory tropisms, the chalky, puckish mask....The glamour rooted in despair, the self-admiring carelessness, the perfected otherness, the shadowy, voyeuristic, vaguely sinister aura.... Nothing is missing. I'm everything my scrapbook says I am."[15]

Two Breasts. 1990
Wax pigment
Left, 21 x 17,8 x 10 cm/8 1/4 x 7 x 3 15/16 in.;
right, 18,5 x 17,8 x 10,5 cm/7 1/4 x 7 x 4 1/8 in.

ROBERT ▶
GOBER
Born in Wallingford, Connecticut, 1954/Lives in New York

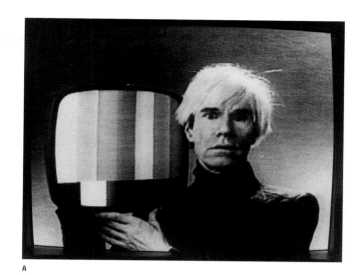

A

B

Warhol worked very hard at being the wrong person for the right part. His "wrongness" was documented in his obsessive archival activities: the publication of his *Diary* and his *Philosophy of Andy Warhol (From A to B and Back Again)*; his scrapbooks and *Time Capsules* (six hundred and ten cardboard boxes that he filled between the early 1960s and the late 1980s with his personal snapshots, periodicals clippings, fan letters, business and personal correspondence, artwork, source images for artwork, books, exhibition catalogues, and telephone messages, along with objects and countless examples of ephemera, such as dinner invitations and cocktail napkins). More than any "artwork" or film he ever made, Warhol's public persona became the most effective device to record and reflect on contemporary life. If the role of the artist today is to search for "aura" in a world of vacuity, Warhol was definitely the wrong person for the right part.

A TDK videotape commercial, 1981, in Japanese with Warhol

B Warhol ad for l.a.Eyeworks, 1985

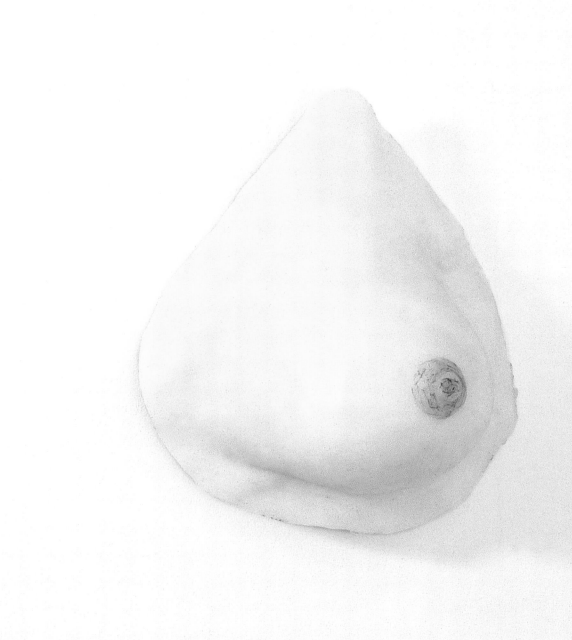

The Eighties: Crass, Conceited, Vulgar, and Unpleasant

"The larger truth is that the '80s remain something of an open wound—not just in terms of the toxic residue of greed and glamour (the 'excess' of journalistic cliché) but simply because of the decade's proximity. There is a traumatic aspect to the process of coming to terms with a period whose developments are 'still unfolding.'"

Jack Bankowsky, "Editor's Notes to Artforum's 40th Anniversary Issue
Dedicated to the 1980s," *Artforum*, March 2003

Slightly younger than the generation of artists that came out of the East Village gallery scene, Christopher Wool began his career as a painter in New York in the mid-1980s. His signature works—sentence fragments that are painted in black-stenciled letters on a white ground—have the uncanny ability to turn a given moment, attitude, or value system into a slogan. Deceptively simple in their execution, these paintings do not immediately reveal their "message," as the text is graphically laid out on the

A Christopher Wool
Untitled (Crass, Conceited, Vulgar, and Unpleasant). 1996
Enamel on aluminum
274,3 x 182,9 cm/108 x 72 in.

The Scary Sink, 1985
Enamel paint on plaster, wire lathe, wood, and steel
158,1 x 140,9 x 140,9 cm/62 1/4 x 55 1/2 x 55 1/2 in.

ROBERT ▶
GOBER

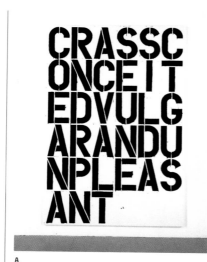

A

canvas to be purposefully awkward. Syllable breaks, punctuation, and grammatical rules are disregarded so that Wool can force the viewer to decrypt each word and take the time to ponder what the text is actually referencing.

CRASSCONCEITEDVULGARANDUNPLEASANT. Wool borrowed this description from a newspaper article about a concert by the legendary punk musician Iggy Pop. As with most of Wool's text-based works, the identification of the original source material is of secondary importance. Even if this painting was executed in 1996, in retrospect it efficiently summarizes the context in which Wool emerged: New York in the 1980s. With more than twenty years of hindsight, this pithy string of adjectives neatly encapsulates the current perception of the art world at that time. The same terms could be applied to all of the players—artists, dealers, collectors, curators—as well as the scene that orbited around the art: its music, fashion, clubs, drugs, and even the discourse. As Anthony Haden-Guest writes in *True Colors: The Real Life of the Art World* (1996), his tell-all account of the 1980s, "Money glimmered all around. Artists were in the glossy maga-

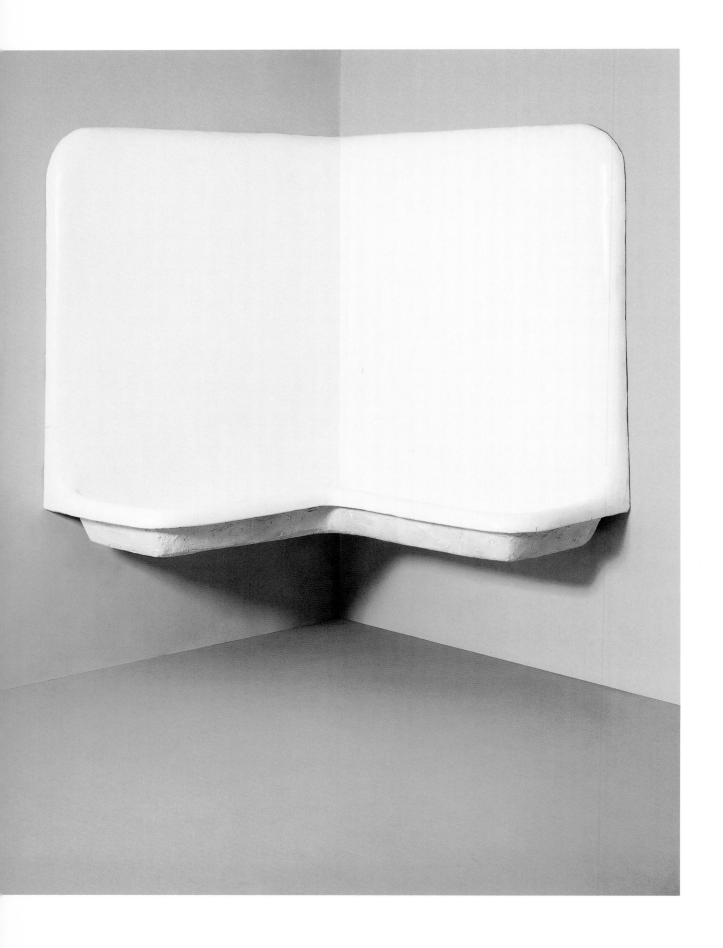

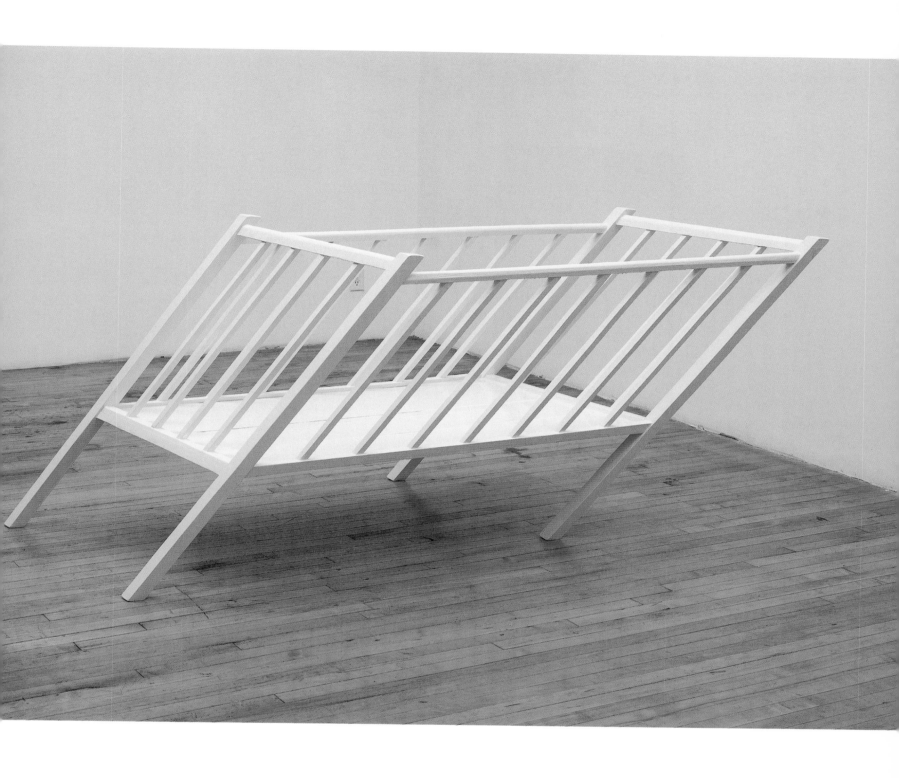

ROBERT GOBER

Pitched Crib. 1987
Enamel paint and wood
97,1 x 186 x 128,2 cm/38 1/4 x 73 1/4 x 50 1/2 in.

zines. Parties were given for them at the Palladium. There were fits and starts of righteousness....Capitalism has overtaken contemporary art, quantifying it and reducing it to the status of a commodity. Ours is a system adrift in mortgaged goods and obsessed with accumulation, where the spectacle of art consumption has been played out in a public forum geared to journalistic hyperbole."[16]

Is capitalism alone really to blame for propelling the eighties art world into the clutches of the Crass, Conceited, Vulgar, and Unpleasant? Were artists merely passive victims of society's wealth and excess? A close reading of two eighties artists who were far from passive in the management of their personas and careers might challenge this received idea. Jeff Koons and Richard Prince offered two versions of the same American predicament.

Corner Bed. 1987
Enamel paint, wood, cotton, and wool
111 x 195 x 105 cm/43 3/4 x 76 3/4 x 41 3/8 in.

ROBERT ▶
GOBER

Jeff Koons in the Position of Adam

"A viewer might at first see irony in my work, but I see none at all. Irony causes too much critical contemplation."

Jeff Koons, *The Jeff Koons Handbook*, 1992

It didn't take long for Jeff Koons to break away from his peers. After his first solo exhibition, entitled *Equilibrium* and held at International with Monument Gallery in 1985, Koons was quickly lumped together with the other so-called commodity artists in the East Village, but he was careful to infuse his rise to stardom with a self-narrated myth. Before this big "break" in 1985, Koons's story resembled those of many other struggling artists trying to make it in New York. He worked odd jobs; he had several brushes with success that never panned out; his friends achieved stardom while he floundered; he had to give up his apartment and move back home to get back on his feet, only to return a half a year later to produce his breakthrough work. Yet unlike the classic "climb up the ladder" success story, the details that surround these elements perfectly fused with the content of his artworks: Koons's day job? Sales (first Museum

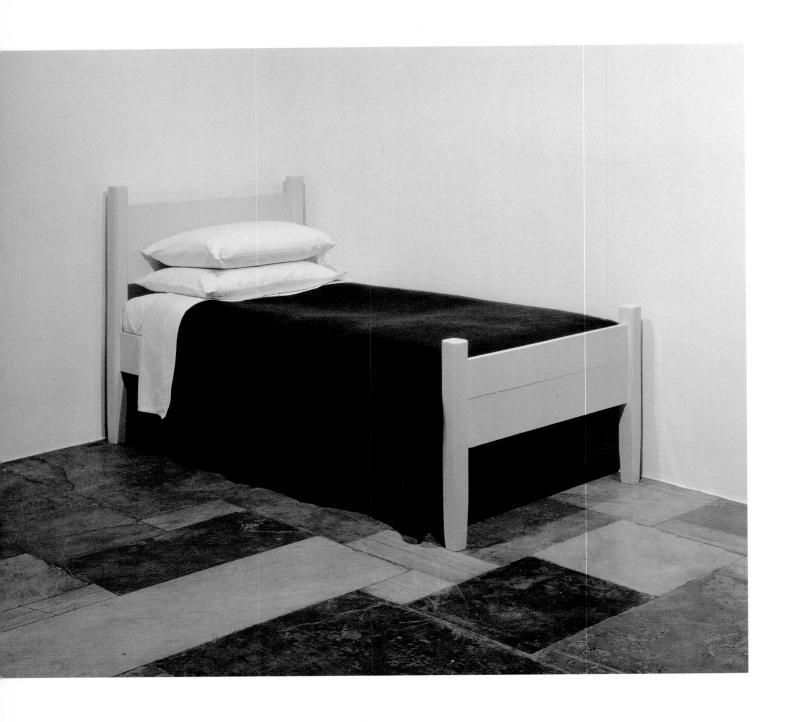

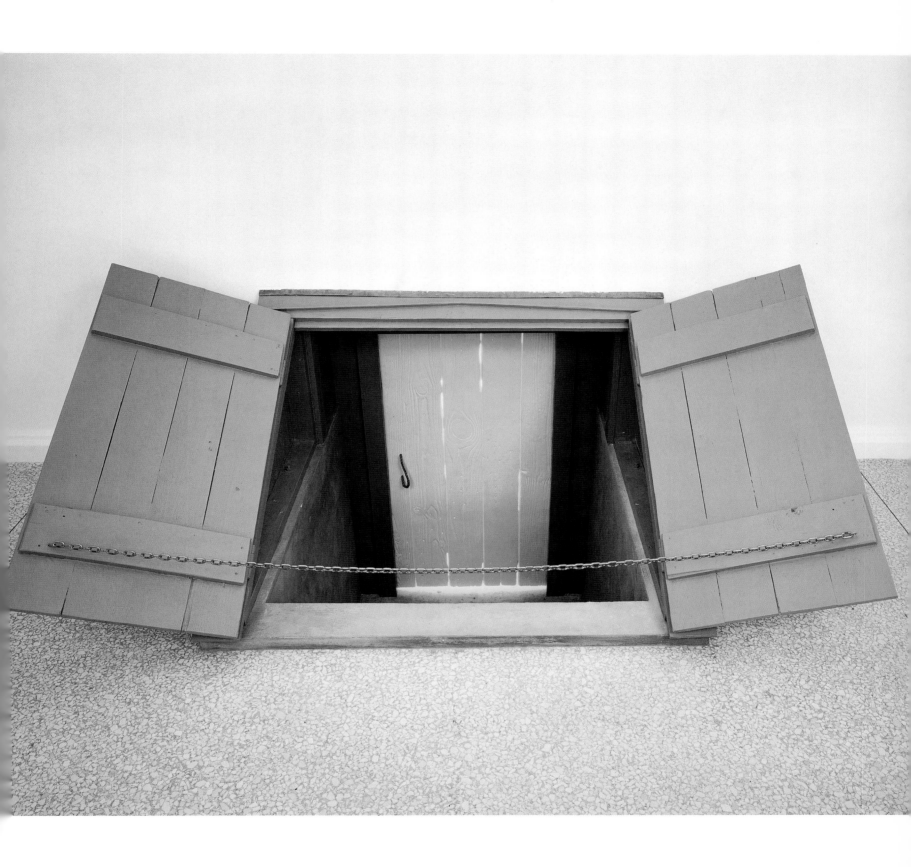

Untitled. 2000–2001
Wood, paint, concrete, cast plastic, and human hair
Approx. 203,2 x 122 x 183 cm/80 x 48 x 72 in. total

of Modern Art memberships, then as a Wall Street commodities trader). His initial strike-out with success? With Mary Boone, the key dealer of the first half of the '80s. His friends? Barbara Kruger, Richard Prince, Julian Schnabel, and David Salle. While others kept a safe, critical distance from power or the market, Koons got his hands "dirty," incorporating tales of his total complicity with the system into his own legend. For the first time since Warhol, a skillful artist emerged who put mass media to use not only as the subject of his work, but in the promotion of himself.

In every interview with Koons, he infuses the otherwise "empty," "vulgar," "icy," and "banal" content of his work with more than just biographical details.[17] His discourse is peppered with pseudo-revolutionary maxims, explaining the desires that drive his art: "to communicate with the masses"; to provide "spiritual experience" through "manipulation and seduction"; to strive for higher states of being promised by "the realms of the

A Jeff Koons
 Art Magazine Ads. 1988–89
 Portfolio of 4 color lithographs
 114,3 x 94,6 cm/45 x 37 1/4 in. each
 The Dakis Joannou Collection, Athens

Two Spread Legs. 1991
Wood, wax, leather, cotton, human hair, and steel
Each leg, 27,9 x 88,9 x 69,8 cm/11 x 35 x 27 1/2 in.

ROBERT ▶
GOBER

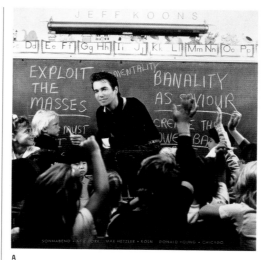

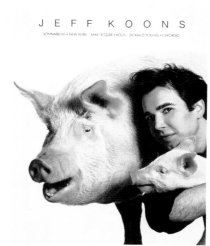

objective and the new."[18] His professed love for the media goes beyond its usefulness as a communication tool: "I believe in advertisement and the media completely. My art and my personal life are based on it."[19]

During the 1988—89 art season, Koons and his galleries put their money where their mouth was. A series of full-page advertisements was purchased in the major trade magazines of the time: *Artforum*, *Flash Art*, *Arts*, and *Art in America*. In the center of each highly theatrical tableau, Koons presided over the scene smiling smugly at the camera, impeccably groomed, obviously airbrushed. Each of the four ads illustrated one of the derogatory aspects of Koons's persona as propagated by the press: Koons as a "breeder of banality" (pictured with two pigs), Koons as "corruptor of the future generation" (photographed in a schoolroom full of children with slogans such as "Exploit the Masses" and "Banality as Saviour" written on the blackboard behind him), Koons as gigolo (pictured in a Hugh Hefner—style robe in front of a boudoir-like tent), and Koons as frivolous ladies' man (posing with bikini-clad models and a braying pony).

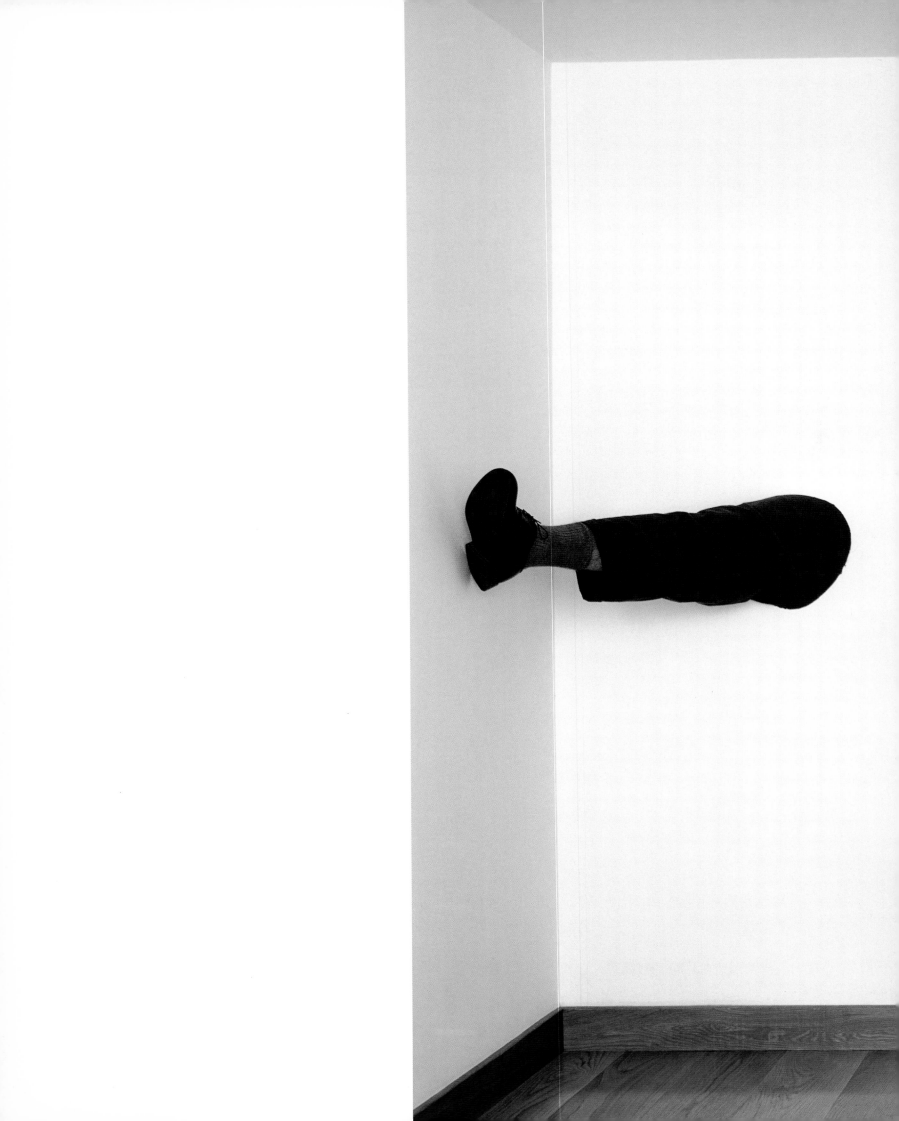

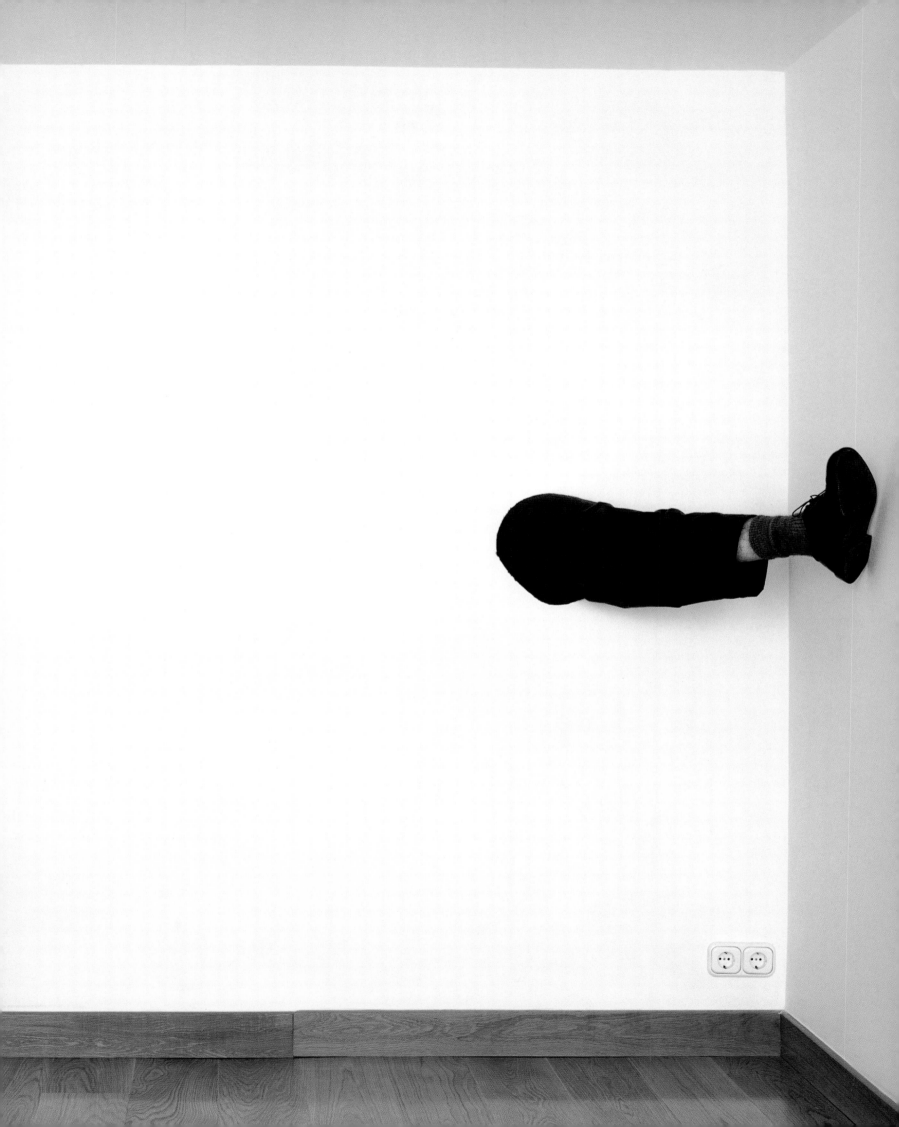

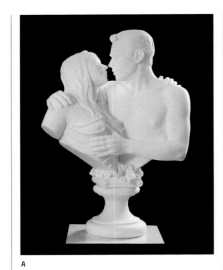

A

B

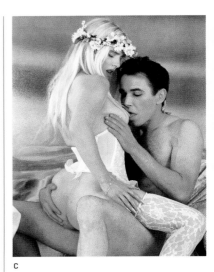

C

These self-satisfied images marked the introduction of Koons's own image into his work while beating the critics to the punch. He called himself a pig, an indoctrinator, a whore, and a narcissist before the guardians of "truth" and "authenticity" could even attack his next body of work: *Made in Heaven*.

By now, everyone knows the story. Koons met the Eurotrash Pop singer/porn star/member of Italian parliament Ilona Staller in 1989 after having based the sculpture *Fait d'Hiver* (from the Banality series, 1988) on a found image of her body. Having initially solicited her involvement in his new body of work to be titled *Made in Heaven*, their collaboration fast turned into a real-life love affair and marriage. The resulting works—an ensemble of life-size sculptures, paintings, glass figurines, as well as a billboard advertising their unrealized porn film—graphically depicted acts of matrimonial consummation. Moral back-

Untitled (Boy Coming Out of Man). 1995
Wood, wax, plaster, brick, leather, cotton, human hair, light bulbs, and motor
101 x 119 x 117 cm/39 3/4 x 46 7/8 x 46 in. total; opening, 76 cm/30 in. wide

**ROBERT ▶
GOBER**

lash aside, this union of art and life pushed the perception of Koons over the edge—even in the art world. In the end, sexual exploitation was a minor irritant in this story. The real taboo that Koons shattered can be located in the manner in which he used his very public relationship with Staller to challenge the humanistic expectations of the role of the artist in contemporary society. As Sylvère Lotringer writes, "[Koons] embraced the System as publicly as he kissed Cicciolina's ass. Ilona Staller became his best PR, using her genitalia, Koons said, to 'communicate a very precise language'. The only one they apparently share in 'real' life. Himself a political flatliner, Koons keeps striding the fluxes of Capital as if Marx had never invented them. He never had to deny or 'deconstruct' anything to make his point. The culture industry was doing it for him."[20]

With this foray into sexploitation, Koons's proclamations about Ilona and himself are most radical when taken at face value. As the "contemporary Adam and Eve,"[21] they were far from adopting the position of passive victims of capitalism's malicious impact on society and art. Twisting the biblical refer-

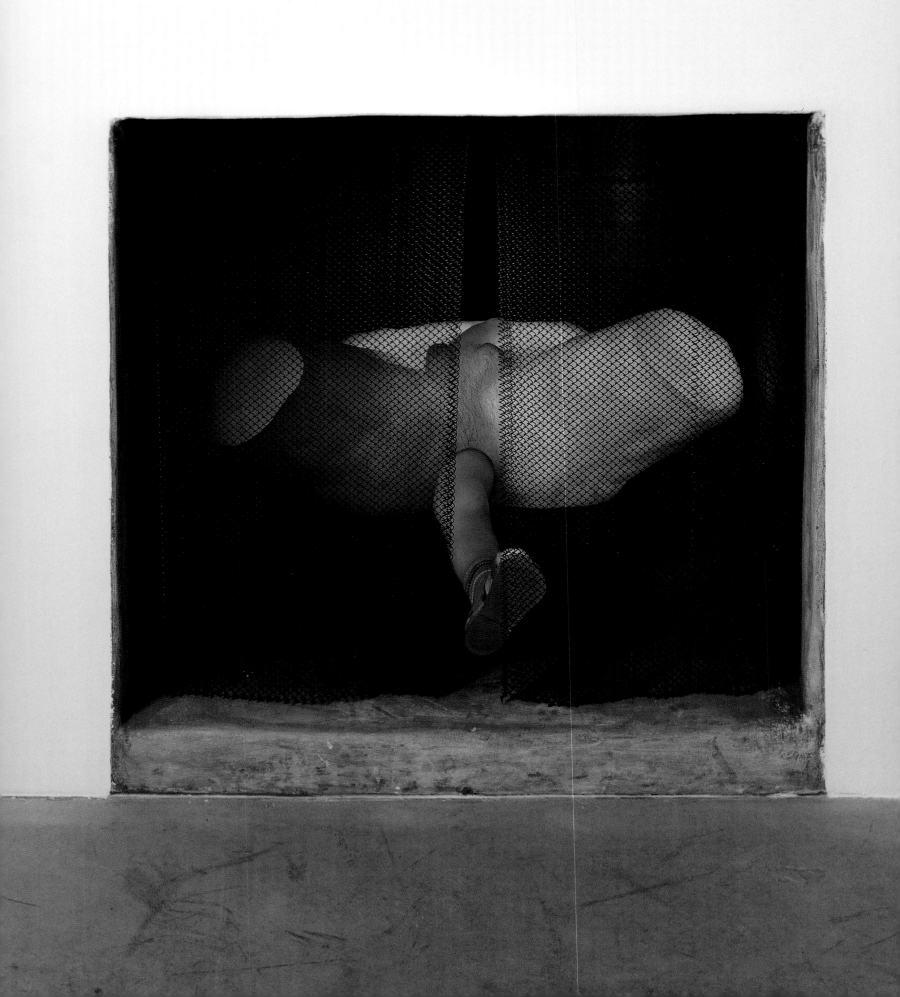

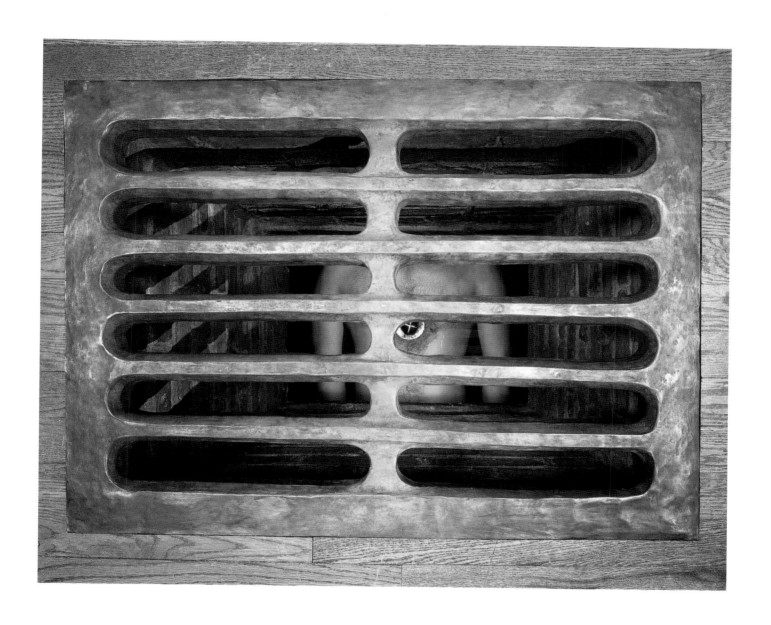

Untitled (Man in Drain). 1994
Bronze, plywood, brick, welded aluminum, beeswax, human hair, chrome, recycling pump, and water
Grate, 3,8 × 74,2 × 55,8 cm/1 1/2 × 29 1/4 × 22 in.; box, 72,3 × 74,9 × 55,8 cm/28 1/2 × 29 1/2 × 22 in.;
tank, 66 × 95,2 × 86,3 cm/26 × 37 1/2 × 34 in.

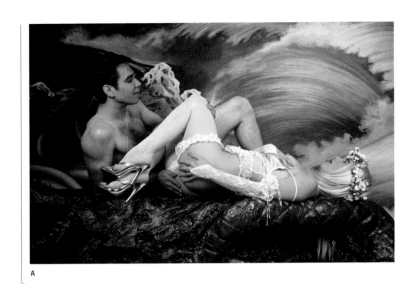

A

ence to fit contemporary life, the Koons-Staller union embraced
the supposed "sins" of the market, brazenly shattering the ex-
pectation that artists should operate in a higher moral realm; it
removed the money, power, and celebrity that corrupts the rest
of society. With this complicity, Koons fulfilled his role as the
new Adam, blissfully savoring the once-forbidden fruit offered
by the American way of life, minus the cynicism or guilt that
plagued his artistic forbears.

Richard Prince's Spiritual America

Larry Clark: "Do you have a spiritual life?"
Richard Prince: "Feelings and Moods, yes. A dominant tendency,
no. A sense of membership, no. Can or have I communicated
with the dead, no. The singing of religious songs, no. Feeling
good at certain times, yes."

Larry Clark, "Interview with Richard Prince," in Lisa Phillips, *Richard Prince*, 1992

A Jeff Koons
 Jeff in the Position of Adam. 1990
 Oil-based inks on canvas
 243,8 × 365,7 cm/96 × 144 in.
 The Dakis Joannou Collection, Athens

Untitled. 1980
Wood, paint, plexiglass, corrugated cardboard,
stones, cement, glue, and formica
69,8 x 119,3 x 55,8 cm/27 1/2 x 47 x 22 in.

ROBERT ▶
GOBER

Richard Prince rarely answers questions in the first person. In interviews as well as in his own writings, he prefers to invert conventional grammar or even use the third person in order to avoid the classical construction of self-expression. When he does employ this type of "I feel...; I think...; I believe..." writing, he expressly empties out the content so that it sounds like a pastiche of appropriated texts or an amalgamation of banal clichés. His most often quoted piece of writing, "Eleven Conversations" (1976), best illustrates how Prince dodges the bullet: "Like most everybody else I don't like to be broke, that means I like money....Like most everybody else I like to be entertained, that means I usually watch television....Like most everyone else I like to fall in love, that means I usually try to gain the friendship and respect of someone who can fulfill my needs. But when I'm horny and need a fuck or a blow job or both, I'll meet someone, get complete control and tell them lies."[22] Et cetera, et cetera. This brief introduction to his writing style demonstrates Prince's ongoing campaign to shroud his identity in a web of tantalizing clues, shadowy images, false leads, carefully constructed rumors, and mythical pseudonyms.

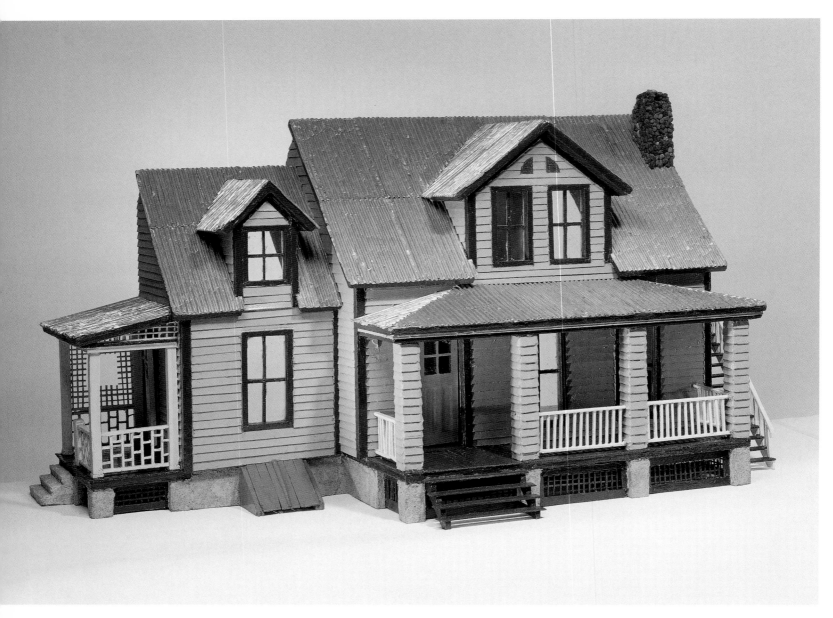

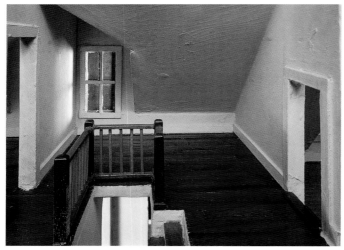

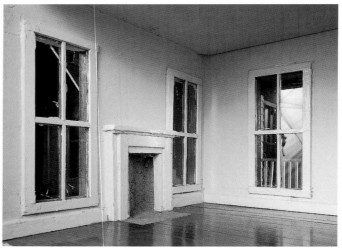

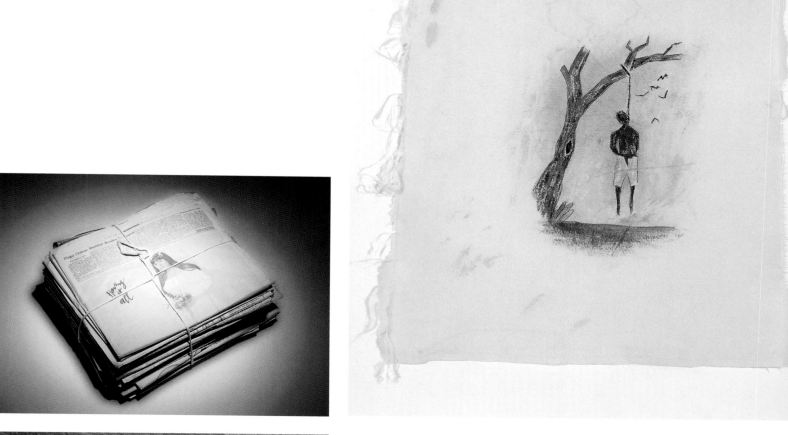

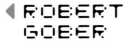

ROBERT GOBER

Newspaper (Having It All—Wedding Gown). 1993
Photolithography on Mohawk Super Fine paper and twine
15,2 x 40,6 x 35,5 cm/6 x 16 x 14 in.

Hanging Man. 1989
Gouache, chalk, and pen on fabric
34,2 x 27,9 cm/13 1/2 x 11 in.

Untitled (Teenager...Love Triangle). 1992
Photolithography on Mohawk Super Fine paper and twine
15,2 x 16,2 x 33,6 cm/6 x 6 3/8 x 13 1/4 in.

A

From the very beginning of his career, Prince explicitly worked on the construction of his public persona without ever having to use his own image in the process of his myth-making. One of his earliest and most successful ploys came in 1983, when Prince opened Spiritual America, a storefront gallery on the Lower East Side of Manhattan. The gallery contained nothing but a receptionist's desk and single work of art in a gilt frame. It was a forgotten image of the child star Brooke Shields. Taken by a commercial photographer in 1973, the photograph shows Shields's fully nude, prepubescent body oiled and glistening as she stood coyly staring in a dry-ice-mist-filled bathroom. As it was destined for controversy because of its sleazy, pornographic content, Prince appropriated this previously obscure picture, which he found while working his day job as a photo researcher. With the assurance that the gallery opening would cause quite a stir in the downtown scene, Prince hired a receptionist (who was kept in the dark about the whole set-up) and high-tailed it out of town. Rosetta Brooks recounted the domino effect that was successfully created by Prince's scheme:

Untitled. 1980
Acrylic paint on canvas
2 panels, 121,9 x 246,3 cm/48 x 97 in. total

JACK ▶
GOLDSTEIN
Born in Montreal, 1945/Died in San Bernardino, California, 2003

It was only by word of mouth, gossip, rumor, innuendo and largely unsubstantiated reports that visitors to the show even realized that there was any connection between the gallery Spiritual America and Richard Prince. For the duration of the exhibition, Prince couldn't be found in New York. Stories circulated downtown that he had gone underground. Or moved to the West Coast. Rumors about hit squads and armies of lawyers alike, looking to hit on him or hit him with subpoenas, circulated around the New York art world. The staging of the exhibition was the stuff of gangster movies, open and shut operations, shady transactions. The whole thing was like a legal mugging; making an illicit image illicit.[23]

Frustrating the public's thirst for putting a face on such a juicy story, *Brooke Shields (Spiritual America)* gave birth to Prince's mystique. His persona was thoroughly bathed in the tawdry, the

A Richard Prince
Brooke Shields (Spiritual America). 1983
Ektacolor photograph
61 x 50,8 cm/24 x 20 in.

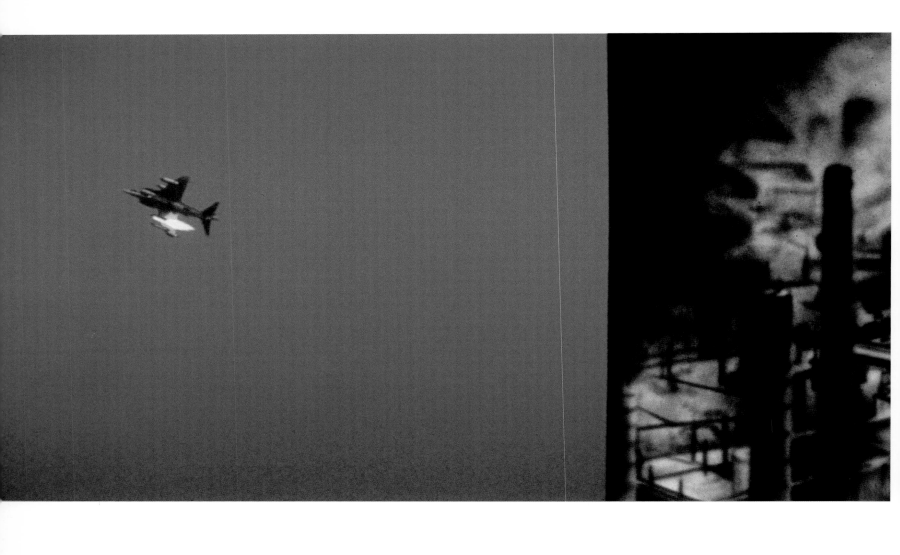

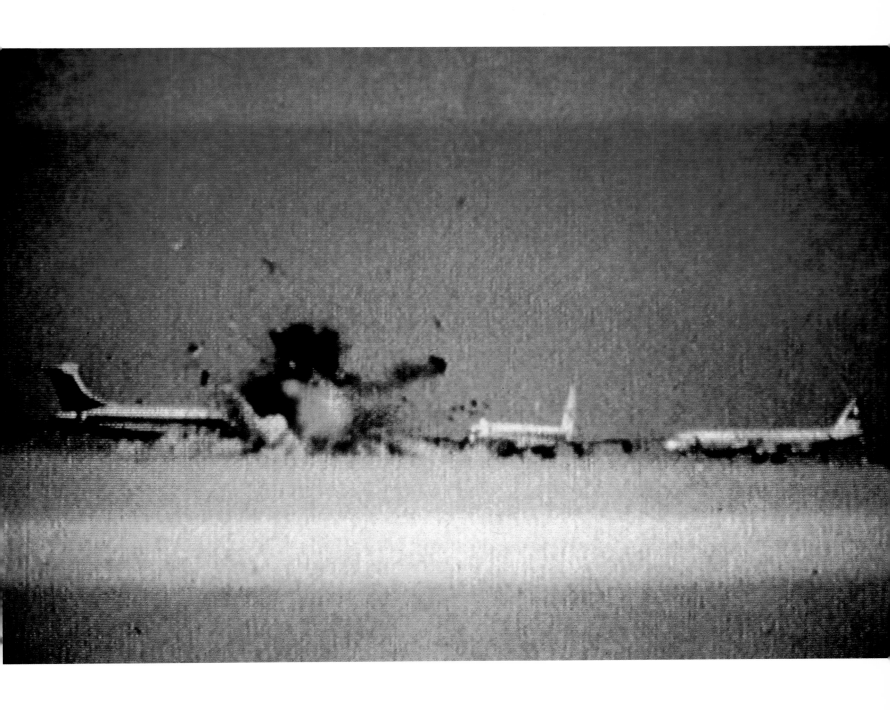

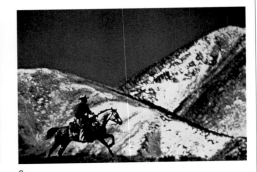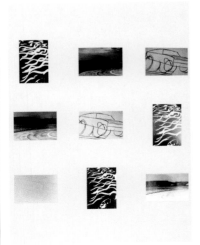

A B C D

banal, and the charm of petty criminality. Prince wasn't just appropriating an image, he was stealing the aura of American culture's dark side.

Both before and after *Spiritual America*, Prince continued to make his work and show in a more conventional gallery circuit. By the time he had his first major solo exhibition, at the Whitney Museum in 1991, the mere mention of Prince's name evoked a complete pantheon of Americana—sexy, dirty cowboys (extracted from Marlboro ads), "gangs" of half-naked biker chicks (Prince parlance for his image grids, usually given the ambiguous title Girlfriends), his Entertainers and Joke paintings (captions such as "I'm missing and presumed dead" from a 1986 work are seen as having autobiographical/Freudian significance). Given that public records lacked any substantive information about Prince's "true" identity, the only way to answer the question "Who is Richard Prince?" was to piece together clues from his writings and to project fantasies on his artworks.

Monument for X. 1998
Video installation on monitor or projection on wall
with semi-tuned-in radio broadcast
Dimensions vary

DOUGLAS ▶
GORDON
Born in Glasgow, 1966/Lives in Glasgow and New York

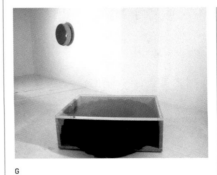

E F G H

Displace the problem. Answer a question with a question. That is Prince's strategy for how best to elude a fixed identity—hence the invention of John Dogg. Who was he, anyway? On the heels of the 1986 Neo-Geo show at Sonnabend, this mysterious artist appeared out of nowhere with a show in the East Village and two shows at 303 Gallery in 1987. His identity was quickly presumed to be fictitious. The small output of high production value, commodity-based sculptures was read in part as a mockery of the reigning art stars. Rumors quickly spread that Dogg was the product of a covert collaboration between Prince and the equally mythologized/subversive pioneer of the downtown scene, Colin de Land.[24] John Dogg's wall-mounted sculp-

A Richard Prince
Untitled (Cowboy). 1980–84
Ektacolor photograph
101,6 x 68,6 cm/40 x 27 in.

B Richard Prince
Untitled (Cowboy). 1980–84
Ektacolor photograph
50,8 x 61 cm/20 x 24 in.

C Richard Prince
Untitled (Cowboy). 1980–84
Ektacolor photograph
50,8 x 61 cm/20 x 24 in.

D Richard Prince
Untitled (for John Dogg). 1987–88
Ektacolor photograph
218,4 x 119,4 cm/86 x 47 in.

E Richard Prince
Live Free or Die (Gang). 1986
Ektacolor photograph
218,4 x 121,9 cm/86 x 48 in.

F John Dogg
Untitled (White Vinyl). 1986
Vinyl and rubber
76,2 x 76,2 x 20,3 cm/30 x 30 x 8 in. diameter
The Dakis Joannou Collection, Athens

G John Dogg, installation at 303 Gallery, New York, 1987

H Colin de Land, ca. 1990

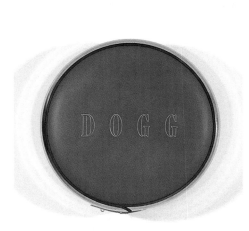

A

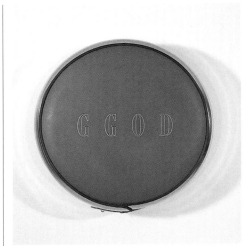

B

C

tures—customized wheel covers made of vinyl and emblazoned with cursive inscriptions such as "John" and "Godd"—indulge in the same motor-centric mystique present in Prince's preoccupation with America's working class (in the series titled Girlfriends, which depicts biker chicks, and his fiberglass sculptures of car hoods, as well as his later Upstate pictures). Until recently, Prince and de Land were tight lipped about John Dogg's true identity, but with de Land's untimely death in March 2003, Prince more or less let the cat out of the bag in this elegiac (probably fictive) anecdote:

A guy comes up to me on the street and asks, "Where's American Fine Arts?" and I say, "You mean the Colin de Land show?" "No," the guy says. "American Fine Arts. It's a gallery." And I say, "No, it's not a gallery, it's a TV show and it's in the back of the gallery...the back room. Like the bar in *Cheers*. The living room in *All in the Family*. The

A John Dogg
 Ulysses (DOGG). 1987
 Rubber and engraved stainless steel
 71,1 x 71,1 x 21,6 cm/28 x 28 x 8 in.

B John Dogg
 Ulysses (GGOD). 1987
 Rubber and engraved stainless steel
 71,1 x 71,1 x 21,6 cm/28 x 28 x 8 in.

C John Dogg, installation at American Fine Arts, Co., New York, 1987

Athens Diptychon. 1995
2 c-prints
180 x 180 cm/70 7/8 x 70 7/8 in. each

ANDREAS ▶
GURSKY
Born in Leipzig, 1955/Lives in Dusseldorf

apartment in *The Honeymooners*." So he says, "It's a sit-com?" And I say, "Well, it's a situation." See, you don't go to American Fine Arts to see a show...you go to see Colin, in the back, that's where the show is. You walk in, he's on the phone, he's got a John Deere baseball hat on, and he's saying "yes" a lot...and Peter Fend is in the corner making Xerox's and Jack Pierson is working on the mailing list and John Waters walks in as himself. "Oh," says the guy..."so who are you?" "I'm John," I say. "John who?" "Just John," the rest of me, the other half, the one who thought it all up, he's in the back, ask him, he'll tell you, the reality has no door, the camera is always on and man's best friend is spelled dogg.[25]

While this story evokes a small but important parenthesis in Prince's artistic career, it also reveals a great deal about his twenty-plus-year construction of his elusive persona. After a hangover of the '80s obsession with critical theory, Prince's in-sistence on his mystery-man persona goes beyond the period's concern with the "death of the author."[26] Prince's strategy of

A

shrouding himself in mystery can be read today as a biting alternative to the "glamour and greed" of the time. While many of his peers were in front of the camera, Prince stayed behind his lens, pitting myth against myth in the Crass, Conceited, Vulgar, and Unpleasant '80s in America.

Bickerton in Bali: Snapshots from the Gauguin of Our Age

Steve Lafreniere: "Is surfing the reason you now live in Bali?" Ashley Bickerton: "It's like Vail or Aspen or Telluride—one of the best places on earth to surf. Whereas in New York sport consisted of chain-smoking, Rolling Rocks, tequila shots and a pool table. No thanks."

"Ashley Bickerton Talks to Steve Lafreniere," *Artforum*, March 2003

"You have been aware for quite a long time of something that I wanted to establish: the right to dare in everything."

Paul Gauguin, letter written from the Marquesas Islands, October 1902

A Ashley Bickerton surfing the fabled Padang-Padang reef, Bali, 2002 B Bickerton in his studio, Bali, 2003, with his son Django, and Gungtri, who is blessing his paintings. The surfboard designs are based on Asmat shields.

Red Shift. 1988
Day-Glo fluorescent pigment and acrylic paint on canvas
114,3 x 365,7 x 8,2 cm/45 x 144 x 3 1/4 in.

Two Cells with Circulating Conduits. 1987
Day-Glo fluorescent pigment and acrylic paint
on Roll-a-tex canvas
196,2 x 350,5 x 8,2 cm/77 1/4 x 138 x 3 1/4 in.

PETER ▶
HALLEY
Born in New York, 1953/Lives in New York

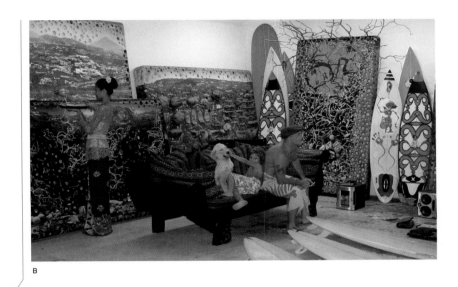

B

Shunning an urban, upper-middle-class life, abandoning family, children, and profession, Paul Gauguin fled from European civilization in 1891 and moved to French Polynesia. It was an act of refusal. Despite critical and financial success in France, his radical decision was as much a rejection of easy glory and gain as it was part of his drive to seek artistic inspiration from the exotic, primitive cultures of the South Pacific.

For many readers, it might be a stretch—even sacrilege—to compare Ashley Bickerton to a Post-Impressionist master.[27] But the two have more in common than having wound up being "mature" artists who chose expatriation in the South Pacific. Like Gauguin's, Bickerton's career has followed a driven yet not too predictable path. After basking in the success of his New York reception in the '80s—one of the four artists in the Neo-Geo manifesto exhibition at Sonnabend Gallery in 1986—Bickerton changed more than just his residential address when he moved to Bali in 1993. David Rimanelli best summarizes his New York trajectory:

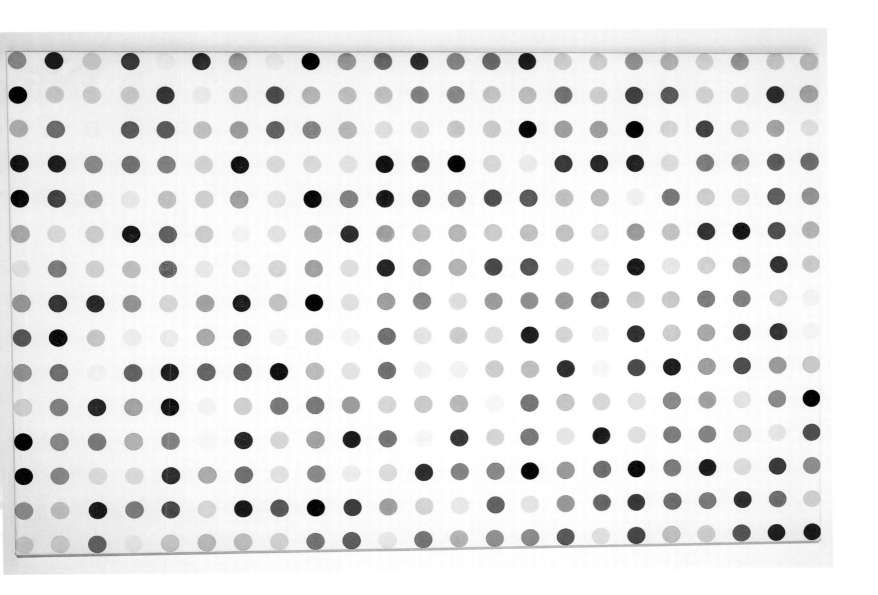

Alphaprodine, 1993
Water-based paint on canvas
334,4 × 456 cm/131 5/8 × 179 1/2 in.

A

B

The works of his "Neo-Geo" phase were perhaps the most concisely sarcastic integrations of Pop and institutional critique in a sarcasm-rich period. The individual subject (the artist himself in most of these pieces) was defined entirely through overlapping networks of commodities, institutional affiliations, and financial transactions. In his next phase, Bickerton dramatically shifted emphasis from the operations of the art system to those of the eco-system. The vivid contrast between the fragile remnants of the natural world and the impressive, Darth Vader-ish containers that Bickerton fashioned for them suggested that something else was at work besides a well-meaning Let's-help-save-the-rainforest stance—something less blandly P.C., something about the artist's ego.[28]

Many chalked up Bickerton's move to Bali as an abdication of the New York art world at the moment of its financial bust, trading in artistic and commercial competition for his surfboard, the pollution and cynicism of the metropolis for a "warm, tropical, skin exposed bliss".[29] To a certain extent, he was drop-

Entrails Carpet. 1995
Silicone rubber
198,1 x 297,1 x 4,4 cm/78 x 117 x 1 3/4 in.

MONA ▶
HATOUM
Born in Beirut, 1952/Lives in London

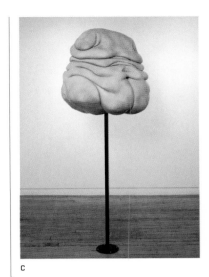

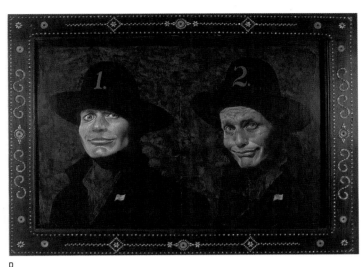

C

D

ping out. But like Gauguin's, Bickerton's decision to leave for
Bali was a defiant refusal of the status quo. Yet unlike Gauguin,
Bickerton did not go to this Indonesian island to find an unblem-
ished and exotic world to fill his canvases. His portraits of par-
adise are far from Gauguin's idealism. Shifting once again, both
formally and conceptually, Bickerton began to make hyper-real-
ist paintings in Bali that depict figures representing the futility
of the human condition. Expatriate beachcombers, philosophi-
cal surfers, silicone-filled blondes, sex-obsessed, repressed
Asian businessmen, and corrosive self-portraits—his subjects
are meticulously rendered and adorned (in a devotional or tribal
fashion) with detritus washed up on the beach (driftwood, shells,
beach glass, flip-flops, and other found bits of rubbish). In
his hands, these images of a tropical paradise are as much a
wasteland of despair and a site of struggle with one's own ego
and id as the more "natural" urban context for an angst-ridden

A Bickerton's Bali studio, 2003

B Bickerton in his studio, Bali, 1998

C Ashley Bickerton
 F.O.B. 1993
 Fiberglass, enamel paint, and steel
 208,2 x 78,7 x 73,6 cm/82 x 31 x 29 in.
 The Dakis Joannou Collection, Athens

D Ashley Bickerton
 Double Self: The Patriots. 2002
 Acrylic paint on paper with wood frame and mother-of-pearl inlay
 81,2 x 111,1 cm/32 x 43 3/4 in.
 The Dakis Joannou Collection, Athens

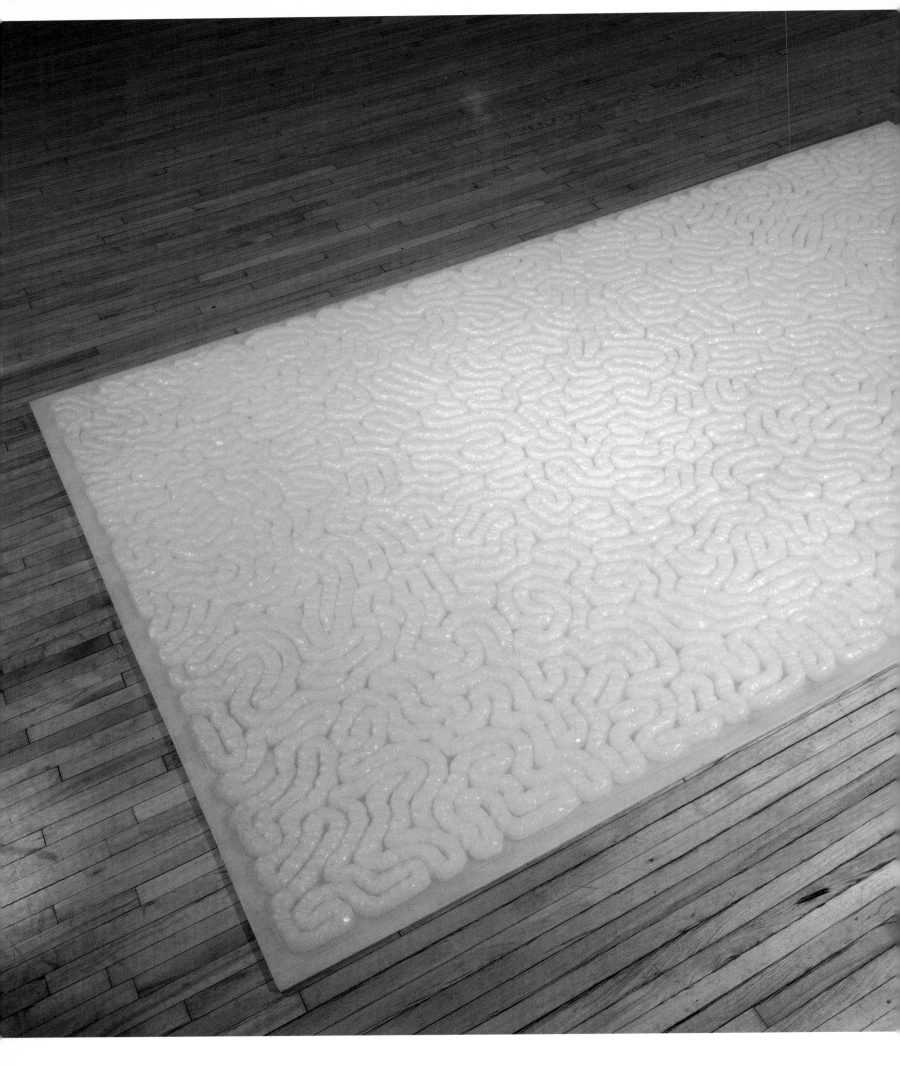

artist. Rejecting the comfort of New York (its arts community, its consensual social structure), Bickerton made a radical move to Bali as a way of intensifying the alienation of his existence, both as an artist and as a participant in the "system." His lifestyle as well as the substance of his art serves as a reminder that not even the most remote corner of paradise can provide a refuge from the artificial, alienating effects of society.

The New Barbarians: Young British Artists in the 1990s

"For a thousand years art has been one of our great civilizing forces. Today, pickled sheep and soiled beds threaten to make barbarians of us all."

Review of the 1999 Turner Prize, *Daily Mail*, 1999

Contemporary art movements rarely cross over into a wider public consciousness. If and when they do, it is only after the artists have been widely exhibited or written about in the specialized publications by the art establishment. In the early 1990s, the advent of "YBA" changed this precedent. Less a cohesive movement of like ideas and forms than a clever market-

Selections from the series Survival. 1984
LED sign and green diode
15,2 x 152,4 x 17,7 cm/6 x 60 x 7 in.

JENNY ▶
HOLZER
Born in Gallipolis, Ohio, 1950/Lives in Hoosick Falls, New York

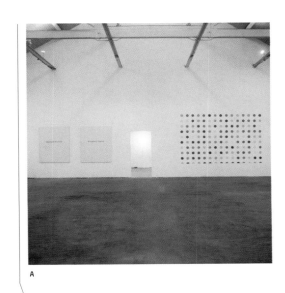

A

ing ploy that pandered to a nationalistic angle, the hype that surrounded the rise of Young British Art bypassed the traditional channels of artistic reception. The infamous tabloid press in the United Kingdom found all the requisite ingredients in order to transform the YBA scene into an object of public fascination: instant wealth, sensationalism, death, sexual promiscuity, religious sacrilege, childish irreverence, flirtation with fascism, cynicism, wit, and a lot of public drunkenness.

The YBA phenomenon began with just two men—according to the official myth (now better than ten years old). Collector Charles Saatchi's ostentatious personal fortune combined with his incredible media savvy found its perfect match in his first YBA "discovery": Damien Hirst. His work was launched in a string of artist-organized exhibitions with titles such as *Freeze* and *Gambler* held in old London warehouses between 1988 and 1990. Without any official institutional endorsement, Hirst's works—tableaux encased in large glass vitrines revealing "shocking"

A Damien Hirst
Installation view of *Freeze*, London, 1988

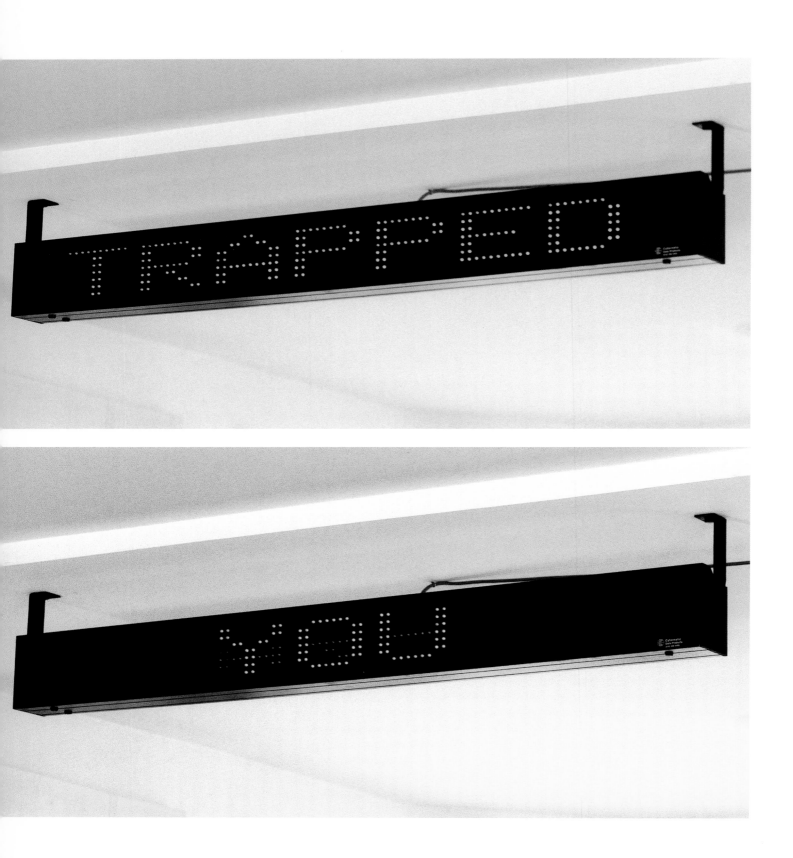

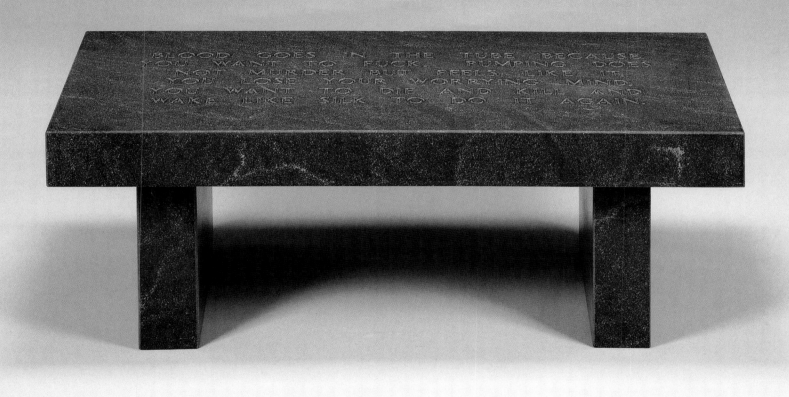

◀ JENNY HOLZER

Selection from the series Under a Rock. 1986
Misty black granite
43,1 x 121,9 x 53,3 cm/17 x 48 x 21 in.

Inscribed, "Blood goes in the tube because you want to fuck. Pumping does not murder but feels like it. You lose your worrying mind. You want to die and kill and wake like silk to do it again."

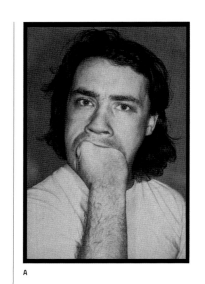

A

content such as a severed cow's head and real flesh-eating flies exposed next to seemingly decorative Spot paintings—captivated Saatchi's attention and pocketbook. With a series of highly publicized purchases by Saatchi, Hirst clinched the role as the central figure of his generation. Matthew Collings, the unofficial critic-cum-spokesperson of the YBA, reminisces: "Maybe Saatchi told Hirst to do *The Physical Impossiblity of Death in the Mind of Someone Living* (1991). I don't know. But I was on the lawn outside the Serpentine Gallery one summer evening, when someone mentioned that Damien Hirst was going to be suspending a shark in Formaldehyde and it was going to cost 50,000 or 12,000 or some very high figure and Saatchi was paying. For a time before this work was eventually seen it was already known about."[30]

Recounting the exact same anecdote, Calvin Tompkins reported in his *New Yorker* profile on Hirst that "Saatchi put up something like sixty thousand pounds for Hirst to make that shark sculpture."[31] Whatever the actual sum, the origin myth of the Saatchi/Hirst couple is indelibly tied to all things crass: populist sensationalism, rumors about powerful public figures, and

U.S. Girl Band near Dark Moon. 2000
Oil paint on canvas
213 x 305 cm/83 7/8 x 120 in.

BRAD ▶
KAHLHAMER
Born in Tucson, Arizona, 1956/Lives in New York

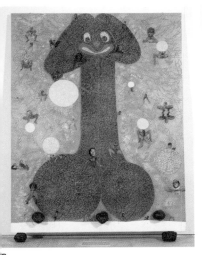

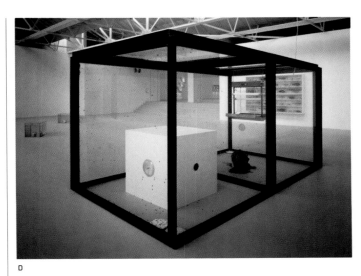

phenomenal sums of money. Hirst's iconic works—pickled animal pieces in glass tanks and Pop-yet-opaque paintings—became a launch pad for the other luminaries of his generation: Jake and Dinos Chapman, Mat Collishaw, Tracey Emin, Angus Fairhurst, Gary Hume, Abigail Lane, Sarah Lucas, Chris Ofili, Fiona Rae, Sam Taylor Wood, and Gillian Wearing. The YBAs were a competitive but tight-knit group. "They drank together, slept together, promoted one another's work, and welcomed talented newcomers."[32] Emerging from an instantly seductive mythology, the "New Barbarians" were born out of the loins of contemporary British culture.

Tabloid Darlings: Damien Hirst, the Chapman Brothers, and the British Love of Distrust

"Hirst is crass and vulgar. He does the type of art that appeals to middle-class people who don't know anything about art but want to bray about it at the dinner table."

Matthew Collings quoted in Carrie O'Grady, "Damien Hirst: Turner Prize Winner, 1995," *The Guardian*, November 1, 2003

A Damien Hirst, 1998

B Chris Ofili
Pimping Ain't Easy. 1997
Oil paint, polyester resin, map pins, paper collage, glitter, and elephant dung on linen
244 x 183 x 13 cm/96 x 72 x 5 1/8 in.
The Dakis Joannou Collection, Athens

C Jorodo
"Art supplies: oils, acrylics, dung."

D Damien Hirst
A Thousand Years. 1990
Glass, steel, MDF, cow's head, fly zapper, and bowls of sugar water
213,4 x 426,7 x 213,4 cm/84 x 168 x 84 in.
Installation view, *Young British Artists,* Saatchi Gallery, London, 1992

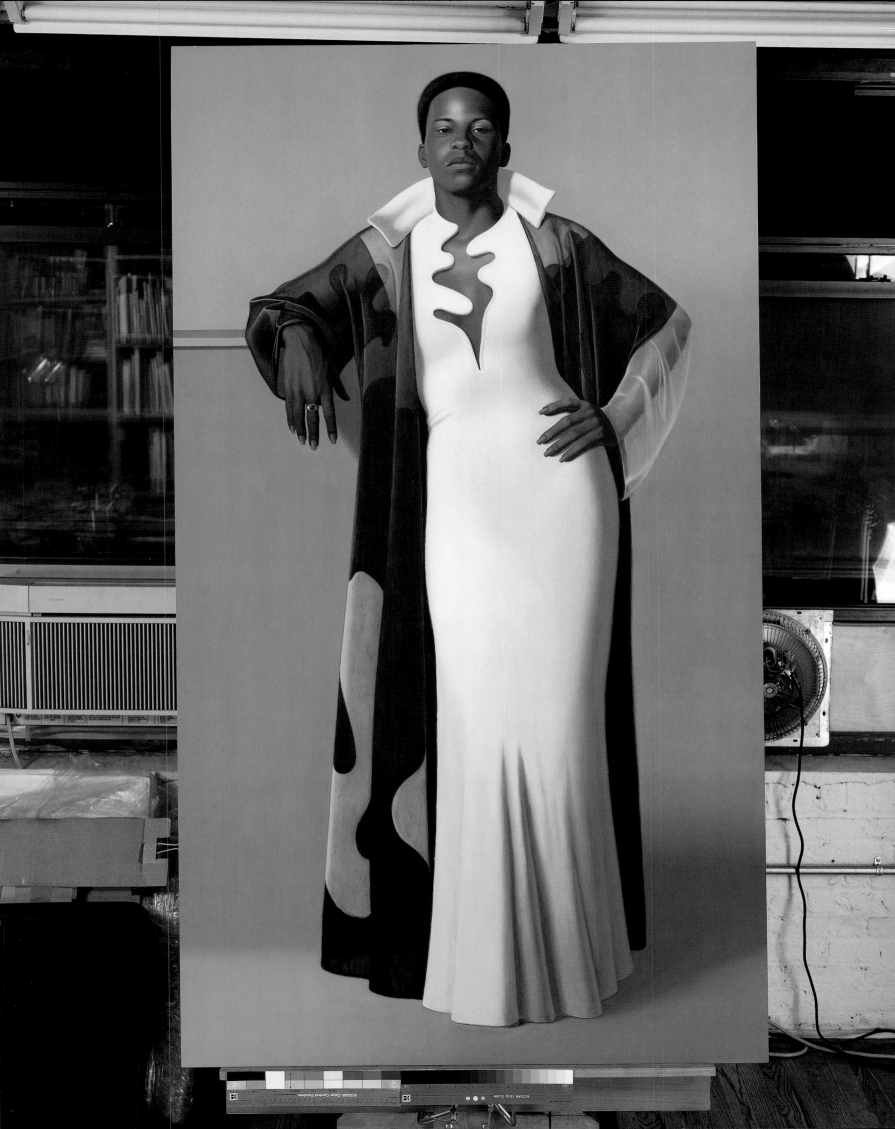

KURT KAUFER
Born in Indianapolis, Indiana, 1966/Lives in New York

Diva Fiction #11. 2000
Oil paint on birch panel
216 x 121 cm/85 x 47 5/8 in.

In terms of popular lore, the formal and conceptual diversity of the actual art practices of the YBA generation is often glossed over. What connects them instead is the way the tabloid press has conflated the often controversial or superficial content of their work with their excessive public exploits. Arguably the most prominent figures—Hirst, the Chapman brothers, and Tracey Emin—perfectly epitomize the British public's captivation with the entwinement of persona and art practice. These four have been the object of countless paparazzi images, gossip pages, Sunday newspaper "People" features, fashion spreads, and newspaper-cartoon lampoons fueled not only by the content of their artwork, but of their semiprivate lives.

In a certain way, Hirst and the Chapmans follow a model established by rock stars and other media-conscious bad boys and riot grrls before them (from the Rolling Stones to Courtney Love). Yet their tabloid-documented lifestyles seem to be symmetrically mirrored in the formulas that operate in their art practices. The schematic equation goes something like this:

La Columna Infinita. 1996
Wood and C-clamps
396,2 x 304,8 x 228,6 cm/156 x 120 x 90 in.

KCHO ▶
(ALEXIS LEYVA MACHADO)
Born in Nueva Gerona, Cuba, 1970/Lives in Havana

Public drunkenness + Physical brawling + Being ejected from posh private clubs in London + Cyclical declarations of "detox" or withdrawl = Sensational art content + Appropriation of commodity forms + High production values + Vulgar/Provocative titles + Banal yet profound meaning about life, love, and death.

Hirst gives bar-room banter titles such as *Beautiful, handsome, tasteless, thoughtless, amazing spinning, cyclone good-in-bed painting* or *Beautiful, kiss my fucking ass painting* to his formally rudimentary Spin and Spot paintings. Almost all of his interviews alternate between contemplative remarks about his fascination with death and his self-created, self-conscious image in the media. As one recent interviewer explained, Hirst's gift for interacting with journalists has propelled him to the top, "Even journalists who write nasty things about him like him, for the chance he gives them to write those nasty things."[33] Constructing a self-aware theater of his own persona in the press while producing slick,

A Knife
 "I've just run over the cat—call Charles Saatchi."

B Des Buckley
 "Celeb Foods: Damien Hirst's voles in brine."

C Jonathan Ruddell
 "Damien Hirst Café"

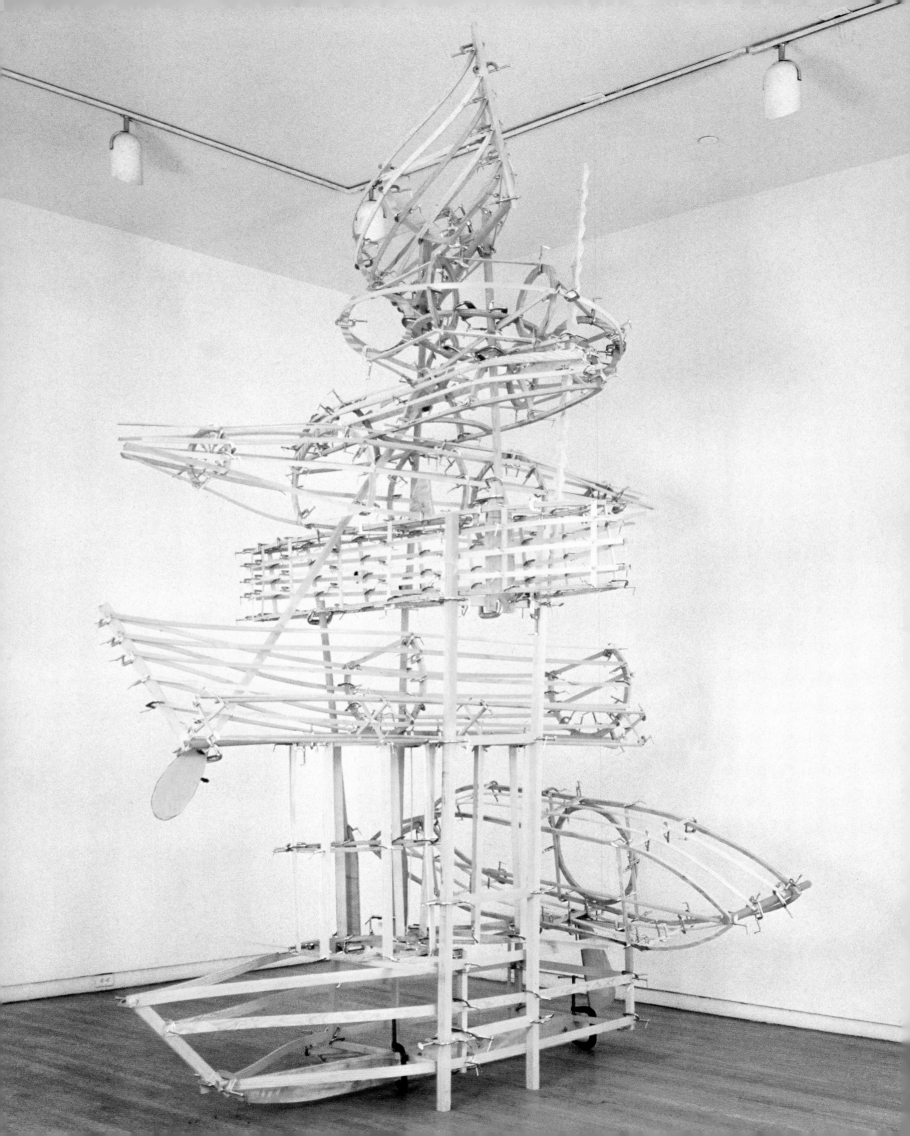

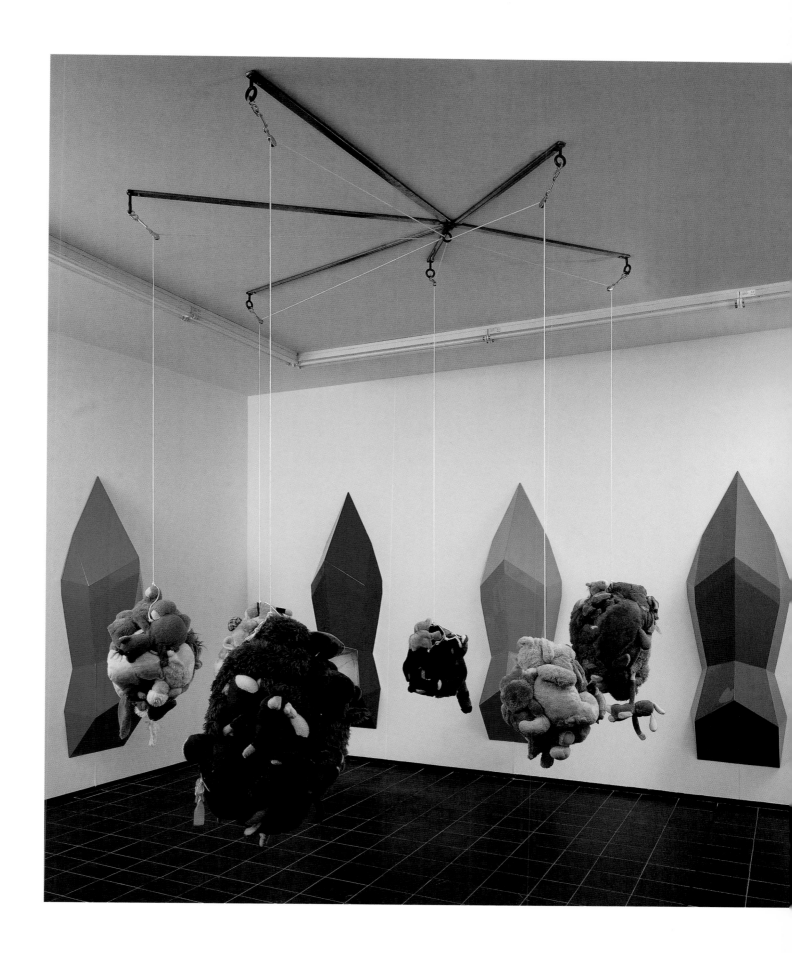

Brown Star. 1991
Stuffed animals, steel, and string
Dimensions vary

A

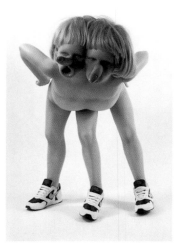

B

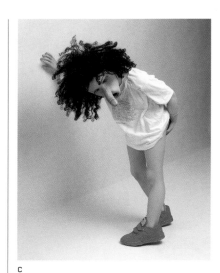

C

surface-driven artworks, Hirst seems intentionally to court accusations of superficiality, corruption, and nihilism.

The Chapmans have cultivated a similar strategy of distrust while dipping into the ever-fashionable allure of psychoanalysis. Their realist sculptural tableaux depict sex and violence, filth and science, obscenity and high-art references (from their allusions to Auguste Rodin's sculptural renderings of human suffering in Hell to their fiberglass reconstruction of Goya's etching *Great Deeds against the Dead*) with disregard to redemptive or critical meaning: child mannequins with genitalia replacing more benign orifices (*Zygotic Acceleration, Biogenetic De-Sublimated Libidinal Model*, 1995), intricate miniature models of Nazi killing fields (*Hell*, 1999–2000), a rendering of the disabled physicist in his computerized wheelchair resting at the edge of a cliff (*Ubermensch*, 1995). Through their references and speech, the Chapmans present themselves as perfect sons of Nietzsche, paraphrasing his critique of societal values. "We suffer the same moral and ethical obligations as everybody else....We are interested in being utterly gratuitous and rejecting critical worth.

Cave Painting. 1984
Synthetic polymer on 12 sheets of paper
365,8 x 487,7 cm/144 x 192 in. total

MIKE ▶
KELLEY

But even more, we are interested in how even the most abject object is recuperated to 'use value'.... We fantasize about producing things with zero cultural value, to produce aesthetic inertia—a series of works of art to be consumed and then forgotten." [34]

Despite the thinly veiled citation of the philosophical underpinnings of their endeavor, British critics cannot help conflating the violent, pornographic content of the Chapmans' work with stories about Jake's violent temper at the Groucho Club or Dinos's extreme reticence, which is occasionally punctuated by biting sarcasm. In "The Legend of Jake," an entire section of Collings's book *Blimey!*, he recounts one of these tales, saying that Jake Chapman was in such "a terrible fight after an art world event one evening that it resulted in his hospitalization. And when he got out, all covered in plaster and on crutches, somehow the fight started up again even if his limbs were all

A Dinos and Jake Chapman, 2002

B Dinos & Jake Chapman
Fuckface Twin. 1995
Fiberglass, resin, paint, wig, and shoes
85 x 64 x 57 cm/33 1/2 x 25 1/4 x 22 in.
The Dakis Joannou Collection, Athens

C Dinos & Jake Chapman
Fuck Face. 1994
Mannequin, wig, resin, paint, and t-shirt
90 x 30 x 50 cm/35 1/2 x 11 13/16 x 19 3/4 in.
The Dakis Joannou Collection, Athens

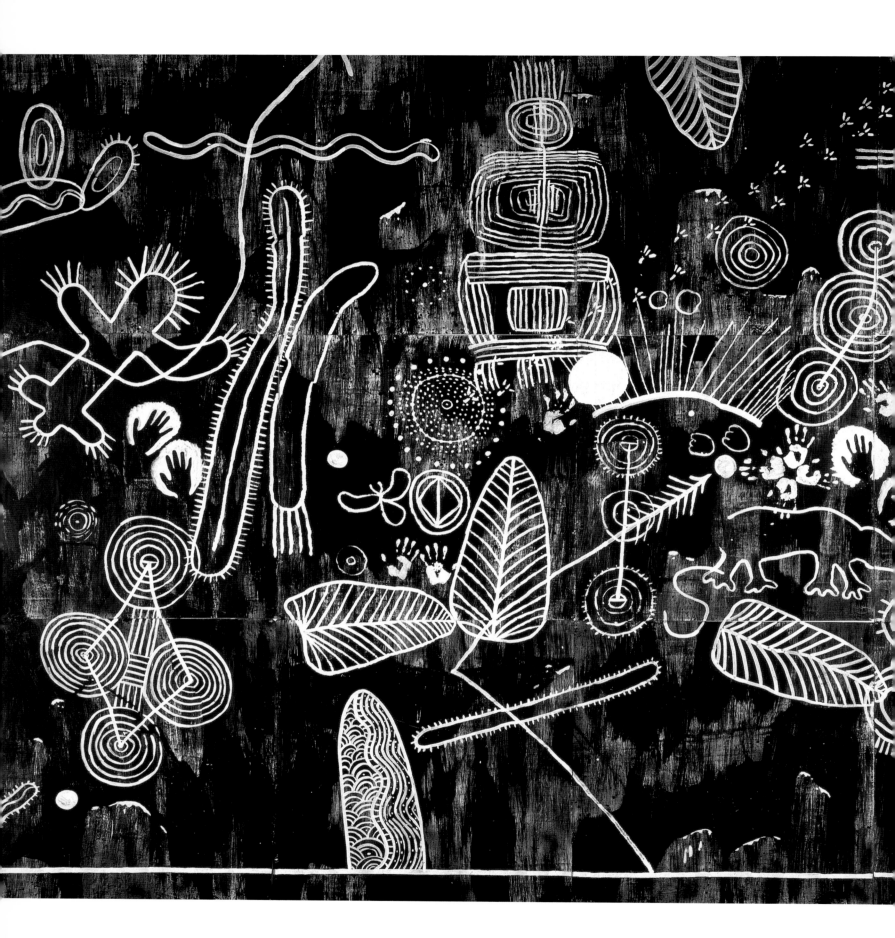

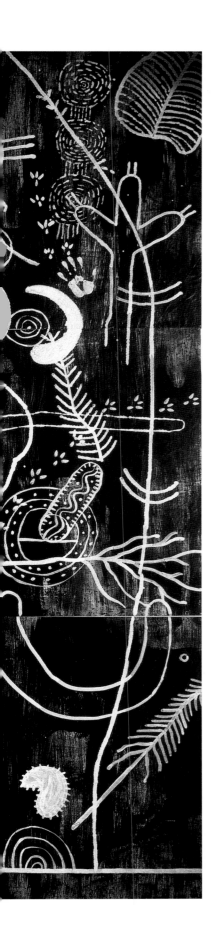

Hidden Meaning, 1985
Acrylic paint on paper mounted
on canvas
80 x 76,8 cm/31 1/2 x 30 1/4 in.

broken."[35] Collings further embellished the "legend" in question, recounting that he received a threatening "sputtering of fucks and fucking hells and cunts from Jake" on his answering machine when Collings was attributed as a source for the same story included in an article by another journalist.

Like Hirst, the Chapmans have good press agents. They have each been accused of being cynical, unauthentic, and fraudulent. They all like to play with self-generated mythology and public image while insisting on the disconnection between work and persona—the same way many governments insist on the separation of Church and State. Whether the reception of their artwork suffers or benefits from this public presence, they remain tabloid darlings because of the British love affair with distrust.

A

Tracey Emin attending the Royal European Charity premiere of *Bright Young Things* at the Odeon Leicester Square, London, September 29, 2003

Heidi House. 1992
Painted wood architectural structure, artificial human figures, various fabrics, wooden objects, 3 pinboards
House, 365,7–396,2 cm/143 3/4–155 7/8 in. high x 365,7 cm/143 3/4 in. wide at bottom and
457,2 cm/180 in. wide at top x 548,6–609,6 cm/216–240 in. deep

KELLEY ▶
& McCARTHY
Mike Kelley: see earlier; Paul McCarthy: see later

A

Tracey Emin: Raping Herself (with Style)

"Not a fake or an impostor but I know what you are saying. Sometimes I do feel, 'Oh no, what is this in my life?' I woke up one day and realized I had raped myself and that is the worst rape of all."

Tracey Emin responding to the question of fraudulence in her work in Nigel Farndale,
"A Real Piece of Work," *Daily Telegraph*, October 30, 2002

Tracey Emin stands in opposition to her YBA masculine comrades: her life and work are indivisible. It is almost impossible to make a hierarchical distinction between the way she uses the press or her artwork as vehicles for the delivery of her autobiographical goods. Excessive drinking, promiscuity, abortions, rape, childhood abuse, suicide attempts—Emin makes no differentiation when narrating her life story in an exclusive *Evening Standard* interview or a bathos-drenched installation. In all that she does, her self-exposure has a constant level of aesthetic panache.

Her now-legendary appearance on national television assured the permanent entwinement of art and life, legend and work. Many British art fans can repeat the transcript of Emin's

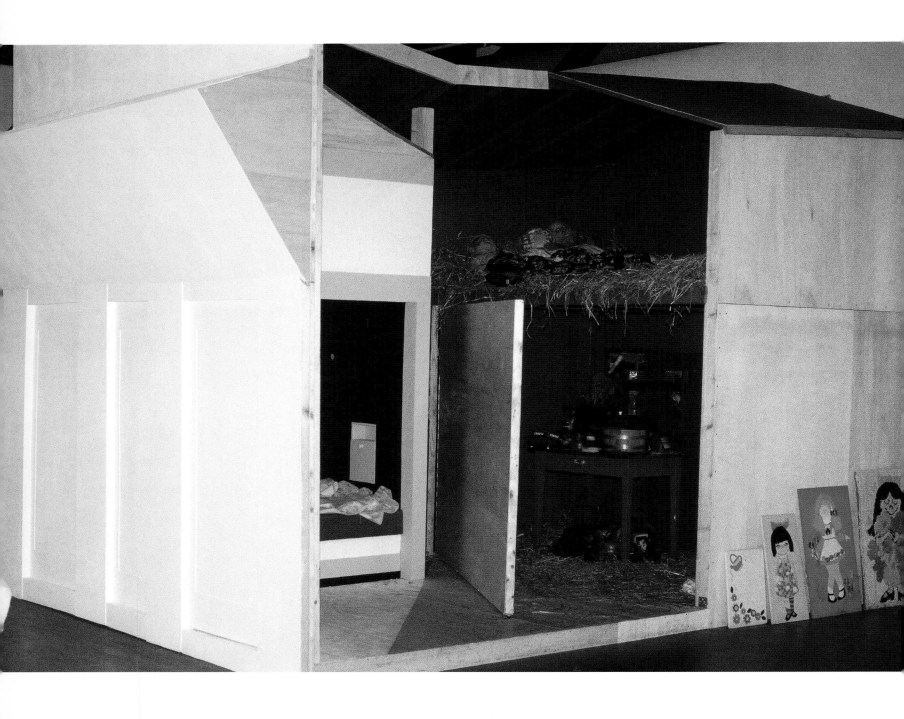

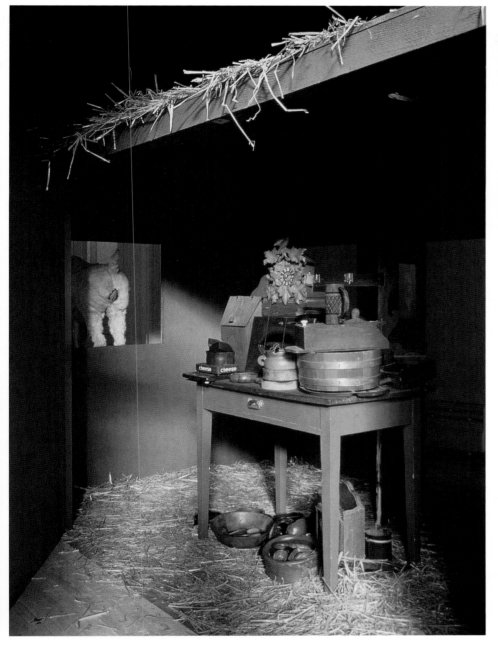

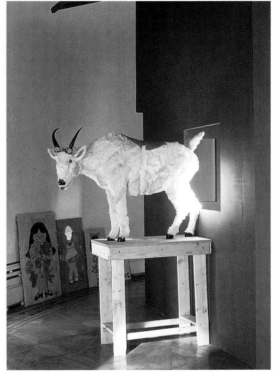

words in karaoke-like admiration: "Listen, I'm the artist from 'Sensation.' I'm here. I'm drunk. I've had a good night out with my friends and I'm leaving now. I want to be with my friends. I want to be with my mum. I'm going to phone her and she is going to be really embarrassed about this conversation. It's live, but I don't give a fuck about it."[36] Arguably, Emin's drunken ramblings on Channel 4 were more visually gripping and emotionally poignant than any of her iconic works, even including her embroidered tent, *Everyone I Have Ever Slept With 1963–1995* (1995), or the installation of her bed in the 1997 Turner Prize exhibition at the Tate Gallery, complete with used condoms, empty bottles, and so on.

Unlike Hirst or the Chapmans, Emin has reached a point where her public persona has attained complete autonomy. The need to connect Emin's media presence to "art" is practically obsolete. The specialized art press has hardly spilled any ink on her art activities since the late 1990s.[37] Most articles in the popular press over the past few years have been related to milestones in her life as opposed to her exhibition calendar (such

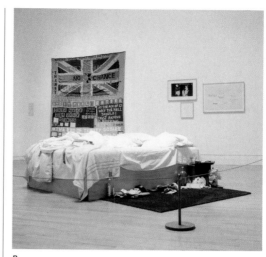

as the extensive coverage of her fortieth birthday, illustrated by a fashion shoot of Emin wearing Vivienne Westwood couture[38]). Emin has quickly changed status from the sensational "bed"/ conceptual artist to a reference point for the average English woman. "Goodness me...much too Tracey Emin," exclaims a woman looking at her reflection in the mirror in a newspaper cartoon. The average reader of an English tabloid doesn't have to have any knowledge of Emin's oeuvre to get the joke. Fast living, hard drinking, and sexy-yet-trashy sense of fashion—Emin has become as much of a contemporary British icon as David Beckham, Stella McCartney, or Kate Moss (all of whom happen to be friends of hers, incidentally).

Given her complete crossover, Emin perhaps has made the greatest "critical" contribution of the YBA generation. In a recent profile, writer Melanie McGrath admits up front that she "doesn't know if Tracey Emin is a good artist," yet McGrath is

A Neil Dishington
 "Goodness me...much too Tracey Emin."

B Tracey Emin
 My Bed. 1998
 Mattress, linens, pillows, rope, and various memorabilia
 79 x 211 x 234 cm/31 x 83 x 92 in.

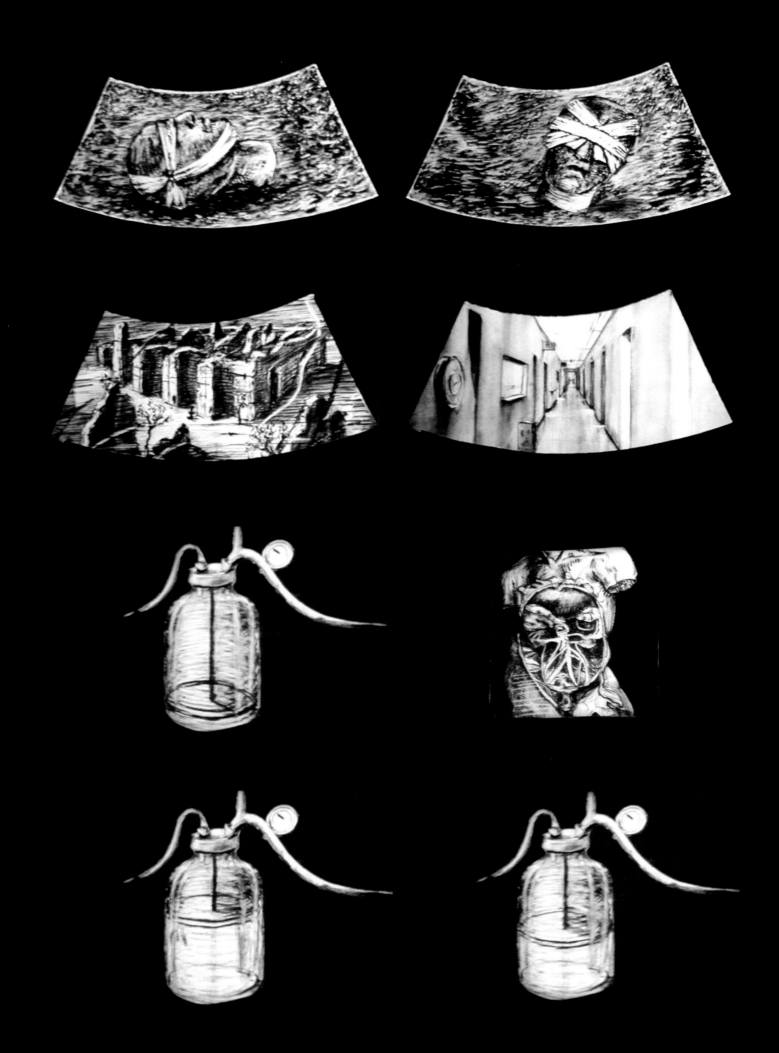

◀ **TOBA KHEDOORI**
Born in Sydney, 1964/Lives in Los Angeles

Untitled. 1994
Oil paint and wax on paper
335,2 × 609,6 cm/132 × 240 in.

A

B

C

able to locate her strength. "While [Emin] doesn't flaunt her money, she doesn't exactly keep quiet about it either. Emin is very well off. She relishes her commercial success with all the enthusiasm of the once-impoverished. And we in Britain don't like that. In the arts especially, it's still not quite done. Unsurprisingly, Tracey Emin is no respecter of these kinds of polite, bourgeois sensibilities."[39] Emin's life in the spotlight might have amounted to her worst trauma, something she has likened to "raping herself." Emin's "everywoman-ness" as conveyed via her persona—in which her actual artworks function as footnotes—has created a more poignant critique of societal values than any sensationalist tableau or strategically "empty" painting of her illustrious YBA peers.

Dirty White Trash: Tim Noble and Sue Webster

Tim Noble and Sue Webster arrived a little late to be considered part of the YBA Zeitgeist. While such unfortunate timing would be the object of angst for most artists, Noble and Webster turned it to their advantage. The couple—who moved to London in 1992 to study at the Royal College of Art, well after YBA had blast-

Memorial of the Good Old Time. 1987
Rubber and plywood
182,8 x 375,9 x 210,8 cm/72 x 148 x 83 in.

MARTIN ▶
KIPPENBERGER
Born in Dortmund, Germany, 1953/Died in Vienna, 1997

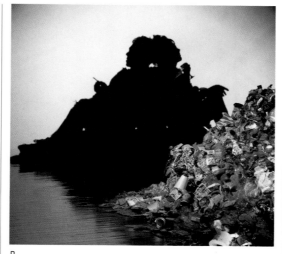

D

"And this magnificent piece is by Tim Noble,
and that bird he hangs round with."

E

ed-off—founded their practice on exclusively self-referential art. They exploited their own likenesses in their work without resorting to Emin-style pathos; they were unapologetically careerist without any overtly critical content. Their artworks combine decadence with vulgarity, a crass celebration of pleasure with punk sang-froid, without the help of tabloid promotion of their public lives.

Making no distinction between their sentimental/domestic life together and their artistic collaboration, Noble and Webster's iconic works depict them as a couple. A pile of rubbish collected over six months from the artists' studio and household is the centerpiece of *Dirty White Trash* (1998). Literally enacting the epithets that could easily be hurled at such careering self-exploiters, a shadow is projected on the wall behind the miniature dump in the likeness of the artists provocatively reveling in their own debasement. In another sculptural piece made with resin in the

A Tim Noble & Sue Webster
 Human Fountain (Sue as a...). ca. 1999

B Tim and Sue in a bar somewhere in Shoreditch, East London, ca. 1999

C *Mustang* (2002) at the home of Isabella and
 Detmar Blow in Gloucestershire

D Tim Noble & Sue Webster
 Dirty White Trash (with Gulls). 1998
 Rubbish, projector, and taxidermied seagulls
 Dimensions vary
 The Dakis Joannou Collection, Athens

E Kes
 "And this magnificent piece is by Tim Noble,
 and that bird he hangs round with."

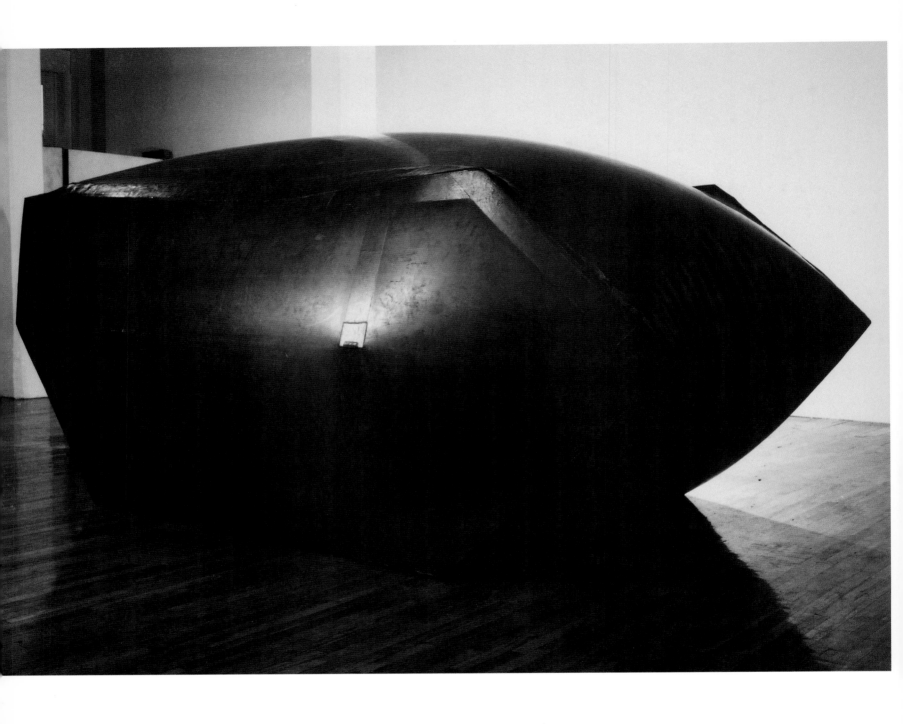

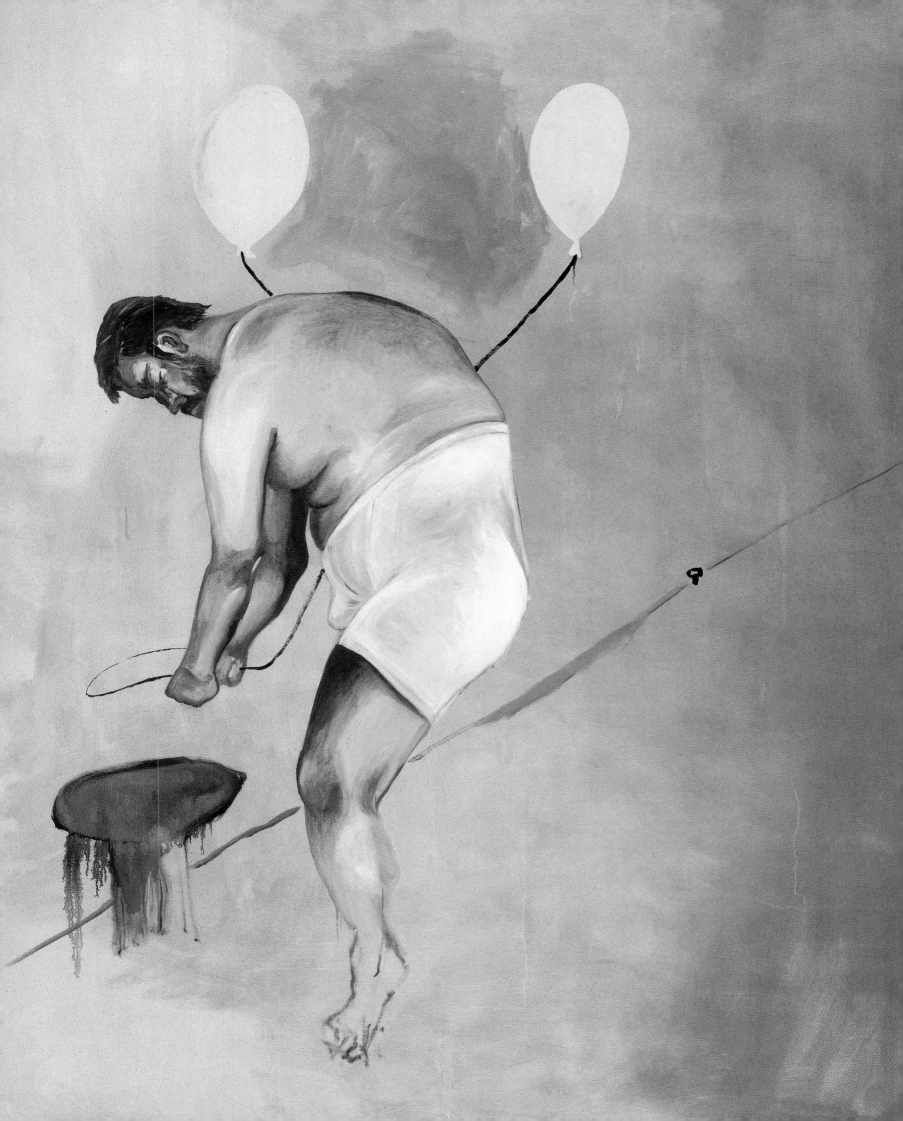

◀ **MARTIN KIPPENBERGER**

Untitled. 1998
Oil paint on canvas
241,3 x 201,9 cm/95 x 79 1/2 in.

A

style of a natural history museum diorama, the couple has graft-ed their own faces onto a Neanderthal couple. *The New Barbar-ians* (1997) is a matter-of-fact portrait of the artists in a post-YBA world. Whether affirming an overtly primitive or trashy role, Noble and Webster take up where their slightly older peers left off. Using their own image as the primary vehicle for their critical commentary, they have pushed to an extreme a complicity in a culture immersed in celebrity and consumerism. Trashy, vulgar, decadent, and rebellious, Noble and Webster's self-denigration speaks as much about the art world as it does about themselves.

Aesthetics and (Dubious) Relations in the 1990s: Somewhere between Melancholia and Malevolence, Generosity and Self-Awareness

For better or worse, a significant proportion of the art that has been produced in the 1990s has been classified under the heading of "relational aesthetics." Nicolas Bourriaud—one of the few contemporary art critics nervy enough to nominate an artistic "movement" in the past decade—has based the notion of *esthé-tique relationnelle* on artworks that attempt to create interactive or

A "Tim Noble & Sue Webster: Masters of the Universe," poster from exhibition at DESTE Foundation Centre for Contemporary Art, 2000

New Hoover Deluxe Shampoo-Polishers, New Hoover Quik-Broom, New Shelton Wet/Drys Triple Decker. 1987
Broom, new Shelton wet/dry 5-gallon, new Shelton wet/dry 10-gallon, plexiglass, and fluorescent tubes
231,1 x 137,1 x 71,1 cm/91 x 54 x 28 in.

**JEFF ▶
KOONS.**
Born in York, Pennsylvania, 1955/Lives in New York

New Nelson Automatic Cooker/Deep Fryer. 1979
Plexiglass, fluorescent tubes, appliance, and wire
69,2 x 36,8 x 40,6 cm/27 1/4 x 14 1/2 x 16 in.

Aquabasketball. 1983
Oil paint on photograph
73 x 57,5 cm/28 3/4 x 22 5/8 in.

Inflatable Flowers. 1980
Plastic flowers and plexiglass mirror
60,9 x 81,2 x 30,4 cm/24 x 32 x 12 in.

intersubjective encounters. While his theory embraces a very diverse range of artists and practices, Bourriaud argues that the generation of '90s artists shares an investment in the establishment of collective spaces and experiences, creating a network of interdependence between the artist, the work of art, the given social context, the environment, and the audience. As art historian and critic Claire Bishop has assessed in her critical rereading of Bourriaud's claims, "Instead of a 'utopian' agenda, today's artists seek only to find provisional solutions in the here and now; instead of trying to change their environment, artists today are simply 'learning to inhabit the world in a better way'; instead of looking forward to a future utopia, this art sets up functioning 'microtopias' in the present (*Esthétique Relationnelle,* p. 13). This do-it-yourself, microtopian ethos is what Bourriaud perceives to be at the core of the political significance of relational aesthetics."[40] In this sense, relational art practices reflect the social and political "reality" of contemporary culture at large. The hallmarks of our time—the depersonalization of everyday life, the rise of service-based industries, the Internet, and the triumph of globalization—are the alleged catalysts for the artistic

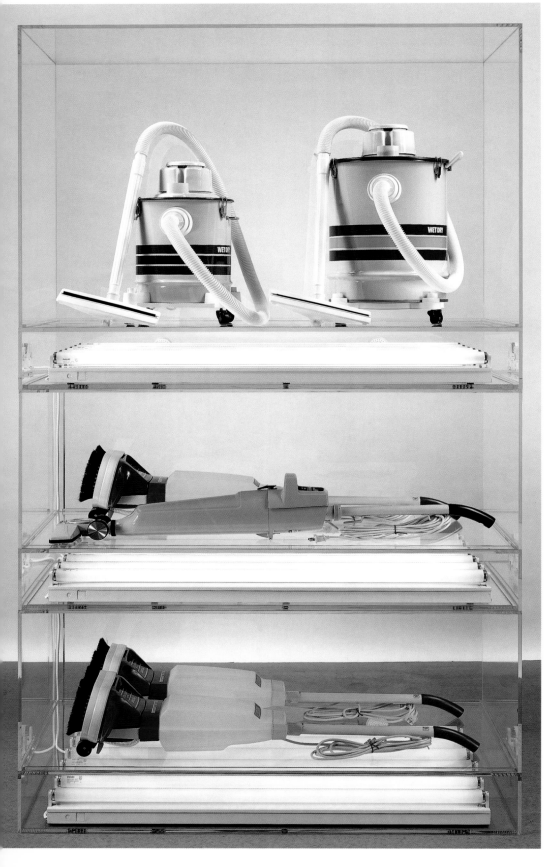

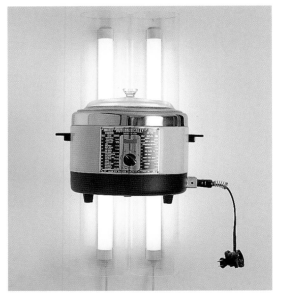

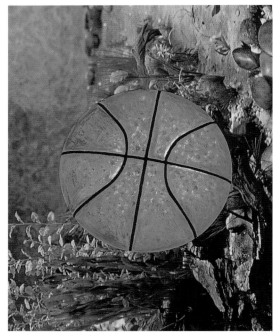

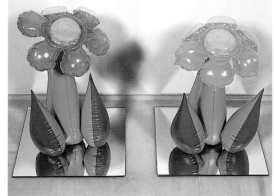

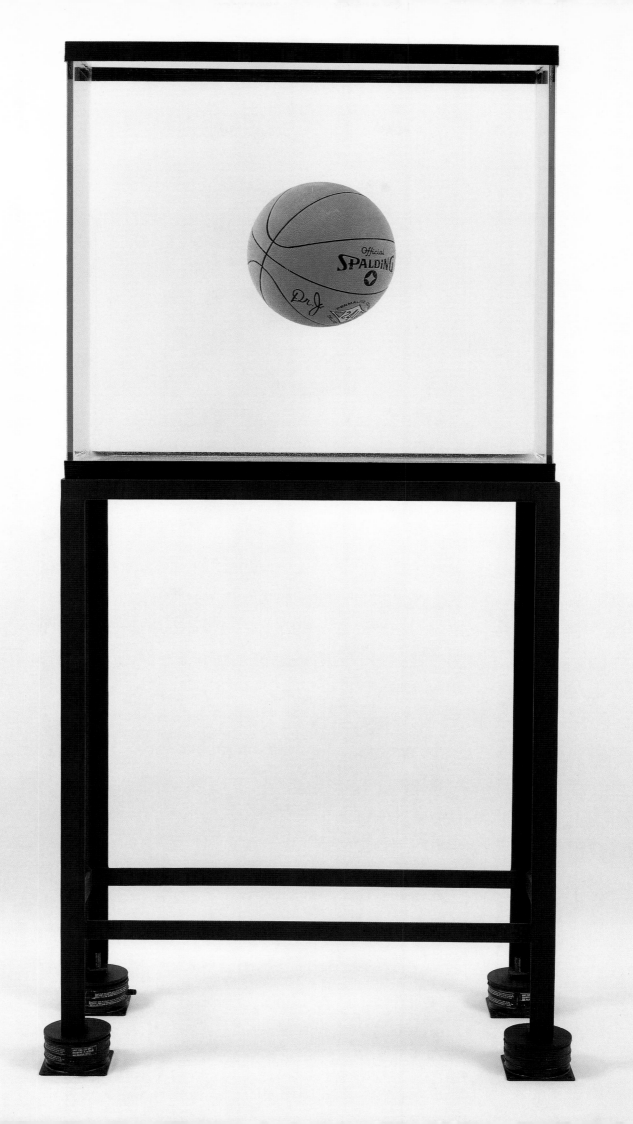

◀ JEFF
KOONS.

One Ball Total Equilibrium Tank. 1985
Glass, iron, water, and basketball
163,8 x 77,4 x 33,6 cm/64 1/2 x 30 1/2 x 13 1/4 in.

need to seek community, experimentation, and exchange (however temporary or precarious).

If there is one place that relational aesthetics has had an undeniable impact in the 1990s it is in the spaces of the museum, Kunsthalle, and gallery. From the mushrooming of the "artist-made bar/bookshop/reading lounge" to the artist-as-curator manifesto exhibition as epitomized by *Utopia Station* at the 2003 Venice Biennale, the dominant trend of the 1990s has taken the form of an ideological campaign to transform the modernist white cube into a laboratory.[41] How much of this phenomenon can be attributed to the artists? As Bishop argues, the theoretical underpinnings of these current museographic trends are derived from "a creative misreading of post-structuralist theory" by curators and museum administrators who have invited artists to "troubleshoot" their institutional amenities. "Rather than the *interpretations* of a work of art being open to continual reassessment, the work of art *itself* is argued to be in perpetual flux."[42] It would seem that the communitarian and microtopian desires that are at stake in the theory of relational aesthetics apply more to the curatorial business than to artistic production.

Louis XIV. 1986
Stainless steel
116,8 x 68,5 x 38,1 cm/46 x 27 x 15 in.

JEFF ▶
KOONS.

Despite the inflated importance of curators' own strategies in the interpretation of current art, networks, social structures, and subjective models are still central preoccupations of much of '90s art practice. Shedding the utopian agendas of the 1960s while digesting that epoch's performative paradigms, the socially conscious basis for certain artists' interest in the "relational" comes from a less altruistic, quite contradictory position. Artists such as Maurizio Cattelan, Rob Pruitt, and Piotr Uklanski have each created "iconic" works that might be categorized under the title Relational Aesthetics. Each has created sculptural objects or orchestrated events that could be read as framing devices for the different roles that are played within the art world, transforming the audience into sociological specimens. Yet these works also share an underlying ambivalence—oscillating between melancholia and malevolence, generosity and self-awareness—that effectively refutes the political ambitions of Bourriaud's theory. As perfect emblems of their decade, Cattelan, Pruitt, and Uklanski have accepted as a given that myth-making and self-promotion are artists' tools equal to any traditional medium.

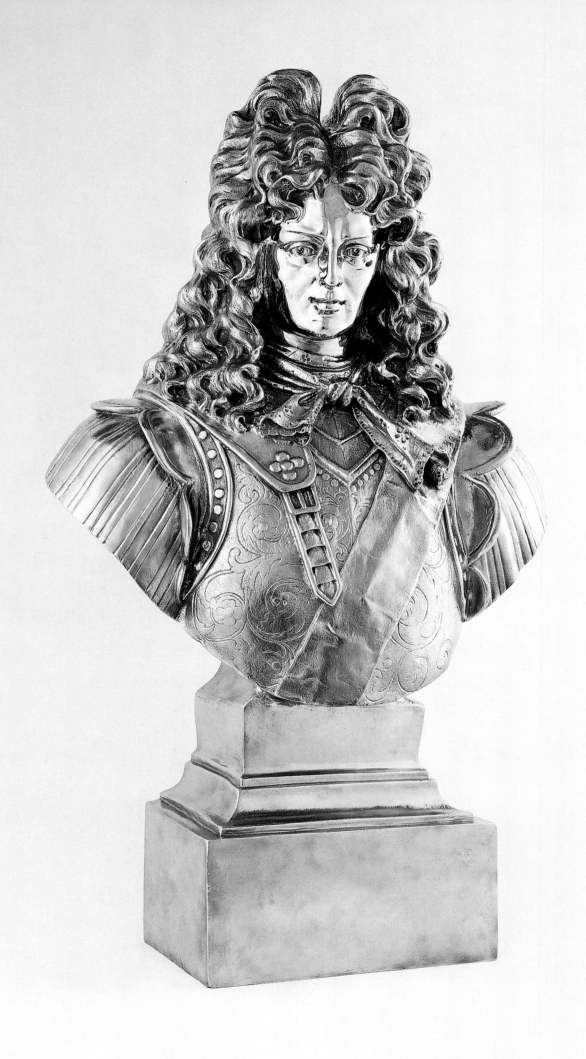

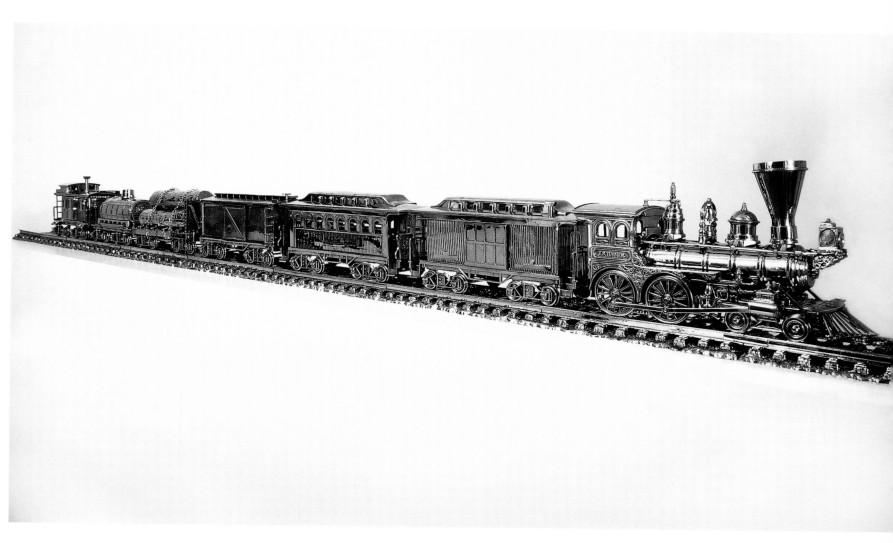

207

◀ JEFF
KOONS

Jim Beam J. B. Turner Train. 1986
Cast stainless-steel Jim Beam bourbon decanters and
cast stainless-steel train track
24,7 x 294,6 cm/9 3/4 x 116 in.

Vest. 1985
Bronze
55,8 x 41,9 x 12,7 cm/22 x 16 1/2 x 5 in.

Maurizio Cattelan's Networking (from the Beach to the Dump)

Anyone familiar with the art of the last ten years knows what Maurizio Cattelan looks like. This has as much to do with the explosion of his art-world celebrity as it does with his use of his own likeness as a primary vehicle for his sculptural works: five hundred latex masks bearing his "distinctive" profile, densely hung on the walls of a gallery (*Spermini*, 1997); a wax-puppet effigy of the artist wearing Joseph Beuys's felt suit hanging from a clothes rack (*La rivoluzione siamo noi*, 2000); his head grafted onto a child's body, forming an animated puppet that peddled through the crowds at the Giardini during the opening of the Venice Biennale (*Charlie*, 2003). The taxidermied animals are him, too: a sleeping dog curled up in the corner of the Castello di Rivoli (*Morto stecchito*, 1997); a squirrel who shot himself in the head in a miniature kitchen (*Bidibidobidiboo*, 1996); a stack of animal skeletons (*Love Lasts Forever*, 1997). In using his own image as well as biographical elements to fuel these sculptural allegories about the human condition, Cattelan offers up his persona for public consumption, and two versions of Cattelan's identity emerge. The first, and perhaps more generous

Dynasty on 34th Street. 1985
Framed poster
111,7 x 80 cm/44 x 31 1/2 in.

The Empire State of Scotch. Dewar's. 1986
Oil-based inks on canvas
113 x 149,8 cm/44 1/2 x 59 in.

JEFF ▶
KOONS.

A

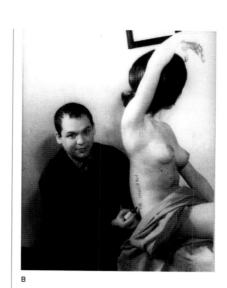

B

view, positions Cattelan as a clown whose carefully orchestrated self-effacement and oft-excessive humor offer a melancholic reflection on a sick society. This account embraces both art historical tradition and his national identity as an Italian, sandwiching him between the neo-avant-garde pranks of Piero Manzoni and the tragicomic figures that populate Italian cinema from Federico Fellini to Roberto Benigni. According to this reading, court-jester buffoonery is an excusable form of provocation because it can offer "an inverted and ironic mirror for contemporary culture."[43]

The second, less-forgiving account paints a portrait of a pure cynic whose opportunistic provocations cruelly transform the art world into the butt of each of his artworks-cum-jokes. This position also has a long tradition in postwar art criticism—uniting in one lineage the fraudulence of Yves Klein's claims to inventing the monochrome, through Martin Kippenberger's belligerent and drunken follies, and ending with the art world's favorite iceman, Koons. United by accusations of acriticality, lack of political engagement,

A Yves Klein dressed as a knight of the order
 of the Archers of Saint Sebastian, 1956
 Archives Yves Klein, Paris

B Piero Manzoni posing with his *Living Sculpture*, 1961
 Archivio Opera Piero Manzoni, Milan

◀ JEFF
KOONS.

Wishing Well. 1988
Gilded mirror
221 x 142,2 x 15,2 cm/87 x 56 x 6 in.

A

B

C

and antihumanism, this family of artists effectively disturbs claims to any notion of truth and authenticity in art practice.

More than any sculpture bearing his likeness, Cattelan's most controversial and biting use of his persona took the form of two ephemeral events that he organized. Using his charisma and charm to hustle the necessary sponsorship and the complicity of his peers, Cattelan organized the 6th Caribbean Biennial in November 1999. Working in collaboration with independent curator Jens Hoffman, Cattelan invited ten high-profile artists of his generation with no particular formal or conceptual connections to St. Kitts Island in the British West Indies for a free vacation on the beach. All of the usual rules of the international art game were followed: a publicist was hired and press releases were distributed, full-page color ads were placed in all the right art magazines, invitations sent, travel reservations made, limousines reserved, rumors generated for the grist mill. Except for the fact that there was no proper show, Cattelan's biennial was totally status quo. The only element that wasn't preplanned was the weather. Hurricane Lenny kept this motley crew on the

Art Magazine Ads. 1988-89
Portfolio of 4 color lithographs
114,3 x 94,6 cm/45 x 37 1/4 in. each

JEFF ▶
KOONS.

island several days longer than planned, adding a little discomfort, a sexy bit of unforeseen danger, some dramatic pictures of distorted palm trees and narrative fodder for the catalogue.

A year and a half later, Cattelan let everyone else in on his previously private mise-en-scène of the art world's players and structures. He published a lushly illustrated book featuring stylish yet credible candid snapshots of the week's activities photographed by Armin Linke. There's Maurizio swimming over to kiss Vanessa (Beecroft) in the hotel pool. A sun-kissed Gabriel (Orozco) and Maurizio are standing arm-in-arm looking like they've had one laugh or drink too many. Elizabeth (Peyton) and Tony (Just) are hanging out at pool's edge, cocktails at hand. Olafur (Eliasson) stands frozen in time waist-deep in the turquoise sea without removing his spectacles. Olafur, Pipilotti

6th Caribbean Biennial, St. Kitts, 1999

A Maurizio Cattelan

B Rirkrit Tiravanija and Olafur Eliasson

C Jens Hoffman, Rirkrit Tiravanija, Tobias Rehberger, Olafur Eliasson, and Vanessa Beecroft

D Gabriel Orozco and Cattelan

E Olafur Eliasson

F Vanessa Beecroft and Cattelan

G Elizabeth Peyton and Tony Just

All photos © Armin Linke

JEFF KOONS

SONNABEND • NEW YORK MAX HETZLER • KÖLN DONALD YOUNG • CHICAGO

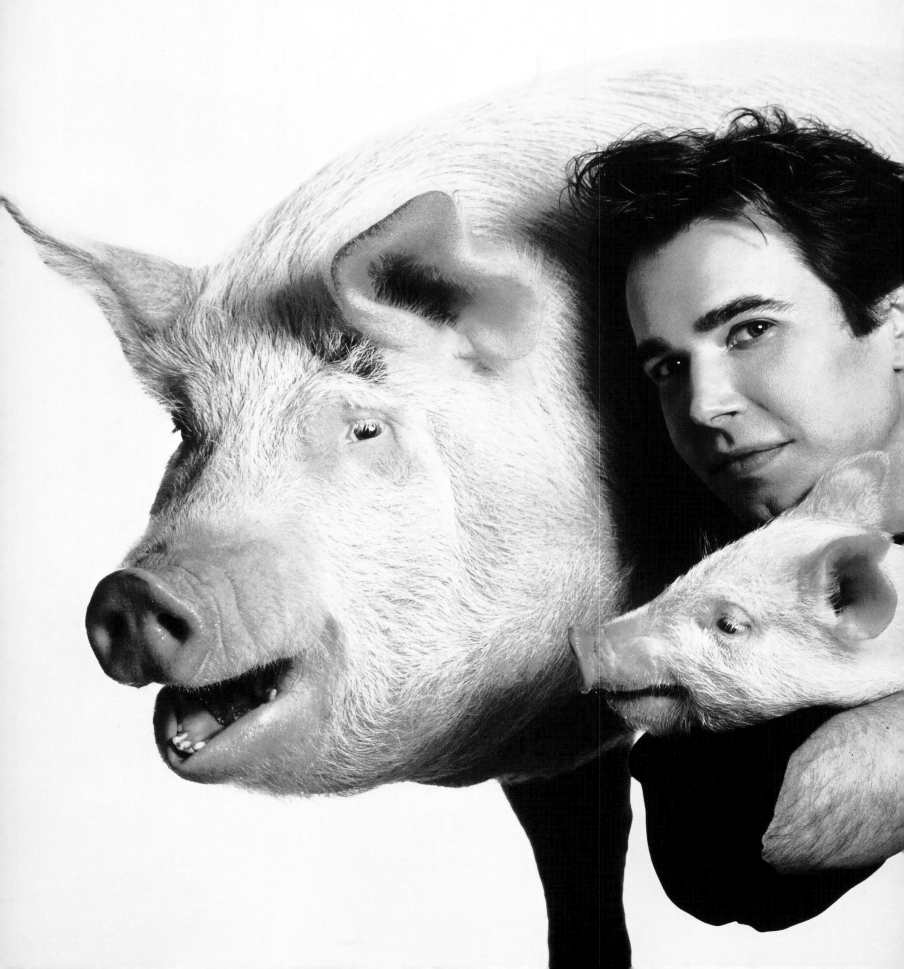

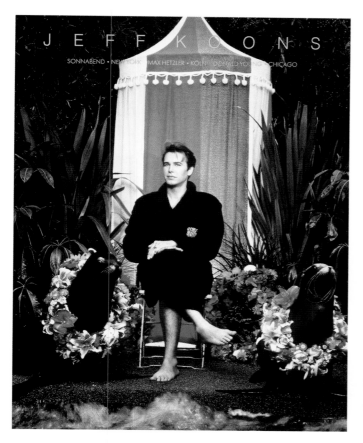

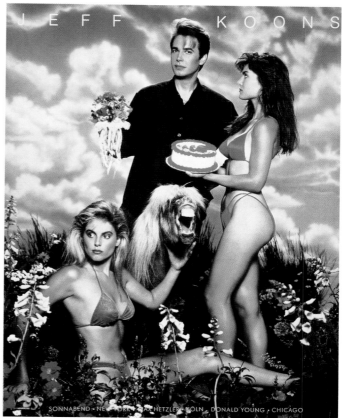

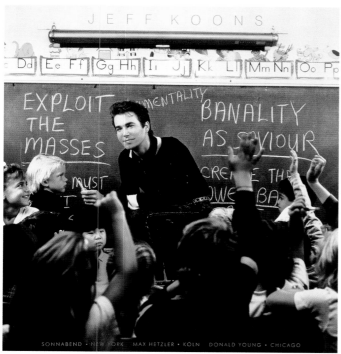

215

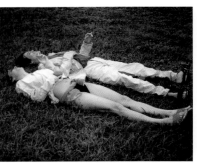

A

B

(Rist), Gabriel, Rirkrit (Tiravanija), and Tobias (Rehberger) pose on the beach under a palm tree as if learning how to hula dance.

Far from the photographic aesthetic usually embraced by some of the participating artists—where every minute detail is controlled, every aspect of their images is groomed (Mariko Mori, Vanessa Beecroft)—the artists in St. Kitts were fully exposed. Their frolicking on the beach was printed and bound for public consumption (and judgment) in the same delicious way celebrity magazines offer us tantalizing shots of J Lo and Ben Affleck enjoying an intimate dinner in a Miami restaurant, or George Clooney laughing while getting into his car with his girlfriend. The aforementioned palm trees that adorn the catalogue's cover—swaying with uncalculated, unkempt grace under the gales of the hurricane—are a de facto logo for the biennial, where the artists enjoyed their "privacy" only to be publicly exposed on film at a later date (with their complicity, of course).

6th Caribbean Biennial, St. Kitts, 1999 C Rirkrit Tiravanija

A Hurricane Lenny All photos © Armin Linke

B Elizabeth Peyton and Tony Just

Michael Jackson and Bubbles. 1988
Porcelain
106,6 x 179 x 82,5 cm/42 x 70 1/2 x 32 1/2 in.

JEFF ▶
KOONS.

c

What did the art critics think of this candid embrace of fun and sun? It wouldn't be a proper biennial without a press junket. An unannounced delegation from *Artforum* and *Frieze* arrived to cover the event (while it shocked many of the artists, Cattelan must have had this in the back of his mind, having hired Massimiliano Gioni to promote the event). In the pages of *Frieze*, Jenny Liu offered a scathing report, weaving together the figures of clown and cynic in her characterization of Cattelan as the primary figure of responsibility. The absence of exhibited art, or any public "discourse" from the artists, provoked Liu into a predictable position of attack. She writes, "This was institutional critique in biennial drag....There's something so sad about so cynical and ambivalent a gesture as the Caribbean Biennial: one would think that a critique of one's own practices would be ethical, even idealistic. Here the humor was both a performance of aggression and a weapon of despair, another cheerless rehearsal of irony and parody."[44] Where is the institutional critique? The main motivation for the Caribbean Biennial was to provide the artists with an expenses-paid week on the beach. Period. This fact was never hidden from the public; it was, on the contrary,

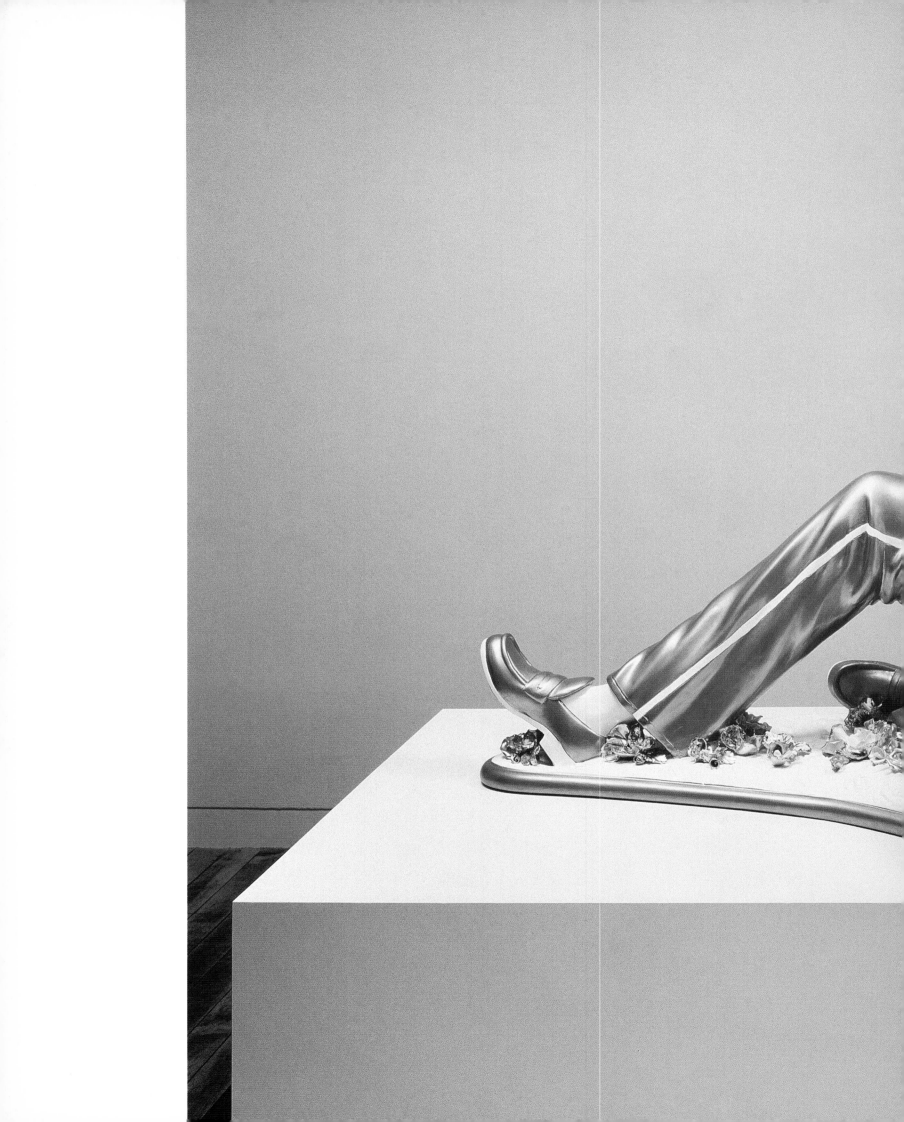

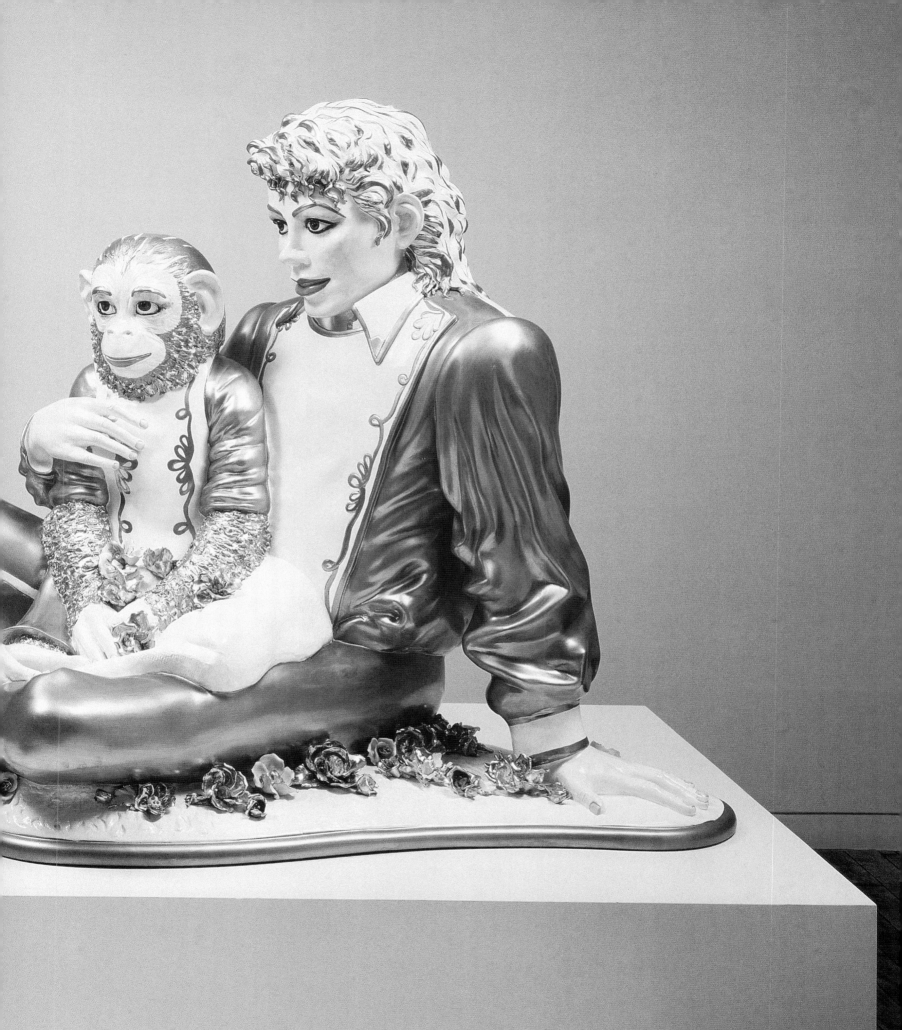

openly promulgated.[45] The only possible "critical" statement was the purposefully obvious and admittedly thinly veiled pretext for the show. It pointed out a banal phenomenon that everyone has already dissected: international biennial and triennial exhibitions have reached oversaturation.

With Cattelan's established track record of "escapism" from the exhibition space—a few examples: *Una Domenica a Rivara*, 1992 (knotted bedsheets hanging out of the back window of a gallery window); *Oblomov Foundation*, 1992 (a travel grant for himself funded by collectors under the guise of an art piece); *Lavorare è un brutto mestiere*, 1993 (selling his exhibition space at the Venice Biennale to an ad agency)—how could Liu honestly expect a "straightforward" biennial or some version of institutional critique? What values (criticality, legitimacy) underlie Liu's disappointment and disgust? Instead of a "hostile takeover of the art world within," as Liu suggests a few lines earlier, her review conceded that Cattelan set up his biennial as a "framing device." The organization of this event might be considered a form of fieldwork. Following the logic of a sociologist, he

rge Vase of F
lychrome
rmica
2 × 1ᶜ

Ponies. 1991
Oil-based inks on canvas
232,4 × 152,4 cm/91 1/2 × 60 in.

JEFF ▶
KOONS.

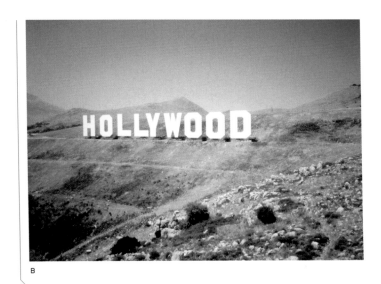

B

...eates and uses such institutional or situational ...this case, a Biennale) to observe (and subsequently ...splay) the microcosm of the art world.

...few years later, on the occasion of the "real" 2001 Venice Biennale, Cattelan took his sociological experiments a few steps further—from the idyllic backdrop of a Caribbean beach to the malodorous setting of a Sicilian garbage dump. His contribution to the show was a monumental facsimile of the Hollywood sign, perched on top of a hill overlooking Palermo. The piece began before anyone (from the art world) even saw the sign in question. A chosen few—dealers, collectors, museum directors, senior curators, journalists, and photographers)—were invited to take a privately chartered plane early one morning in the middle of the three-day vernissage in Venice to Palermo for the "opening reception" of Cattelan's project. In the days before the already fabled flight, the rumors were swirling. As the art world's

A Maurizio Cattelan with reporters and Mariuccia Casadio at the opening of Cattelan's *Hollywood* project for the 2001 Venice Biennale, Palermo, Sicily
Photo © Armin Linke

B Maurizio Cattelan
Hollywood. 2001
Scaffolding, aluminum, and lights
23 × 170 m/75 ft. 6 in. × 557 ft. 8 in.
Installation, 2001 Venice Biennale, Palermo, Sicily
Photo © Armin Linke

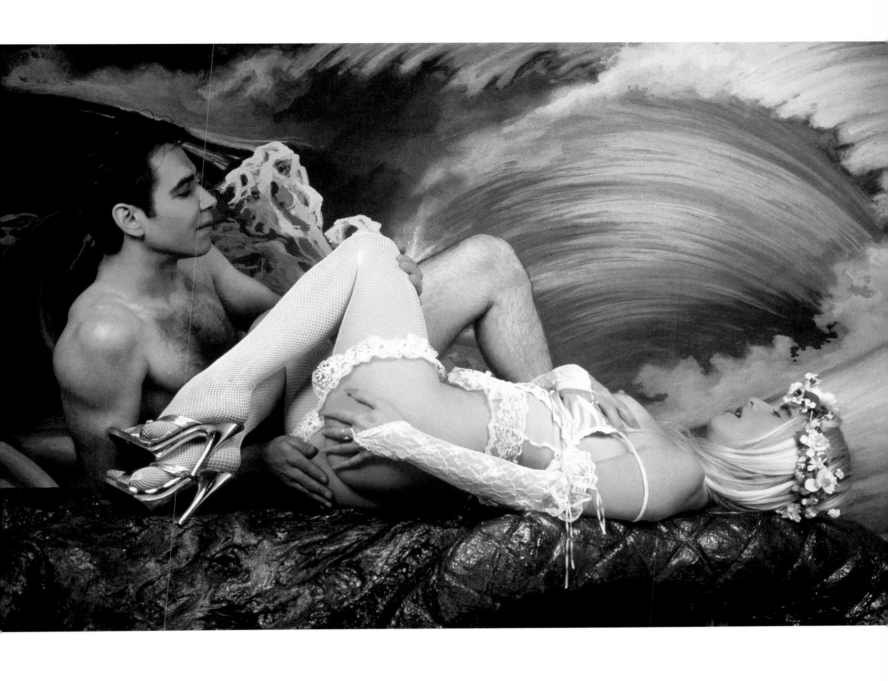

◀ JEFF
KOONS.

Jeff in the Position of Adam. 1990
Oil-based inks on canvas
243,8 x 365,7 cm/96 x 144 in.

actors shuttled from the Giardini to party to palazzo in their water taxis, you could hear the buzz. "Are you going? Are you invited?" At 6 a.m. on Thursday morning, a sleepy group of 150 people turned up at Marco Polo airport to board the flight—many having gotten but a few hours of sleep (not to mention a dreadful hangover) because of the density of social activities in Venice. Upon arriving in the scorching heat at the Palermo airport, this elite group boarded two chartered buses to make their way through the chaos of downtown traffic, up a steep and winding dirt road to what turned out to be the municipal garbage dump. Several black Mercedes sedans (with the requisite tinted windows) greeted the buses at the front gates of the dump. Without even having to comment aloud, almost everyone on the bus had their *mafioso* fantasies fulfilled upon seeing the well-suited men standing next to these cars.

Once out of the bus, the group was led along a footpath allowing for the first unobstructed glimpse of the Hollywood sign. In its exactitude and sun-soaked glamour—gently countered by the pervasive stench coming from the refuse upon

Tulips. 1996
Oil paint on canvas
283,2 x 332,1 cm/111 1/2 x 130 3/4 in.

JEFF ▶
KOONS.

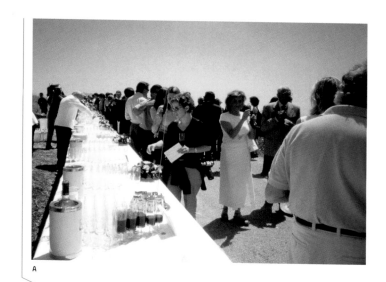

which it stood—Cattelan's sign further deepened the blow to the same mythology that Ed Ruscha captured in his deadpan paintings. Even more impressive than the sign itself was the scene that was laid out below it. A banquet table about ten meters long offered the high-powered invitees platters of petits fours, hors d'oeuvres, and bottomless glasses of Prosecco. Waiters in white tuxedos served drinks and *gelati* under the hot sun as television helicopters droned overhead filming the event for Italian television. The guests could contain neither their pleasure nor their banter. It was pure Passolini. Cattelan himself seemed to try to disappear into the crowd, allowing Gioni, his "double" and frequent co-conspirator, to give official on-camera interviews in his place. By early evening, the enchanted group was shuttled back to Venice in time to recount the whole over-the-top affair at that night's edition of Biennale opening parties and dinners. Cattelan's contribution demonstrated the first lesson for success: insider gossip and a press scoop are the key to stealing the show in Venice.

A · Reception for the opening of Cattelan's *Hollywood* project
for the 2001 Venice Biennale, Palermo, Sicily
Photo © Armin Linke

B · Cattelan at the opening of his *Hollywood* project
Photo © Armin Linke

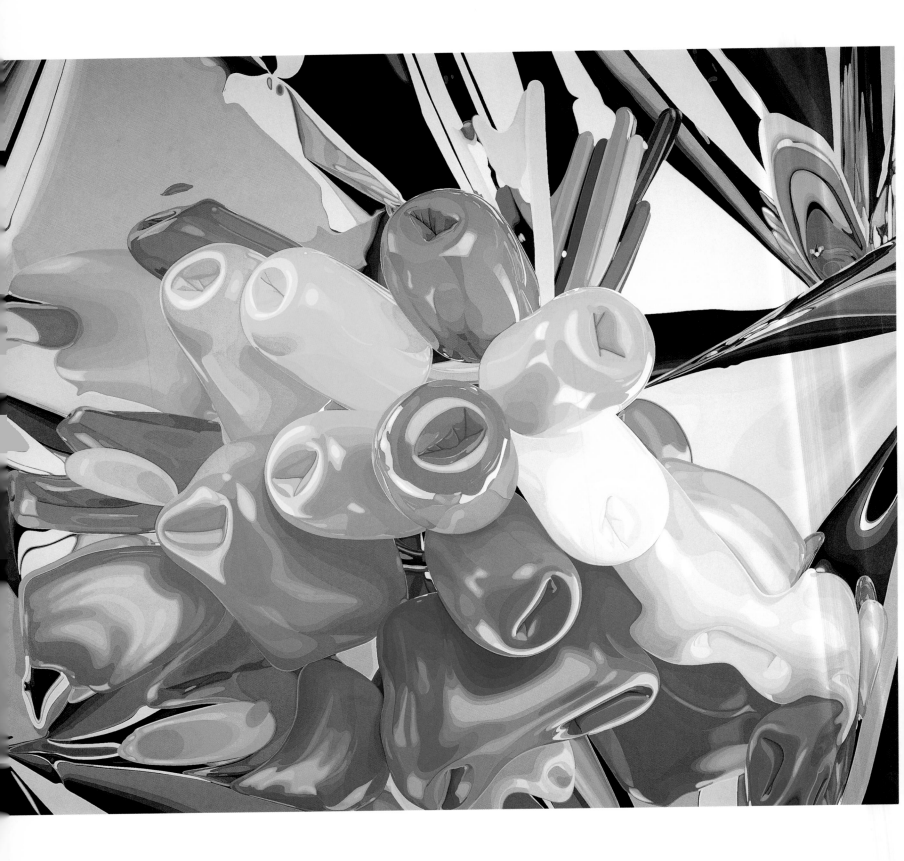

◀ JEFF
KOONS.

Bourgeois Bust—Jeff and Ilona. 1991
Marble
113 x 76 x 58 cm/44 1/2 x 29 7/8 x 22 7/8 in.

As with the organization of the Caribbean Biennial, the success of the *Hollywood* event hinged on Cattelan's charismatic persona, his intimate understanding of the growing importance of social aspects of the art world, and his now-legendary networking skills. In the 1990s art world, creating the allure of the elite and exclusive often means more than the actual "content" that is on view. Cattelan put his finger on the sociological significance of a current art-world trend. His artworks-as-events create a situational frame to display the oft-perverse, over-mythologized structures at play in the art world. In this regard, Cattelan might be seen as the artistic heir of the pioneering sociologist Erving Goffman. In *The Presentation of the Self in Everyday Life* (1959), Goffman developed an extended metaphor of theatrical performance to understand formation of social roles and structures in quotidian activities. Cattelan rehearses the same notion of sociology. In a conversation I had with the artist, he observed that one of the most salient points of the Caribbean Biennial was that each artist never "broke character"—even if they were thousands of miles from a formal art stage.[46] This fascination with behavior as dictated by social structures

Donkey. 1996
Oil paint on canvas
289.5 x 454.6 cm/114 x 179 in.

JEFF ▶
KOONS.

supplies the primary source for his enterprise. Everyday life becomes the real agent provocateur.

Yet there is one main difference between what motivates Goffman's and Cattelan's "sociological" fieldwork. Cattelan has stated, "I'm always borrowing pieces—crumbs, really—of everyday reality."[47] Critics cannot locate critique in Cattelan's work because no search for truth or claims for legitimacy underlie his actions. If anything, this aspect of Cattelan's practice lays bare more than relentless reinforcement of the theatrical roles assigned to him and the actors who surround him. His sociological set-ups lack any type of definitive moral or ethical judgment in their intent. Like Kippenberger, Klein, and Koons before him, Cattelan disavows the role of the artist as guardian of the enlightenment ideals of moral rationality, historical consciousness, and truth. Instead, his sociology sets into motion a much more disturbing scenario where these values are questioned without giving a stable, prescriptive interpretation of the world he so freely borrows from to create his art. His use of persona and myth (of himself, of his "participants") is powered by melancholia and malevolence, generosity and self-awareness.

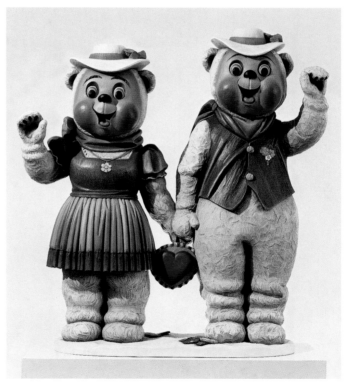

 JEFF KOONS

Ushering in Banality. 1988
Polychromed wood
96,5 x 157,4 x 76,2 cm/38 x 62 x 30 in.

Winter Bears. 1988
Polychromed wood
121,9 x 111,7 x 39,3 cm/48 x 44 x 15 1/2 in.

Rob Pruitt: Comeback or Riposte?

A meteoric rise, an inevitable fall from grace, a difficult period of atonement, a glorious resurrection. Gripped by the ever-growing cult of celebrity, America has chosen the comeback story as one of its favorite genres. From cable's most popular show, to VH1's soft-edge documentaries on near-forgotten pop stars, *Behind the Music*, to cable television's *E! True Hollywood Story*, stardom is almost always presented as a tumultuous rollercoaster; with every rise there must be a fall. Struggle is intrinsic to fame, giving rise to two key elements that are present in any comeback story.

First and foremost, many comebacks are dependent on the constantly changing tides of fashion. The cyclical returns of once-forgotten or obsolete trends in popular culture can completely rehabilitate an individual career or official dead style or category. Fashion designers' recent retreat to the two poles of the 1980s—the nouveau-riche, glamorous excess epitomized by "Dynasty" (Steven Meisel's campaign for Versace) or the edgy street look (Ann Demeulemeester's elegant revisitation of post-

Hanging Heart. 1996
Oil paint on canvas
332,7 x 254 cm/131 x 100 in.

JEFF ▶
KOONS.

punk)—has gone hand in hand with the return of new wave and post-punk music of the same period. The fascination and nostalgia for past decades as broadcast on MTV find an echo in the art world. Exhibitions such as P.S.1's *1984* and *Artforum*'s attempt to write an admittedly incomplete history of the 1980s are examples of a larger process of cultural reterritorialization.

The second essential component of a successful comeback story is a sincere and lengthy act of contrition on the part of the fallen star. American politics provides the most convincing examples of this phenomenon. After reconciling with Hillary and with the blessing of his Christian ministers, Bill Clinton put Monica Lewinsky and his impeachment proceedings behind him to the point that most analysts foresaw a third term in office had constitutional law permitted.

The downtown art scene's recent (re)embrace of Rob Pruitt—bad-boy artist accused of politically incorrect address of racial issues in the early 1990s, causing his complete exile from the art world for over seven years—is as compelling a comeback

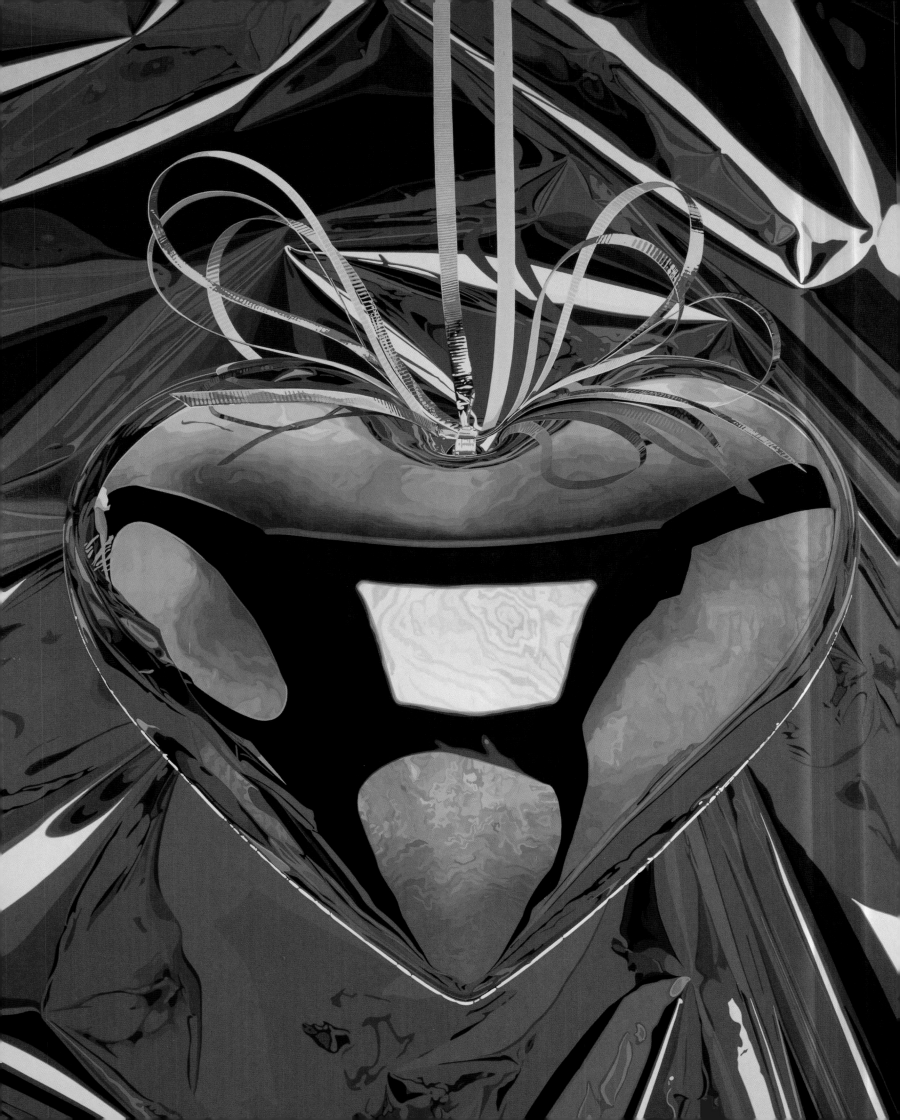

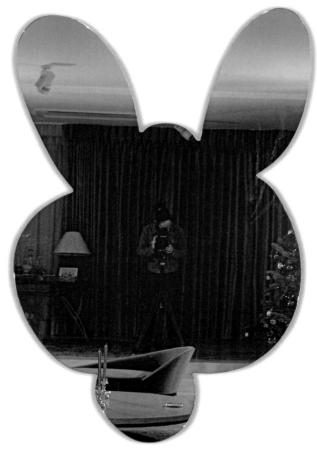

Kangaroo (Blue). 1999
Crystal glass, colored plastic, mirrored glass,
and stainless steel
232,4 x 149,5 x 4,4 cm/91 1/2 x 58 7/8 x 1 3/4 in.

A

story as any. Pruitt's dramatic fall from grace came at the moment that should have been the pinnacle of his rise to glory. After an initially warm critical reception, Pruitt and his then collaborator, Jack Early, were invited to do a solo exhibition at Leo Castelli Gallery in 1992, a clear step up from their previous outings on the scene. Entitled *The Red, Black, Green, Red, White and Blue Project*, the show was centered on works that showed unironic images of these two seemingly middle-class white artists appropriating the street culture, dress, and language of black urban youth.

Just when the art world was waking up with a Neo-Geo hangover, the show opened to a scathing reception, causing a total eclipse of Pruitt and Early's career. They were accused of pure cynicism and, more detrimentally, were considered racist. Yet as Pruitt admits in the *New York Times*'s glowing chronicle of his recent comeback, his reacceptance in the art world is based on his admission that the controversial Castelli show was provocative but poorly timed. "We wanted to point out the commodification of black heroes by predominantly white-owned companies, but we didn't realize what a land mine it was," Pruitt said.

236

Balloon Dog. 1994–2000
High chromium stainless steel with
transparent color coating
320 x 378,4 x 119,3 cm/126 x 149 x 47 in.

Moon. 1994–2000
High chromium stainless steel
330,2 x 330,2 x 101,6 cm/130 x 130 x 40 in.

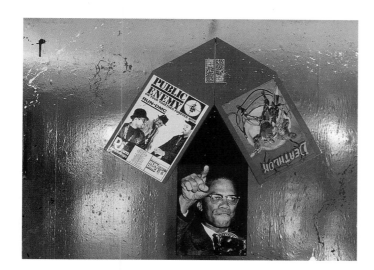

"At the time, the art world was very sensitive to identity issues and political correctness, but you could only be an authority if you were talking about who you were and where you came from."[48] After this public avowal of remorse, Pruitt has adeptly used coy humility to wriggle his way back in to the hearts of New York art audiences.

After this admission of "guilt," how did Pruitt ensure his comeback? He approached his first show since the Pruitt and Early fiasco with the right formula. Contrition when mixed with apparent generosity often does the trick. In 1998, the Fifth International—an artist-run exhibition series organized by Chivas Clem and Jennifer Bornstein—invited Pruitt and a then-relatively unknown group of artists (Rachel Feinstein, Jonathan Horowitz, and others) to do a studio show. With the promise of the discovery of new, emerging talents, the resourceful organizers managed to pack the exhibition opening with the *glitterati* of the New York scene. Top dealers, collectors, and critics were all spotted

A Pruitt & Early
The Red, Black, Green, Red, White and Blue Project. 1992
Installation at Leo Castelli Gallery, New York, 1992

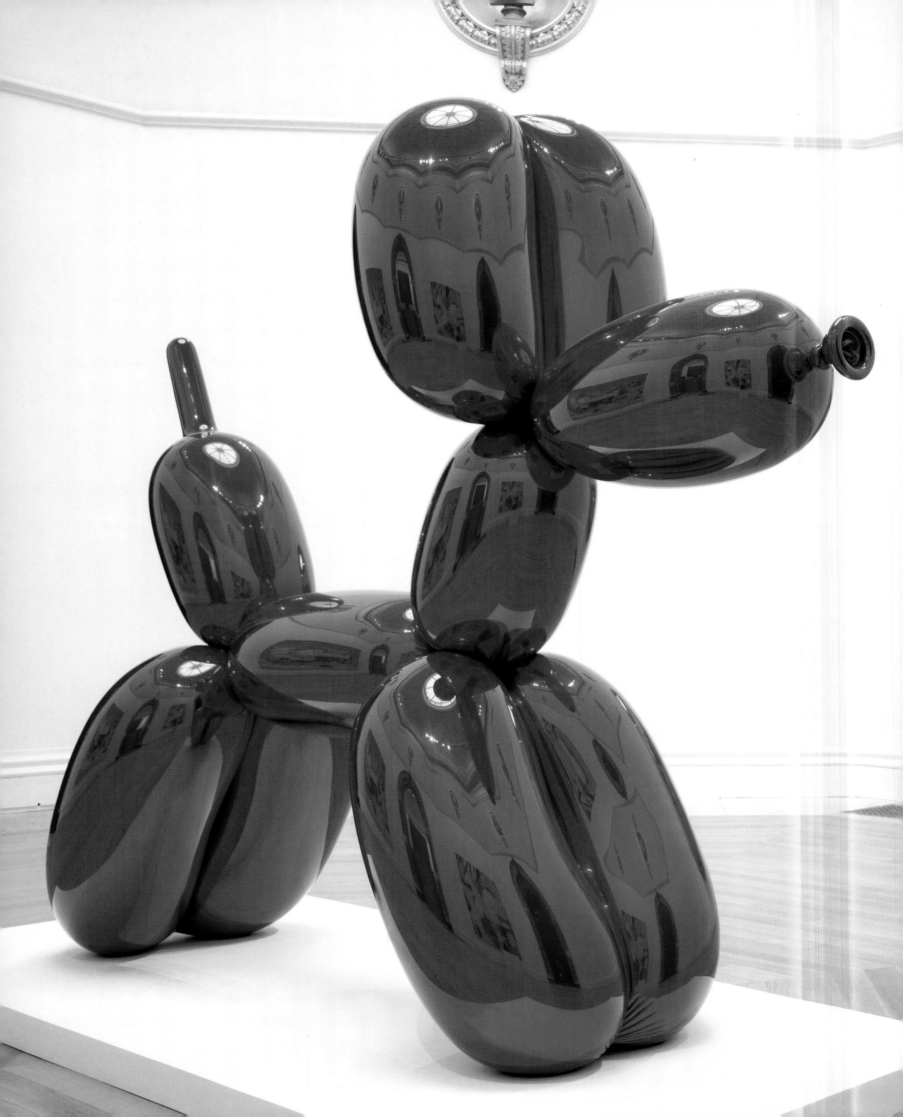

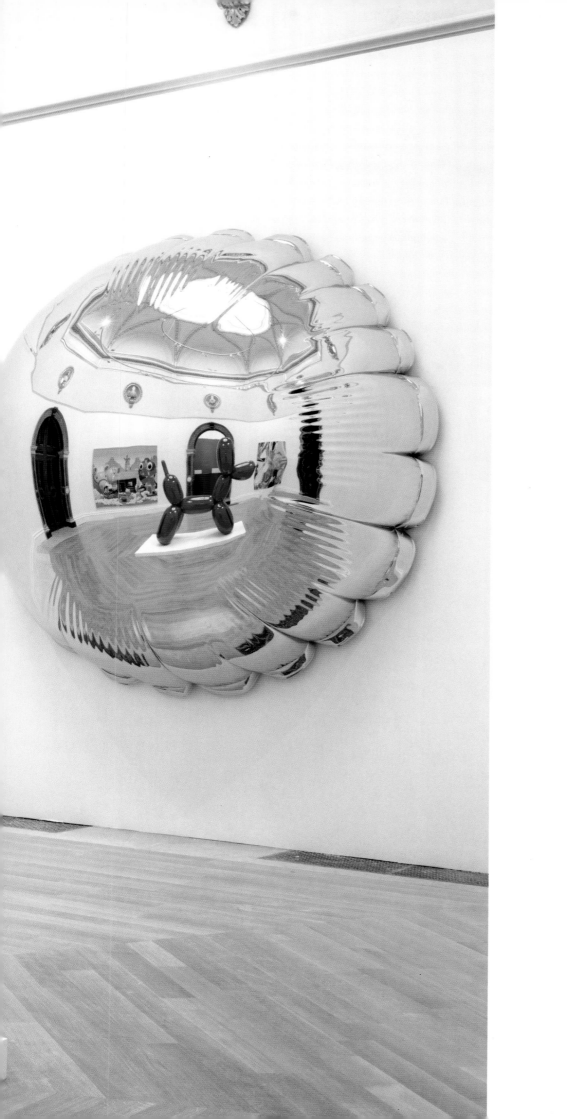

A

at the opening, where Pruitt presented a new sculpture.
A sixteen-foot mirror was placed at the center of the floor with
a giant line of cocaine for all to share. *Cocaine Buffet* (1998) not
only guaranteed a particularly festive opening party, but instan-
taneously enveloped Pruitt in an aura of downtown mythology.

Like many of Pruitt's subsequent pieces, the altruism
of his intentions was left extremely ambiguous. For as much
as the *Cocaine Buffet* literalized relational aesthetics of 1990s
art, its apparent generosity and its community-based inten-
tions seemed to be less than utopian. This performative sculp-
ture placed in a very specific context offered a clear-cut un-
derstanding of the hypocrisy that presides over artistic and
social acceptance. Pruitt's explicated decadent work—while
genuinely appreciated by his peers and gladly consumed by New
York tastemakers—held up an uncomfortable mirror to the art
world's chameleon-like persona. The very same art world that
disavowed its own excess of the 1980s in exchange for the po-
litically correct militancy of early 1990s was only to again find
it acceptable to indulge (both literally and symbolically) in the

Pancakes. 2001
Oil paint on canvas
274,3 x 213,4 cm/108 x 84 in.

JEFF ▶
KOONS.

decadence offered by Pruitt's sculpture. Was this tale a simple comeback story or a sly riposte by one of the contemporary artists who most vividly rode the rollercoaster of art-world celebrity? The jury is still out.

Piotr Uklanski: A Thousand and One Beautiful Nights

"'Why are you making such crappy films? You used to do better stuff,' the trash man calls over the fence of our villa as he picks up the trash barrel. I rub my fingers together to signify cash. He understands and smiles."

Klaus Kinski, 1988

"Entertainment/art, please tell me what the difference is?"

Piotr Uklanski, "Piotr Uklanski: Projects 72," exhibition brochure, 2000

As one of the most revered actors of "Eurotrash" cinema, Klaus Kinski is celebrated for his screen presence as much as his unorthodox career choices. After establishing his career with

A Rob Pruitt
Cocaine Buffet. 1998
2 plexiglass mirrors
30,5 x 243,8 cm/12 x 96 in. each
Installation at the Fifth International, New York, 1998

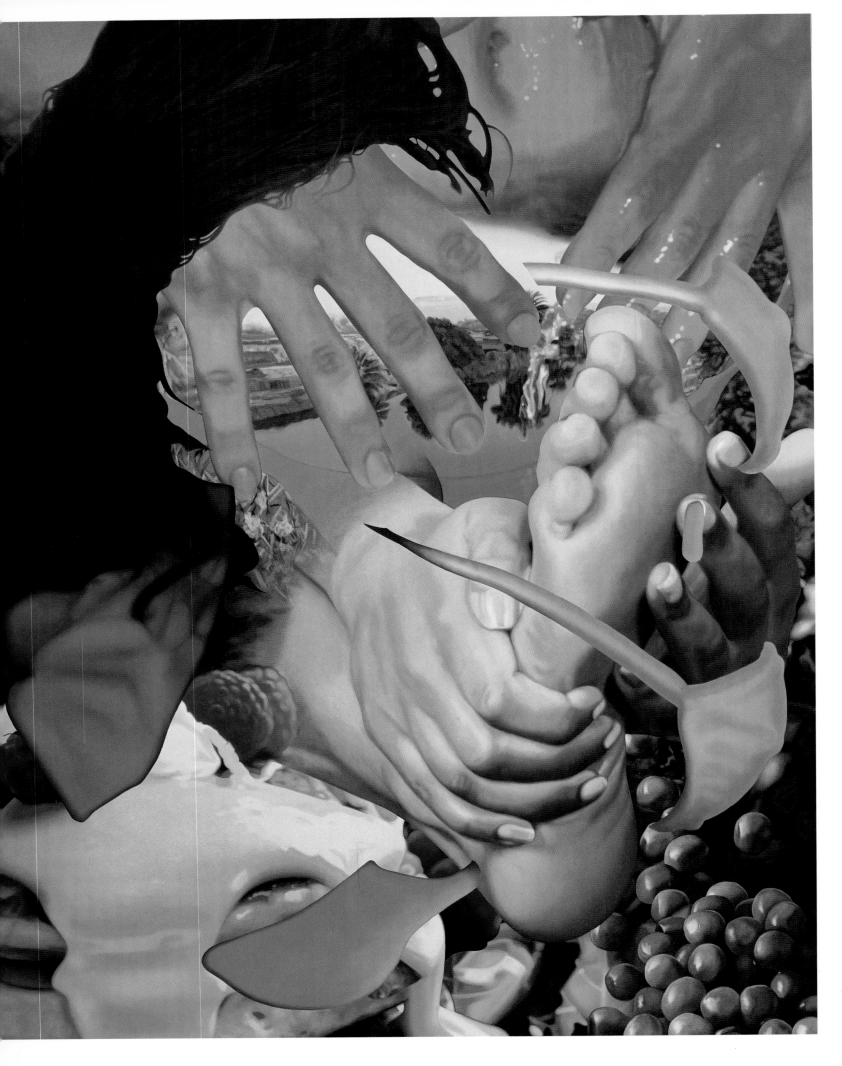

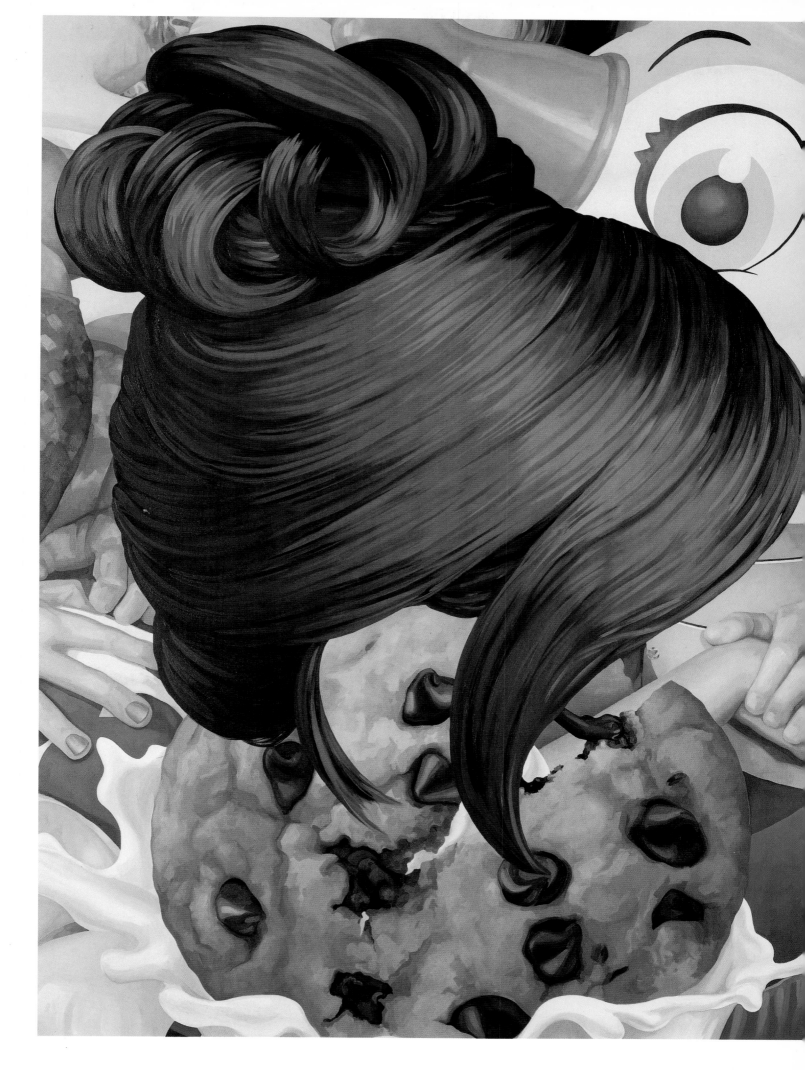

Hair. 1999
Oil paint on canvas
274,3 x 200,6 cm/108 x 79 in.

his stage work, performing the monologues of Shakespeare and Goethe, in the 1960s Kinski appeared in such classic films as *Dr. Zhivago* and *For a Few Dollars More*. Despite his close collaborative relationship with the art-house director Werner Herzog in the 1980s, Kinski established his persona through his bitterly antagonistic, cynical view of the profession. With the conviction that acting should be done for the highest price, Kinski systematically turned down scripts from established *auteurs* in favor of more lucrative paychecks in exploitation cinema (erotica, European westerns, thrillers, as well as general trash). Kinski would happily refer to himself as a "whore" reveling in his own crassness.

More than any strategy offered by a visual artist, Piotr Uklanski has adopted Kinski's attitude as the basis for his own approach to the distribution and reception of his work. In the same way that Kinski would lend his time to the film project for the

A Piotr Uklanski
Dance Floor. 1996
Installation at Gavin Brown's Enterprise, New York, 1996

B Piotr Uklanski
Dance Floor. 1996
Installation at Passerby, New York, 1999. Dj Boney M and Raphildu were at the bar.

C Piotr Uklanski
Dance Floor. 1996
Opening of installation in the Sculpture Garden, The Museum of Modern Art, New York, 2000. Shown is a member of the art band Actress.

Wrecking Ball, 2002
Polychromed aluminum, carbon steel
(coating), steel, and vinyl
219,7 x 43,1 x 52 cm/86 1/2 x 17 x 20 1/2 in.

Chainlink, 2002
Galvanized steel and polychromed aluminum
264,1 x 162,5 x 38,1 cm/104 x 64 x 15 in.

JEFF ▶
KOONS.

A

B

C

highest price—even for a cameo role—Uklanski has no qualms about lending his deliberately empty, seductive works to opportunistic "misreading." Given the calculated hollowness that runs throughout much of his art, Uklanski has exploited a string of false impressions, be they social, political, or decorative.

His *Dance Floor* is the perfect case in point. From the work's first appearance in the gallery space of Gavin Brown's Enterprise in 1996, the laconic, open-ended wording of the exhibition's press release purposefully courted almost any reading or "use" of Uklanski's work. "In his first one-person show in New York, Polish artist Piotr Uklanski will present a sculpture in red, blue, yellow and white. A fully functioning dance floor will cover the entire space of the gallery. The floor will perform a fifteen minute long choreography of computer controlled light patterns. Like a concubine, it beckons you, suggesting the rich hopes and possibilities of a thousand and one beautiful nights."[49] Is this grid of flashing lights a Pop-conceptualist's response to the high seriousness of minimalism? A revision of

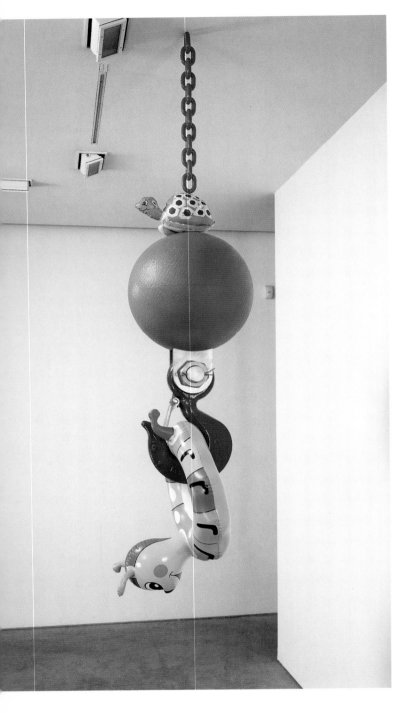

Olive Oyl. 2003
Oil paint on canvas
213,3 x 274,3 cm/84 x 108 in.

early modernist painting paradigms without the canvas? Or is it a cynical celebration of the conflation of art and entertainment?

Judging from the extensive exhibition history of *Dance Floor,* Uklanski's work was quickly received as an emblem of relational aesthetics. *Dance Floor* can be tailored to fit almost any functional or exhibition space—an office, a hip bar, a museum—and the easy spectacle it provides provokes some sort of participation. Yet unlike the overtly redeeming political intent of other socially driven works of the '90s (such as Tiravanija's communalism or Liam Gillick's democratic structures), *Dance Floor* is a willfully empty receptacle with a shiny veneer of hedonism and spectacle. As Uklanski has said, "[It is] an object that would be all generosity and no ideology. An object that would give and give and give but at the end of the night, be unknowable as its true nature resides in our own pleasure....It is an object truly of our own making—all light bulbs and transcendence." [50]

Petrino, Spetses, Greece. 2001
Neon installation
48,5 m/159 ft. 1 11/16 in. long

Translation. 1966
Photo-transfer on acrylic board
5 panels, 88,9 x 139,7 cm/35 x 55 in. each

JOSEPH ▶
KOSUTH
Born in Toledo, Ohio, 1945/Lives in New York and Rome

Given the countless photographs of artists, dealers, collectors, scenesters, or just passers-by standing, dancing, drinking, or posing in the glow of the primary-colored lights, it seems safe to say that *Dance Floor* definitely creates a community, albeit temporary. Its festive atmospherics almost always manage to goad the viewer into abandoning the passivity of visual consumption in order to "contribute" to a showcase for the many personas that constitute the art world. Sharply contradicting the kind of "microtopian" community advocated by Bourriaud, *Dance Floor* frames the antidemocratic exclusivity of the art world, with its social hierarchies, cliques, colorful personas, partying, gossiping, networking, and flirtation.

In the end, both the art and entertainment industries boil down to supply and demand. When read as a Kinski-esque response to the art world's *demand* for socially driven works in the 1990s, Uklanski's *Dance Floor* literally *supplies* a social platform that incites the staging of the behaviors, social rituals, excesses that are also intrinsically part of the art world—without forcing any specific social model or passing judgment on those

translat‖e [træns′leɪt] пе-
реводи́ть; **~ion** [-′leɪʃn] пе-
рево́д; **~or** перево́дчик.

translate, *v.t.* fasiri, tafsiri, geuza
lugha nyingine; (*transfer*) weka,
pengine, hamisha. **translation,** *n.*
kufasiri, fasiri, tafsiri &c. **trans-
lator,** *n.* mfasiri.

translate, v.tr. into another language,
(*con*)*vertĕre* (in gen.), *transferre* (word for word,
Quint.), *reddĕre* (= to render accurately), *inter-
pretari* (= to interpret) ; to — into Latin, *in Lati-
num* (*con*)*vertĕre, Latine reddĕre ;* lit., faithfully,
exactly, *verbum e verbo* or *de verbo exprimĕre, ver-
bum pro verbo reddĕre.* **translation,** n. *liber
scriptoris conversus* or *tra*(*ns*)*latus ;* — of a speech,
oratio conversa. **translator,** n. *interpres,
-ētis,* m. and f.

παλαιὸ πρόβλημα του για ποιο λόγο μια τόσο μεγάλη ποσότητα νεροῦ δεν φαίνεται πουθενά

translation [tRans*lay*shn] *ούσ.* μετάφρασις ‖ ἐξήγη-
σις ‖ μετάφρασις, μεταφρασθὲν ἔργον ‖ ἀπόδοσις
εἰς ξένην γλῶσσαν ‖ μετακίνησις, μετάθεσις ‖
(*μηχ.*) παράλληλος μετατόπισις.

translation. Unuhina. *Literal translation*, unuhi
kūlike loa, unuhi pili. *Free translation*, unuhi
laulā loa.

251

roles. Like the concubine, the work is malleable enough to conform to whatever the client (curator, collector, critic) desires—given that the client pays the bill at the end of the night.

"Every Artist Is a Person": Kippenberger as *Selbstdarsteller*

Martin Kippenberger didn't need to die prematurely at age forty-three to become a cult figure—at least in the European context.[51] At the end of the 1970s, before deciding to become a visual artist, Kippenberger's main preoccupation was self-invention. He went to Florence in 1976 "looking like Helmut Berger on a good day" but was never discovered.[52] He returned from Italy and temporarily moved to Paris to become a novelist (he never finished his novel, but continued writing throughout his life). In 1978, he established the Büro Kippenberger in Berlin with Gisela Capitain; this marked his formal debut as a visual artist, although his office was more than a studio, as it blended all forms of artistic endeavor à la Warhol's Factory. Shortly thereafter, Kippenberger became co-owner and manager of the S.O. 36 in Kreuzberg, the center of the punk and new wave scene. To mark his twenty-fifth birthday that same year, he printed a

Untitled (I Shop Therefore I Am). 1987
Photograph
231,1 x 125 cm/91 x 49 1/4 in.

BARBARA ▶
KRUGER
Born in Newark, New York, 1945/Lives in Los Angeles and New York

A

poster picturing himself with a hooker, with the banner title, "A Quarter of a Century as one of you, among you, with you." The self-designated epithets "show-off," "hypervoyeur," "pretender," "informer," "organizer," "ringleader," "long-a-painter," and "big spender" surrounded his head like a halo.[53] During this early yet hyperactive phase in his life, Kippenberger's indecision about his vocation produced a maelstrom of creative activities. The only thing that was constant was his tireless, systematic promotion of his persona.

Kippenberger's invention of Kippenberger was not limited to his early career; it was an ongoing process. His nicknames and alter egos appeared everywhere he worked: Kippy, Der Kippenberger, MK, Spiderman, a crucified Frog, or just plain Martin. He wore as many hats as he had names for himself: painter, sculptor, architect, writer, poet, underground club manager,

A Martin Kippenberger standing in front of a map
of Mitteleuropa, from *Tempo* magazine, 1989
Archives of the Martin Kippenberger Estate, Cologne

◀ SEAN
LANDERS
Born in Palmer, Massachusetts, 1962/Lives in New York

Joy of Sex. 1995
Oil paint on linen
213,3 x 310 cm/84 x 122 in.

My Rock Friend. 1992
Ink on paper and envelope
8 leaves, 28 x 21,5 cm/11 x 8 1/2 in. each;
envelope, 15,2 x 29 cm/6 x 11 3/8 in. Total dimensions vary

A

B

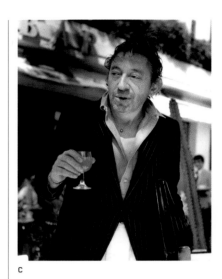

C

musician, promoter, exhibition maker, and director of his own museum (MOMAS, the Museum of Modern Art Syros). It was impossible to disentangle his self-promotion from his way of life.

The German language offers a perfectly tailored word to designate Kippenberger's programmatic drive. *Selbstdarsteller*, as Diedrich Diederichsen writes, is "often translated as 'self-publicist' or 'self-promoter' but literally means 'self-performer.'"[54] In his text on Kippenberger's art and life between 1977 and 1983, Diederichsen goes on to explain that in contemporary German parlance, the term *Selbstdarsteller* is most often used as an epithet in the realm of politics, while in the arts it takes on a more ambivalent tone. Kippenberger as *Selbstdarsteller* can be compared to equally self-promoting/self-performing artists, "poised somewhere between Serge Gainsbourg and Klaus Kinski."[55] Yet the nuance offered by the German term—its oscillation between

A Martin Kippenberger
 Architectural Model of the MOMAS. 1993
 Archives of the Martin Kippenberger Estate, Cologne

B Martin Kippenberger
 Arrow Pointing to the MOMAS (Museum of Modern Art Syros).
 1993. Signpost by Christopher Wool
 Archives of the Martin Kippenberger Estate, Cologne

C Serge Gainsbourg standing in front of a bar in Cannes, 1983

D Martin Kippenberger with bandaged head, 1986
 Archives of the Martin Kippenberger Estate, Cologne

New Members for the Burghers of Calais. 1992–93
Iron, plaster, polyurethane, and red cloth
Folded, 220 x 100 x 70 cm/86 5/8 x 39 3/8 x 27 1/2 in.;
unfolded, 220 x 300 x 200 cm/86 5/8 x 118 x 78 3/4 in.

GEORGE ▶
LAFFAS
Born in Cairo, 1950/Lives in Athens

D

promotion/publicity and performance of the self—raises an important distinction. Unlike the purely cynical marketing strategies in the mainstream of the music business and the art world, Kippenberger's *Selbstdarstellung* contained a complex economy of checks and balances, promotion and self-effacement, exuberance and humility, gut-splitting humor and profound melancholia.

"Every artist is a person," Kippenberger would say.[56] Originally used to combat Beuys's maxim "Everyone—each person—is an artist....The Revolution is in us," Kippenberger's humble statement might seem to contradict his own self-generated mythology. Kippenberger's first artwork—a cycle of one hundred small-format paintings titled *Uno di voi, un Tedesco in Firenze* made out of frustration with his acting career in 1977—might hold the key to this seeming contradiction. *One of You, A German in Florence* offers a panoply of snippets from Kippenberger's everyday life in the modern Renaissance city, rendered in black and white oil paint.[57] This multipaneled work—deliberately reminiscent of Gerhard Richter's grisaille *48 Portraits of Important Men*—is Kippenberger's first attempt to create an open system of images,

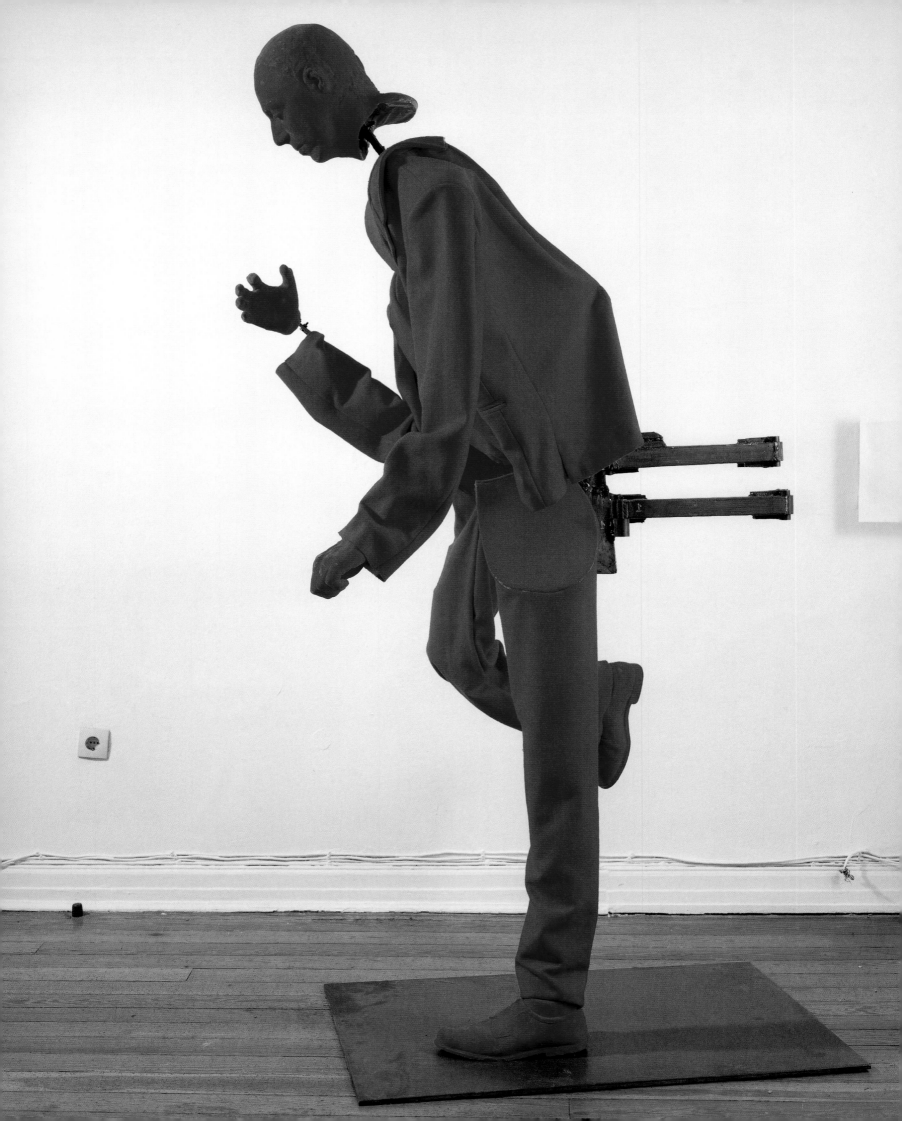

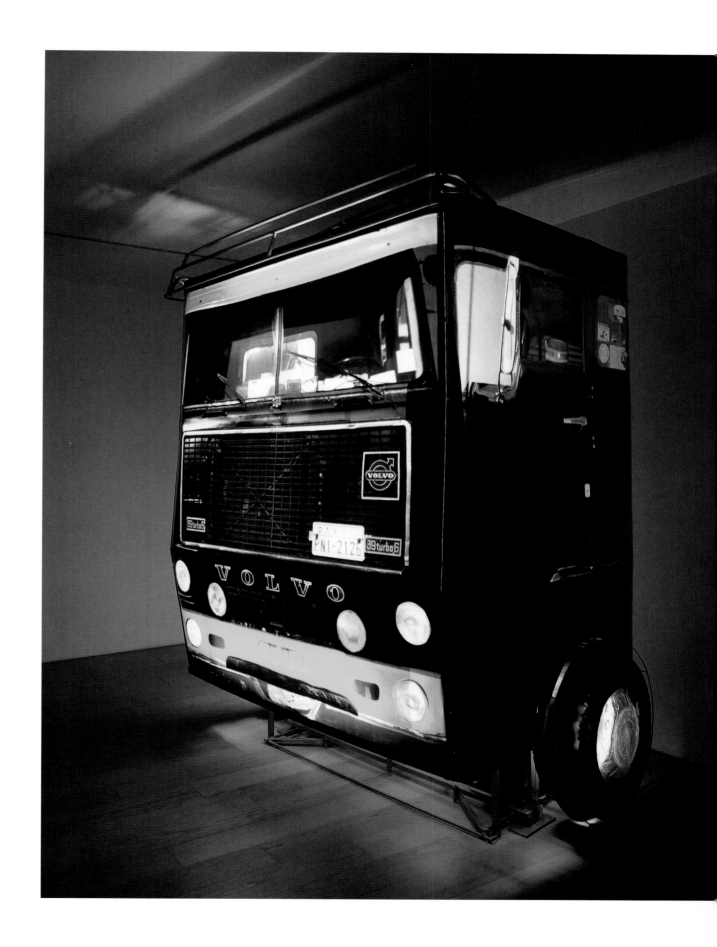

Truck. 2001
Photographic membrane, PVC, iron, and neon lights
310 x 180 x 230 cm/122 x 70 7/8 x 90 1/2 in.

signs, language, high and low cultural references, and architectural motifs. From a typical hole-in-the-ground toilet to a neon sign of a local ice-cream parlor, "Perche'no," from a portrait of an Italian crooner to a neighborhood milk man and a copy of Sandro Botticelli's *Portrait of a Young Man with a Medallion* (1470–75), this is more than a picture of the human condition. Kippenberger always counted himself among us, *uno di voi.*

While representing only a small portion of Kippenberger's prolific, extremely varied oeuvre, the following accounts are exemplary of Kippenberger's unique entwinement of art, alcohol, and persona:

Self-Portrait. 2000
Cast polyester resin and glass beads
Approx. 164 cm/64 1/2 in. high

LIZA ▶
LOU
Born in New York, 1969/Lives in Los Angeles

Alkoholfolter (The Torture of Alcohol)

Kippenberger's drinking was legendary—the anecdotes are as numerous as his entire body of work. In the self-portraits he made throughout his career, Kippenberger frequently depicted his lifelong relationship to alcohol, often painted from actual photographic sources. When examined in its entirety, Kippenberger's dependence on alcohol was as much a search for productive intensity as it was the cause of his self-destruction.

JUST PLAIN DRUNK: A photorealist painting from the *Lieber Maler, male mir...* series (1981), showing Kippenberger from behind, arm-in-arm with a friend, as he drunkenly totters down a busy Dusseldorf street.

A PRISONER OF BOOZE: An early gestural painting from 1981, *Alkoholfolter (The Torture of Alcohol)*, shows Kippenberger handcuffed by the plastic rings of a six-pack of cheap beer.

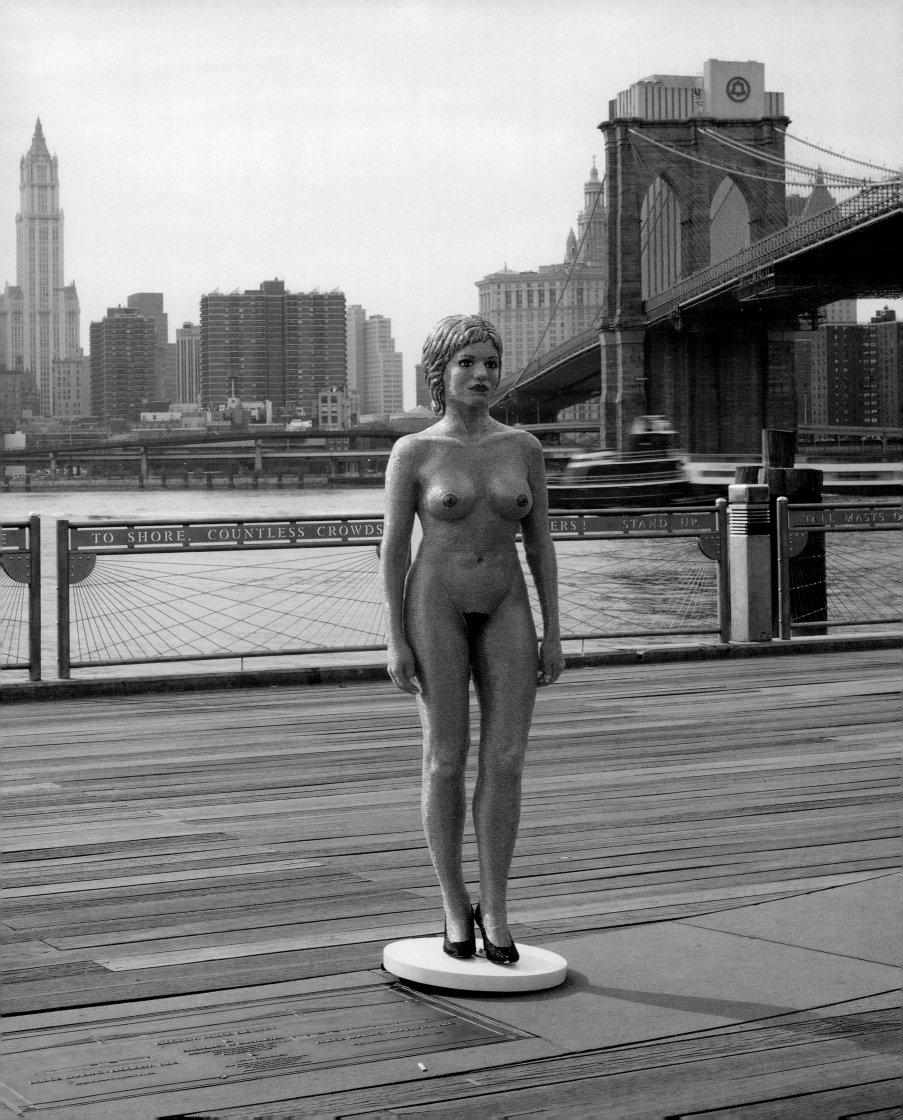

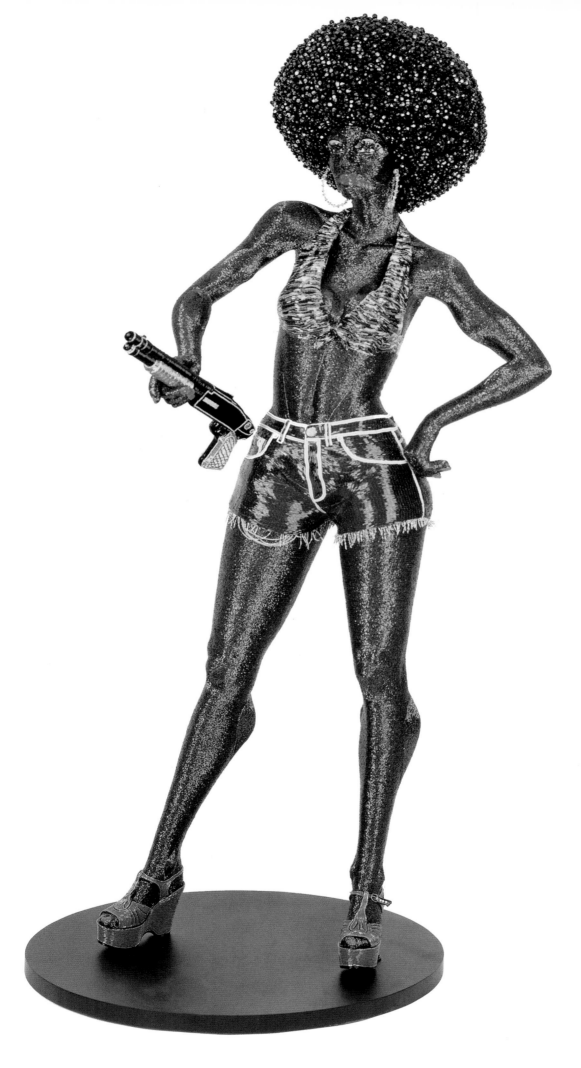

◀ LIZA
LOU

Super Sister. 1999
Glass beads and mixed media
213 x 91 cm/83 7/8 x 35 7/8 in.

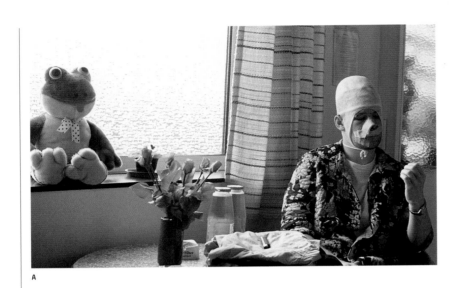

A

BERLIN BY NIGHT: Photographs of Kippenberger's bandaged and bruised face, taken in Berlin's Urban Hospital after fights in the night club S.O. 36, were the documentary source for his now-famous triptych *Berlin by Night* and the large-scale painting *Dialogue with the Young* (1982). He recycled these images in later works, posters, and artist books.

POETRY DISGUISED AS DRUNKEN BABBLE: He often used word play in his titles, which were ambiguously spelled to suggest slurred speech. *Fiffen, Faufen und Ferfautfen* (*Fuck, Booze and Sell* or *Smoke Pot, Buy and Get Drunk*); *Ich hab' kein Alibi, höchstens mal ein Bier, hör auf zu mosern, so geht's nich' nur Dir* (*I Have No Alibi, Only a Beer at Best, Why Don't You Stop Whining, You're Not Worse off Than the Rest*).

DRINKER IN MID-LIFE: After several years of hard work and drink, Kippenberger reportedly awoke on the morning of his thirty-fifth birthday in 1988 to see the effects of twenty years of sex, drugs, and rock 'n' roll in the mirror. In a series of paintings of that same year, Kippenberger shed his uniform of a tailored suit to expose his beer belly, sagging skin, heavy body,

Boneyard. 1990
Cast hydrostone
750 telephone receivers
Total dimensions vary

CHRISTIAN ▶
MARCLAY
Born in San Rafael, California, 1955/Lives in New York

and slouching posture. The pathetic party balloons that figure in these portraits are analogous to Kippenberger's wounded sense of vanity.

A DYING MAN: In his last full painting cycle, made in 1996, right before his death, Kippenberger created seventeen self-portraits as the characters in Théodore Géricault's famous painting of dying passengers on the raft of the Medusa. These gestural, expressive paintings, based on photographs taken by his wife, Elfie Samotan, offered a dramatized allegory of his struggle in life and in art. As his life was coming to a premature end due to liver cancer (no doubt abetted by drink), "Kippenberger depicted himself as suffering, sorrowful, desperate, wounded and hopeful, not ironically, but with a refreshing vanity free of any false inhibition." [58]

A Kippenberger with bandages, sitting in his
 hospital room after he was beaten up by some punks, 1979
 Archives of the Martin Kippenberger Estate, Cologne

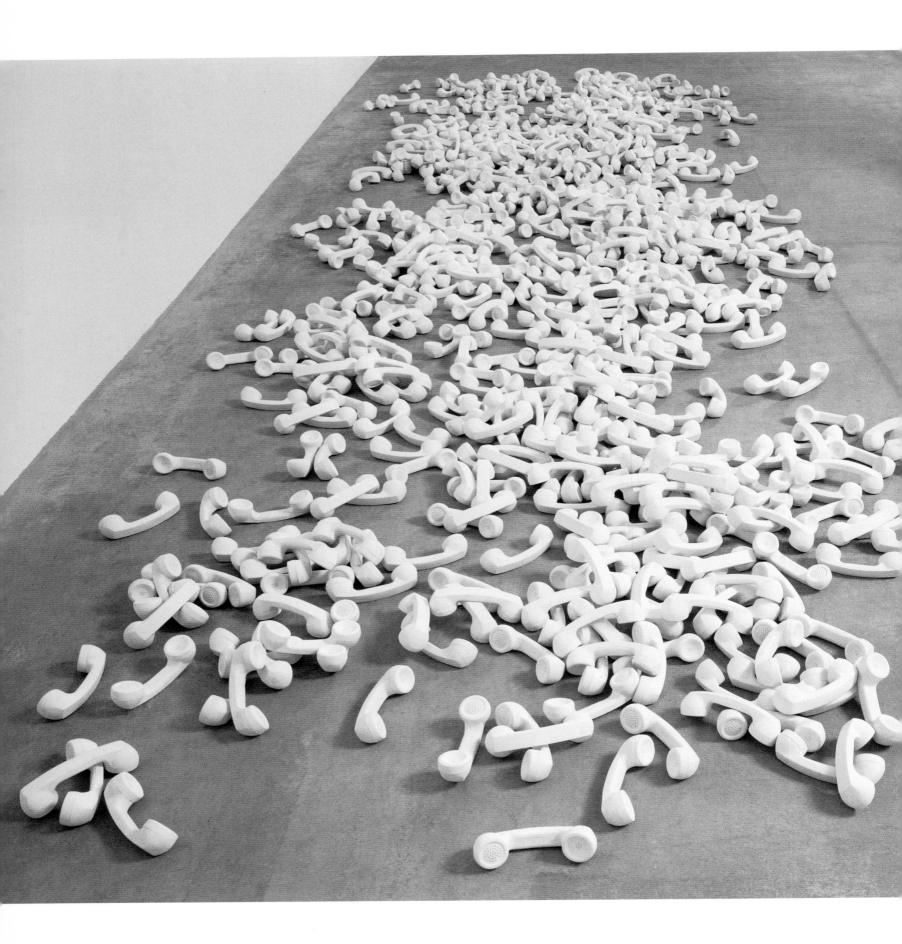

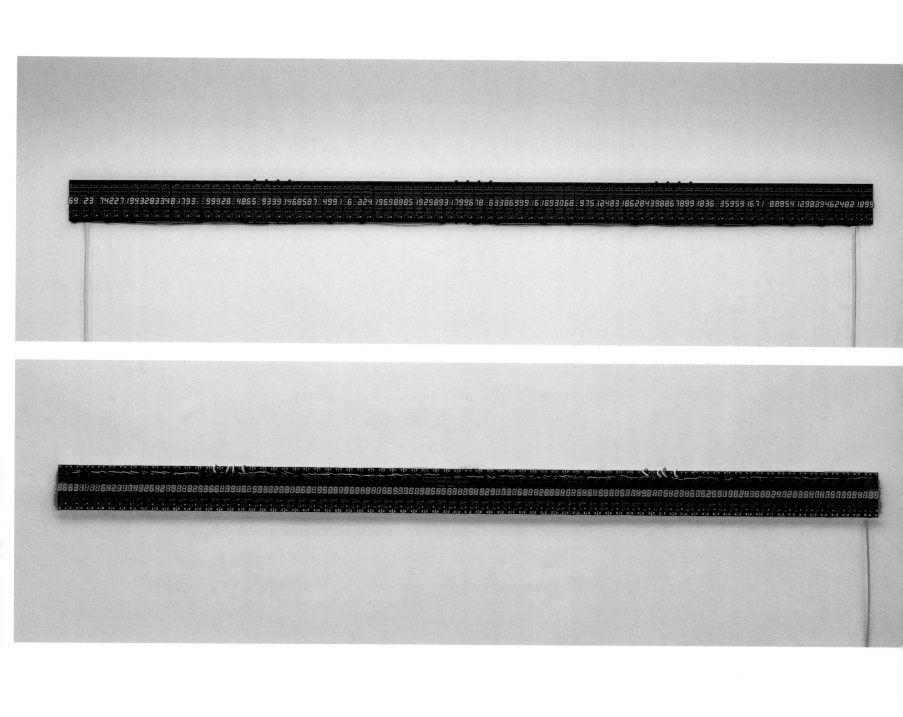

TATSUO MIYAJIMA
Born in Tokyo, 1957/Lives in Tokyo

Counter Line No. 4. 1988
LED sign and green diode, IC, electric wire, aluminum panel, metal, plastic, and transformer
11 x 208,4 x 3,5 cm/4 5/16 x 82 x 1 3/8 in.

Counter Line No. 5. 1990
LED sign and red diode, IC, electric wire, and aluminum panel
11 x 198 x 4,5 cm/4 5/16 x 78 x 1 3/4 in.

"Martin, Go in the Corner, Shame on You!"

 "The Artist as Exemplary Alcoholic" is the title of an article written about Kippenberger and his friend Günther Förg by an influential German art critic. The author described Kippenberger as a "German petty bourgeois" and "like all cynics, [he was] finally a coward." [59] "Absolutely correct!" was Kippenberger's retort. His public response came in the guise of a sculpture entitled *Martin, Go in the Corner, Shame on You!* (1989). A cast-wax mannequin in Kippenberger's likeness stood in the corner of the gallery space like an admonished school boy, his hands behind his back, his head looking down remorsefully.

 "Kippenberger staged his public life because he thought he could bear it better in its mythologized form. He demythologized art and the conditions of its creation so that it would not lose

its credibility." [60] This poignant distinction between mythologized life and demythologized art offers the perfect conclusion to "The Birth of Crass." In the same manner that Warhol marked a shift in the perception of artistic persona, integrating it into his art practice, so does Kippenberger's contradictory yet poignant self-performance/ self-promotion offer a model (impossible to replicate) for generations to come.

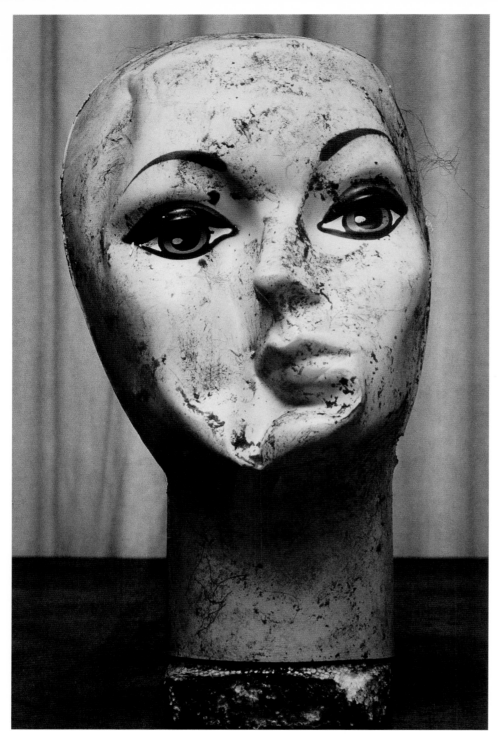

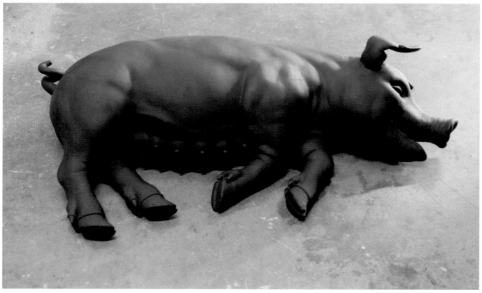

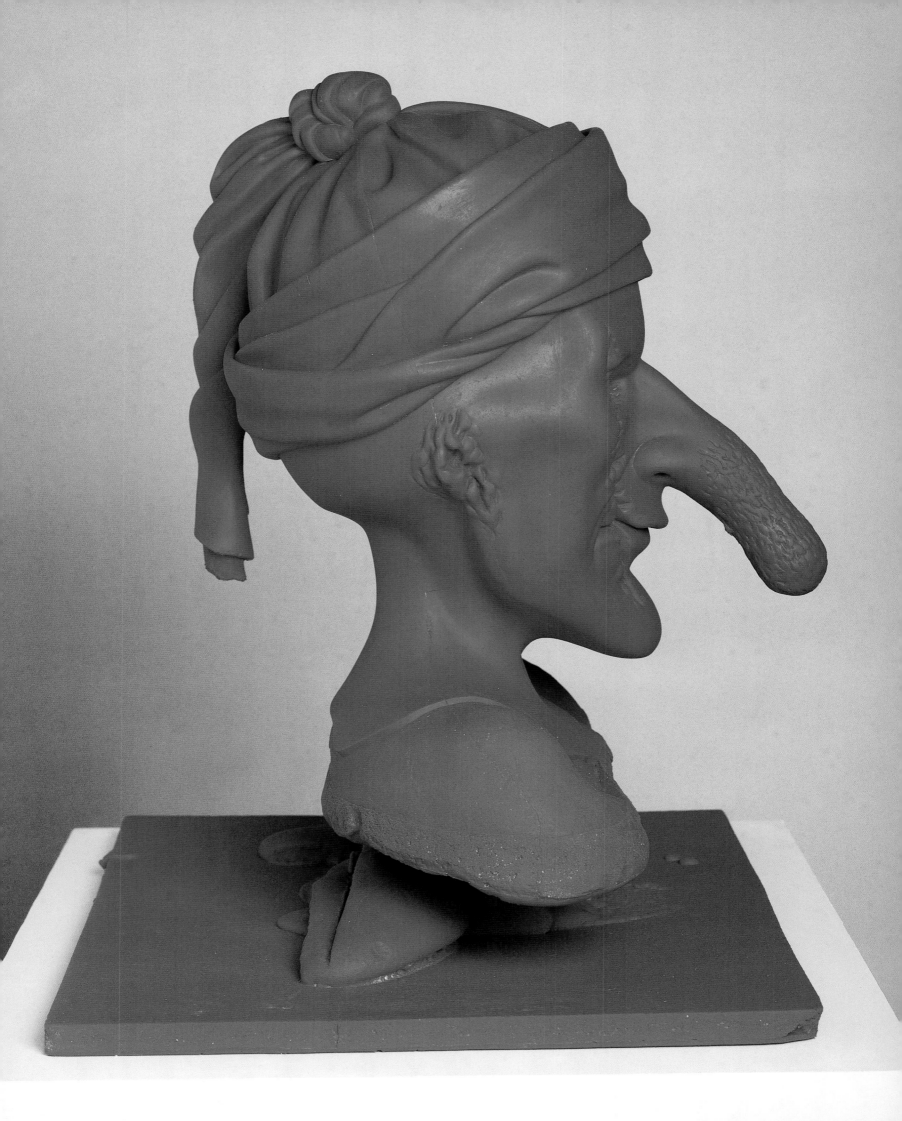

◀ PAUL
MCCARTHY

Untitled (Jack). 2002
Red silicone rubber
60 × 60 × 46 cm/23 5/8 × 23 5/8 × 18 1/8 in.

Notes

1 Paul Barolsky, "Giorgio Vasari: Art and History," *The Art Bulletin*
 (June 1998), 380.

2 Benjamin H. D. Buchloh, *Neo-Avantgarde and Culture Industry:
 Essays on European and American Art from 1955 to 1975*
 (Cambridge, Mass.: MIT Press, 2000), xxxiii.

3 In the course of research for her master's thesis, Sara Cochran
 uncovered the source photographs for thirty-three of forty-four known
 nude paintings by Picabia. An extract of her thesis is published in the
 exhibition catalogue by Zdenek Felix, ed., *Francis Picabia: The Late Works,
 1933–1953* (Ostfildern-Ruit: Verlag Gerd Hatje, 1998).

4 Benjamin H. D. Buchloh, "Figures of Authority, Ciphers of Regression:
 Notes on the Return of Representation in European Painting,"
 October, no. 16 (spring 1981), 39–40.

5 Biographical information about Picabia's Côte d'Azur period is taken from
 an interview with Olga Picabia in Pierre Calté, Hans Ulrich Obrist, and
 Stefan Banz, "Francis Picabia: An Independent Mind," in Stefan Banz and
 Iwan Wirth, eds., *Francis Picabia: Fleurs de chair, fleurs d'âme*
 (Cologne: Oktagon, 1997), 29–40.

6 Carole Boulbes, "Francis Picabia: Delicious Monsters—Painting, Criticism,
 History," in Alison M. Gingeras, ed., *Dear Painter, paint me...Painting the Figure
 since Late Picabia* (Paris: Centre Pompidou, 2002), 30–31.

7 Andy Warhol, Kasper König, Pontus Hultén, and Olle Granath, eds.,
 Andy Warhol (Stockholm: Moderna Museet, 1968), unpag.

8 Peter Gidal, *Andy Warhol: Films and Paintings–The Factory Years*
 (London: Studio Vista, 1971), xii.

9 Ibid., xi.

10 Annette Michelson, "Where Is Your Rupture? Mass Culture and the
 Gesamtkunstwerk," in *The Andy Warhol Files, October Files*
 (Cambridge, Mass.: MIT Press, 2001), 101.

11 Ibid., 93.

12 Ibid., 102.

13 Andy Warhol, "Fame," in Andy Warhol, *The Philosophy of Andy Warhol
 (From A to B and Back Again)* (New York and London: Harcourt Brace
 Jovanovich, 1975), 92.

14 Ibid., 7.

15 Ibid., 10.

16 Anthony Haden-Guest, *True Colors: The Real Life of the Art World*
 (New York: Atlantic Monthly Press, 1996), 183.

17 These are some of the most frequently used adjectives in the writing on
 Jeff Koons and his work.

18 These "maxims" were all taken from Jeff Koons, *The Jeff Koons Handbook*
 (London: Anthony d'Offay Gallery, 1992).

19 Roberta Smith, "Rituals of Consumption," *Art in America* (May 1988), 164.

20 Sylvère Lotringer, "Immaculate Conceptualism," *Artscribe International*, no. 90
 (Feb.–Mar. 1992), unpag.

21 "Ilona and I were born for each other. She's a media woman. I'm a media
 man. We are the contemporary Adam and Eve." Koons, *The Jeff Koons
 Handbook*, 140.

22 Richard Prince, "Eleven Conversations," *Tracks*, no. 2 (fall 1976), 41–46.

23 Rosetta Brooks, "Spiritual America: No Holds Barred," in Lisa Phillips,
 Richard Prince (New York: Whitney Museum of American Art, 1992), 87–88.

24 "For some, Colin de Land was a champion of art's radical promise, for
 others their nagging conscience. Given that he was a cofounder of the
 Armory Fair—where he could be seen sporting a trucker's cap detourned
 with a simple piece of tape to read, DON'T BOTHER ME UNLESS YOU'RE
 BUYING—it may have been hard to understand the importance he placed
 on tweaking the moneymaking side of dealing in art. But Colin's politics
 turned on a single word: gallery. Opening in 1980 as a small spare room
 in a photographer's uptown studio before moving through the Lower East
 Side, the East Village, SoHo, and finally Chelsea, Colin's space never of-
 ficially took that name. More than a gallery, it was, he said, his attempt
 to 'reenter society,' and Colin knew better than anyone how art turned on
 the creation of social value. As ArtClub 2000's Danny McDonald (to whom
 Colin vouchsafed the 'company,' with Christine) puts it: 'Colin's ability to
 create a dynamic social space in his gallery was legendary. There was al-
 ways a great mix of artists, animals, art-world veterans, and a few brave
 collectors to be seen there at any hour of the day or night. We all showed
 up to run into each other, but really everyone was trying to get a hold
 of Colin, who generously directed the flow by simply never saying no.'"
 Gareth James, "Shaggy Dogg: Gareth James on Colin de Land," *Artforum*
 (summer 2003), 29.

25 Richard Prince quoted in ibid.

26 Despite the fact that Prince is lumped together with other "death of the
 author" artists such as Cindy Sherman, he never participated in Douglas
 Crimp's exhibition *Pictures*. "I've never said this before, but Doug Crimp
 actually asked me to be in that show. I read his essay and told him it was
 for shit, that it sounded like Roland Barthes. We haven't spoken since."
 From "Richard Prince Talks to Steve Lafreniere," *Artforum* (Mar. 2003), 70.

27 I am indebted to my exchange with art historian and critic Meghan Dailey
 for this insight.

28 David Rimanelli, "Ashley Bickerton: Just Another Shitty Day in Paradise,"
 Artforum (Feb. 1994).

29 Ashley Bickerton, e-mail to the author, 2003.

30 Matthew Collings, *Blimey! From Bohemia to Britpop: The London Artworld from
 Francis Bacon to Damien Hirst* (Cambridge, England: 21 Publishing, 1997),
 19–21.

Holdfast. 1999–2000
Mixed-media installation
Dimensions vary

Barry McGee: Born in San Francisco, 1966/
Lives in San Francisco
Margaret Kilgallen: Born in Washington, D.C., 1967/
Died in San Francisco, 2001

MCGEE &
KILGALLEN

31 Calvin Tompkins, "After Shock: What Has Damien Hirst Done to British Art?" *New Yorker*, Sept. 20, 1999, 89.

32 Ibid., 90.

33 William Leith, "Avoiding the Sharks: Interview with Damien Hirst," *Observer Life*, Feb. 14, 1999, 15.

34 Robert Rosenblum, "Revelations: A Conversation between Robert Rosenblum and Dinos and Jake Chapman," in *Unholy Libel: Six Feet Under* (New York: Gagosian Gallery, 1997), 149.

35 Collings, *Blimey!*, 42.

36 Transcript of Tracey Emin's appearance on the television show "Is Painting Dead?," broadcast live on the night of the Turner Prize Awards, 1997.

37 Melanie McGrath, "Something's Wrong," *Tate Magazine* (Sept.–Oct. 2002), 52.

38 Sophie Leris, "Naughty at Forty: Tracey Emin as You've Never Seen Her Before," *Evening Standard Magazine*, July 18, 2003, 30–35.

39 McGrath, "Something's Wrong," 58.

40 Claire Bishop, "Antagonism and Relational Aesthetics," unpag. Forthcoming in *October* (spring 2004).

41 Ibid.

42 Ibid.

43 Nancy Spector, "Interview with Maurizio Cattelan," in Francesco Bonami, Maurizio Cattelan, Nancy Spector, et al., *Maurizio Cattelan* (London: Phaidon Press, 2000), 17.

44 Jenny Liu, "Trouble in Paradise," *Frieze*, no. 51 (Mar.–Apr. 2000), 52–53.

45 Cattelan readily admits that the Biennial was conceived as a paid vacation. See the interviews with Nancy Spector (see n. 43) and Massimiliano Gioni with Jens Hoffman, "Blown Away—Blown to Pieces," *Material*, no. 2 (Zurich: Migros Museum, 1999), reprinted in Bonami et al., *Maurizio Cattelan*, 140–42.

46 Maurizio Cattelan, conversation with the author, 2000.

47 Spector, "Interview with Maurizio Cattelan," 17.

48 Rob Pruitt quoted in Mia Fineman, "Back in the Arms of the Art World," *New York Times*, June 17, 2001, 30.

49 Press release, Oct. 19–Nov. 16, 1996, Gavin Brown's Enterprise, New York.

50 Piotr Uklanski, quoted in "Piotr Uklanski: Projects 72," exhibition brochure (New York: The Museum of Modern Art, 2000).

51 Kippenberger died of complications related to liver cancer, on March 9, 1997, in Vienna. Unfortunately, during his lifetime the Anglo-American scene mostly wrote him off as just another German Neo-Expressionist painter. His oeuvre remains widely unfamiliar in the U.S. and Britain.

52 "Kippenberger sans peine/Kippenberger leicht gemacht. Interview with Daniel Baumann," in Christian Bernard, ed., *Martin Kippenberger* (Geneva: Musée d'Art Moderne et Contemporain, 1997), 10.

53 Daniel Baumann, "The Way You Wear Your Hat," in Peter Pakesch and Zdenek Felix, eds., *Martin Kippenberger* (Basel: Kunsthalle Basel, 1998), 61.

54 Diderich Diederichsen, "Selbstdarsteller: Martin Kippenberger between 1977 and 1983," in Eva Meyer-Hermann and Susanne Neuburger, eds., *Nach Kippenberger* (Vienna: Museum Moderner Kunst Stiftung Ludwig Wien, 2003), 43.

55 Ibid., 45.

56 Kippenberger quoted in the exhibition didactics for *Nach Kippenberger*, Van Abbemuseum, Eindhoven, the Netherlands.

57 For an excellent, complete description of this work, see Kathleen Bühler, "Uno di voi, un Tedesco in Firenze," in Meyer-Hermann and Neuburger, *Nach Kippenberger*, 30–33.

58 Baumann, "The Way You Wear Your Hat," 69.

59 Ibid., 67.

60 Ibid., 70.

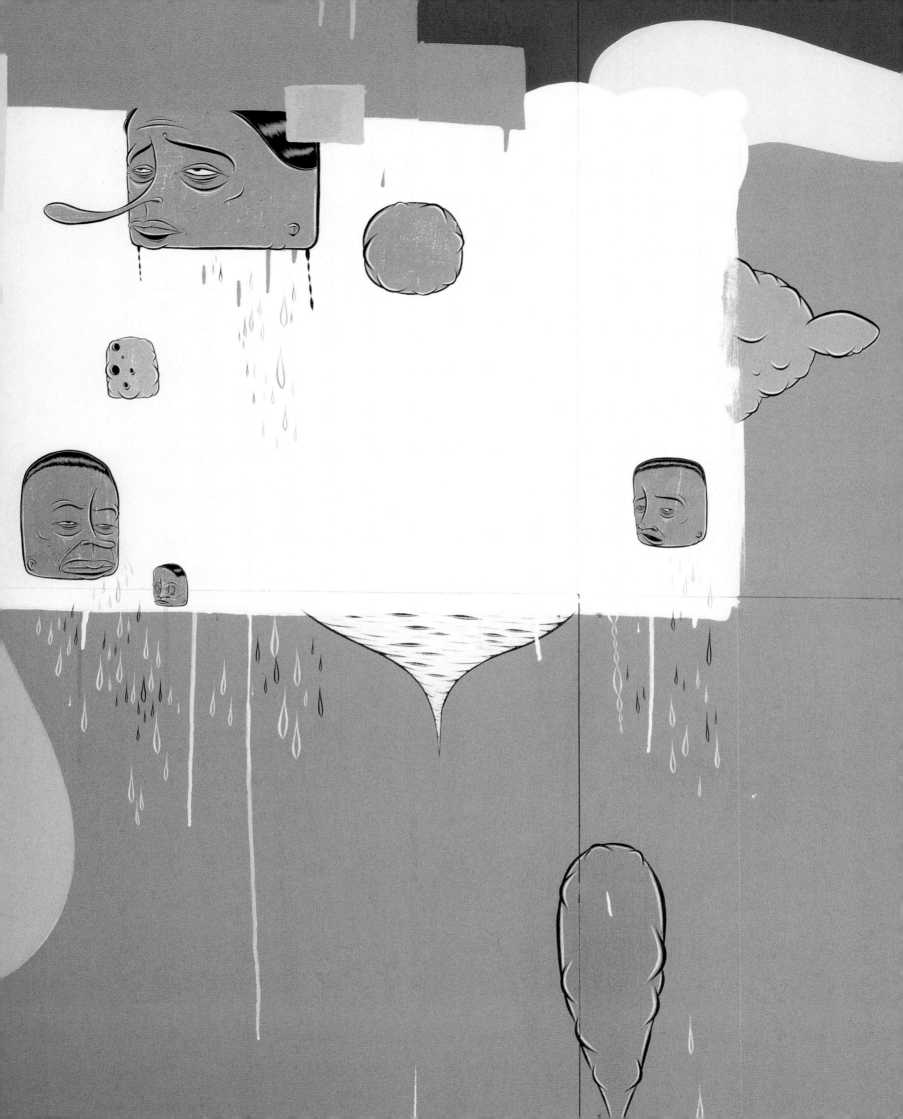

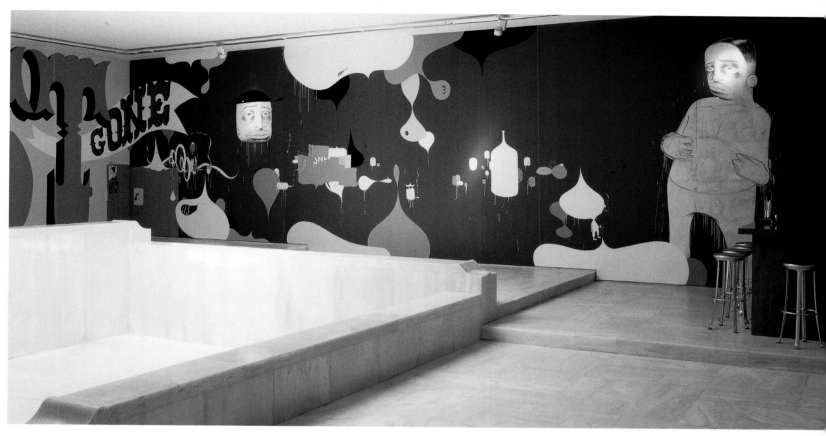

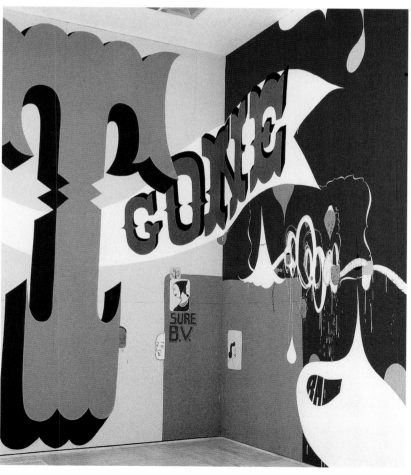

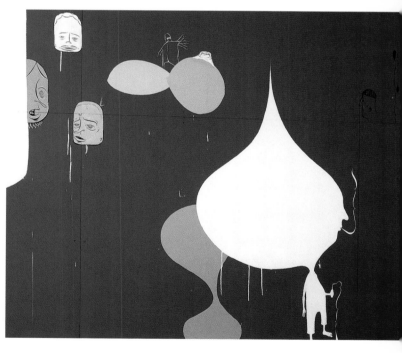

A

Massimiliano Gioni

The Visitors

Artworks often speak in a foreign language, but they always try to tell us something about our own surroundings: they open up potential worlds that strangely resemble the ones we live in. Juxtapose one artwork with another, and you will have a miniaturized universe, a portable solar system—a refraction of the present, and a vector to the future.

Rewind to 1985. A perfect moment of suspension: an orange basketball gently hovering in midair, nestled in some sort of amniotic fluid, coldly trapped in a glass vitrine. Jeff Koons's *One Ball Total Equilibrium Tank* is a Pop cosmogony, a ciphered history of the world. With algid precision, it freezes the spirit of the eighties, forever preserved in a time capsule. As seen behind Koons's

Entropy of Love. 1996
Glass with photograph interlayer
5 panels, 3,05 m x 6,1 m x 2 cm/
10 ft. x 20 ft. x 7/8 in. total

Miko No Inori. 1996
Video
4 min. 17 sec. (180-min. loop)

**MARIKO ▶
MORI**
Born in Tokyo, 1967/Lives in New York and Tokyo

glass encasements, the world appears as an endless parade of commodities, aligned with manic, aseptic detachment—a corporate paradise of glacial precision. The whole universe is on display, but rigorously out of reach. Welcome to the new world order.

Less than twenty years later, hiding behind the deceptive title *Celebration*, Koons starts to portray a world that has ruptured into bits and pieces. Especially in his paintings, he seems to have abandoned any desire to construct a fictional yet stable balance. Reality has all of a sudden become porous, tentacled, and chaotic. There is no hope of restoring any classical perfection, but rather a generous and frantic attempt to capture the world in its multifaceted cacophony of images and colors. At the end of the nineties, Koons's explosion of forms comes across as a pagan ritual of dispersion and confusion, like some modern-day Bacchanalia: a joyful yet somewhat desperate embrace of complexity.

A

Jeff Koons
One Ball Total Equilibrium Tank. 1985
Glass, iron, water, and basketball
163,8 x 77,4 x 33,6 cm/64 1/2 x 30 1/2 x 13 1/4 in.
The Dakis Joannou Collection, Athens

Burning Desire. 1996–98
Glass with photograph interlayer
5 panels, 3,05 m x 6,1 m x 2 cm/
10 ft. x 20 ft. x 7/8 in. total

Mirror of Water. 1996–98
Glass with photograph interlayer
5 panels, 3,05 m x 6,1 m x 2 cm/
10 ft. x 20 ft. x 7/8 in. total

Koons's stylistic trajectory describes a crucial passage from clarity to opacity, from simplicity to density—a passage that reflects a larger psychological and social scenario, departing from the mirage of perfect equilibrium and clashing against the spectacle of radical asymmetry.

Just two decades later and a few thousand light-years away from that basketball tank, today's world might as well resemble the labyrinth of Gregor Schneider's house. A tangle of corridors, tunnels, and black holes unraveling with no apparent order or reason—a distorted mirror of our fears and desires.

Pure Land. 1996—98
Glass with photograph interlayer
5 panels, 3,05 m x 6,1 m x 2 cm/
10 ft. x 20 ft. x 7/8 in. total

MARIKO ▶
MORI

Prisoners of Speed

Number of airports in the world: 44,715

Meanwhile, even our unconscious has been colonized, our intimacy revealed. Under the scrutiny of television, the border between the private and the public has grown thinner and thinner. And when dreaming, do we use blood or ketchup for our special effects?

Quite significantly, in the everyday mythology promoted by the mass media, bioengineering has taken over the role that psychoanalysis played in the sixties: biotechnology is seen as the final frontier, the ultimate access to the meaning of life. In this context, our body is experienced as a set of forces and tensions, a flowing aggregate of energy fields. And it's pretty much the same rhetoric that newspapers and TV use when describing political consensus and global transactions. In its vulgate, the information age thus appears as a completely reversible exchange between micro and macro systems, as though, finally, inside and outside were completely overlapped.

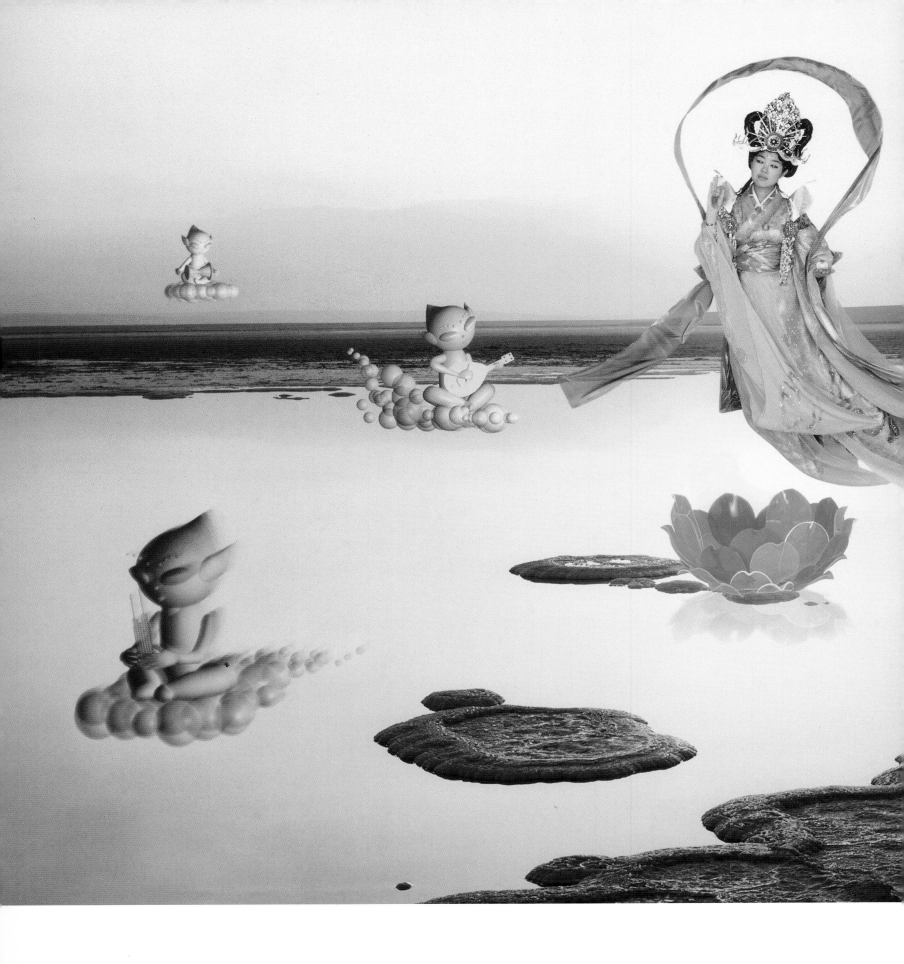

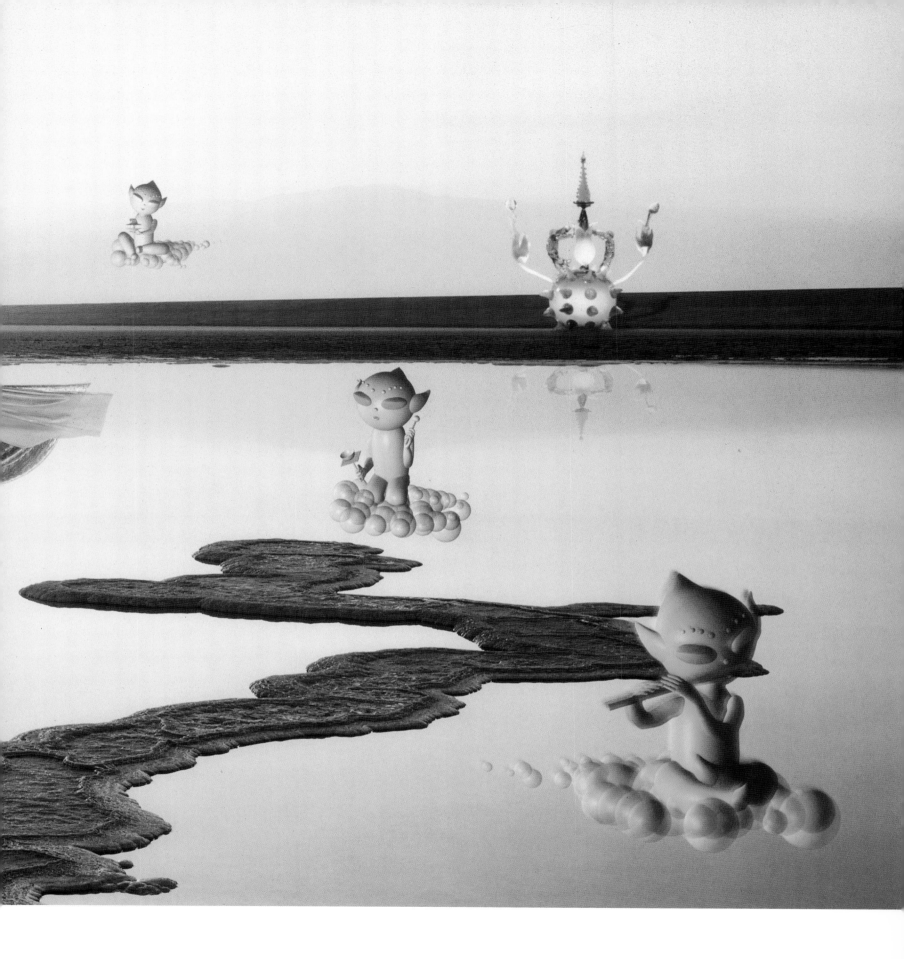

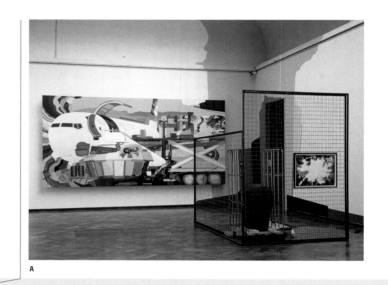

A

Moving in totally opposite directions, Matthew Ritchie and Franz Ackermann have almost arrived at the same end-point. Both are indefatigable explorers of invisible worlds, and both compile maps and travelogues. As Ritchie plunges into the depths of biological life, Ackermann follows the diagrams of frequent flyers and accidental tourists. While Ritchie's cosmos proliferates with convulsive notations and pseudo-scientific scribbles, Ackermann's psychogeographic drifts mix personal memories and objective documentation. Their planets couldn't be farther apart. And yet as our real world spirals out of control, and the specter of biological terror seems to bridge the gap between the infinitely small and the sublimely vast, both Ritchie and Ackermann might be showing us that the whole universe is precariously resting on a handful of dust.

A Franz Ackermann
Boarding. 2002
Mixed media and oil paint on canvas
280 x 540 cm/110 1/4 x 212 1/2 in.
The Dakis Joannou Collection, Athens

From One to Ten. 1990
Bronze and wood
53,3 x 59,9 x 59,9 cm/21 x 23 1/2 x 23 1/2 in.

JUAN
MUÑOZ

Born in Madrid, 1953/Died in Ibiza, 2001

Traveling without Moving

Number of languages spoken in the world: 6,120

Geography has become an obsession. With one eye focused on United Colors of Benetton's ads and the other absorbed in Toni Negri and Michael Hardt's *Empire*, we have become perfect armchair travelers. Globally conscious and locally scared, we even seem a little worried when a butterfly comes flying by, as its wings could easily cause a hurricane in some exotic country. Connected, tuned in, confused, mildly entertained, and already elsewhere: in spite of international conflicts, geographical displacement is still one of our strongest industries. For a few million others, traveling remains just a desperate option called migration or exile.

Contemporary art has dwelled in these fractal, often contradictory territories for a few years now, tracing imaginary landscapes and sentimental journeys across space and time. The fixation with geography, in fact, also corresponds to a rediscovery of both personal and collective stories. "Geography is history," repeated the ads for a cell phone company a couple of years ago. Time has sneaked in through the back door: slowly,

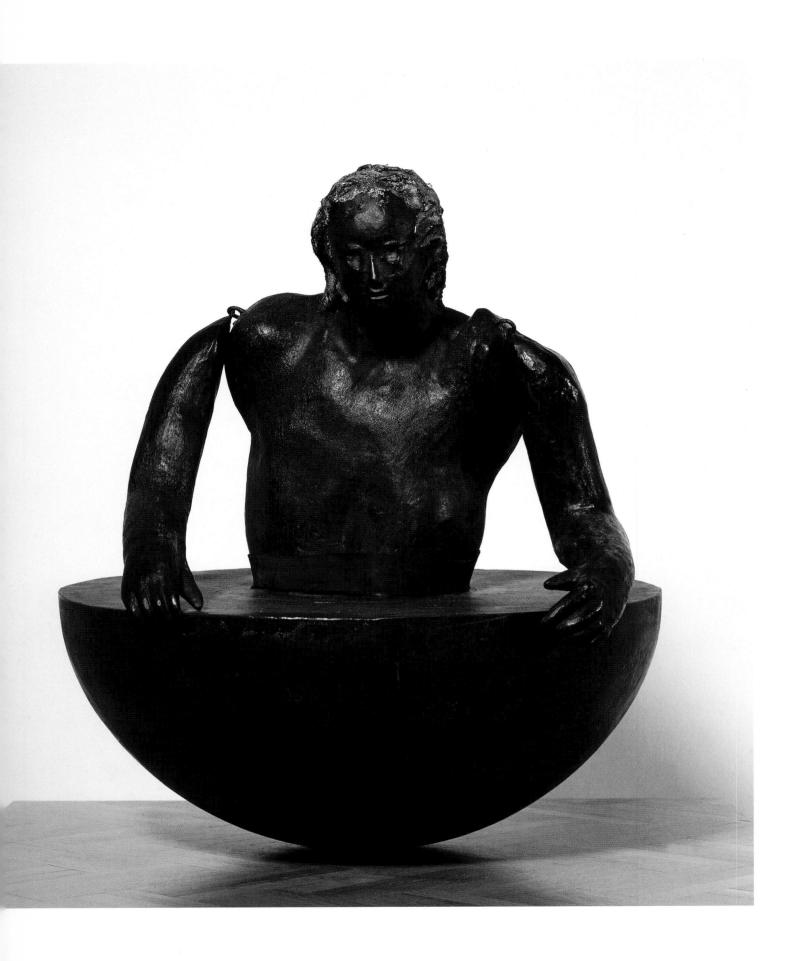

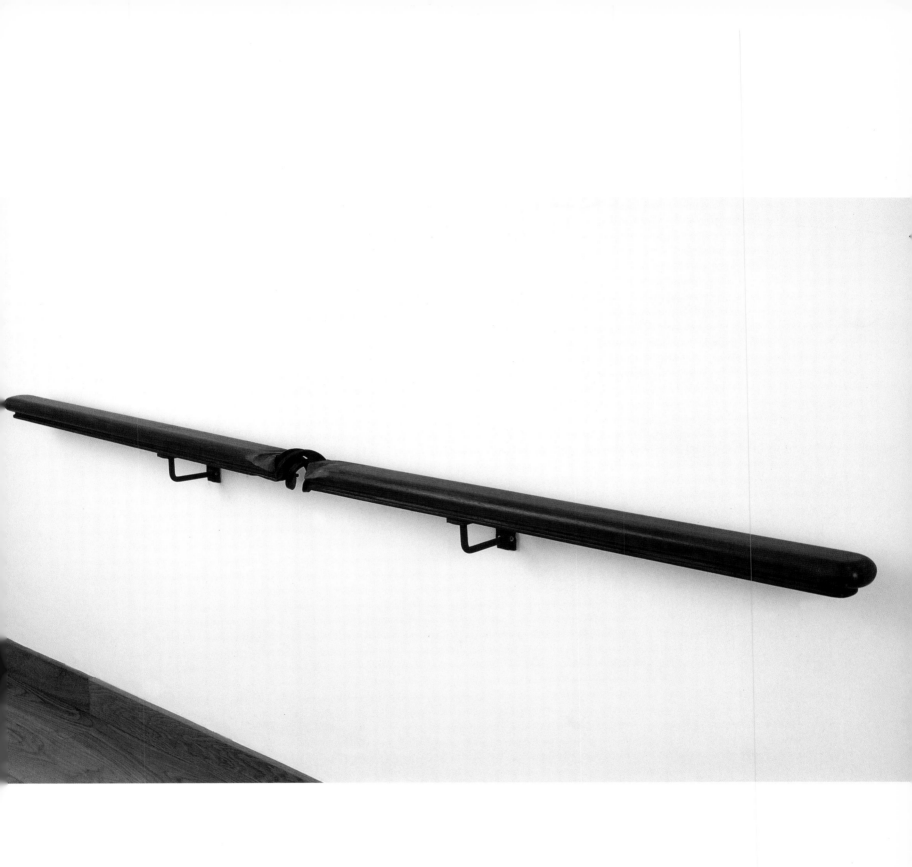

Pasamanos Favorito. 1988
Wood and steel
8 x 220 x 8 cm/3 1/8 x 86 5/8 x 3 1/8 in.

A

little by little, debris and ruins have taken the place of the shining novelty of the eighties.

The epic novels composed by artists as diverse as William Kentridge, Shirin Neshat, and Kara Walker or the rough assemblages of Cai Guo-Qiang, Chen Zhen, and Kcho describe endless combinations of possible worlds, suspended between the nostalgia for one's native culture and the refusal of one's origins. Reflected through these works, the world appears as a waste land crossed by frictions and sudden affinities: a world experienced through continuous translations and lateral movements. Despite the proliferation of global corporations and transnational networks, the art of today doesn't portray a homogenized space, nor does it speak one single language. On the contrary, contemporary art tries to open up a space of multiplicity, which is also reflected in the variety of media and expressions that artists so easily engage with. Artists today are speaking in tongues.

A Cai Guo-Qiang
The Dragon Has Arrived. 1997
Wood, electric fans, flags (People's Republic of China), and lights
Dimensions vary
The Dakis Joannou Collection, Athens

Inochi (original model, 1/6 size). 2003
Sculpey and resin
39 x 15,5 x 7,8 cm/15 3/8 x 6 1/8 x 3 1/16 in.

TAKASHI ▶
MURAKAMI
Born in Tokyo, 1962/Lives in Asaka City, Saitama, Japan

Divided We Stand

*Last year in which no film, screenplay, or performance
relating to mental illness was nominated for an Oscar: 1953*

In a world infatuated with traveling, it's quite usual to be affected by jet lag and other side effects. We like to think of ourselves as business-class nomads, but our bodies keep telling us that borders and time zones always have a physical and psychological impact on our lives. Being jet-lagged is not a symptom of internationalism; it's rather a proof of our sedentary nature, like an alarm clock ringing in the middle of the night, just to remind us of our own fragility: we can become ubiquitous but we will be weaker; always present, but almost powerless. The age of real-time accessibility has resulted in a systematic corrosion of character, and flexibility might just as well be a euphemism for schizophrenia.

The more our world veers toward abstraction and complexity, the more artists seem committed to going back to a primal level of representation, starting from what's right there, in front of their eyes: today's art is often about faces, people, individuals, or masses: the story of I, or the family album of a multi-

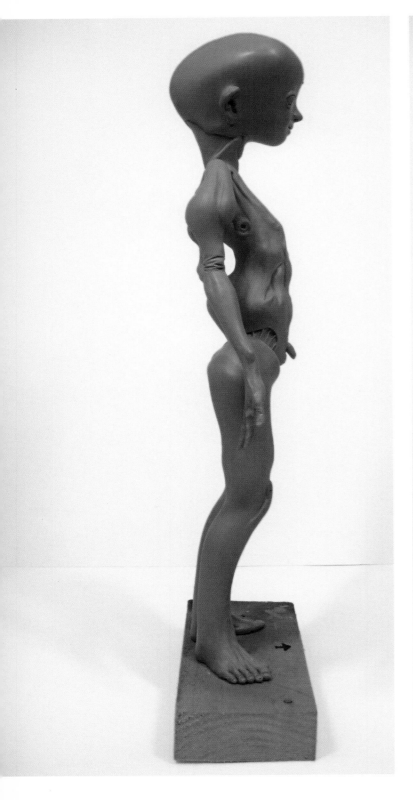
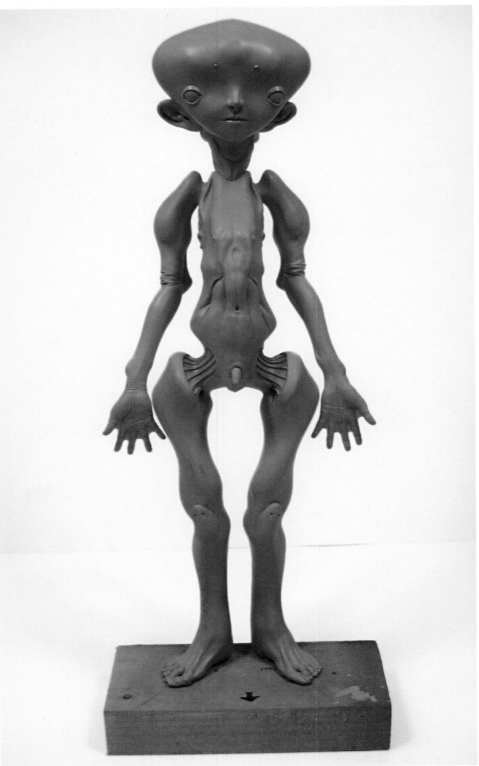

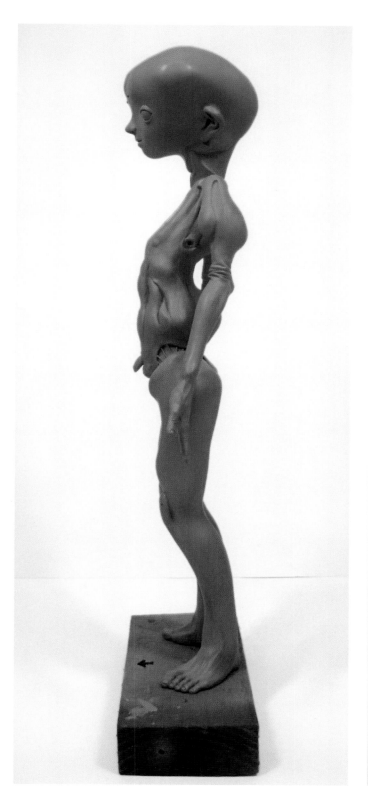
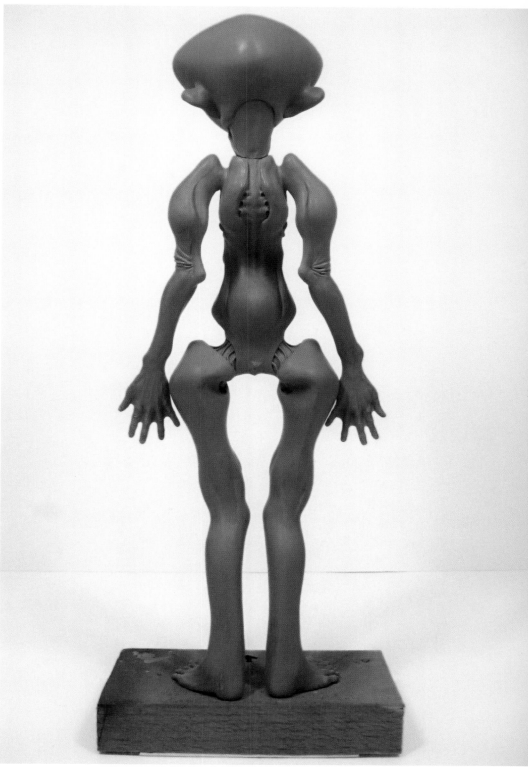

◀ TAKASHI
MURAKAMI

Inochi (not illustrated). 2004
Fiberglass
140 × 62,5 × 36,5 cm/55 1/8 × 24 5/8 × 14 3/8 in.
Edition 1/3

A

tude. It's a procession of portraits, in which everyone seems affected by some kind of mental disorder. From Gillian Wearing's desperate ordinary men to Vanessa Beecroft's tormented beauties, from Rineke Dijkstra's exhausted youths to Kutlug Ataman's split personalities, the art of today comes across as a gallery of dysfunction, an explosion of masks similar to Maurizio Cattelan's interchangeable self-portraits. This dissemination of identities speaks of a world on the verge of a nervous breakdown: welcome to Prozac Nation.

But what is it exactly that makes our existence so frightening? Well, just listen to the litany of questions flashing up in Peter Fischli and David Weiss's slide installation *Questions* (1981–2002)—a veritable encyclopedia of today's distress: "Is it dangerous to always think of a different life? Why do I always have to fight? Do they still need me?"

A Gillian Wearing
Signs That Say What You Want Them To Say.... 1992–93
C-print
120,1 × 79,7 cm/47 1/4 × 31 3/8 in.
The Dakis Joannou Collection, Athens

Traps. 1998
Video installation
Trap I: The Transparent One, 16 min. 50 sec.
Trap II: The Yellow One, 15 min. 56 sec.

NIKOS
NAVRIDIS
Born in Athens, 1958/Lives in Athens

First, Are You Experienced?

Estimated percentage of matter in the universe
determined to be invisible: 98

When we're lost and lonely, it's easy to turn reclusive: stay quiet and distant—go native. That's why today's art also unravels as a story of private universes and worlds apart. This solipsistic attitude is probably just an attempt to exorcise a state of crisis, or a struggle to build a space of silence, outside the pollution of everyday life—for sure, many artists seem to be preoccupied with preparing the conditions for a new ecology of vision. Their efforts often result in a sort of compulsive repetition: details get enlarged, time paralyzed, space stretched. It's an enlightened perception, recalling a microscopic, scientific gaze or a hypersensitive stare generated by some synthetic drug. After all, mad scientists and rave kids might be distant relatives; they share the same passion for frozen instants and are both transfixed by the sex appeal of the inorganic.

293

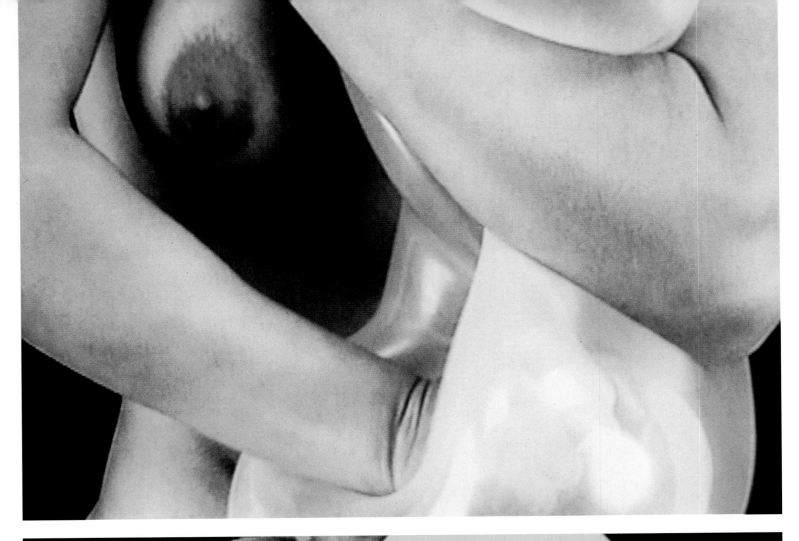

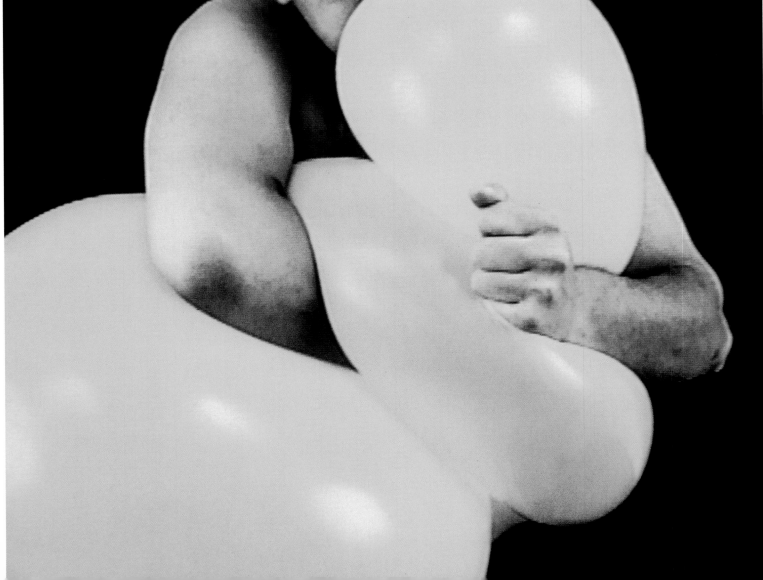

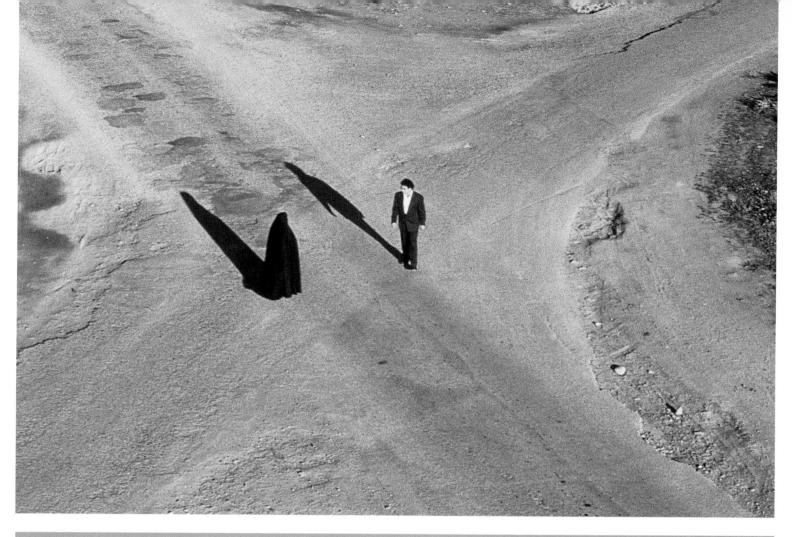

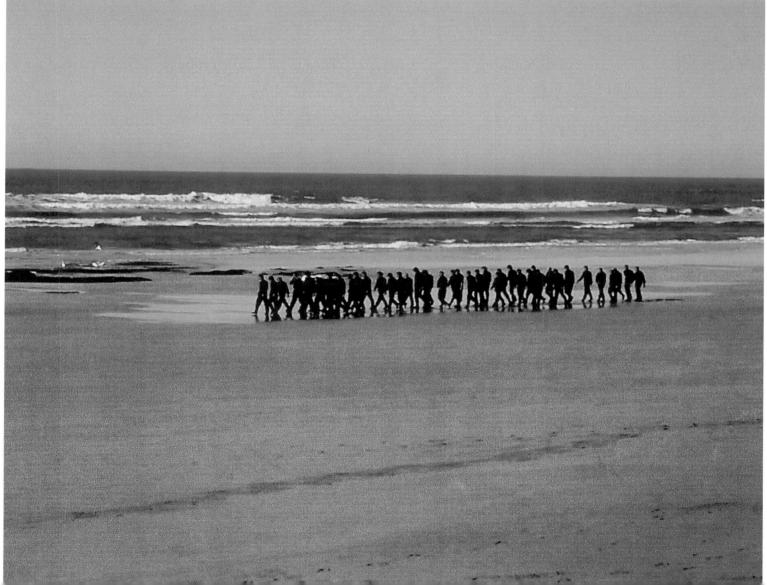

SHIRIN NESHAT
Born in Qazvin, Iran, 1957/Lives in New York

Fervor. 2000
2-channel black-and-white video
and sound installation
10 min.

Passage. 2001
Color video and sound installation, 35mm film
transferred to DVD
11 min. 30 sec.

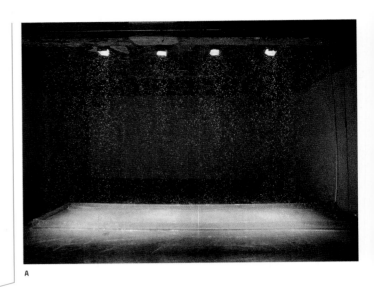

A

Whether enveloped in Olafur Eliasson's permanent storm, absorbed in Douglas Gordon's perpetual kiss, or hypnotized by Gabriel Orozco's still waterfall, we witness the ephemeral in the very moment that it becomes monumental. The peripheral slowly moves into the spotlight and turns into a drama made of nothing but pure emotions and amplified sensations. It's a form of spectacular realism, very peculiar to our times: an intense realism that relies on manipulation rather than representation. Our perceptions are transformed, while the world probably remains the same.

At other moments, the world jumps right out at you, an assault on your senses carried out with a sort of primitive roughness. That's what happens in Wolfgang Tillmans's photos and installations, and it's why they always have something tribal about them.

A Olafur Eliasson
Your Strange Certainty Still Kept. 1996
Water, light, plexiglass, plastic, recirculating pump, and wood
Dimensions vary
The Dakis Joannou Collection, Athens

Masters of the Universe. 1998–2000
Translucent resin, fiberglass, plastic, and human hair
137,1 x 68,5 x 78,7 cm/54 x 27 x 31 in.

NOBLE &
WEBSTER

Tim Noble: Born in Stroud, England, 1966/Lives in London; Sue Webster: Born in Leicester, England, 1967/Lives in London

Or the world can be completely absorbed, digested, and transformed into a dreamscape. Working on his Cremaster saga, Matthew Barney has lived in a kingdom of his own invention for almost ten years, without ever revealing all the secret rituals that control his private mythology. With very different sensibilities and intensities, artists such as Anna Gaskell, Mariko Mori, and Pipilotti Rist keep building complex alternative universes. A room of one's own is not enough—we now need a whole parallel reality.

Excessive Sensual Indulgence. 1997
Lightbulbs, UFO caps, Foamex, and sequencer
190 x 90 cm/74 3/4 x 35 3/8 in.

Masters of Puppets

Number of cinemas in the world: 60,126

Escapism is key to understanding contemporary art and culture. Ours is the age of cruel miracles: the Disneyfication of reality has apparently satisfied all our needs and appetites, but abundance kills desire. Trying not to die of indifference, we have reacted by continuously shortening our attention span, constantly moving our targets: throw the stick a little farther, run after it, driveling. Do it again.

Perfectly sated and yet always voraciously hungry, we live in a state of simultaneous overexcitement and placid passivity: a cultural bulimia or maybe just a prolonged adolescence. Like eternal teenagers, we are perennially undecided between satisfaction and frustration, between cheap tenderness and ultraviolence.

A

Paul McCarthy
Untitled (Jack). 2002
Red silicone rubber
60 x 60 x 46 cm/23 5/8 x 23 5/8 x 18 1/8 in.
The Dakis Joannou Collection, Athens

A

It's no wonder, then, that this age has produced an art made of dolls, marionettes, and robots—overgrown babies playing with giant toys, their proportions perfectly fit for our Pantagruelian hunger. Contemporary art depicts a world of carnival pleasures. But, as in any grotesque representation, the atmosphere of wild, uncontrolled happiness often hides much creepier undertones: it's an art of cartoons and loony characters, although the scripts seem to be adapted from some ancient funeral song. A memento mori runs through today's art, saying "Beware children, things are getting out of control. The party will be over soon."

Paul McCarthy is the bearded director of this circus of excess. Charles Ray is having tea with Alice, and they are probably both talking backward. Andreas Slominski is growing a pointy nose, wooden legs, and everything. Individually and according to his own personal history, each one seems to be tinkering with absurdity as a form of passive-aggressive resistance against a culture of hypertrophic enthusiasm and programmed apathy.

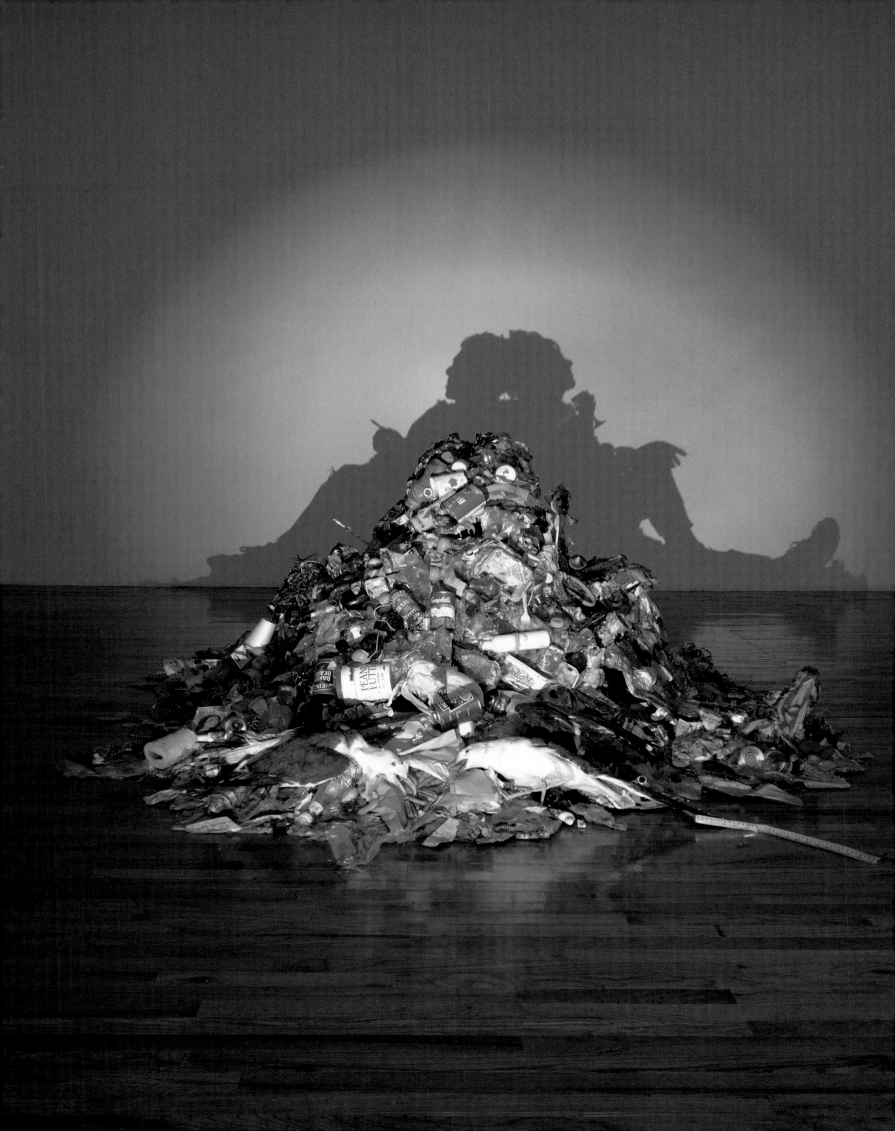

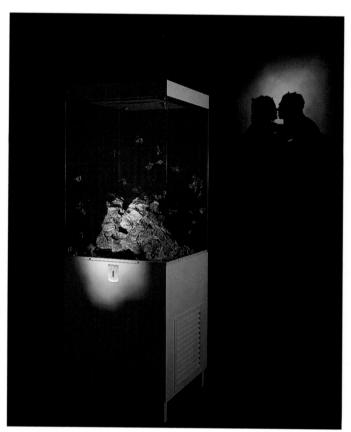

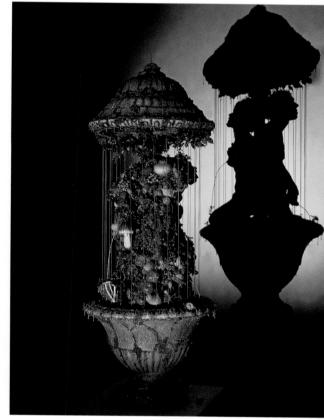

Made of Money. 2002
GBP 5 notes, GBP 10 notes, GBP 20 notes, GBP 50 notes, MDF, formica, Perspex,
3 electric fans, slot-machine mechanism, plastic tokens, and light projector
221 x 76,2 x 76,2 cm/87 x 30 x 30 in.

The Original Sinners. 2000
Artificial fruit, wood, moss and berries, plastic ornamental bowls, fishing wire,
cooking oil, pump mechanism, metal, MDF, and light projector
22 x 60 x 60 cm/8 5/8 x 23 5/8 x 23 5/8 in.

Simply Natural. 1999
Photographic montage on hair-dye boxes
2 boxes, 17 x 10 cm/6 11/16 x 3 15/16 in. each

London Swings. 1997
Poster montage
48 x 70 cm/18 7/8 x 27 1/2 in.

At the same time, a younger generation of artists in-cluding Verne Dawson and Urs Fischer has adopted a set of neoprimitive and often monstrous forms and references. Seen through their work, the world seems quite hallucinated, brutal-ly archaic, vaguely totemic: half preachers and half shamans, they give voice to a surreal spirituality, offering yet another way out of mediocrity.

Interiors

Number of times "evil" has been cited in State of the Union
addresses by George W. Bush: 5

If you can't escape, you might as well start digging, sink-ing deeper and deeper. There is still plenty to be discovered and brought up to the surface. After all, we are producing more trash now than in the whole history of humanity; both physically and metaphorically, we are immediately consigning our pres-ent to the past. In an age of planned obsolescence, wastes be-come of crucial importance. Not only do they threaten our daily lives with their massive presence, but they also capture the mirror image of our universe, reflecting the darker side of the affluent society.

He/She. 2003
Welded metal and light projector
He, 185 × 96 × 148 cm/72 7/8 × 37 7/8 × 58 1/4 in.
Dimensions vary

NOBLE ▶
WEBSTER

The art of today investigates the specters and shadows of our present by excavating the backyard of contemporary culture. Acting as both anthropologists and exorcists, artists chase the ghosts and eerie creatures that haunt middle-class houses. Often tinged with political connotations, this research unearths a diffuse sense of uneasiness, which seems to have spread through our culture like an infectious disease.

From Cady Noland's archaeology of the American dream to Robert Gober's frightening bedtime stories, our universe seems to unravel like a claustrophobic space of latent violence. Stimulating the nerve that connects our most private fears to collective catastrophes, Noland and Gober stage a world of paranoia and constant terror: their assemblages and rooms seem to be built on shaky ground, resting on piles of junk and dangerous secrets.

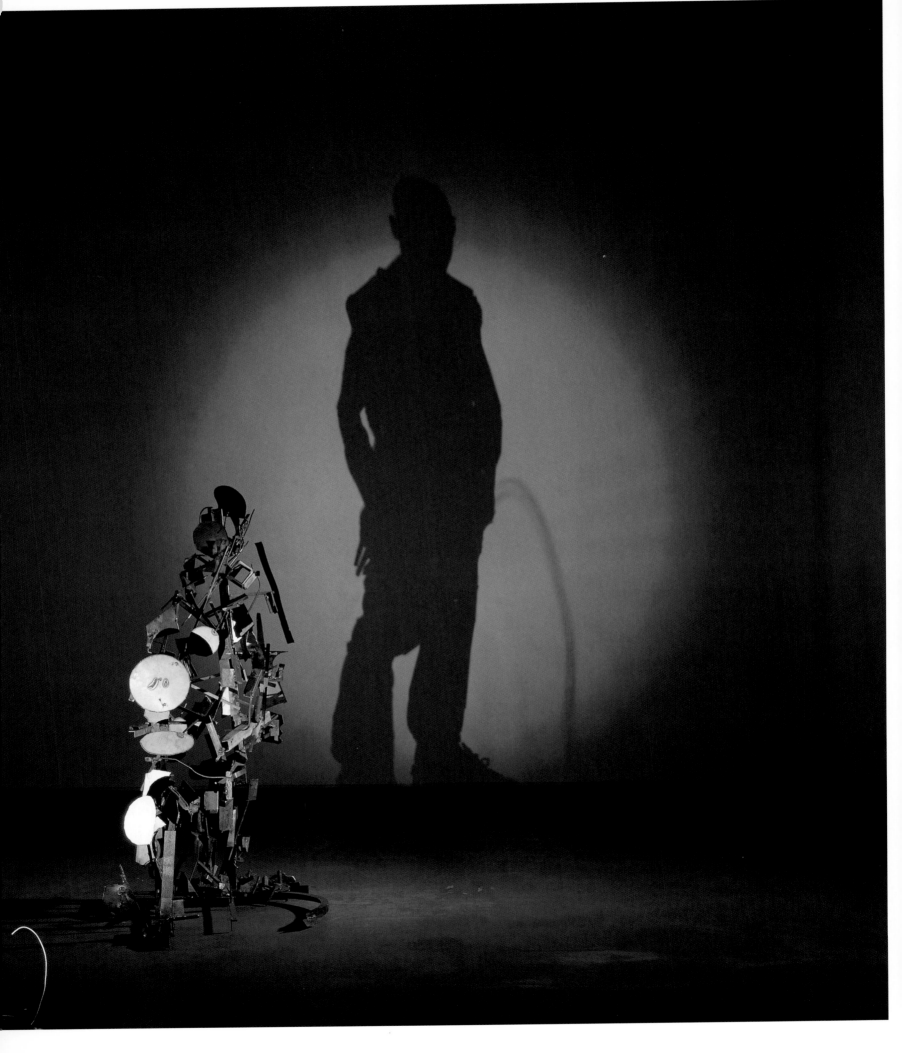

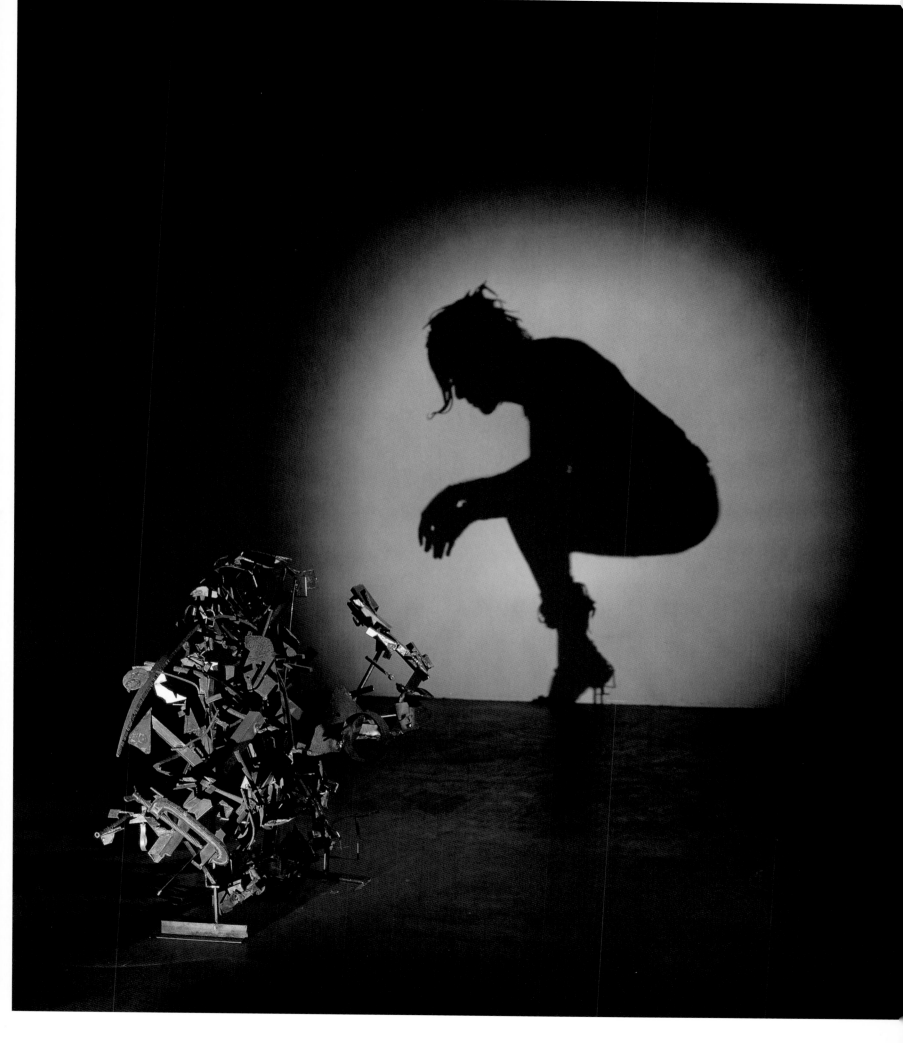

He/She. 2003
Welded metal and light projector
She, 114 × 100 × 186 cm/44 7/8 × 39 3/8 × 73 1/4 in.
Dimensions vary

A

A couple of generations younger, and therefore probably more desperate, Gregor Schneider has secluded himself in his own house, building a maze of corridors and dark rooms that resembles the convulsive architecture of our minds. Again there seems to be no way out, no apparent connection to the outside. And yet Schneider's house serves as a microcosm, a model of our own unstable universe.

The spectacle of uncertainty has also attracted Gregory Crewdson, whose photographs capture moments of paranormal suspension. He conjures another suburban still life, reflected on the screen of a TV set, where poltergeists and celebrities accidentally mix.

A
Gregor Schneider
Totes Haus ur, Gute Mutter. 2002
Mixed media
230 × 110 × 210 cm/90 1/2 × 43 1/4 × 82 5/8 in.
The Dakis Joannou Collection, Athens

Forever. 2001
FO caps, light bulbs, Foamex, and sequencer
4 x 226 x 7 cm/33 x 89 x 2 3/4 in.

'E$. 2001
acquered brass, 335 ice white turbo reflector caps,
ght bulbs, fittings, and electronic sequencer
48,6 x 294,6 x 25,4 cm/58 1/2 x 116 x 10 in.

I Love You. 2000
Foamex, aerosol paint, 298 bulbs, fittings, colored UFO
reflector caps, and electronic sequencer/transformer
160 x 180 x 8 cm/63 x 70 7/8 x 3 1/8 in.

Kill Your Idols

Number of Australians who listed "Jedi" as their
spiritual affiliation on the country's census: 70,509

Fame has become a religion. And just like any other religious group, our Cathodic church has produced its own rituals and martyrs, its own prophets and saints. Furthermore, we have constructed a mirage of democratic instant celebrity, opening the path of fame to potentially anyone. But no matter what we like to believe, we all know that access to visibility requires a fair amount of sacrifice: the fictional characters that artists as different as Barney, Cattelan, and Koons create through their work speak of carefully manipulated personalities and branded identities. It's more than just plastic surgery or makeup—it's as though something had happened deep down inside, at a genetic

Puny Undernourished Kid and Girlfriend from Hell. 2003
Kid, 40 multicolored neon sections and 4 transformers; *Girlfriend*, 42 multicolored neon sections and 5 transformers
Kid, 284 x 180 cm/111 3/4 x 70 7/8 in.; *Girlfriend*, 280 x 210 cm/110 1/4 x 82 5/8 in.

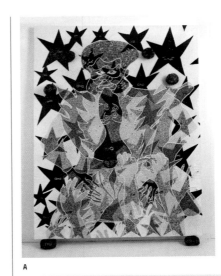

A

level. Their self-portraits often seem like empty simulacra, as though they had to surrender their humanity in order to reach out to a mass audience. And, what's more important, their personifications are always unstable, as if they were uncomfortably caught in their role: Barney's characters are constantly drifting, volatile, impossible to grasp; Cattelan's figures are systematically debased, both literally and metaphorically; and Koons's deities are too artificial to be trustworthy.

Other artists, such as Chris Ofili or Tim Noble and Sue Webster, are just as obsessed by do-it-yourself celebrity, and they are building altars of shining lights and glittery stars; but their small cathedrals are timidly balanced on heaps of trash and elephant dung. Ofili's superheroes and Noble and Webster's fetishes come out of a rock 'n' roll culture of broken dreams and self-destruction.

Drag. 1990
Metal poles, helmet, and found objects
Dimensions vary

CADY
NOLAND
Born in Washington, D.C., 1956/Lives in New York

Split between iconoclasm and iconophilia, contemporary artists seem trapped in a paradoxical exercise: in the very moment when they proclaim themselves divinities, they are already offering an antidote to their own authority. This systematic practice of doubt might be the most tragic revelation of today's art, but it is also its ultimate strength: trust no one, not even yourself.

The title of this essay is borrowed from a work by Olafur Eliasson, and the statistics from issues of *Harper's* magazine.

A
Chris Ofili
The Adoration of Captain Shit and the Legend of the Black Stars. 1997
Mixed media on canvas
244 × 183 × 13 cm/96 × 72 × 5 1/8 in.
The Dakis Joannou Collection, Athens

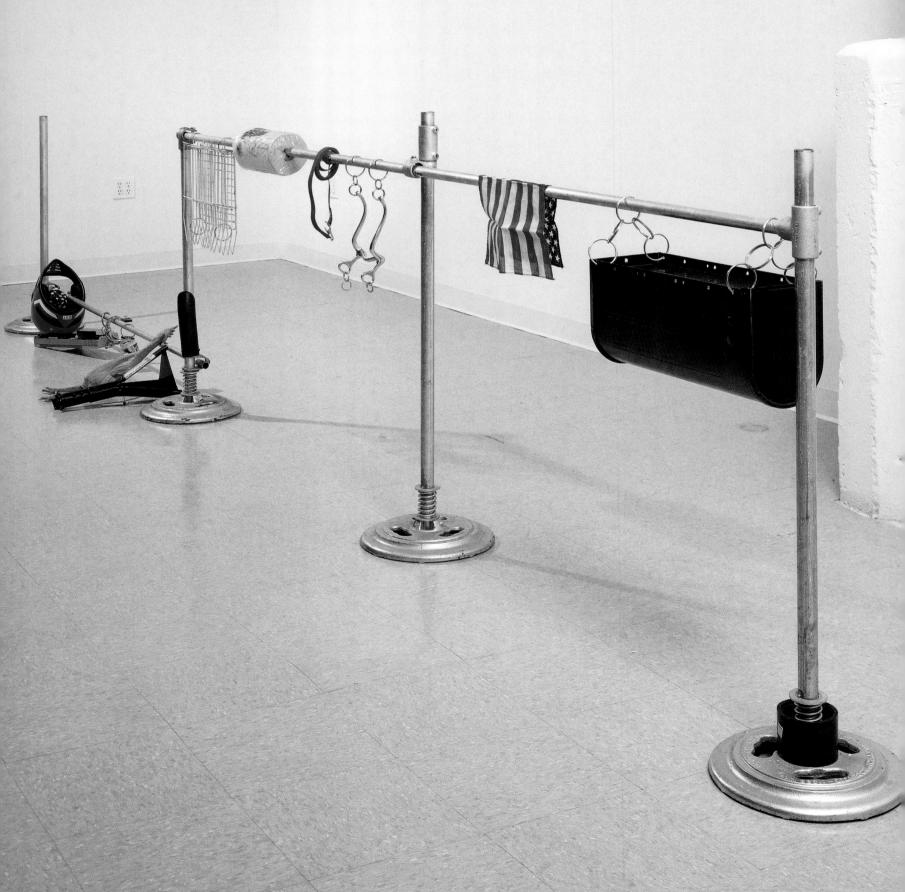

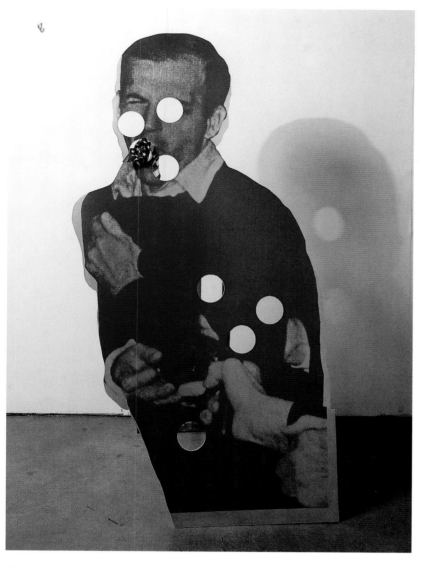

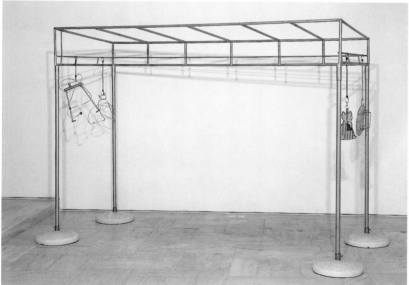

Bluewald. 1989
Screen print on aluminum and printed cotton flag
182,8 x 85 x 90,1 cm/72 x 33 1/2 x 35 1/2 in.

Awning Frame with Cat. 1990
Aluminum awning frame, metal poles, concrete pods, metal cat-shaped basket,
flag, bungee cords, barbecue rack, and metal mannequin
238,7 x 170,1 x 355,6 cm/94 x 67 x 140 in.

This Statement Is False

Dan Cameron

Most of the time, the inherent inability of language to convey whatever we want to express remains hidden to us. We are not usually aware, for example, that certain words do not exist in our native tongue until we come across foreign words that completely defy translation, at which point a hole opens up in our sense of certainty about language itself. How is it possible, we wonder, that particular feelings, impressions, or concepts exist within the realm of human experience, but only some groups of people are able to indicate them directly? This phenomenon is hardly limited to those stereotypical cases of exotic cultures, such as the rich vocabulary of words spoken by the Inuit people to identify various types of snow. In art terminology, the only way to refer to the German notion of a total artwork, *Gesamtkunstwerk*,

Pimping Ain't Easy. 1997
Oil paint, polyester resin, map pins,
paper collage, glitter, and elephant dung on linen
244 x 183 x 13 cm/96 x 72 x 5 1/8 in.

CHRIS ▶
OFILI
Born in Manchester, England, 1968/Lives in London

is by employing the word itself—there simply is no adequate English equivalent requiring less than a dozen words.

The paradox represented by the simple phrase "This statement is false" is in some ways an example of the opposite effect, in that it describes an area of logic where language itself literally breaks down. As opposed to a tautology, in which a self-evident characteristic is pointed to in an act of unnecessary linguistic redundancy, "This statement is false" represents a circumstance in which the meaning of the phrase seems quite clear, but the internal mechanics of logic proposed by the statement transform it into nonsense. In order for the declaration to be true, within the self-imposed limits of the four words, it would have to be false, which would in turn make it true, and so on, with the internal contradiction vanishing in an endless spiral of meaninglessness.

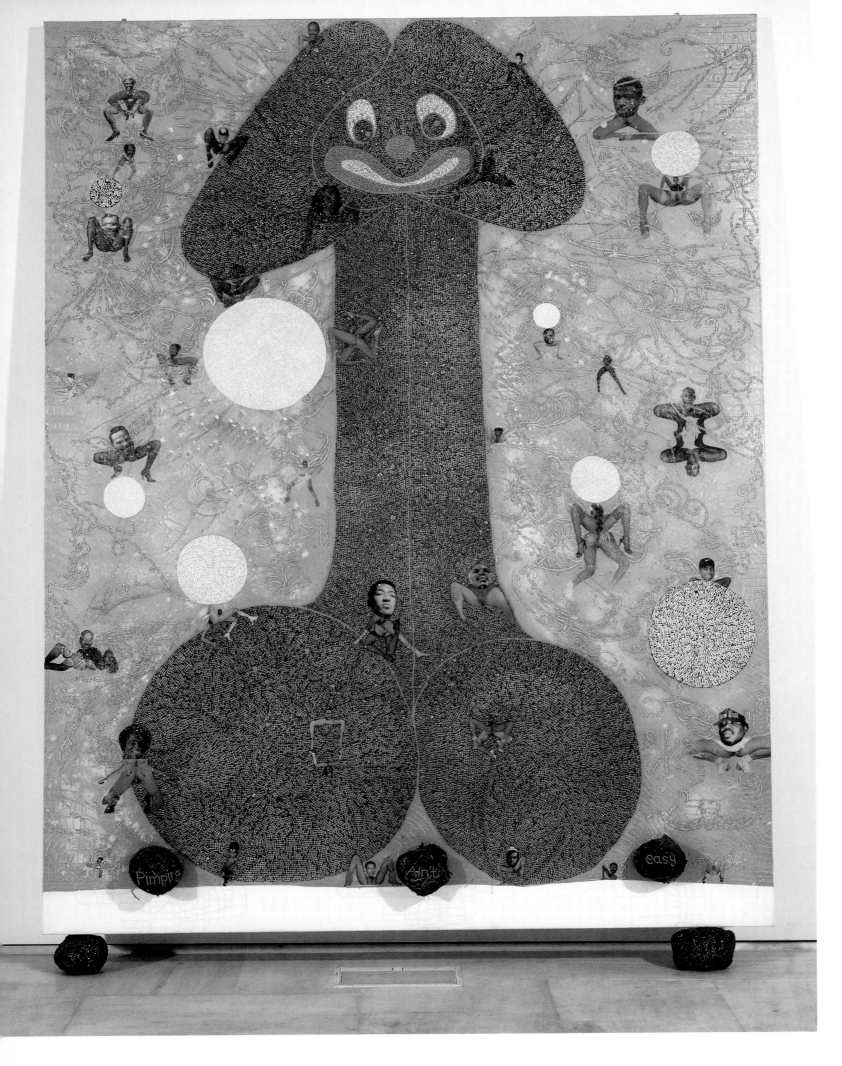

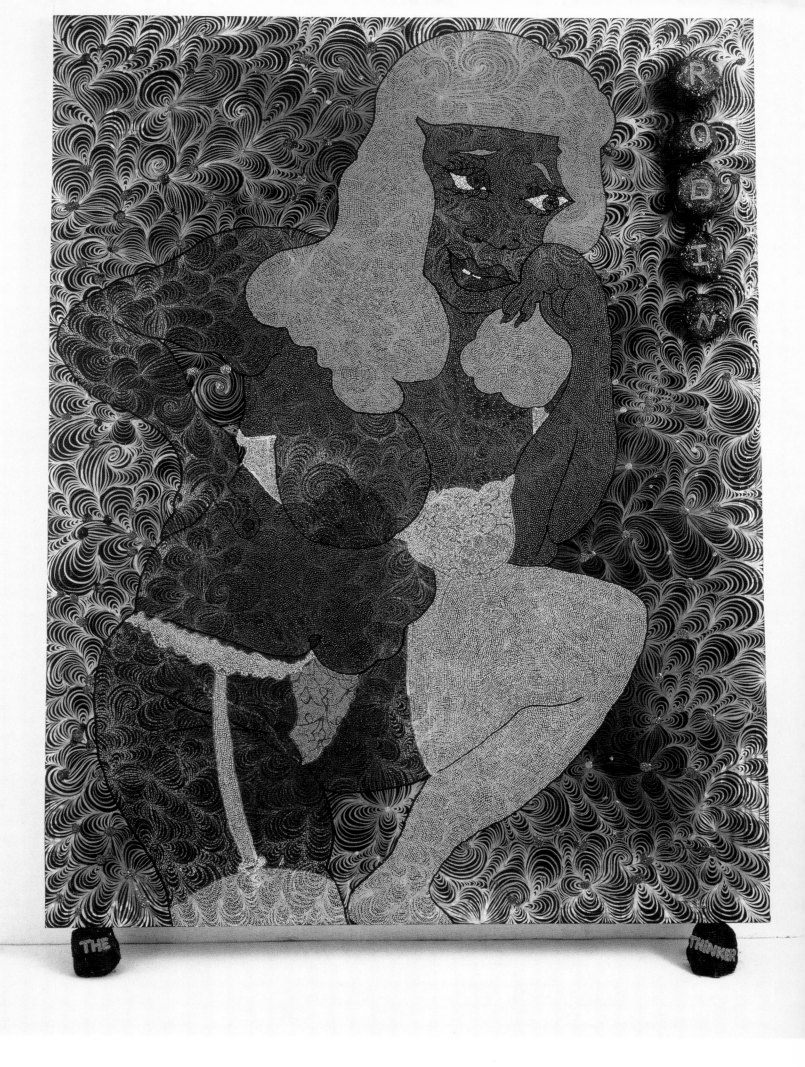

Rodin...The Thinker. 1997
Acrylic paint, oil paint, polyester resin, glitter,
map pins, and elephant dung on canvas
244 x 183 x 13 cm/96 x 72 x 5 1/8 in.

Of course, language is full of such blind spots and sink-holes, largely because of the fact that a word can almost never mean exactly the same as the thing that it refers to, a self-evident point that nevertheless has provided fuel to numerous tomes on both linguistics and logic. At best, we can hope for an approximation of the meaning, or more likely an agreement that even though the word "apple" can signify so much more than the specific apple lying on the table in front of me, we all subscribe to certain conventions of linguistic meaning that enable us to say things, or to read and write them, and agree that we all seem to understand what they mean. The only time that our attention is drawn to such lapses is when a case arises in which the limits of language fall glaringly short of their target, or when words struggle to mean something but end up meaning nothing at all.

The fact that spoken and written language contain these sorts of internal contradictions becomes pertinent once these systems are put into play in order to discuss visual art, which occupies a completely different realm of experience. Works of

**The Adoration of Captain Shit and
the Legend of the Black Stars.** 1997
Mixed media on canvas
244 x 183 x 13 cm/96 x 72 x 5 1/8 in.

CHRIS ▶
OFILI

art do not mean things other than themselves, or at least not in
the same sense that words do. A painting or a sculpture is not
a representation of an idea, although it is fair to argue that art-
works do fall into the category of symbolic events—that is, they
have an importance that supersedes the limits of the materials
from which they are made, and even surpasses their function as
images. A painting not only means more than the canvas, paint,
and support that go into its creation, but it also means more
than what the painting might or might not represent in purely
visual terms. The way that a painting means something is via
cultural conventions that rely on a somewhat specialized knowl-
edge of the history of the medium, its schools and great prac-
titioners, and, most important, what other kinds of paintings
were being made at the time of the painting in question.

In this context, the statement that works of art repre-
sent only themselves is also intended as an assertion that
their meanings are completely imbedded in the specific histori-
cal-cultural context in which the works came into being, and
that the use of written and spoken language to extricate these

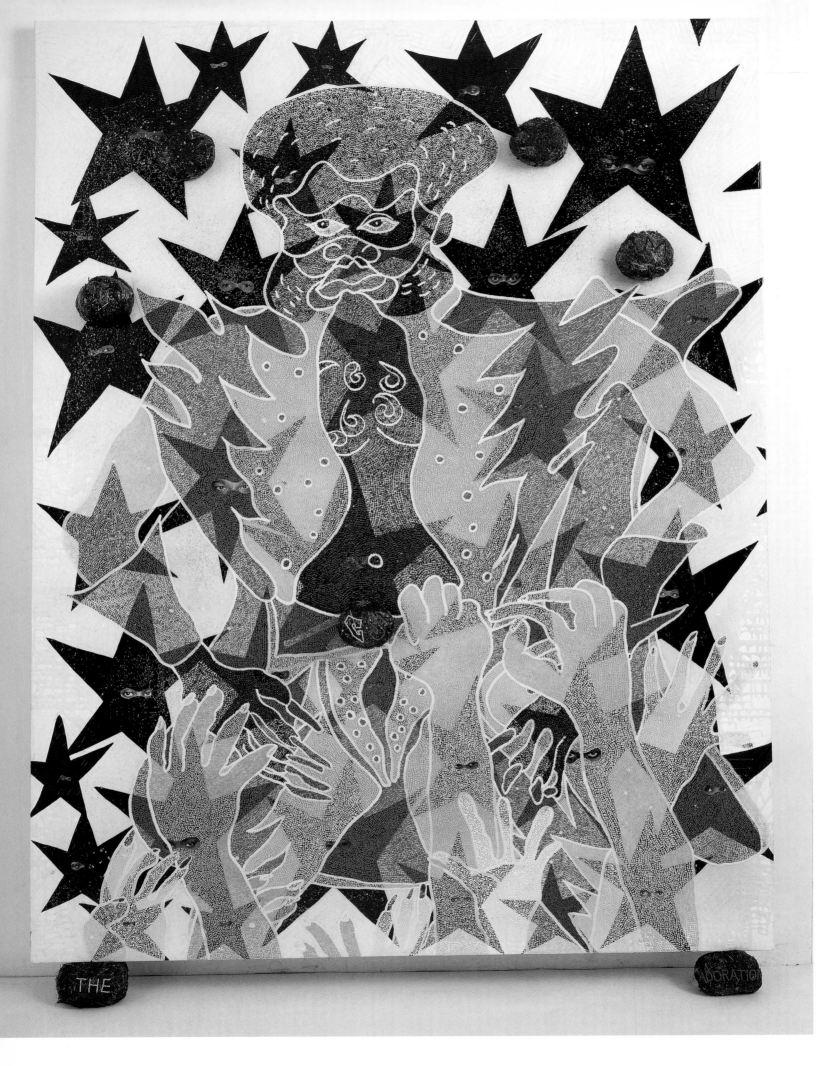

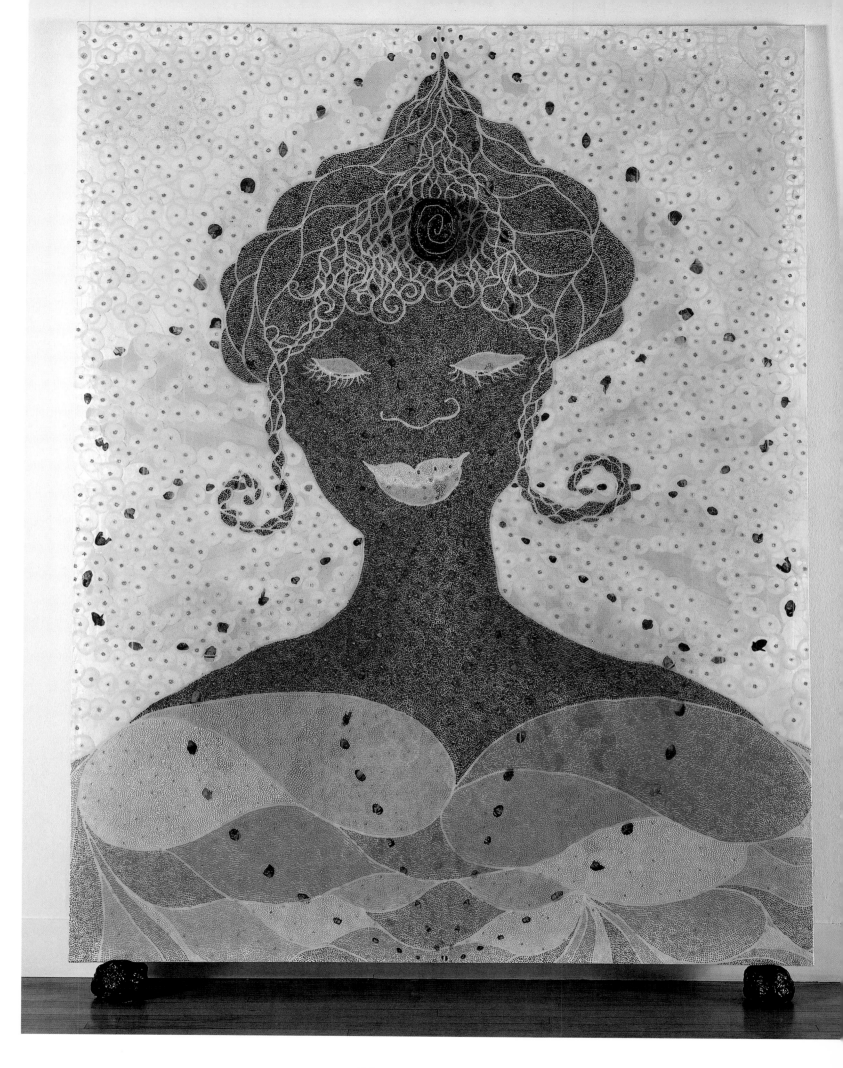

Inner Visions. 1998
Acrylic paint, oil paint, polyester resin, glitter, collage,
map pins, and elephant dung on canvas
244 x 183 cm/96 x 72 in.

meanings is similarly conditioned by place, time, and circum-
stance. Most of this is, of course, self-evident, but what is less
so is the degree to which works made in the postmodern era—
that is, roughly from the late 1970s to the present—have used
the premise of conditional meaning to build their own frame-
works of historic and stylistic reference to reflect the highly
problematic function of cultural meaning in the current moment.
Speaking generally, meanings seem more conditional, less ab-
solute, than at any comparable time in the recent past, and
this state of conditionality appears to be accelerating, instead
of resolving itself toward greater clarity and substantiality. The
artworks of our time are, therefore, entirely suited to it, insofar
as they highlight this state of contingency, of meanings that are
piled on top of other meanings, but without a foundation to bind
them together or to deeper cultural truths.

Afronirvana. 2002
Acrylic paint, oil paint, polyester resin, glitter, map pins,
and elephant dung on linen with two elephant dung supports
274 x 365 cm/107 7/8 x 143 3/4 in.

CHRIS ▶
OFILI

"This statement is false" can, from this standpoint, be understood in an entirely different way: as an anti-logical proposition that also happens to accurately reflect the ways in which visual artists today incorporate the possibility of meaning into their work. Of course, it might be equally plausible to propose that such a principle be applied almost equally to every manifestation of cultural production at the present moment, but an allowance should be made here for the principle of relative degrees—some artworks may simply be clearer than others in the way they embody the idea of internal contradiction. To clarify this point, it is helpful to examine several works of art that specifically address the ways in which internal contradiction, rather than being a limitation to the ways in which artistic meaning is communicated, has become a kind of talisman of our time, pointing to different strategies by which art can continue to express vital truths about culture long after the point when the principle of truth itself has ceased to have any mutually agreed upon clarity of function.

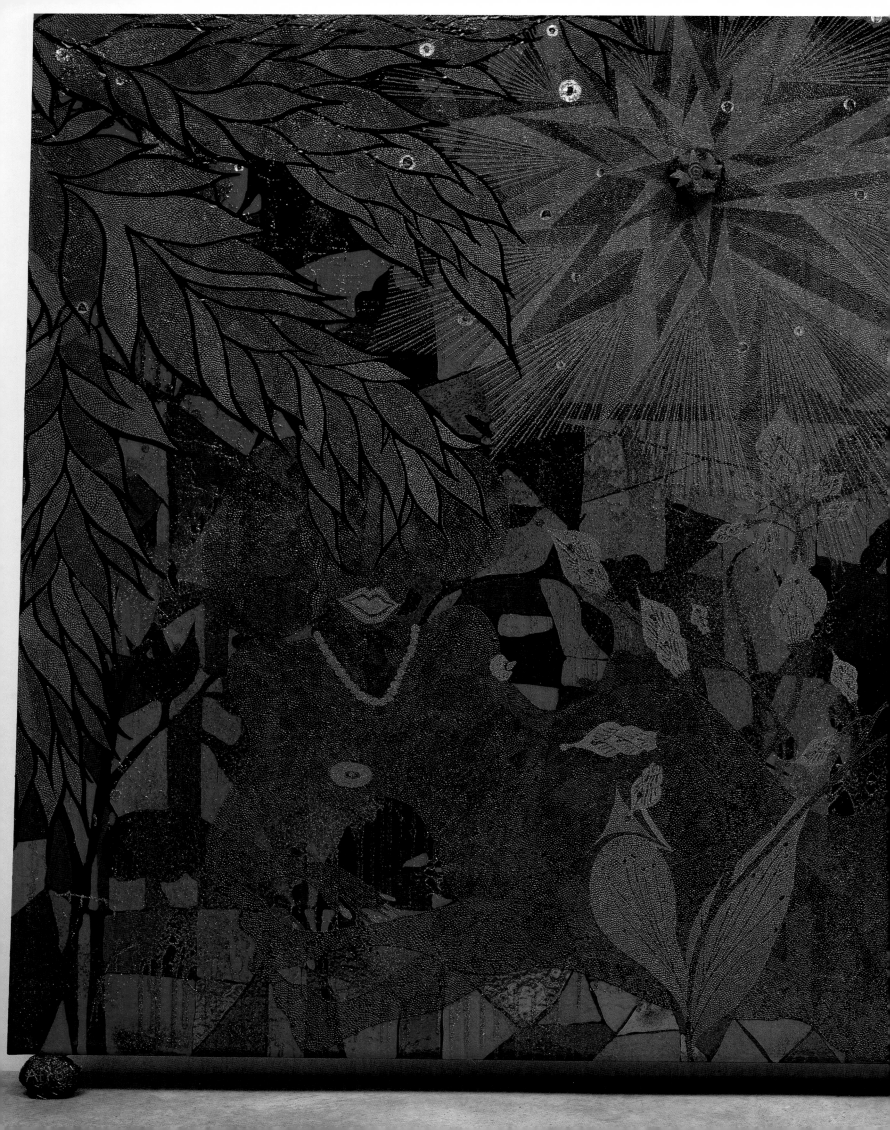

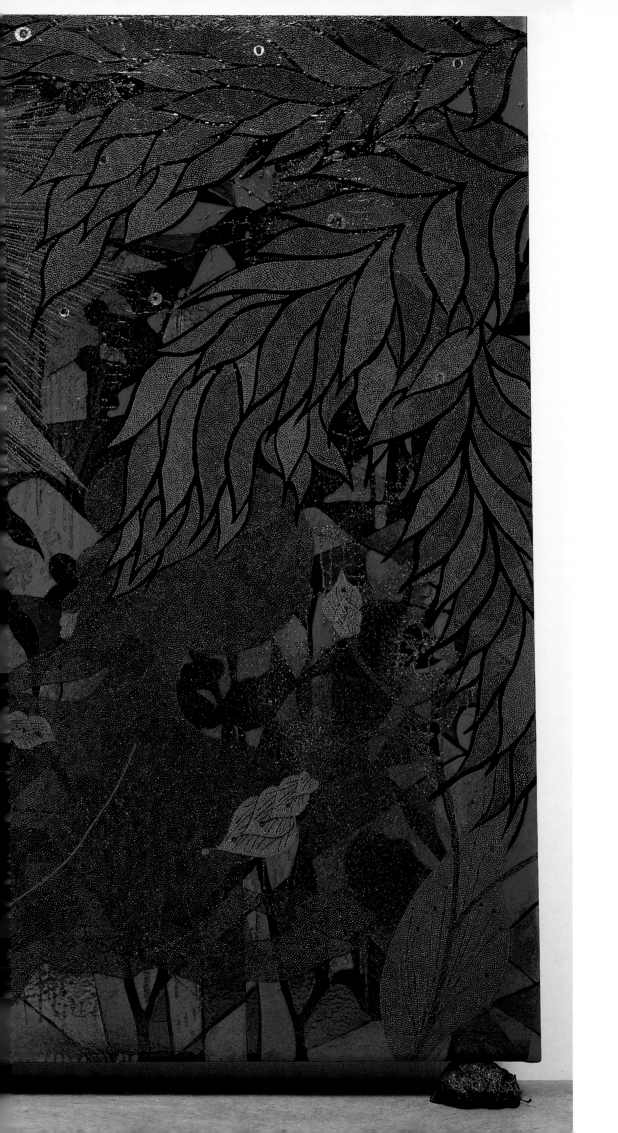

The 1980s was the first decade in which a crisis of meaning became part of the everyday vocabulary of artistic expression, a point that is probably best summed up by the use of the prefix "post" to designate every significant development in artistic style during that ten-year period. Taken by itself, "post" suggests that the era of original movements has come to an end, and that all that is left for artists to do is plunder the remains of past epochs and styles, and construct simulated versions of genuine developments as a kind of echo of the possibility of authentic meaning. Throughout the 1980s, in fact, one of the most frequently used words in critical discourse was "simulacrum," which had been derived from the writings of the philosopher Jean Baudrillard to denote a sign that continues to be used long after its inherent connection to a primordial source of meaning has been eroded. At this moment, the work of such artists as Ashley Bickerton, Peter Halley, Jeff Koons, Sherrie Levine, and Cindy Sherman came to represent a form of histori-

A Jeff Koons
Pancakes. 2001
Oil paint on canvas
274,3 x 213,4 cm/108 x 84 in.
The Dakis Joannou Collection, Athens

B Cindy Sherman
Untitled #113. 1982
Color photograph
127,6 x 85,1 cm/50 1/4 x 33 1/2 in.
The Dakis Joannou Collection, Athens

B

cal passage, from a collective quest for authenticity to an embrace of the limitations of a society that seemed bent on transforming the most vital cultural expressions into commodified versions of the self's desire for narcissistic gratification.

Sherman and Levine, whose photographs ushered in the age of appropriation by making their artistic debt to preexisting stylistic and formal norms the most apparent aspect of their techniques, represent a kind of bridge from the era of late conceptual art to the epoch of "post." In Sherman's case, the principle of cinematic glamour, which in many ways served as the antithesis of the high artistic ideals of the 1970s, was recycled as part of a do-it-yourself methodology in which makeshift props and costumes were put in the service of a vision that managed to convey the essence of the Hollywood "original" without ever needing to convince her viewers of the illusion she was echoing. The mere act of making the reference was, for Sherman, a liberation from the avant-garde's overweening mandate of originality. When considering her work from the late 1970s through the mid-1980s, we are never sure whether

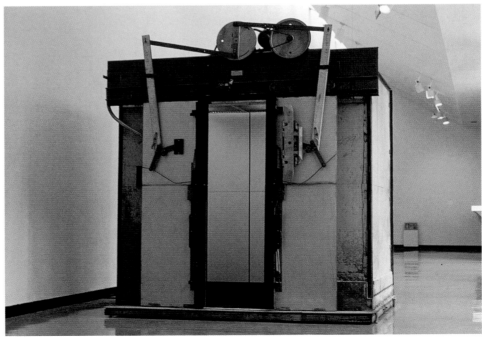

RICHARD PRINCE
Born in Panama Canal Zone, 1949/Lives in New York

Untitled (King Kong). 1985–86
Ektachrome print
218,4 x 119,3 cm/86 x 47 in.

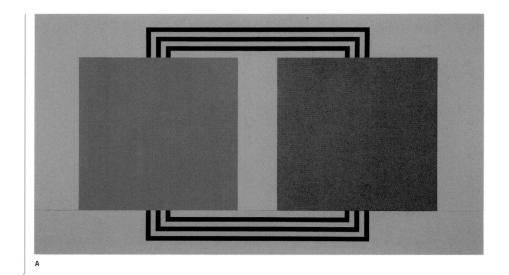

A

she wished to fool her viewers, and in this ambiguity the work achieves its power. For Levine, the act of appropriation was more directly tied to specific artistic predecessors—the photographs of Walker Evans or the paintings of Joan Miró. Taking the coffee-table art book as her starting point, Levine created photographs or watercolors from the reproductions as if they were originals, so that each resulting "original," while also a copy, nevertheless aspired to restore something of the aura of the handmade to an industrially printed, photomechanically produced residue.

Halley's Day-Glo, synthetic stucco-textured paintings, which came into prominence around 1985, can be credited with having achieved the most obvious and successful translation of the postmodern predicament into the plastic vocabulary of a painter's tools and techniques. Transforming the language of geometric abstraction into a new mode of representation, Halley described the brightly colored squares in his paintings as "cells," with specific reference to modern architectural spaces. In so doing, he invited his viewers to discard

Fall '91. 1992
Mixed media
243,8 x 66 x 91,4 cm/96 x 26 x 36 in.

CHARLES ▶
RAY
Born in Chicago, 1953/Lives in Los Angeles

any allegiance to the modernist custom of seeing abstraction in transcendental terms, and thereby helped expand the field of visual reference beyond its previous limits as either "abstract" or "representational."

Similarly, Bickerton, whose work was also first shown in the mid-1980s, used a mode of extreme self-conscious reference to constantly remind his viewers that what they were observing was not an object with its own absolute identity, but a cog within a highly conditional system of references. Utilizing, for example, his own signature and the artwork's date, the structure of the picture's support and surface, and certain assumptions about the wall the painting would hang on as key referents in the picture's range of motifs, he created works that were extreme reiterations of the terms by which they existed within the world. Although in the past decade Bickerton has gradually developed a more conventional framework for present-

A
Peter Halley
Two Cells with Circulating Conduits. 1987
Day-Glo fluorescent pigment and acrylic paint on Roll-a-tex canvas
196,2 x 350,5 x 8,2 cm/77 1/4 x 138 x 3 1/4 in.
The Dakis Joannou Collection, Athens

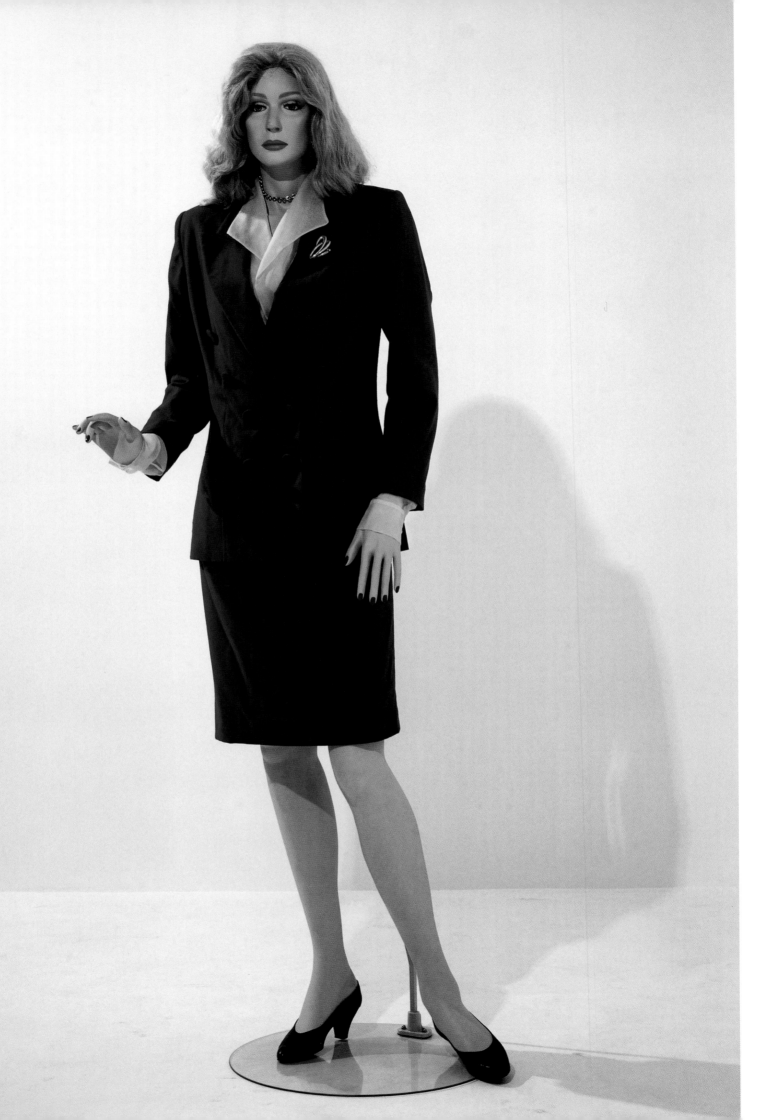

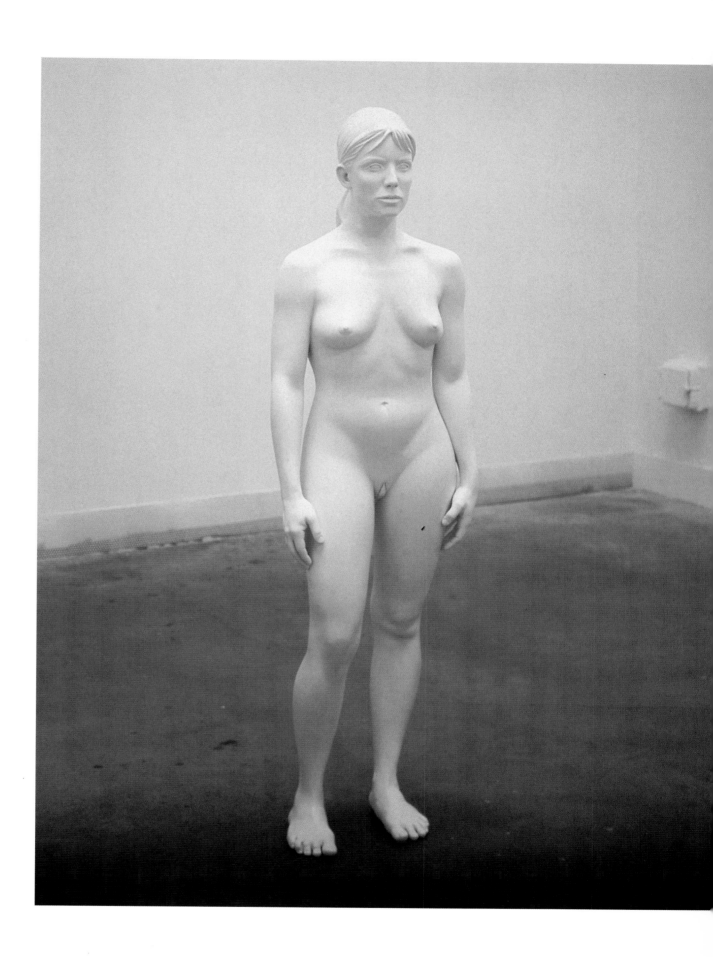

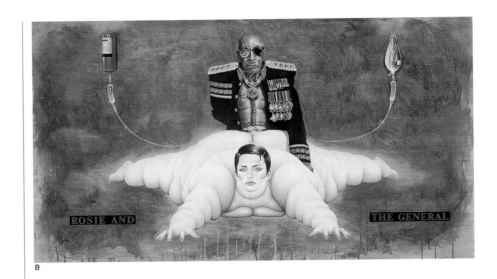

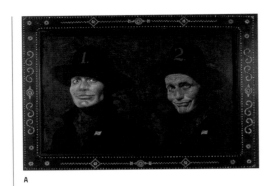

ing his paintings, he has also imbued them with a more drastic narrative and representational program, embracing science fiction, history, and his own life story as a means of questioning the role of the artist within society. For example, *Rosie and the General* (1996) and *Double Self: The Patriots* (2002), with their vivid depictions of a violent sado-anthropological cosmology, simultaneously repel the viewers' attention while keeping them engrossed in the artist's complex system of symbols and actions.

Although it requires the space of a decade to link Bickerton's early efforts with the recent paintings of Fred Tomaselli, the two artists are actually much closer in both age and sensibility than their positions within two distinct generations might

A
Ashley Bickerton
Double Self: The Patriots. 2002
Acrylic paint on paper with wood frame and mother-of-pearl inlay
81,2 x 111,1 cm/32 x 43 3/4 in.
The Dakis Joannou Collection, Athens

B
Ashley Bickerton
Rosie and the General. 1996
Oil paint, acrylic paint, and pencil on wood
122,2 x 209,5 cm/48 1/8 x 82 1/2 in.
The Dakis Joannou Collection, Athens

C
Fred Tomaselli
Gravity in Four Directions. 2001
Leaves, pills, photocopies, acrylic paint, and resin on wood
183 x 183 cm/72 x 72 in.
The Dakis Joannou Collection, Athens

Blauer Liebesbrief. 1992–98
1 projection, 1 player, 1 audio system, and painted wall
Dimensions vary

**PIPILOTTI ▶
RIST**

Born in Rheintal, Switzerland, 1962/Lives in Los Angeles

C

suggest. Tomaselli began showing his cosmic abstractions—
many of which he produced by adhering large quantities of pills
and marijuana leaves to the work's surface—in the late 1980s,
at a moment when the resurgence of new forms of abstraction
suggested a reading of his paintings that emphasized the role
of artificial stimulation and the ubiquitous presence of the phar-
maceuticals industry in mainstream American culture. The fact
that Tomaselli's work did not reach a broader art-world audience
until a few years later, however, meant that those aspects of
his art which most attracted critical notice were ones that con-
nect his vision to the cosmic quest of the 1960s counterculture.
Indeed, as Tomaselli has expanded his technique and scale over
the past ten years to embrace an even more discernibly cosmic
perspective, he has also become associated with the desire on
the part of a younger generation of artists to integrate their vi-
sions with current developments in music, film, and more inter-
disciplinary modes of creative communication.

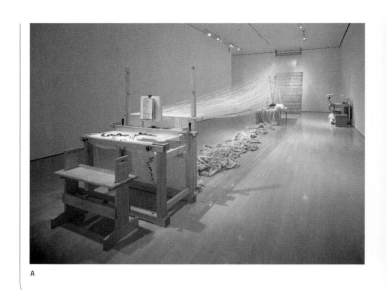

A

Beginning in the early 1990s, with the gradual shift away from an aesthetics based on the parameters of the art market and toward the function of art within a broader cultural spectrum of activity, a number of artists gained public attention through pieces that incorporated a complex range of viewpoints that sought to reposition the artist in the larger world. For many artists, Janine Antoni and Mona Hatoum among them, developing a body of work using performance as a starting point became a way of linking the history of post-object art to the quite different requirements of the decade following the very public crash of the art market at the end of the 1980s. In her early performance works, such as *Loving Care* (1992), Antoni set out to bring together issues of beauty and endurance. She later produced highly ambitious installations such as *Slumber* (1994), in which the initial desire to create art while asleep led to a com-

The Fast Set. 2000
Mixed-media installation
Dimensions vary

MATTHEW
RITCHIE ▶
Born in London, 1964/Lives in New York

341

B

C

plex system by which her brain waves were measured while she slept and were then woven into a blanket by the artist upon awaking. Later examples, such as *Mom and Dad* (1994) and *Saddle* (2000), are more explicitly addressed to the contradictions inherent in her role as an autonomous artistic creator, and the more intricate, private experience of her life as an organic process that is interconnected with those of her family and friends.

Hatoum, whose background as part of the Palestinian diaspora figures strongly in her choice of subject matter, began her artistic career in London in the late 1980s, creating performances and videos that dramatized her feeling of being an outsider displaced from her home and forcibly separated from her family. The often misunderstood place of Islamic culture in the contemporary Western world has enabled Hatoum to construct elaborate metaphors in her work by inviting viewers to place themselves in a similar outsider position. Dehumanization occurs in many forms today, and the devalued political position of the Palestinian intelligentsia can also be interpreted as simply the latest chapter in a millennia-old process by which more

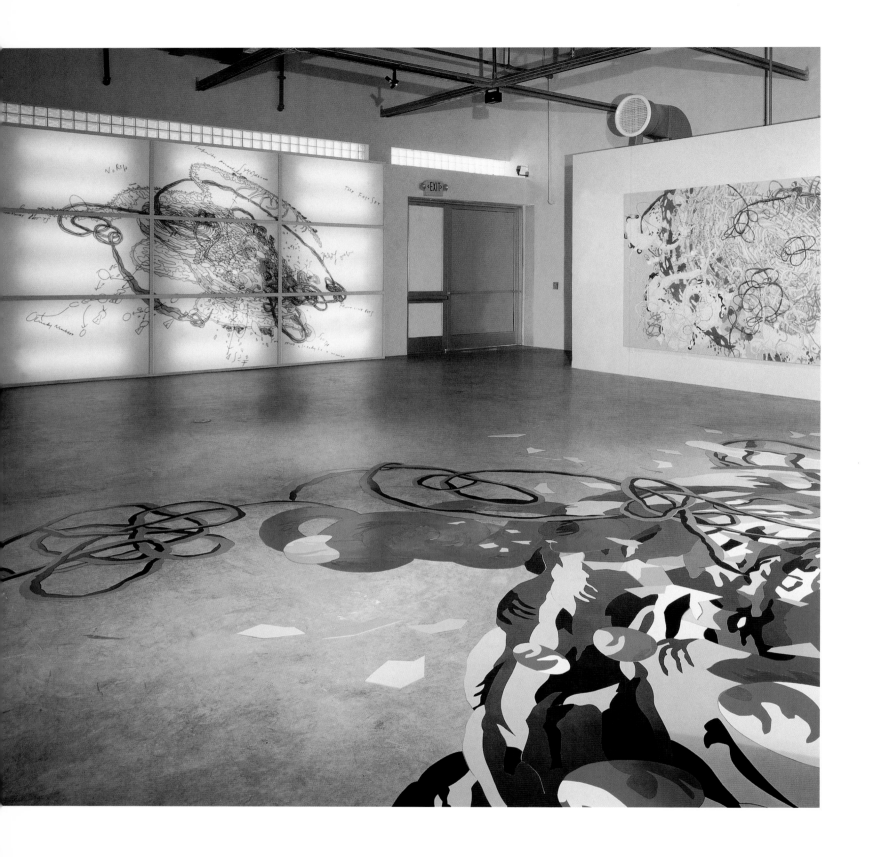

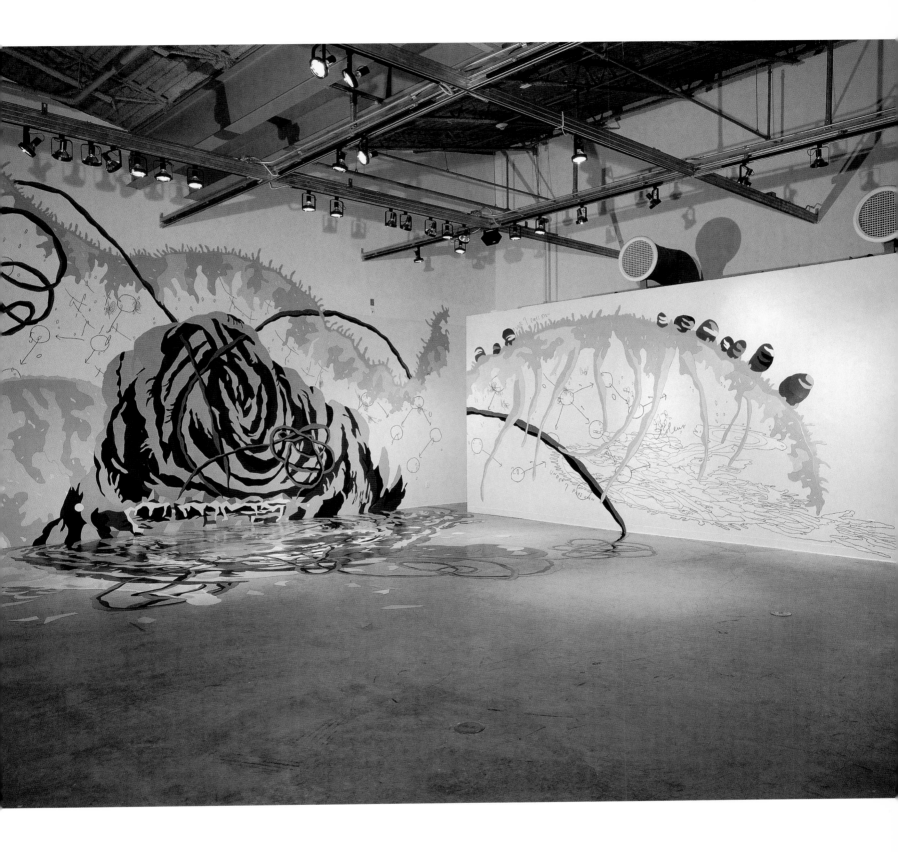

powerful forces attempt to undercut the legitimacy of those whom it is trying to disenfranchise. *Entrails Carpet* (1995), a rubberized version of a Middle Eastern rug, would never be mistaken for one that is used for prayer, since its undulating composition and pearlescent surface refer specifically to the shape and consistency of human intestines. Although on one level Hatoum intends to remind us of the unique human entity who might deploy a more conventional rug as part of a ritual of worship, she also tempts us to imagine that the barrier separating us from the work's human subject is not one of religion or ethnicity, but rather of simple biological difference. In the end, she succeeds in converting the pseudo-anthropological category of "other"—which is often wielded by those who fear the emancipation of the weak—into an unsubstantiated fiction supported mostly by prejudice and fear on the part of those who have long since taken freedom for granted.

Two Boeing 767s. 2001
Foamcore, hot glue, Uniball micro pen, plywood,
white-out, and clear tape
Each airplane, 185 x 193 x 23 cm/72 7/8 x 76 x 9 in.

TOM ▶
SACHS.
Born in New York, 1966/Lives in New York

For many artists whose work first came to public attention in the mid- to late 1990s, identity is not a category that can be easily condensed into a straightforward declaration of either genetics or geography. William Kentridge, a South African whose parents are both of northern European extraction, grew up in a prominent, well-to-do family in which opposition to apartheid was an important badge of distinction. Trained in both visual art and theater, he gradually turned his attention to film, specifi-cally a form of handmade animation in which he is able to freely improvise on the lives and situations of a small handful of his countrymen, most of whom occupy a state of willful oblivious-ness to the fundamental transformations gripping their country. While he does not consider himself a political artist, Kentridge has specialized in works like the film *Echo* (1998), in which an underlying state of crisis infiltrates the texture and substance of its inhabitants' worlds, right down to their subconscious. An avowed humanist, Kentridge envisions all substantive change as originating in the minutiae of daily life, so that a total meta-morphosis such as that undergone by his country since the end of apartheid in 1994 occurs not so much as an abrupt and

Presidential Seal. 2003
Synthetic polymer on plywood, hot glue, and metal stars
153 cm/60 1/4 in. diameter

American Flag. 2003
Construction barrier and hardware
65,6 x 61 cm/25 7/8 x 24 in.

A

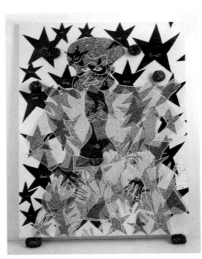

B

drastic shift, but as the accumulation of numerous tiny developments, many of which take place just outside the limits of the average person's consciousness.

Chris Ofili, who is British of Nigerian descent, first received attention for a style of drawing that utilized obsessively repetitive patterns that also incorporated images of black life that are more closely connected to the Black Power movement of the 1960s and 1970s than to the mainstream of Afro-British culture of the more recent past. Taking an almost phantasmagoric approach to the depiction of African identity, Ofili turned to painting in the late 1990s, using rich washes of vibrant color, collage fragments from magazines, and built-up layers of pointillist dots to assemble sensuous, larger-than-life renderings of quasi-comical black subjects. Bearing pseudo-lurid titles like *Pimping Ain't Easy* and *The Adoration of Captain Shit and the Legend of the Black Stars* (both 1997), Ofili's canvases reflect an eagerness to embrace the mythic imaginativeness of black popular culture while adding to a vocabulary of painterly invention that owes as much to color-based abstraction as to any discernible

Théâtre des Amis. 1989
Acrylic paint, oil paint, canvas, fabric, and 3 wood chairs
288,2 × 478,1 × 101,6 cm/113 1/2 × 188 1/4 × 40 in.

DAVID ▶
SALLE
Born in Norman, Oklahoma, 1952/Lives in Bridgehampton and New York

canon of figure-based painting. One of Ofili's best-known inno-
vations is his use of balls of dried elephant dung as makeshift
bases on which to prop his pictures or to secure them as they
lean against the wall, and/or to adorn the surfaces of the work,
both a kind of backhanded reference to the complex position of
African identity within his practice.

Yinka Shonibare, also British with first-generation fam-
ily ties to Nigeria, has developed his creative approach in close
dialogue with the history of African colonization and its residual
presence in an increasingly postcolonial society. Although he
has made paintings, Shonibare is best known for his sculptural
tableaus, which employ as a starting point the implicit clash of
cultural identities between late-empire Britain and the former
European colonies of West Africa. Shonibare's installations of-
ten take the form of mannequin-like groupings of headless hu-
man figures, dressed in brightly patterned fabrics that are best

A Chris Ofili
 Pimping Ain't Easy. 1997
 Oil paint, polyester resin, map pins, paper collage, glitter, and elephant
 dung on linen
 244 × 183 × 13 cm/96 × 72 × 5 1/8 in.
 The Dakis Joannou Collection, Athens

B Chris Ofili
 The Adoration of Captain Shit and the Legend of the Black Stars. 1997
 Mixed media on canvas
 244 × 183 × 13 cm/96 × 72 × 5 1/8 in.
 The Dakis Joannou Collection, Athens

known as products of the Senegalese batik industry but were in fact imported to Africa in the eighteenth century by Dutch traders hoping to find a market for inexpensive cotton cloth bought in Indonesia. This inadvertent mix-up of cultural references is intensified in such works as *Dressing Down* (1997), which illustrates the ambiguity generated when these hybrid motifs adorn figurative sculptures whose posture and cut of clothing explicitly indicate a Victorian sensibility, at the same time that the artist's sharp refusal to specify facial features or skin pigmentation leads viewers to question whether any precise ascription of racial or cultural identity is necessary or even meaningful in such a situation and, by extension, today in general.

Totes Haus ur, Gute Mutter. 2002
Mixed media
230 x 110 x 210 cm/90 1/2 x 43 1/4 x 82 5/8 in.

GREGOR ▶
SCHNEIDER
Born in Rheydt, Germany, 1969/Lives in Mönchengladbach, Germany

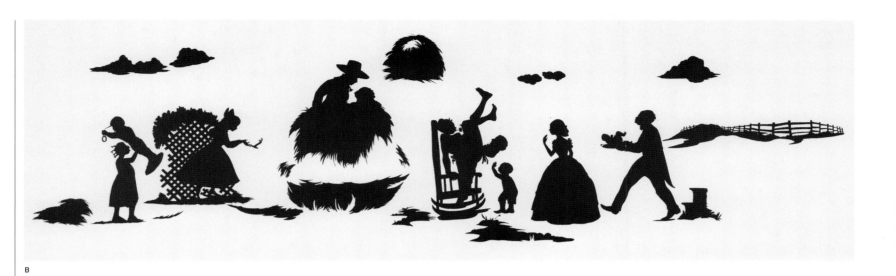

B

Because of the history of violent struggle for emancipation and equal rights in the United States, issues of racial and ethnic identity are often more starkly played out in the work of American artists than in that of their European counterparts. The drawings and cut-out silhouettes of Kara Walker, in which comic depictions of violence, rape, miscegenation, and incest are woven into cliched depictions of life in the agrarian South, are a perfect case in point. Walker gained prominence early in her career, and this quick rise was met with vociferous protests, usually from older African-American artists, who saw in her work a refutation of the ideals of dignity and self-respect that their own life struggles had so keenly emphasized. For Walker, however, the works, in which the horrific and the preposterous freely intermingle, the decision to play free and fast with historical tropes was not necessarily the result of any personal misgivings about the validity of that history so much as a dramatic assertion that each generation must be permitted to construct the historical perspectives that suit its specific needs. In such evocative and ambitious pieces as the wall-scale *Being the True Account...*(1996), which incorporates dozens of figures in a panoramic fantasy about

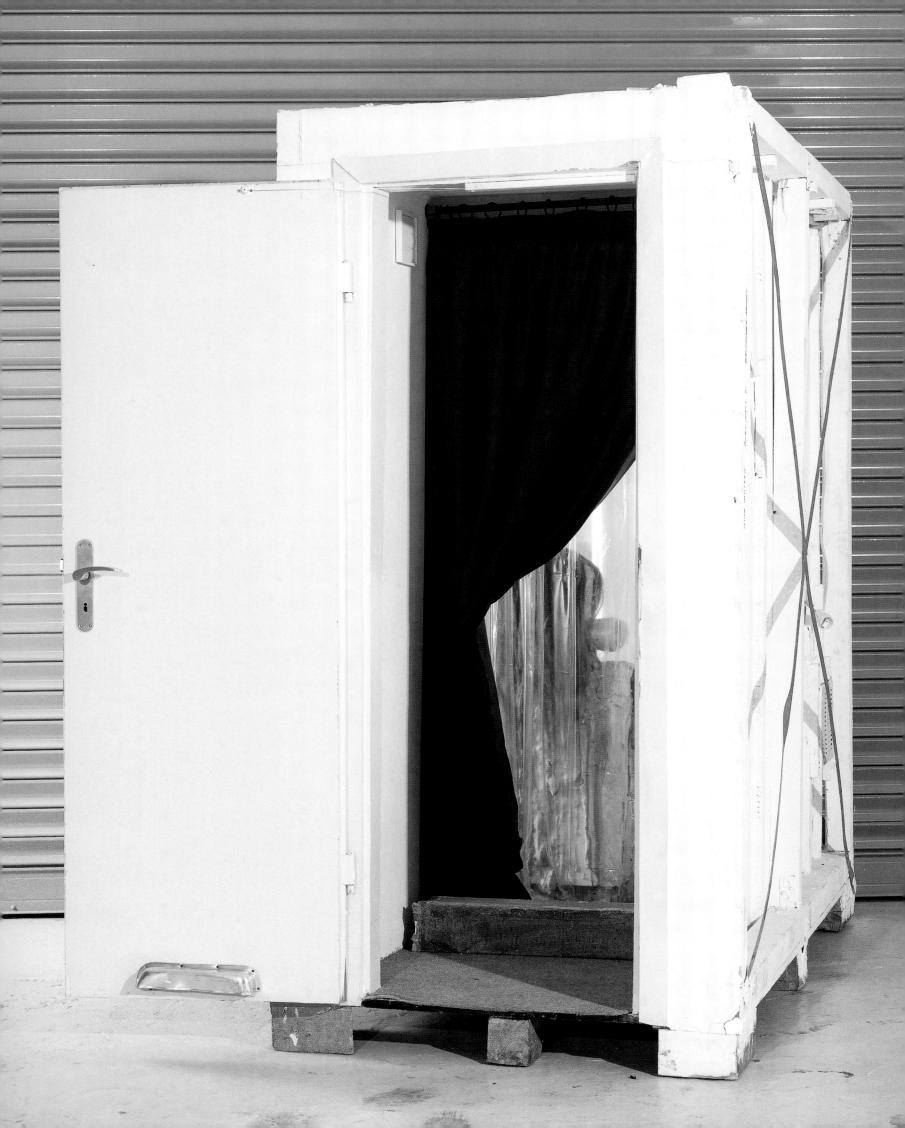

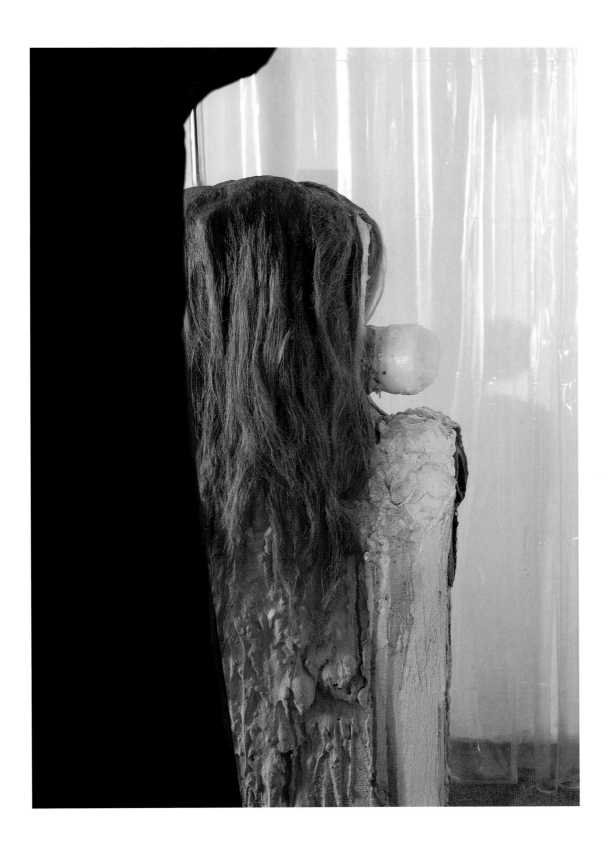

slavery, sexual violence, and childhood, Walker leaves virtually no taboo unaddressed, and her light touch in rendering even the most unspeakable acts suggests that a personal as well as cultural exorcism is at the core of her otherwise shocking act of self-liberation.

Shahzia Sikander comes from a distinguished family in Pakistan and now resides in the U.S. She studied the techniques of traditional miniature painting at the fine arts academy in Lahore and then earned an art degree from Rhode Island School of Design; these experiences helped produce one of the more intriguing cultural fusions to emerge in American art in recent years. Although she first made a name for herself through the creation of small-scale works on paper that owe a pronounced formal debt to her academic training, Sikander has devoted the past several years to making a remarkable transformation in scale, technique, and subject matter. She has not departed

A Shahzia Sikander
Veil 'n' Trail. 1997
Acrylic paint on linen
3 panels, 168 x 244,5 cm/66 1/8 x 96 1/4 in. total
The Dakis Joannou Collection, Athens

Untitled #100. 1982
Color photograph
114,3 x 76,2 cm/45 x 30 in.

Untitled #113. 1982
Color photograph
127,6 x 85,1 cm/50 1/4 x 33 1/2 in.

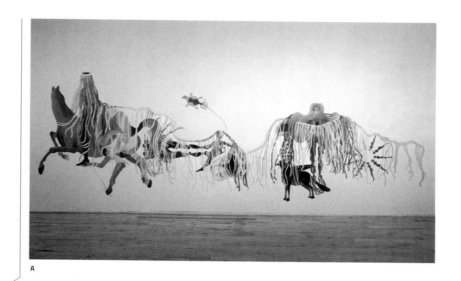

A

significantly from the methods that first brought attention to
her art, but she has combined them with a more diverse range
of approaches that have enabled her to produce large-scale
canvases, wall paintings, and even videos. Sikander's subject
matter has also expanded dramatically, and she is unafraid of
taking on the often hypocritical policies and cultural blindness
that have warped the way Americans see the rest of the world in
the wake of 9/11, and have irrevocably altered the way the world
looks at Americans. Rather than consider her work in strict-
ly East-West terms, however, Sikander speaks from a recently
evolved position in which those who feel the freest to represent
the state of the world today are those who are straddling more
than one culture. As a kind of permanent nomad working in the
U.S., Sikander offers a point of view that is neither one thing
nor the other, but many things all at once, and in this way prob-
ably more indicative of the vast cultural complexities that con-
front any artist today who wishes to place his or her work at the
service of a vision that benefits all of humanity, and not just a
small sector of it.

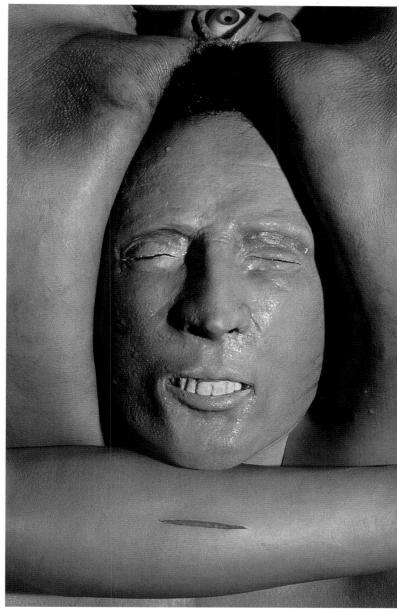

Although the full range of formal and stylistic possibilities that lend themselves to the conceptual framework of internal contradiction cannot be covered by the examples described here, the artists whose work has been included in this discussion are in many ways typical of the growing desire to imbue art with a multilayered approach toward meaning. While it is certainly possible, and in some instances unavoidable, to know things through our exposure to art, we cannot be certain today—if we ever could in the past—that a direct line exists between the artist's intentions and the viewer's experience. So much of current art practice is bound up in the vagaries of firsthand experience that it has become increasingly difficult to synthesize all these meanings into straightforward ideas, principles, observations, and intuitions. It might even be hypothesized that one of the sustaining values of art today is that it implies a way of encountering the world that goes beyond the limits of linguistic transposition. Art, unlike language, can be simultaneously true and

Dressing Down. 1997
Wax-printed cotton, crinoline, aluminum, plastic, and felt
150 x 150 x 175 cm/59 x 59 x 69 in.

YINKA
SHONIBARE
Born in London, 1962/Lives in London

false, and might be said to thrive on this
atmosphere of sustained illogic. To press
the point one step further, we might say
that art's seemingly limitless capacity to
refer to and link up with realms of knowl-
edge that otherwise fall beyond the grasp
of our rational frame of reference is what
makes its place in our lives, over time,
less a matter of choice and more a case
of absolute necessity.

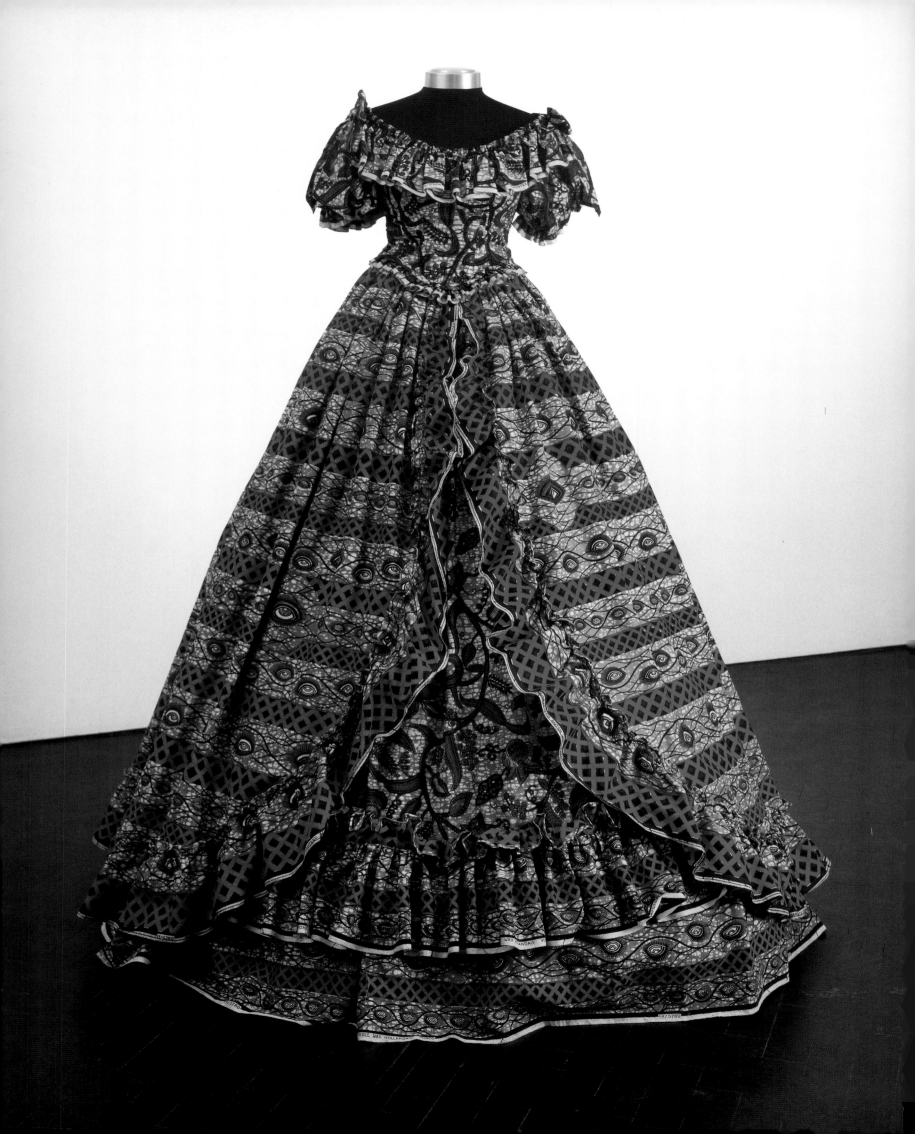

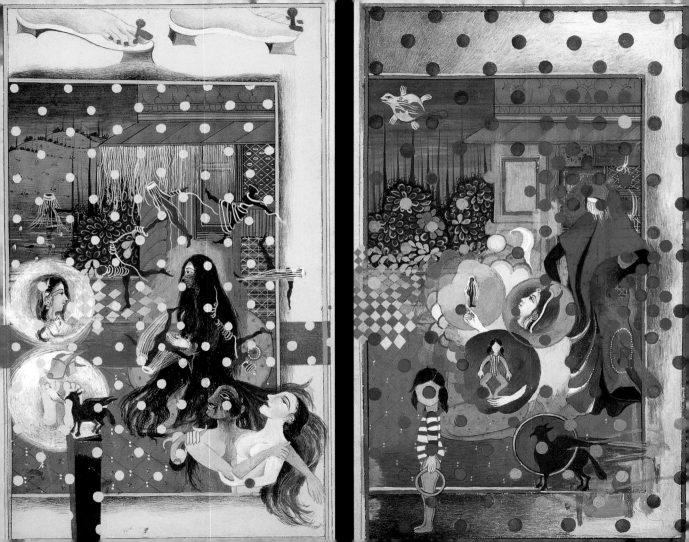

SHAHZIA
SIKANDER
Born in Lahore, Pakistan, 1969/Lives in New York

Then and N.O.W.—Rapunzel Dialogues Cinderella. 1997
Vegetable color, dry pigment, watercolor, and
tea on hand-prepared *wasli* paper
38,1 x 32 cm/15 x 12 5/8 in. framed

Red Riding Hood. 1997
Vegetable color, dry pigment, watercolor,
and tea on hand-prepared *wasli* paper
38,1 x 32 cm/15 x 12 5/8 in. framed

Fifteen Minutes Is No Longer Enough

Nancy Spector

A

The cold-blooded murder of Lee Harvey Oswald was broadcast live on national television just two days after he assassinated President John F. Kennedy. He was gunned down by Jack Ruby in the basement of the Dallas city jail while awaiting transfer to the county facility on November 24, 1963. This crime was recorded and simultaneously transmitted as part of a media marathon that commenced right after the assassination and ended with the president's funeral four days later. During that period, the television networks provided twenty-four-hour coverage, obsessively documenting every detail without a single commercial break.[1] The country was transfixed; nine out of ten Americans watched as this drama unfolded in real time, joined in a kind of collective disbelief and mourning facilitated by electronic

Veil 'n' Trail, 1997
Acrylic paint on linen
3 panels, 168 x 244,5 cm/66 1/8 x 96 1/4 in. total

SHAHZIA ▶
SIKANDER

B

media.[2] The first presidency to capitalize on the mythmaking capacities of television—with the studied construction of "Camelot" for the camera—met its end in the living rooms of millions of American viewers. Unlike typically scripted television, however, this story offered no closure. On the contrary, it ushered in decades of doubt and dissent for a nation whose own, self-defining narrative was beginning to unravel.

Cady Noland specializes in the disruption of the American dream. Her unruly sculptures, assembled from the flotsam of a degenerate and degenerating society—discarded Budweiser beer cans, handcuffs, rubber tires, empty wire baskets, aluminum barriers, chrome car parts, and walkers—reflect a world coming undone. Her photographic portraits, culled from the mass media, enlarged, and silkscreened onto thick aluminum sheets, highlight cult icons, like Patty Hearst and Oswald, from America's tabloid-saturated imagination. Noland's photographic sculpture

A Lee Harvey Oswald, in police custody, speaks to reporters in Dallas, Texas, November 23, 1963.

B The assassination of President Kennedy in Dallas, Texas, November 22, 1963

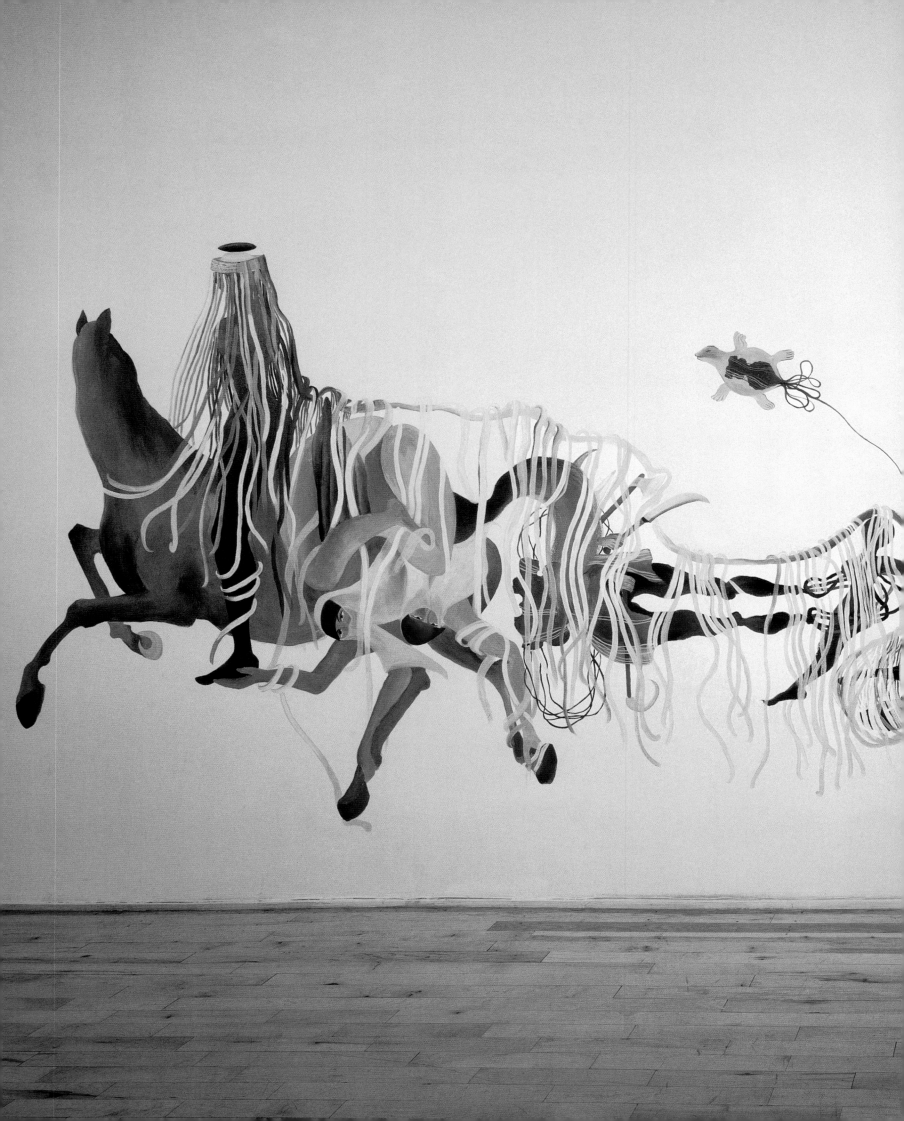

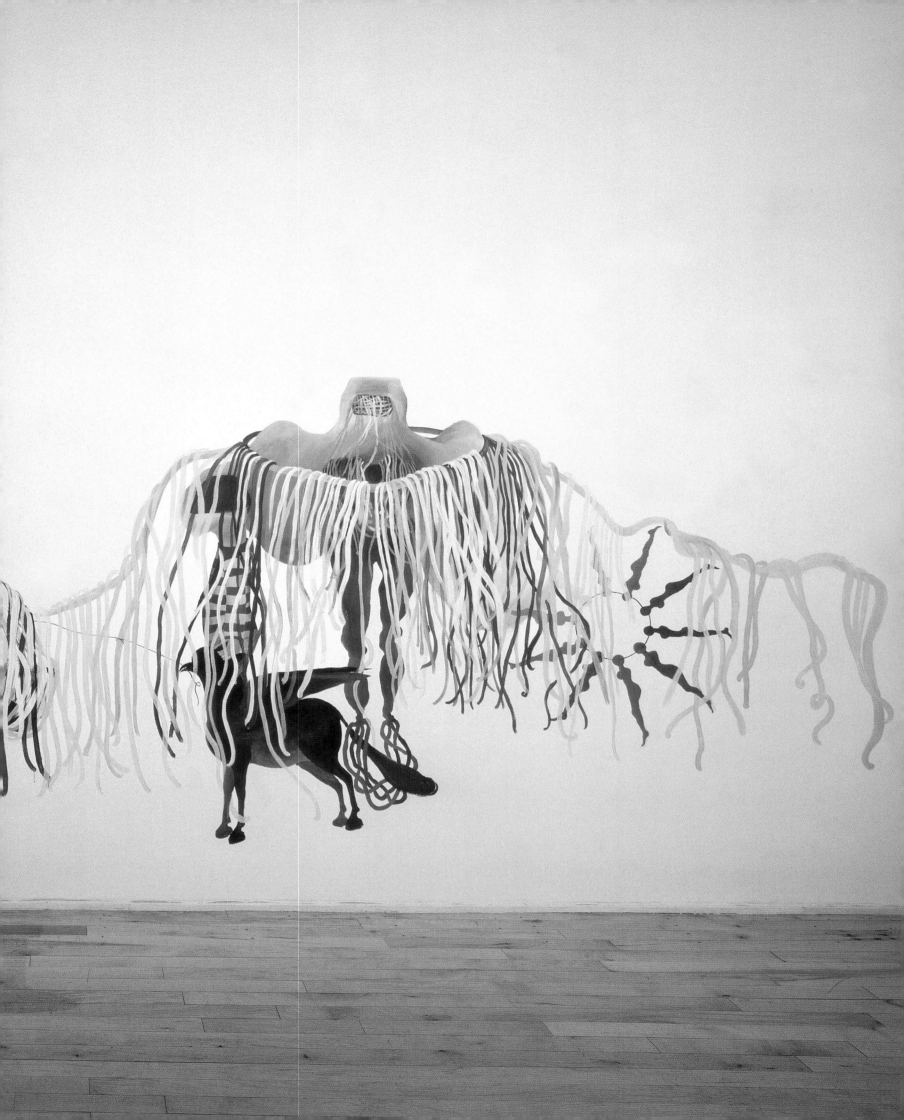

Bluewald (1989) depicts Oswald at the moment of his own assassination; Ruby's .38 special is pointed directly at his stomach. The cut-out figure is perforated with seven holes, three of which obscure Oswald's face as he turns to stare at his murderer and the flashbulbs beyond. Cast with a bluish tint, the portrait appears as if illuminated by the nocturnal light of a television set in a darkened room, an insomniac's refuge with its 24/7 programming. With *Bluewald* and its conflation of violence, spectacle, intrigue, and voyeurism, Noland aptly targets a cultural phenomenon peculiar to the United States, which has its roots in the political and social upheavals of the 1960s and continues to flourish in our millennial world.

The 1960s was a decade of great disillusionment and great mobilization. The escalation of the Vietnam War and the assassinations of President Kennedy, Robert F. Kennedy, Martin Luther King, Jr., and Malcom X all contributed to an erosion of public trust in the government. The overarching illusion of the U.S. as a benevolent world force was beginning to crumble. The nation's perception of itself as a "victory culture," informed by the tri-

Viktoria, 1996
Mixed media
354 x 260 x 235 cm/139 3/8 x 102 3/8 x 92 1/2 in.

ANDREAS
SLOMINSKI
Born in Meppen, Germany, 1959/Lives in Hamburg

umphs of two world wars, was increasingly undermined as the debacle of America's involvement in Vietnam came under ever greater scrutiny.[3] The antiwar movement, coupled with epic human-rights initiatives—including the women's liberation movement, civil rights demonstrations, and the Stonewall Rebellion, which inaugurated the modern-day gay and lesbian rights movement—marked a sustained, multivalent attack on the status quo. The country's "dominant fiction"[4] of a victorious government acting in the interests of its citizens in a transparent process accessible to all was debunked with each national catastrophe. In 1968 alone, the assassinations of Kennedy and King, the My Lai massacre,[5] the Tet offensive,[6] and the violent riots at the Democratic National Convention in Chicago (which culminated in the much-publicized Chicago Seven trial[7]) signaled a crisis in the national consciousness. The U.S. government seemed utterly unscripted, and, unlike today, much of the media refused to echo any propagandistic, patriotic jargon put forward by the administration. Television anchors criticized the Vietnam War on air; Walter Cronkite, whom President Lyndon Johnson once described as "Mr. Average Citizen," announced on CBS after a visit

to Southeast Asia that the war was "mired in stalemate."[8] But this journalistic independence was relatively short lived. By and large, the military strategists and hawks in government felt betrayed by the American media, which reiterated and further inflamed the country's deep ambivalence over a war with an elusive enemy and no apparent exit strategy. During the ensuing decades, the autonomy of print and broadcast journalism gradually diminished as media conglomerates consolidated independent stations, and the military increasingly controlled access to combat zones during wartime.[9] This deliberate restraint on the freedom of the press culminated in the 1991 Persian Gulf War, which was a government-produced media spectacle resembling the abstraction of a video game. The raw footage that once pulled a nation through the days following the Kennedy assassination was replaced by the slick, heavily mediated spin that constitutes our television culture today.

Baghdad skies erupt with anti-aircraft fire as U.S. warplanes strike targets in the Iraqi capital early in the morning on January 18, 1991.

Untitled (Bowed Woman). 1995
Brown wrapping paper and horsehair
134,6 x 45,7 x 127 cm/53 x 18 x 50 in.

KIKI ▶
SMITH
Born in Nürnberg, Germany, 1954/Lives in New York

The drift from television news as (allegedly objective) information to packaged entertainment can be dated to the end of the 1960s when the concept of "Happy Talk News" was introduced by an ABC-affiliate station in Chicago to boost its ratings. This involved a shift from the single "talking head" reading from what was presumed to be investigative reportage to casual banter between co-anchors in order to humanize and ameliorate the onslaught of horrific news stories that marked the era. "Happy Talk" rhetoric masked the irresolution of the nation's current conflicts and further fragmented any news deemed incendiary, such as the coverage of the civil rights and antiwar movements. In his three-channel video installation, *Evening* (1994), Stan Douglas charts this historical moment—the birth of infotainment—by juxtaposing broadcasts of the evening news from three different Chicago-area network affiliate stations from two moments in time: January 1, 1969, and January 1, 1970. Rather than simply appropriating footage from the original programs (which in fact is not archived), Douglas scripted and directed a performance based on actual events of the period. The anchors discuss, to varying degrees, the release of three prisoners of war by the Viet

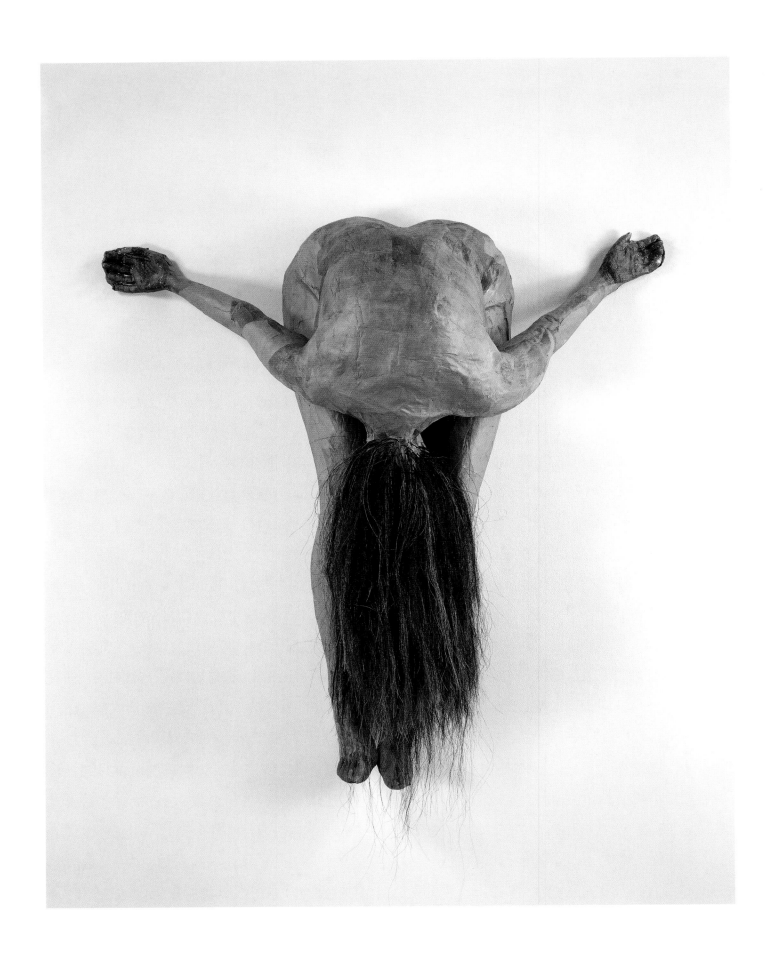

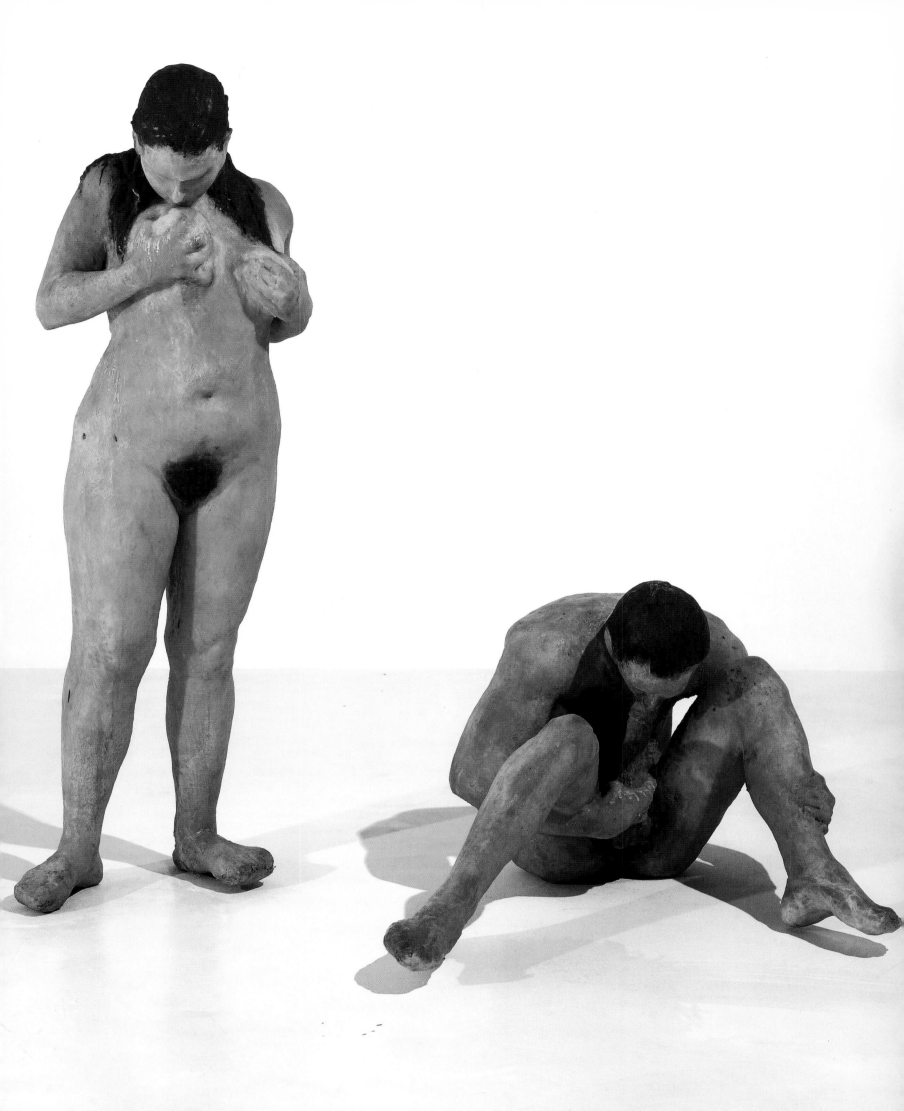

Mother/Child, 1993
Beeswax with hardener, cheesecloth, dowels,
and powder pigments
Life-size

Cong; the reinstatement of Adam Clayton Powell in Congress after being investigated for the misappropriation of Congressional funds; the My Lai trials; Mayor Richard Daley's delay in appearing at the trial of Abbie Hoffman during the Chicago Seven hearings; and the initial inquest into the assassination of Black Panther deputy chairman Fred Hampton. The not-so-subtly fictionalized stations, "WAMQ—The News That Matters" (NBC), "WBMB" (CBS), and "WCSL—Your Good News Station (ABC)," each reveal their transition to the relative trivialization of major news stories over the one-year span represented.[9] Douglas's carefully calibrated fugue of simultaneous broadcasts—creating a polyphony of sound interrupted only by commercial breaks indicated by "place ad here" signs—invokes the mind-numbing repetition of televised news, which is perpetuated today on our "all-news, all-the-time" cable stations: CNN, FOX, MSNBC, and Bloomberg.

Mother/Child, 1993
Beeswax with hardener, cheesecloth, dowels,
and powder pigments
Life-size

Untitled (Hanging Woman), 1992
Gampi paper, Nepal paper, lithography ink, and glue
187,9 x 81,2 x 81,2 cm/74 x 32 x 32 in.

KIKI ▶
SMITH

The propensity of the media to deliver the news—however
tragic or trivial—in short, digestible "sound bites," which are then
incessantly repeated until a story has lost its broadcast value,
creates a rhythm that is analogous to the symptoms of trauma.
Derived from the Greek word for wound, trauma is an acute psy-
chic injury with physiological manifestations. Although it was rec-
ognized for hundreds of years, trauma is particularly linked to the
twentieth century. In fact, it is almost inextricable from modernity
and its attendant technological advances, which have brought
both boundless invention and mass destruction.[10] The modern
comprehension of trauma dates to the late nineteenth century,
when railway travel—with its unprecedented speed, noise, pollu-
tion, and potential for catastrophic accidents—created widespread
apprehension. The great velocity of the locomotive destabilized
and forever altered perceived coordinates of time and space.
Even Sigmund Freud suffered from railway phobia. The twentieth
century gave rise to horrors facilitated by technological progress
on a scale unimaginable by previous generations: two world wars,
ethnic, religious, and ideological genocide, nuclear explosions
and their fallout, deterioration of the world's fragile ecosystem,

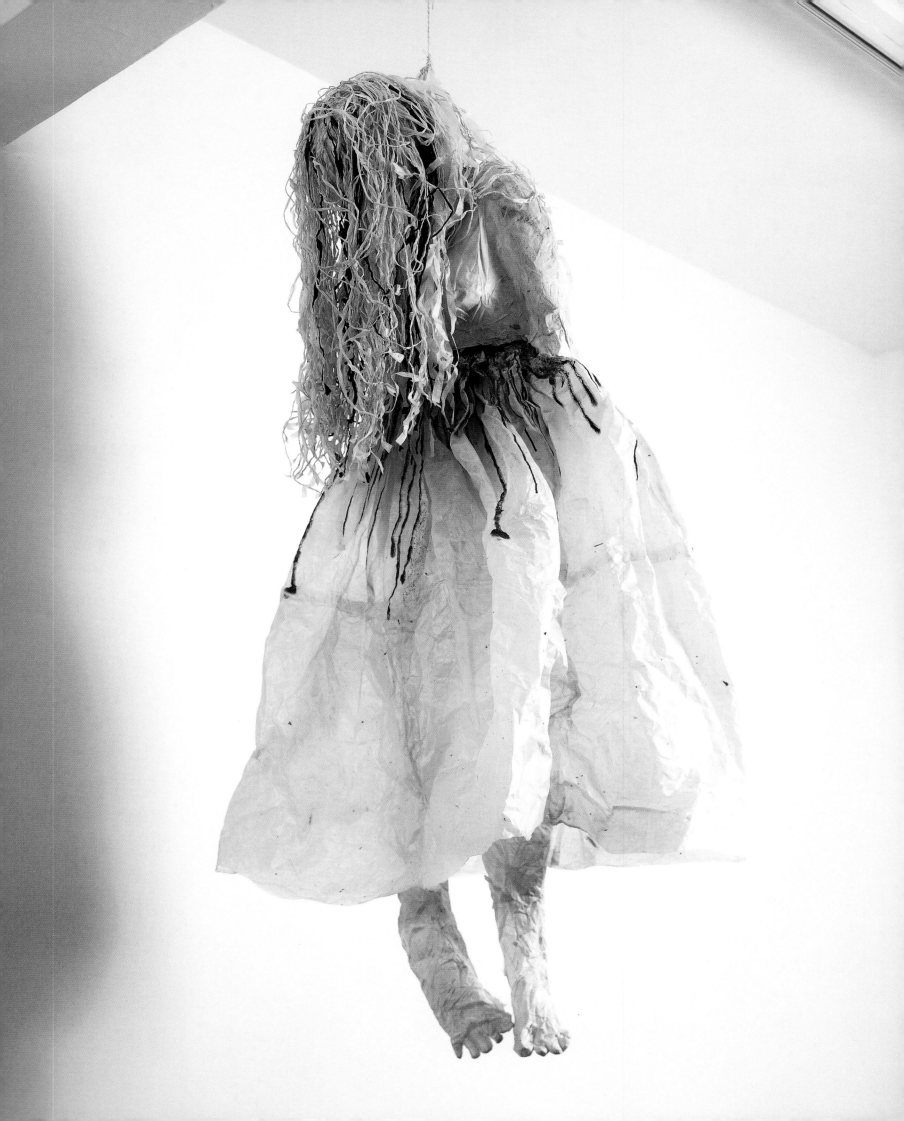

Untitled (Skin). 1992
Cast aluminum
2 parts, 71,7 x 127,6 cm/28 1/4 x 50 1/4 in. each

Untitled (Head with Tongue). 1995
Bronze and silver plate
25,4 x 25,4 x 15,2 cm/10 x 10 x 6 in.

the proliferation of fatal illnesses caused by industrial contami-
nants, aeronautic disasters, and international terrorism. Trau-
matic experience of such events cannot be processed or contex-
tualized through normal channels of description, interpretation,
or memory.[11] Trauma is thus theorized as nonrepresentational,
beyond language, that which cannot be narrated. In *The Writ-
ing of the Disaster*, Maurice Blanchot relates that "the disaster...is
what escapes the very possibility of experience—it is the limit of
writing....The disaster de-scribes. Which does not mean that the
disaster, as the force of writing is excluded from it, is beyond the
pale of writing or extratextual."[12]

The traumatic experience cannot be forgotten, but at the
same time it cannot be sufficiently remembered, articulated,
assimilated. This twilight state between past and present, in
which the traumatic event refuses to recede and is relent-
lessly reencountered in altered form—flashbacks, nightmares,
depression, obsession, paralysis, violence, and/or guilt—is
a condition of utter disassociation. Officially acknowledged
in 1980 by the American Psychiatric Association as a specific

<table>
<tr><td>

Untitled (Cane). 1994
Red and clear glass
40 pieces, dimensions vary

</td><td>

Intestine. 1992
Cast bronze
914,4 x 20,3 x 30,5 cm/360 x 8 x 12 in.

</td><td>

KIKI
SMITH ▶

</td></tr>
</table>

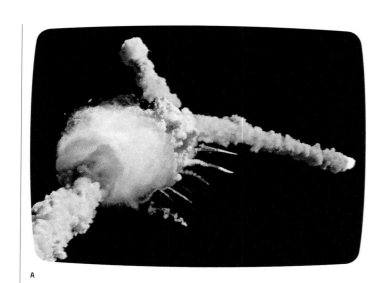

A

pathology (albeit one with a wide range of often conflicting symptoms), post-traumatic stress disorder (PTSD) is manifest today on both the individual and cultural levels. Vast portions of a society can be afflicted with the psychic wounds associated with widespread trauma; the collective unconscious may be entirely altered by atrocity. Examples abound in the twentieth century: the Holocaust, apartheid, the Cultural Revolution in China, the Vietnam War, the AIDS epidemic, and the civil wars in Central America, Liberia, and Rwanda, to name only some of the most egregious and world-transforming events of the not-so-distant past.

In today's world, the perpetual onslaught of information—no matter how sanitized or diffused it may be—reflects the repetition compulsion inherent to post-traumatic stress disorder. Footage from national disasters like the *Challenger* and *Columbia* explosions or the devastation of the terrorist attacks on 9/11 was replayed again and again over the course

A The space shuttle *Challenger* explodes shortly after lifting off from the Kennedy Space Center, January 28, 1986.

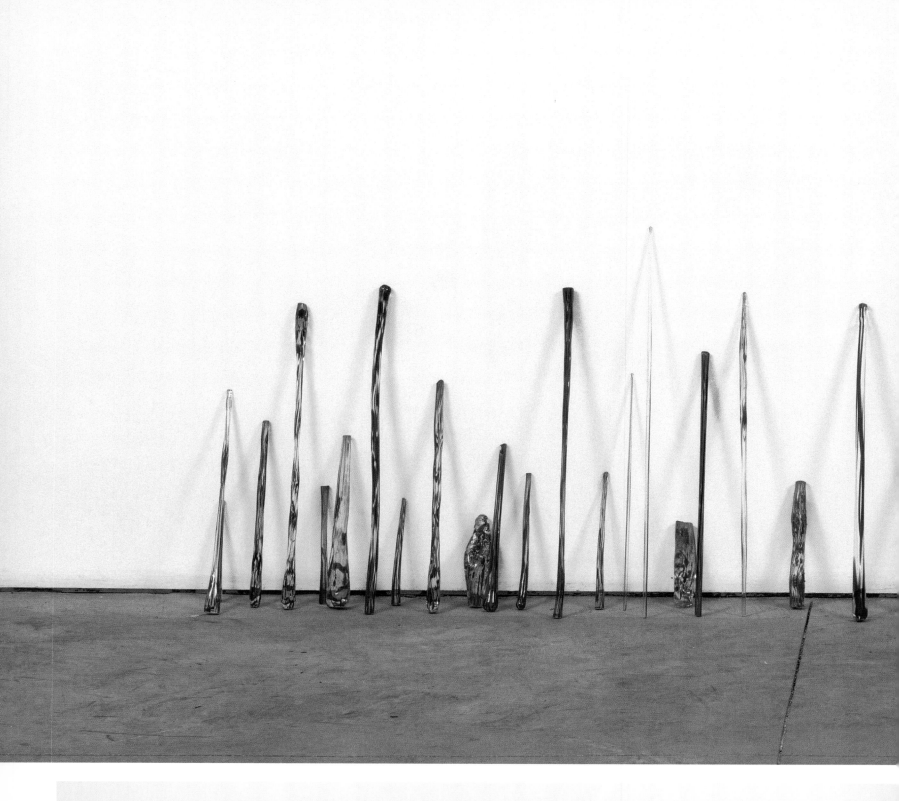

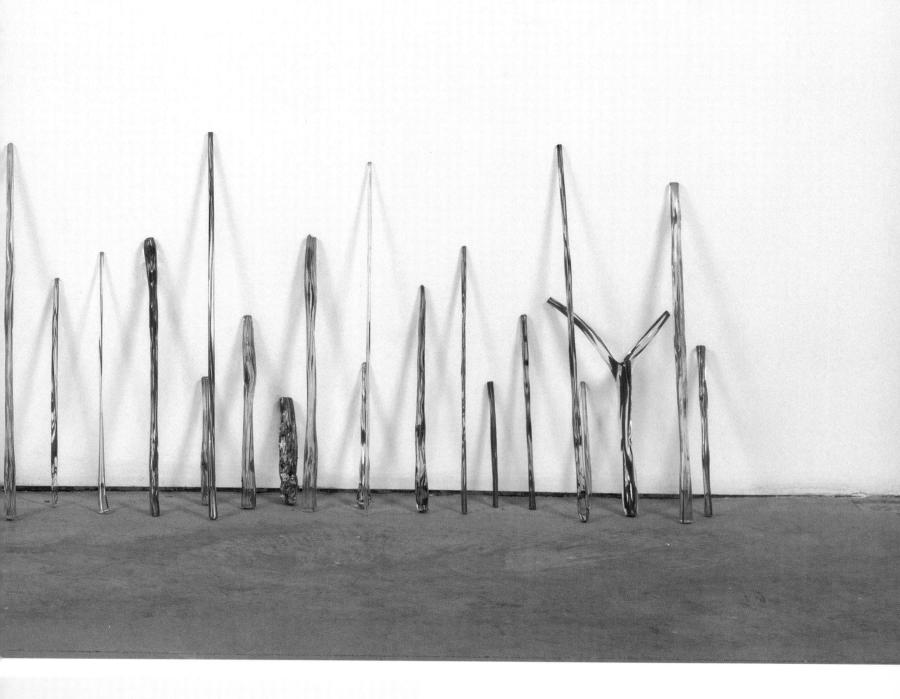

of months, as if the incessant visual recurrence of the events would somehow provide clues to their meaning. The media's endless obsession over intrigue, crime, and tragedy, like the O.J. Simpson trial or the JonBenet Ramsey murder, works less to provide closure than to deflect our real inability to articulate a narrative that effectively portrays the cataclysmic impact of trauma. Attempting to actually tell the story of catastrophe has its own inherent dangers, however; narration can aestheticize, fictionalize, and/or fetishize an event that otherwise refuses to cohere. In fact, some cultural theorists propose that the only way to appropriately address a phenomenon too painful to remember, but too profound to forget, is through modernist representational strategies such as fragmentation, circularity, abstraction, and disassociation.[13]

This idea has had great resonance in recent visual culture. After decades of conceptually oriented art, much of which interrogated codes of representation, a generation of artists emerged during the 1990s who incorporated storytelling in their work. For many, such as Matthew Barney, Mariko Mori, Matthew

One Minute Manager No. 3. 1989
Mixed-media construction
72,3 × 266,7 × 35,5 cm/28 1/2 × 105 × 14 in.

HAIM
STEINBACH
Born in Rechovot, Israel, 1944/Lives in New York

Ritchie, Katy Schimert, and Shahzia Sikander, the narrative structure itself has served as a medium in its own right, providing a new kind of raw material with which to craft individual cosmologies, however eccentric or obscure. For others, narrative is only hinted at, obliquely suggested through isolated fragments. Robert Gober's disembodied legs and torsos are allusive part-objects—at once erotic and uncanny—imbued with an ever elusive content. They appear as mute symbols for a world of indescribable horror or incredible possibility—where bodies split apart and rejoin to form hybrid beings, where a man may give birth to a grown boy, and people become one with watery, subterranean realms of sewers and drainage systems. In the sculpture *Two Spread Legs* (1991), phantom limbs, cast from wax with trompe-l'oeil exactitude and outfitted with men's trousers, socks, and shoes, protrude from the wall in an anatomically impossible split. The gulf between the left and right legs suggests even further fragmentation than the initial, unsettling appearance of amputation. As in all of Gober's richly suggestive work, this piece operates on more than one connotative level. The splayed legs can also function as an invitation, like open arms,

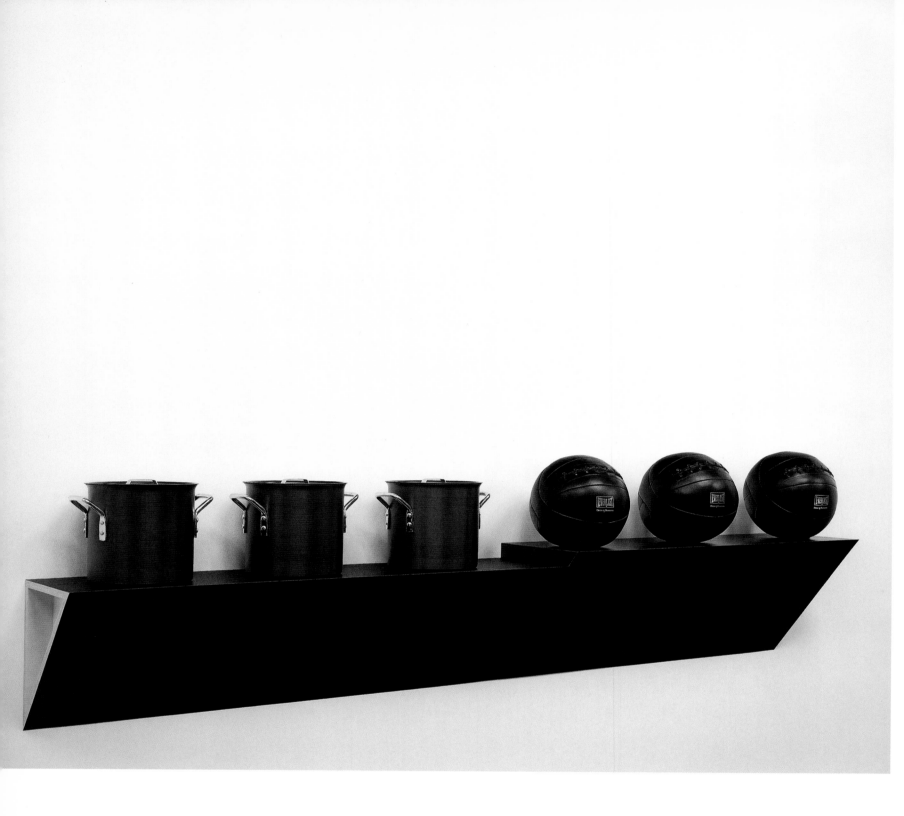

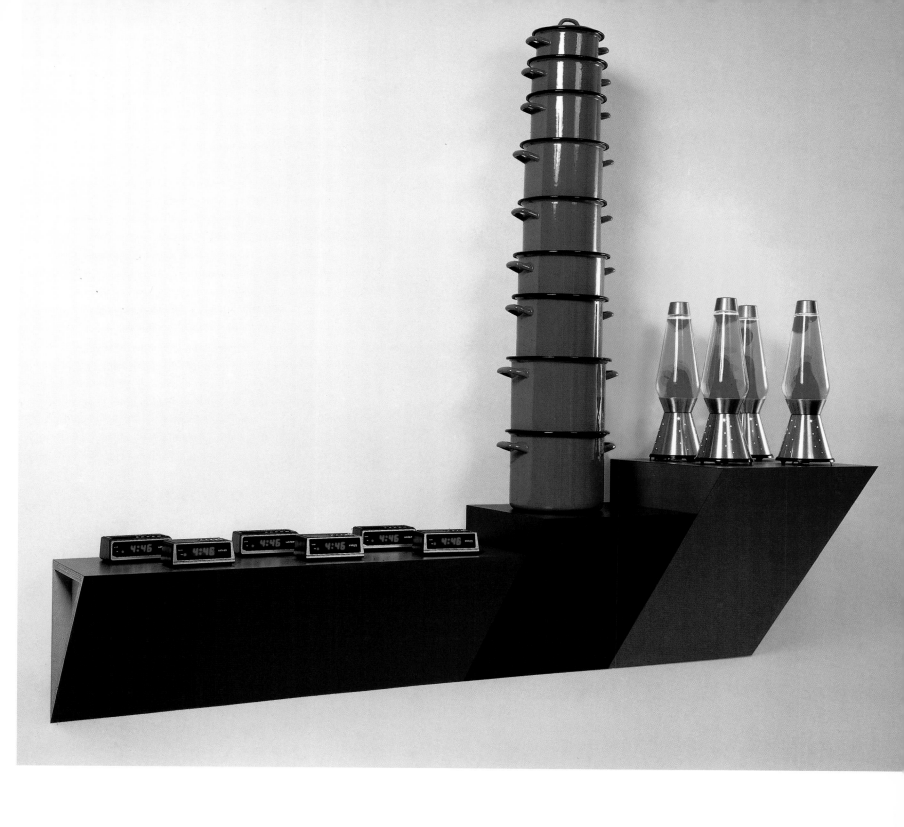

◀ HAIM
STEINBACH

Ultra Red. 1986
Wood, formica, 9 red cooking pots, 6 digital clocks, and 4 lava lamps
167 x 193 x 48,8 cm/65 3/4 x 76 x 19 1/4 in.

to a potentially (homo)erotic encounter. Similarly, *Untitled (Boy Coming Out of Man)* (1995), a surreal birth tableau set inside a glowing fireplace, is at once horrific and oddly propitious. While fire is destructive, it is also a primal force, and in this light the sculpture begins to envision a self-propagating universe. Gober achieves an analogous, double-edged effect with *Untitled* (2000-2001), which features a basement door—an architectural fragment taken from vernacular domestic design, but suggestive of other worlds. This sculpture of an external entrance into an underground chamber is carved directly into the floor. The two entry flaps are open, revealing a set of descending stairs that lead to a closed yellow door; a glowing light emanates from behind. The theme of excavation is a recurrent motif in Gober's art: sculptures and drawings invoking underground sewers and the culverts that feed them allude to human conditions of fluidity and connectedness as well as unconscious states of terror and transmutation. In *Untitled*, Gober has created an equally mysterious work, one that entices as a passage to either redemption or some unknown, personal hell.

Hippodrome. 1997
Video
15 min.

LINA ▶
THEODOROU
Born in Athens, 1970/Lives in Athens

While Gober's work has always circulated around the dys-
topic state of American culture—particularly his early, hand-
crafted, hauntingly empty sinks, cribs, beds, and dog baskets—
his introduction of disembodied limbs during the early 1990s
invoked, however indirectly, a current crisis in the body politic.
Like works by other artists, such as Felix Gonzalez-Torres and
Kiki Smith, that addressed issues of corporeality, Gober's sev-
ered legs—some punctured by open drains, others sprouting
candles—reflect a time in which the physical body itself became
a highly contested site. The AIDS epidemic, by then reaching
global proportions, had focused social paranoia and intoler-
ance on the diseased body.[14] Because of the early association
between homosexuality and AIDS, this body was considered
"perverse" by nature of its perceived "otherness." Explicit ar-
tistic representations of the body—as anything but the norma-
tive, unigender, heterosexual, law-abiding (preferably white) be-
ing—proved to be profoundly disturbing to a culture gripped with
fear and loathing of a disease yet to be comprehended medi-
cally, ethically, or socially.[15] The impulse for contemporary art-
ists to represent the vulnerable and embattled body through eli-

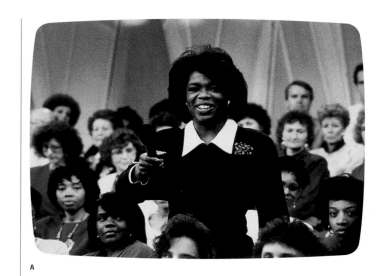

A

B

sion, fragmentation, or metaphor stemmed less from a desire to avoid censorship than from an attempt to invoke what is essentially without form, to articulate what is singularly inexpressible—the body in pain, the silence of illness, the isolation of death.

It is ironic that while visual artists were turning to an aesthetics of absence to convey the prevalence of trauma in contemporary society, mainstream culture was witnessing an explosion of ever more explicit media attention to trauma—on both the personal and public levels. By the end of the 1980s, a new television genre had emerged: the confessional talk show. Introduced in 1986 when Oprah Winfrey launched her particular brand of compassionate, intrapersonal interviews during her pilot season, the genre quickly proliferated and mutated into the most debased programming ever envisioned by the television networks. The talk shows that followed in quick succession—*The Jenny Jones Show* (1989) and *The Jerry Springer Show* (1991), to name only the most popular—appeal to the lowest common denominator with episodes devoted to sexual betrayal, sexual perversion, petty crime, and incest. Guests tell their sagas, often

London Installation 1999–2002. 2002
Ink-jet prints and c-prints
Dimensions vary

WOLFGANG ▶
TILLMANS
Born in Remscheid, Germany, 1968/Lives in London

c

directly confronting those they have hurt the most, swindled, or used. Goaded by a live audience desperate to witness conflict—like the bloodthirsty spectators of the gladiator games in ancient Rome—the shows' participants often come to blows. In episodes devoted to subjects like "I'm Stealin' My Daughter's Man!" and "Explosive Family Affairs" (*Springer*, Sept. 11 and 12, 2003), people reveal and flaunt the darkest of secrets.[16] The confessional talk show, along with its recent offspring Reality TV, has effectively erased any vestige of a boundary between the public and the private spheres (quasi-mythological realms to begin with). Even the legal system, which purportedly protects one's right to privacy, has gotten into the act. *Judge Judy*, a highly popular, nationally syndicated program on the air since 1996, televises courtroom dramas. A sampling of trials presented for the week of September 8–12, 2003, includes the following: "A Colorado mailman demands that his ex-girlfriend pay for the breast augmentation surgery he bought for her," "A pregnant

A *The Oprah Winfrey Show*

B Jerry Springer talks to his guests and audience on the set of *The Jerry Springer Show*, 1998.

C *Judge Judy*, 2002

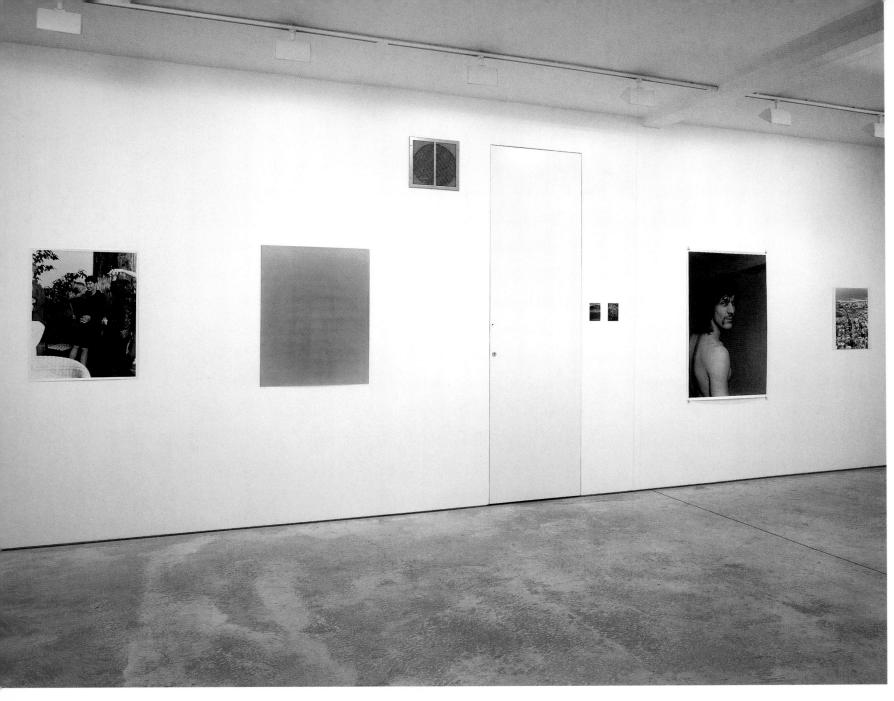

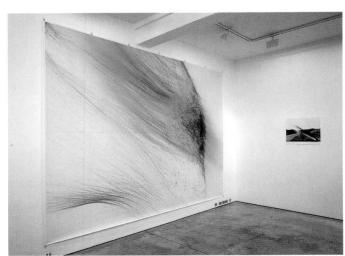

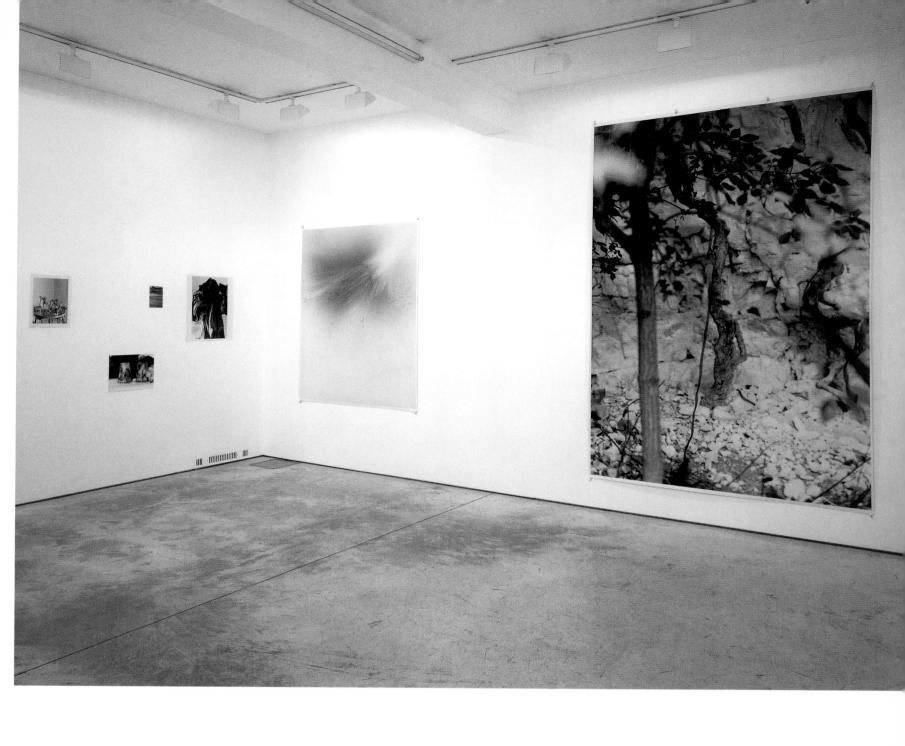

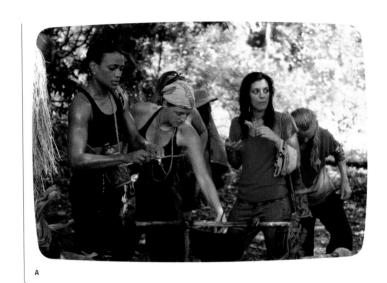

A

woman from North Carolina claims she was kicked in the stomach during a fight with another woman over a gas pump," and "A Minneapolis man claims he loaned his ex-girlfriend thousands in her struggle to regain custody of her youngest daughter."[17]

In American culture today, people will apparently do just about anything to appear on television. Afflicted with what *New York Times* critic Frank Rich has called an advanced case of "telephilia,"[18] average Americans are desperate enough to confess their innermost secrets, participate in the most humiliating competitions, and conduct the most private of rituals like choosing a mate in front of millions of viewers. The immense popularity of Reality TV programs like *Survivor, Who Wants to Marry My Dad?, Extreme Makeover, I Want a Divorce, Freshman Diaries, Temptation Island,* and *Dog Eat Dog* proves that, to many, television has become the barometer of their self-worth. It offers that momentary brush with celebrity that Andy Warhol so

A *Survivor: The Amazon,* 2003. Shown are JoAnna Ward, Christy Smith, Jenna Morasco, and Heidi Strobel.

Moby. 1993
Bubble-jet print
101,6 x 179 cm/40 x 70 1/2 in.

Corinne on Gloucester Place. 1993
Bubble-jet print
180,3 x 177,8 cm/71 x 70 in.

WOLFGANG ▶
TILLMANS

milkspritz. 1992
Bubble-jet print
119,3 x 177,1 cm/47 x 69 3/4 in.

prophetically announced when he said that "in the future every-one will be world famous for fifteen minutes."[19] That illusory fif-teen minutes, it seems, is no longer enough. People are clamor-ing for any kind of public exposure that will, they think, elevate their daily existence to that of a Hollywood celebrity. Maurizio Cattelan's installation *Spermini* (1997), comprising five hundred latex masks of the artist's face, humorously invokes this seem-ingly insatiable, culture-wide urge for notoriety. In his onanistic celebration of the self, Cattelan pokes fun at the masturbatory impulse, equating autoerotic pleasure with both the expenditure and multiplication of one's being.[20] While probably not intended as a subtext of the piece, the correlation between masturba-tion, wasteful expenditure, and the endless duplication of one's image slyly alludes to the absurd ends individuals will go to in order to participate in the electronic flow of Reality TV, with its delusion of self-importance and fame.

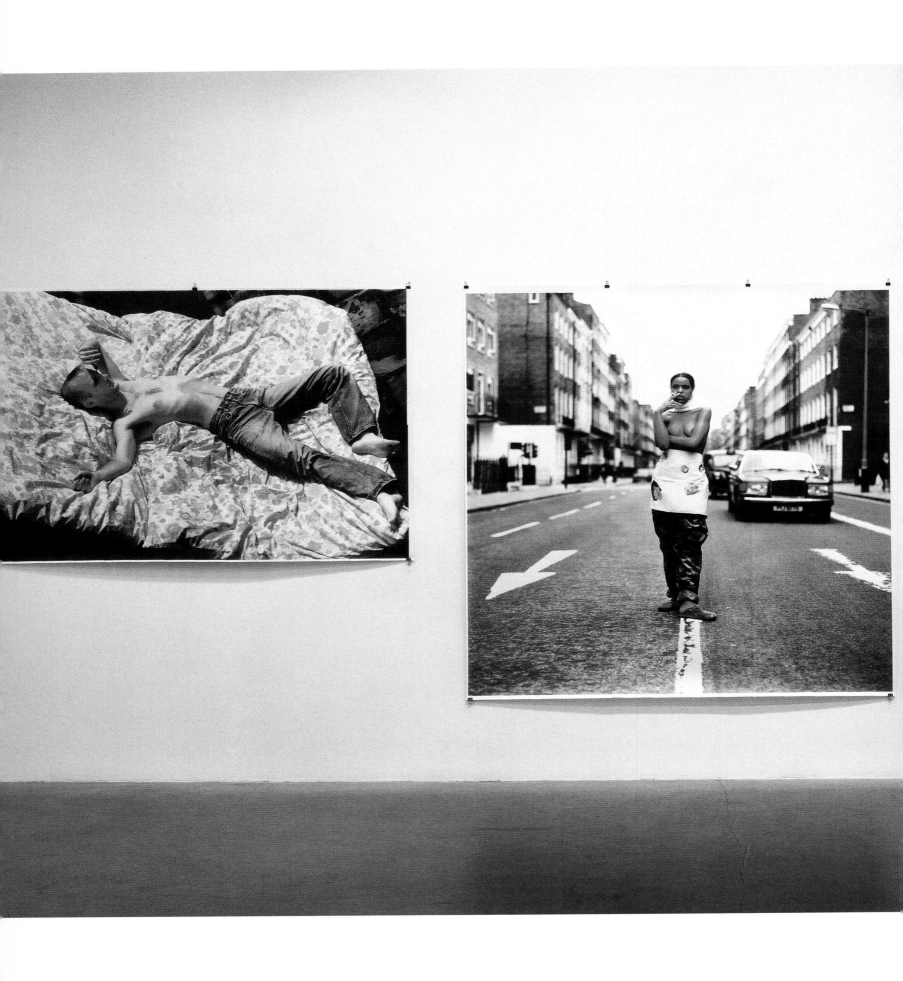

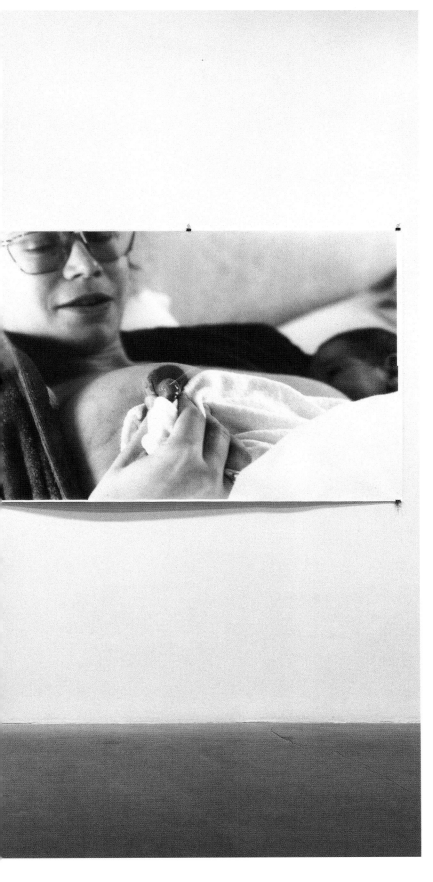

America's obsession with television extends well beyond
the desire for instant celebrity. It marks a new kind of relation-
ship to the Real. For some time now, society has utilized the me-
dia as its mirror, representing itself to itself, sensationalizing
the effects of trauma but minimizing critical information about
its causes. The superficiality of current news reportage, coupled
with the inanity of the confessional talk show and Reality pro-
gramming, have inured viewers to the depth and complexity of
modern life. Television's carefully packaged "reality" has come
to seem more real, more valid, more vivid than daily existence
for its ever growing audience. The television-addicted Gladney
family in Don DeLillo's *White Noise* (1985)—who reserves every Fri-
day night to collectively watch the spectacle of suffering broad-
cast into their living room—has become a paradigm for today:

> That night, a Friday, we gathered in front of the set, as
> was the custom and the rule, with take-out Chinese. There
> were floods, earthquakes, mud slides, erupting volca-
> noes. We'd never been so attentive to our duty, our Friday
> assembly....We were...silent, watching houses slide into

Gravity in Four Directions. 2001
Leaves, pills, photocopies,
acrylic paint, and resin on wood
183 x 183 cm/72 x 72 in.

FRED ▶
TOMASELLI
Born in Santa Monica, California, 1956/Lives in New York

the ocean, whole villages crackle and ignite in a mass of advancing lava. Every disaster made us wish for more, for something bigger, grander, more sweeping.[21]

When true disaster strikes the town where the Gladneys live in the form of a toxic railway spill, people are actually disappointed, even outraged, when no media coverage of their evacuation materializes. Without the validation of broadcast television, victims of the catastrophe felt the depth of their experience was discounted:

At seven p.m. a man carrying a tiny TV set began to walk slowly through the [evacuation center], making a speech as he went...."There's nothing on network," he said to us. "Not a word, not a picture. On the Glassboro channel we rate fifty-two words by actual count. No film footage, no live report. Does this kind of thing happen so often that no one cares anymore? Don't those people know what we've been through?...Are they telling us it was insignificant, it was piddling? Are they so callous?...Don't

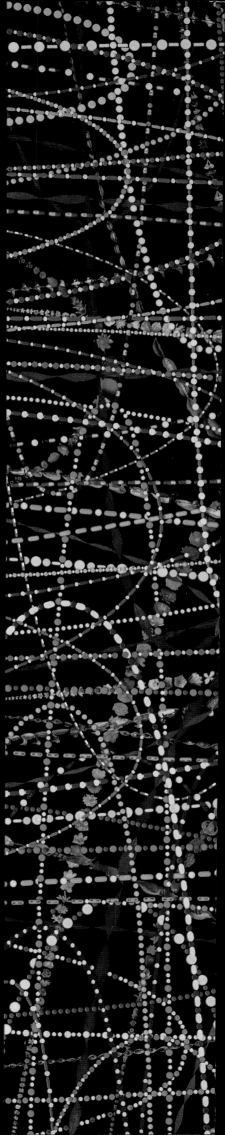

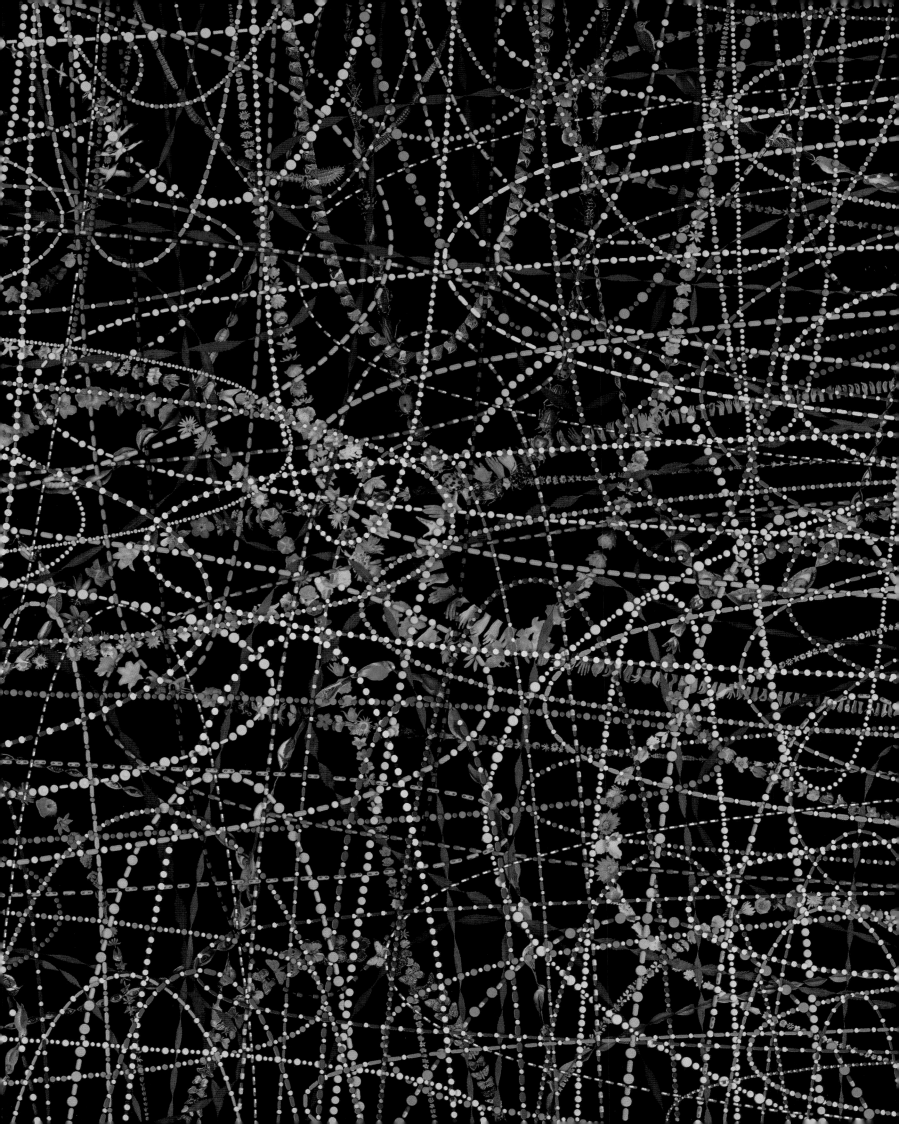

they know it's real? Shouldn't the streets be crawling with cameramen and soundmen and reporters?...Even if there hasn't been great loss of life, don't we deserve some attention for our suffering, our human worry, our terror? Isn't fear news?" [22]

DeLillo's acerbic conflation of voyeurism and exhibitionism in relation to television perfectly encapsulates the telephilic condition contaminating our culture. Nothing is considered valuable or real unless broadcast by the media, no matter how exaggerated or frivolous it may appear. In the recent past, this truth has been aggressively exploited by politicians and terrorists alike. Television has become a propagandistic tool, promoting a campaign of fear and intimidation that serves (inadvertently) both those in power and those seeking to destroy that power. Johan Grimonprez's video *Dial H-I-S-T-O-R-Y* (1997)—a gripping montage of television footage recording acts of global terrorism from the 1950s to the early 1990s—is prescient in its analysis of how terror feeds the media, which in turn feeds our contemporary "wound culture." [23] The work takes as its subject

O.T. (Fleckenbild). 1988
Wool
160 x 360 cm/63 x 141 3/4 in.

ROSEMARIE ▶
TROCKEL
Born in Schwerte, Germany, 1952/Lives in Cologne

the history of hijacking from the earliest seizures of flights to Havana as explicit political gestures to the anonymous suitcase bomb that brought down Pan Am Flight 103 over Lockerbie, Scotland, in 1988. Graphic disaster scenes are intercut with cameo appearances by world leaders, public figures, and terrorists alike: Richard Nixon, Fidel Castro, Yasir Arafat, Che Guevara, Nikita Khrushchev, along with members of the Baader-Meinhof group and the PLO. The documentary footage—which shows the evolution of television technology, from black-and-white to color—is collaged with excerpts from older newsreels, the scene of the flying house from *The Wizard of Oz*, instructional films about terrorism deterrence, and video fragments showing airport interiors. The visuals are set to a disco soundtrack (compiled by composer David Shea) punctuated by excerpts from DeLillo's *White Noise* and *Mao II* (1991). Songs like "Do the Hustle," which accompanies the final sequence of planes plummeting from the sky, are interspersed with a fictional DeLillion conversation between a terrorist and a novelist about the fact that today acts of terrorism are providing a new, profound narrative capable of penetrating and transforming the cultural consciousness, a goal

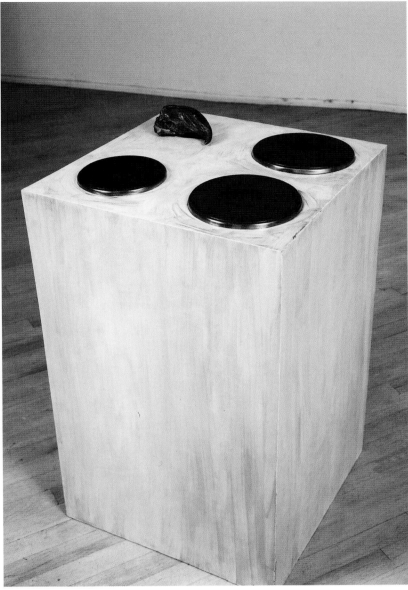

◀ ROSEMARIE
TROCKEL

Untitled. 1987
Iron, electric burners, enamel paint, and plaster with patina
50.1 x 50.1 x 88.2 cm/19 3/4 x 19 3/4 x 34 3/4 in.

typically belonging to the literary realm. For DeLillo, in a society anesthetized by repetition, superficiality, and flagrant consumption, terror may be the only significant act. Even so, in this post-9/11 world, we have seen how unimaginable terror can itself be used to fulfill society's insatiable need for celebrity and the most trivial forms of entertainment. Grimonprez understood as much; *Dial H-I-S-T-O-R-Y* ends with footage of a hijacked plane crashing into the ocean that was unintentionally recorded on a camcorder by vacationing newlyweds, who were immediately invited to appear on CNN's *Larry King Live* to relate their experience of the tragedy.

The events of 9/11 and their continuing aftermath seem intended for television consumption. The perpetrators of the attacks choreographed a suicidal mission designed to insure maximum international media coverage, which, in turn, transformed a geographically specific massacre into a global-scale assault. Terrorism has no recognized boundaries.[24] While tragically real, events related to the destruction of the World Trade Center, the invasions of Afghanistan and Iraq, and the continuing

The Whole Public Thing. 1986
Process inks on canvas and toilet seats
45,7 x 177,8 x 177,8 cm/18 x 70 x 70 in.

In the Vicinity of History. 1988
Process inks and acrylic paint on canvas
243,8 x 438,1 x 21,5 cm/96 x 172 1/2 x 8 1/2 in.

MEYER ▶
VAISMAN
Born in Caracas, 1960/Lives in Barcelona

A B

terrorist-initiated violence around the world seem scripted for
the TV viewer: from George W. Bush's carefully staged "Top Gun"
appearance on the *Abraham Lincoln* aircraft carrier to announce
(erroneously) the "mission accomplished" in Iraq, to Osama Bin
Laden's periodic pronouncements of doom on Al-Jazeera, which
are immediately picked up by the international press. The po-
litical and commercial exploitation of 9/11 was not lost on cul-
tural provocateur Tom Sachs, whose handcrafted *bricolage* work
examines the marketing of modernist phenomena, from Le Cor-
busier's International Style architecture to Hello Kitty children's
toys. Under his signature label of "cultural prosthetics," Sachs
created a major art world controversy in 1998 when he fashioned
a miniature German death camp inside a Prada merchandise box
for an exhibition at the Jewish Museum in New York.[25] In reaction
to 9/11, he created the sculpture *Two Boeing 767s* (2001), large-
scale, foamcore models of the aircraft used as missiles to down
the Twin Towers. Created shortly after the crisis—with the speed

A President Bush boards a Navy S-3B Viking plane at North Island Naval
 Station in Coronado, California, on May 1, 2003, to fly to the aircraft car-
 rier the USS *Abraham Lincoln*, where he will deliver a speech to the nation.

B President Bush tours the *Abraham Lincoln* on May 1, 2003, off the
 California coast. In his speech aboard the aircraft carrier that evening,
 as it steams toward San Diego following a record ten-month deployment,
 Bush will declare that major combat in Iraq is finished.

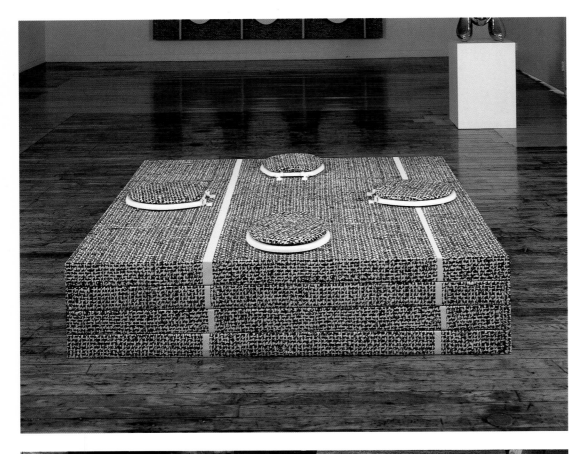

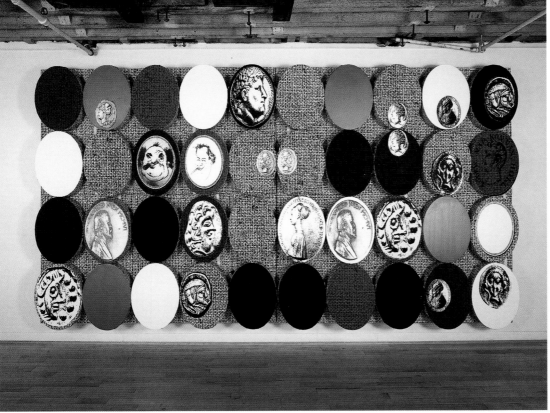

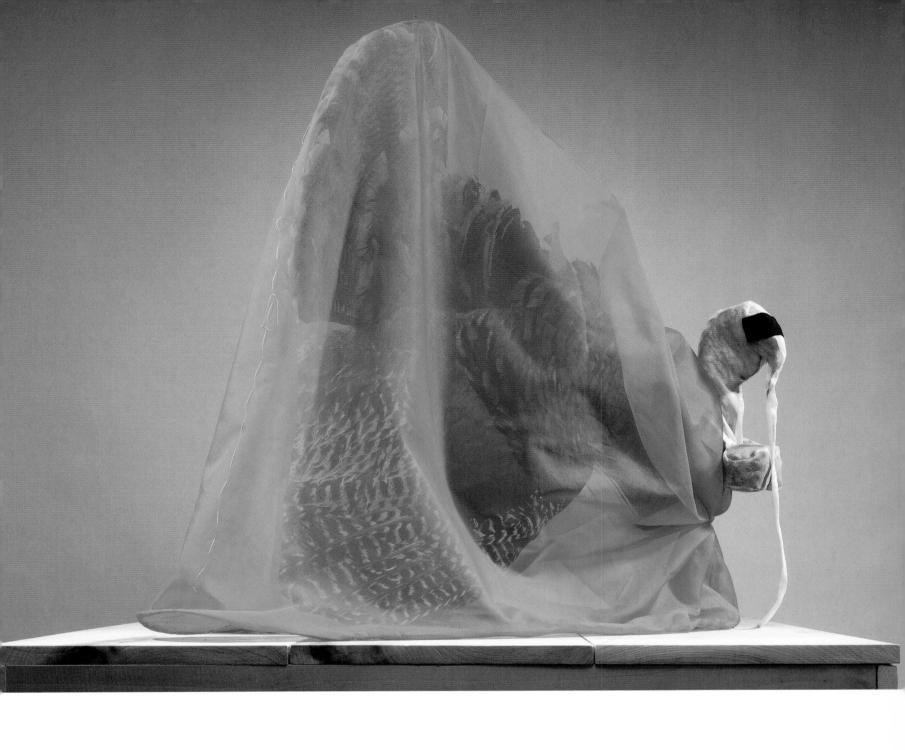

Untitled Turkey VIII (Fuck Bush). 1992
Silk organza men's underwear, stuffed turkey, and other media
81 x 111,5 x 86 cm/31 7/8 x 43 7/8 x 33 7/8 in.

and seeming callousness that is a hallmark of Sachs's artistic persona—the two planes hover in parallel formation like bloated souvenirs of an indescribable horror. They function as early reminders of how 9/11 would be mourned, manipulated, and consumed by disparate factions all over the world.

Cattelan, art-world prankster par excellence, posited a different response to the implications of 9/11. As in all of his conceptual practice, the sculpture *Frank & Jamie* (2002) is at once comical and somber. Two perfectly crafted, life-size, wax effigies of New York City policemen, one with arms crossed casually across his chest, lean against the wall staring into the distance. All is seemingly well except for the fact that the two figures are upside-down, balancing on their NYPD caps. Their parallel poses and identical uniforms create a human analogy to the symmetrical architecture of the World Trade Center towers. Cast in wax, like

Being the True Account of the Life of N. 1996
Paper and adhesive
Approx. 12 x 4,5 m/39 ft. 4 1/2 in. x 14 ft. 9 1/8 in.

KARA ▶
WALKER
Born in Stockton, California, 1969/Lives in Providence, Rhode Island

all the historical characters immortalized
in Madame Tussaud's uncanny mausoleum
to fame, *Frank & Jamie* forms an unlikely
memorial to the victims of 9/11 and the un-
stable world left in its wake. Master of the
poignantly disarming gesture—like his er-
satz homeless figures huddled in a corner
or the lifeless (taxidermied) dogs "sleeping"
on chairs—Cattelan interrupts reality with
a dose of reality. His all-too-human monu-
ment to 9/11 reminds us that ours is a cul-
ture without a coherent narrative; we are
now living in a world literally downside-up.
Even the powers that be and their most ef-
fective mouthpiece, broadcast television,
can no longer make sense of it.

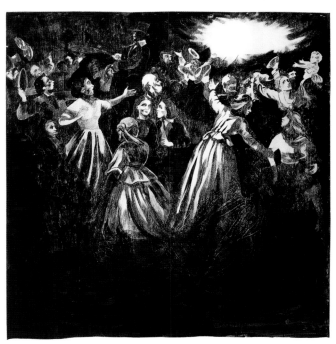

Untitled. 2000
Charcoal, gesso, and gouache on paper
205,7 × 199,3 cm/81 × 78 1/2 in.

Notes

1 Tom Engelhardt, *The End of Victory Culture: Cold War America and the Disillusion-ing of a Generation* (Amherst: University of Massachusetts Press, 1998), 182.

2 Ibid.

3 Engelhardt's *The End of Victory Culture* analyzes this phenomenon and its political repercussions in great detail from the mid-1940s to the Persian Gulf War. Much of the sociopolitical commentary presented here is in-debted to Engelhardt's penetrating study.

4 See Kaja Silverman, *Male Subjectivity at the Margins* (New York and London: Routledge, 1992), for her discussion of the "dominant fiction," a cultural contract in place for centuries that secures patriarchal power.

5 On March 16, 1968, in the village of My Lai on the Battambang Peninsula in Quangngai Province, South Vietnam, American soldiers killed 502 people, including more than 170 children. Three hundred houses were destroyed, countless women raped, and 870 head of cattle killed. More than twenty months went by before true accounts of the atrocity were published by the American media after a prolonged military cover-up.

6 During the Tet Holiday in 1968, the North Vietnamese launched a synchro-nized attack on more than one hundred targets throughout the South, including Saigon. In order to take back the conquered regions, the U.S. resorted to air strikes, nearly leveling many of its targets.

7 Antiwar protesters used the convention as a platform. What began as peaceful demonstrations ended in violent skirmishes with the police. As the riots escalated, Mayor Daley called in the troops. In total, 11,900 Chicago police, 7,500 Army regulars, 7,500 Illinois National Guardsmen, and 1,000 FBI and Secret Service agents were stationed in the city. Police and other authorities used force to keep the demonstrators away from the delegates' headquarters. At the close of the convention, authorities claimed that 589 people had been arrested and more than 119 police and 100 demonstrators injured.

8 Walter Cronkite quoted in Engelhardt, *The End of Victory Culture*, 243.

9 In a recent study of one hundred local television newscasts in fifty-six cities by the Rocky Mountain Media Watch, it was reported that local crime occupied 30 percent of what little time was actually devoted to the news (40 percent). Commercials consumed an almost equal amount of time (36 percent). Sports and weather filled 22 percent; anchor chatter, 2 percent. See Lawrence K. Grossman, "Why Local TV News Is So Awful," *CJR* (Colum-bia University, N.Y.) (Nov.–Dec. 1997), *www.cjr.org/year/97/6/grossman.asp.*

10 The literature on trauma is vast, spanning psychoanalytical studies to film theory. The works consulted for this essay include: Cathy Caruth, ed., *Trauma: Explorations in Memory* (Baltimore and London: Johns Hopkins University Press, 1995); Kirby Farrell, ed., *Post-Traumatic Culture: Injury and Interpretation in the Nineties* (Baltimore and London: Johns Hopkins University Press, 1998); Ruth Leys, *Trauma: A Genealogy* (Chicago and London: Univer-sity of Chicago Press, 2000); and *Trauma and Screen Studies*, special issue of *Screen* (London) 42, no. 2 (summer 2001), ed. Simon Frith, Annette Kuhn, and Jackie Stacy.

11 This text deals only with cultural-scale trauma and not individual trauma such as that resulting from infantile sexual trauma (for example, fear of castration) or childhood abuse.

12 Maurice Blanchot, *The Writing of the Disaster*, trans. Ann Smock (Lincoln and London: University of Nebraska Press, 1986), 7.

13 Such is the thesis put forth by Hayden White, "The Modernist Event," in Vivian Sobchack, ed., *The Persistence of History: Cinema, Television, and the Mod-ern Event* (New York and London: Routledge, 1996), 17–38.

14 In 1996, the Global Aids Policy Coalition estimated that in 1990 some ten million people were infected worldwide. By 1996, they cited some 30.6 mil-lion infected, noting that the pandemic would only worsen, with its great-est toll in developing nations. See William Harver, "Interminable AIDS," in Linda Belau and Peter Ramadanovic, eds., *Topologies of Trauma: Essays on the Limit of Knowledge and Memory* (New York: Other Press, 2002), 37.

15 For example, the controversy that arose when four American performance artists—Karen Finley, Tom Fleck, Holly Hughes, and Tim Miller—sued the National Endowment for the Arts after grants awarded them in 1990 were rescinded on grounds of indecency reveals how disruptive an arena the dystopic body and its representations can be. Federal monies were denied the artists on the pretense that public funding should not support "obscenity." First amendment rights aside, what the right wing, funda-mentalist faction of the government regarded to be pornographic about these artists' works was less about nudity, profanity, and references to bodily excess (phenomena with little shock value anymore) than the fact that they made manifest—in the most graphically visual and visceral terms—the embattled state of the body. The deliberate outrageousness of much performance art made this work an easy target for conservative politicians seeking tokens of moral degeneracy in order to bolster plat-forms that preached "family values" premised on xenophobia, homopho-bia, and misogyny. In this intellectually regressive climate, a veritable crusade was launched against almost any artwork—from photographs by Robert Mapplethorpe to sculptures by Kiki Smith—that openly questioned the body as a unified subject, protested coercive attitudes toward sexu-ality, and celebrated the polymorphousness of desire.

16 The following descriptions of the shows are taken from the program's official Web site, *www.jerryspringer.com*: "Volita will reveal a horrible secret to her daughter, Silina. She has been sleeping with Silina's boyfriend, Marcus, for 6 months! Silina begs Marcus not to leave her, but even her confession that she's pregnant will not sway him from her mother! Next... Nikki's brother, Billy, is not happy to find out that his sister is a prostitute. He's even more disgusted when Nikki's boyfriend comes out to defend her! Then... Sharon and Nick are here to make Sharon's husband, Bryan, understand that Sharon is leaving him. Sharon loves Nick and will even accept his proposal of marriage!" (Sept. 11, 2003). "Siblings, Brandy and Chris have a lot of explaining to do... They've been sleeping together for two years! Both of them will be confronted by Chris' wife, Brandy's husband and even their own mother! Next... A different Brandy promised her husband, Won, she'd stop sleeping around with women. But she'll confess today that she's back to her old ways... with his sister!" (Sept. 12, 2003).

17 Quoted from *www.judgejudy.com.*

18 Frank Rich, "The Irresistible Rise of Telephilia," *New York Times*, June 8, 2003, Arts and Leisure section, *www.nytimes.com.*

19 Andy Warhol, Kasper König, Pontus Hultén, and Olle Granath, eds., *Andy Warhol* (Stockholm: Moderna Museet, 1968), unpag.

Allegory. 1996
Gouache on paper
162 × 131 cm/63 3/4 × 51 1/2 in.

Philadelphia. 1996
Gouache on paper
204,5 × 131 cm/80 1/2 × 51 5/8 in.

Duet. 1996
Gouache on paper
157,5 × 131 cm/62 × 51 1/2 in.

Leaving the Scene. 1996
Gouache on paper
155,5 × 131 cm/61 1/4 × 51 1/2 in.

20 Cattelan made a total of five hundred masks; they were split into ten pieces with fifty masks each. *Spermini* is used to illustrate an excerpt from Philip Roth's *Portnoy's Complaint* (1969) on the adolescent angst and pleasure associated with masturbation included in Francesco Bonami, Massimiliano Gioni, Nancy Spector, et al., *Maurizio Cattelan*, rev. ed. (London: Phaidon Press, 2003), 102–5.

21 Don DeLillo, *White Noise* (New York: Viking Critical Library, 1998), 64.

22 Ibid., 161–62.

23 The term is Mark Selzer's. See his "Wound Culture: Trauma in the Pathological Public Sphere," *October* 80 (spring 1997), 3–26.

24 See Bill Schaffer, "Just Like a Movie: September 11 and the Terror of Moving Images," *www.senseofcinema.com/contentws/01/17/symposium/schaffer/html*. "By seizing control of four planes, [the terrorists] also commanded our perception, acting as voluntary directors of their own death scenes, orchestrators of a worldwide special effects display. The deliberate choice of the World Trade Centre as target announced a suicidal-homicidal will that could not be bargained with at any level. The implied promise that all viewers are potential victims added a frightening 'interactive' dimension to the spectacle."

25 The model concentration camp was exhibited as part of the show *Mirroring Evil: Nazi Imagery/Recent Art* at the Jewish Museum in New York, where it generated great controversy by inflaming art critics and Holocaust survivors alike.

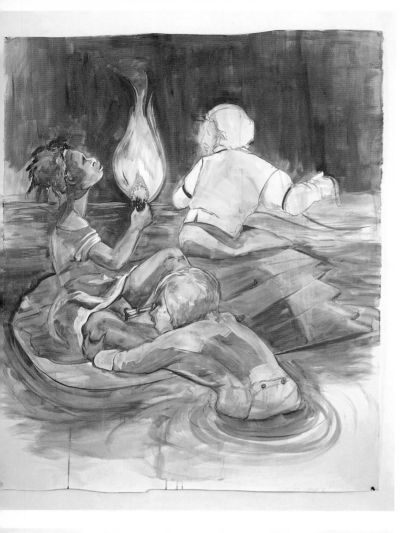

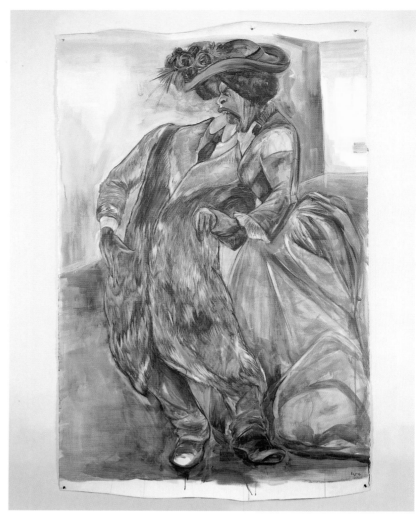

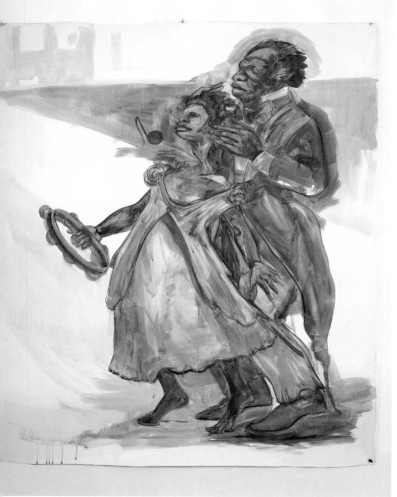

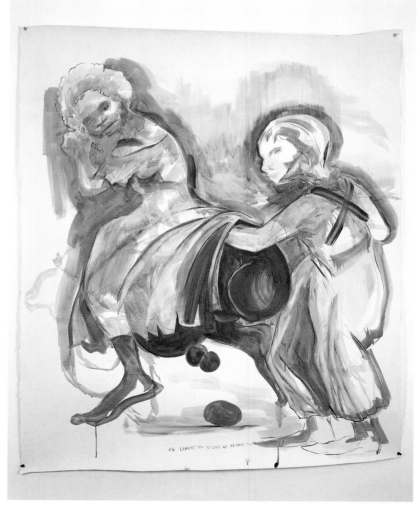

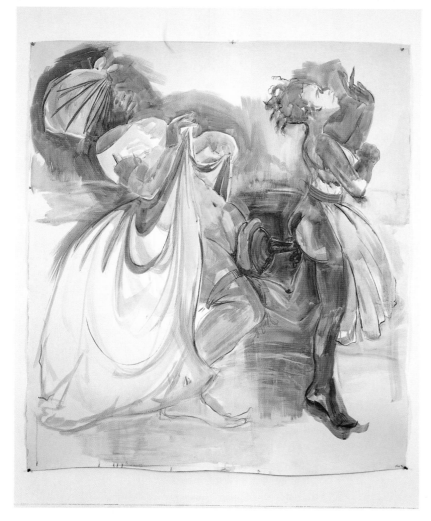

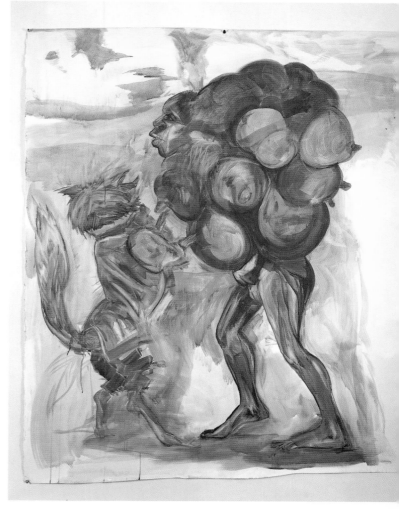

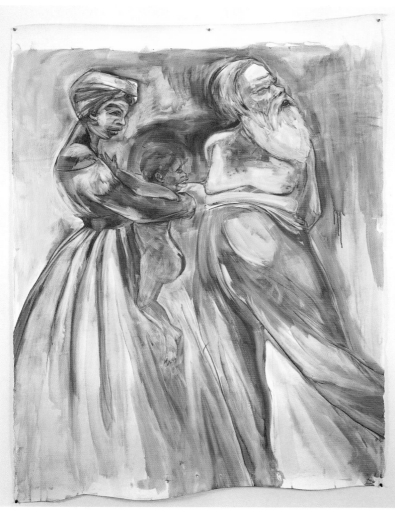

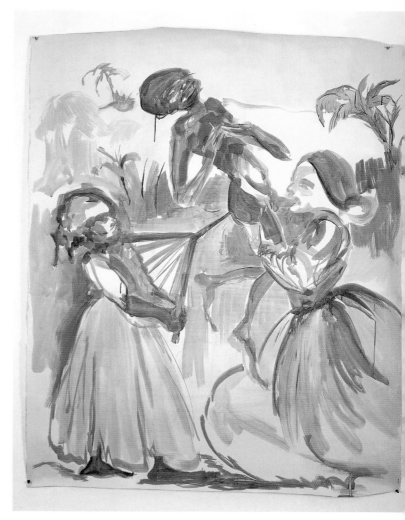

Selected Installations of Works from the
Dakis Joannou Collection

Cultural Geometry

Psychological Abstraction

Artificial Nature

Post Human

Everything That's Interesting Is New

Global Vision: New Art from the 90s
(Parts I and II)

Jeff Koons: A Millennium Celebration—
Works from the Dakis Joannou Collection
1979–1999

Tim Noble & Sue Webster—
Masters of the Universe

Dakis Joannou residence

Dakis Joannou yacht

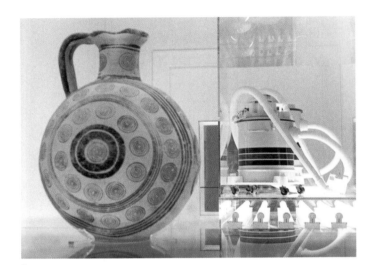

A

B

A, B *Cultural Geometry*, The House of Cyprus, Athens,
18 January–17 April 1988

Hunger Cradle. 1996
Mixed media
Dimensions vary

NARI ▶
WARD
Born in Kingston, Jamaica, 1963/Lives in New York

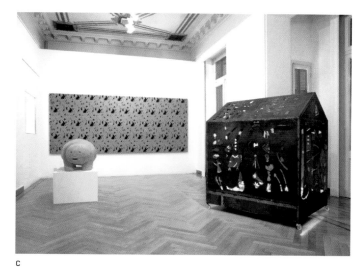

C

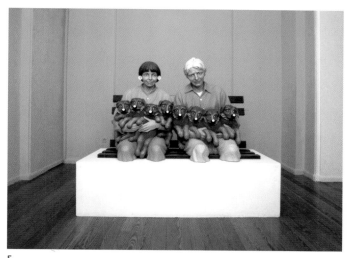

E

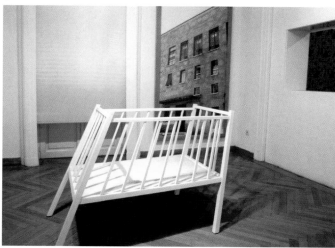

D

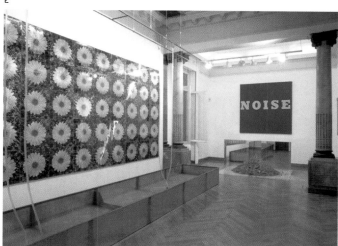

F

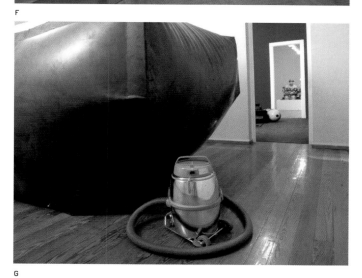

G

C, D *Psychological Abstraction*, The House of Cyprus, Athens,
18 July–16 September 1989

E, F, G *Artificial Nature*, The House of Cyprus, Athens,
20 June–15 September 1990

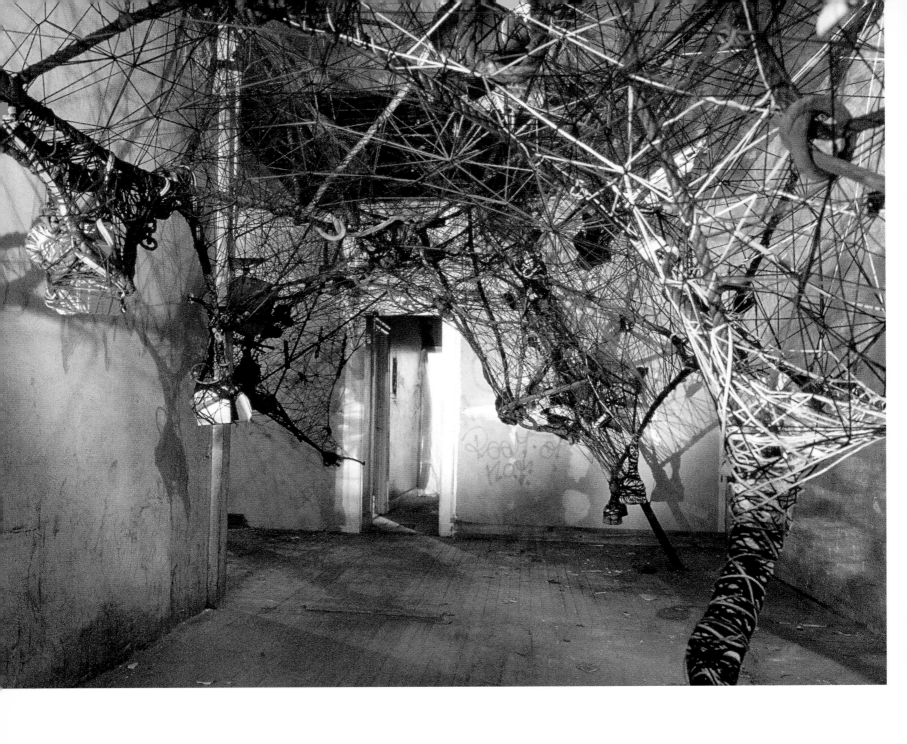

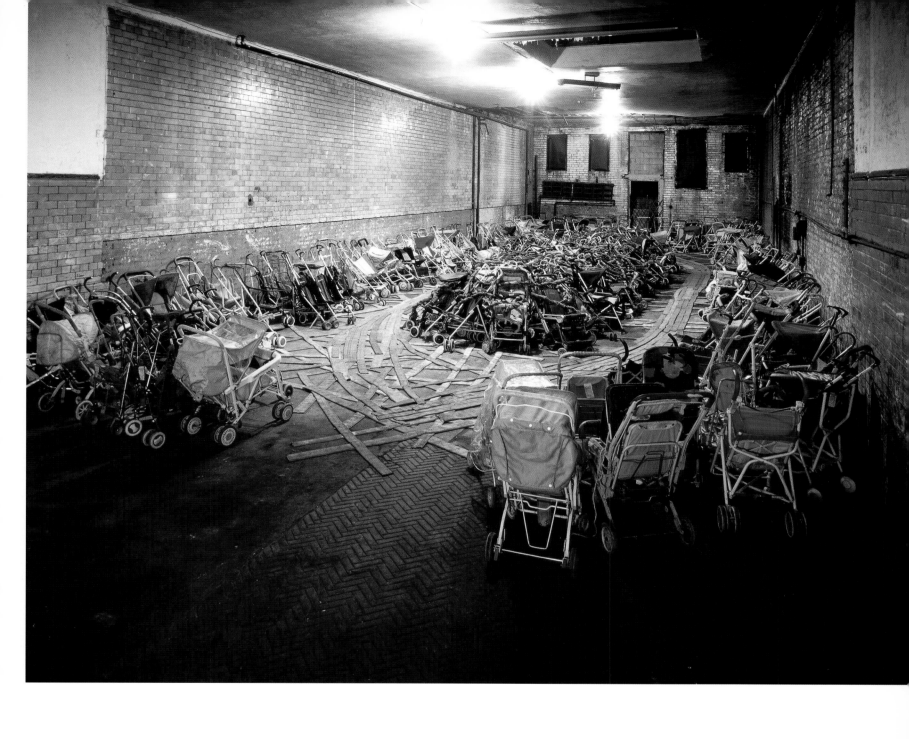

Amazing Grace, 1993
280 baby carriages, fire hose, and cassette tape
Dimensions vary

A

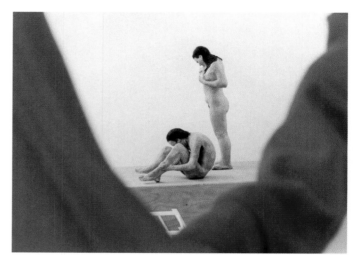

B

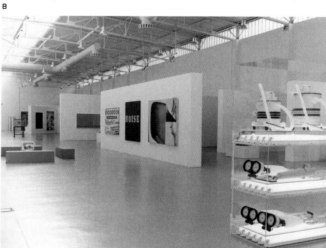

C

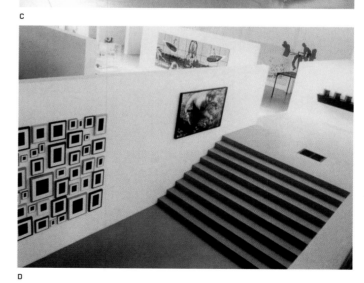

D

A *Post Human*, The House of Cyprus, Athens,
3 December 1992–14 February 1993

B, C, D *Everything That's Interesting Is New*, The Factory, National School of Fine Arts,
Athens, 20 January–20 April 1996

Brillo Box. 1964
Silkscreen ink on wood
43,1 x 43,1 x 35,5 cm/17 x 17 x 14 in.

ANDY ▶
WARHOL
Born in Pittsburgh, Pennsylvania, 1928/Died in New York, 1987

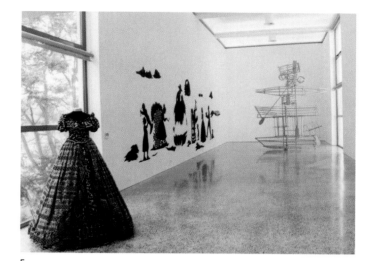

E

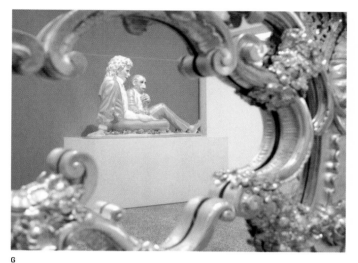

G

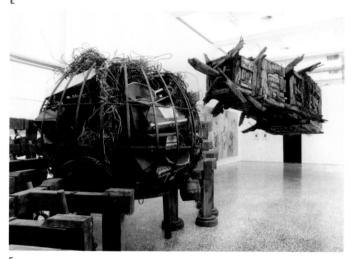

F

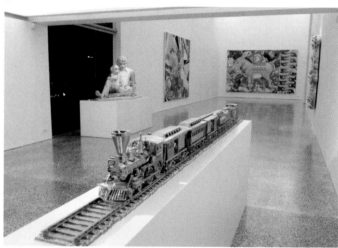

H

E *Global Vision: New Art from the 90s* (Part I), DESTE Foundation
Centre for Contemporary Art, Athens, 7 May–28 June 1998

F *Global Vision: New Art from the 90s* (Part II), DESTE Foundation
Centre for Contemporary Art, Athens, 7 July–7 November 1998

G, H *Jeff Koons: A Millennium Celebration—Works from the Dakis Joannou Collection
1979–1999*, DESTE Foundation Centre for Contemporary Art, Athens,
15 December 1999–15 May 2000

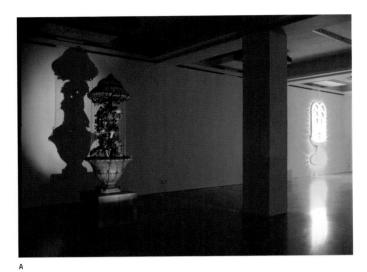

A

B

A *Tim Noble & Sue Webster—Masters of the Universe*, DESTE Foundation
Centre for Contemporary Art, Athens, 25 September–11 November 2000

B Tim Noble and Sue Webster during the installation of
Masters of the Universe

428

Signs That Say What You Want Them To Say.... 1992–93
C-print
120,1 × 79,7 cm/47 1/4 × 31 3/8 in.

GILLIAN ▶
WEARING
Born in Birmingham, England, 1963/Lives in London

C

F

D

G

E

C, D, E Dakis Joannou residence

F, G Dakis Joannou yacht

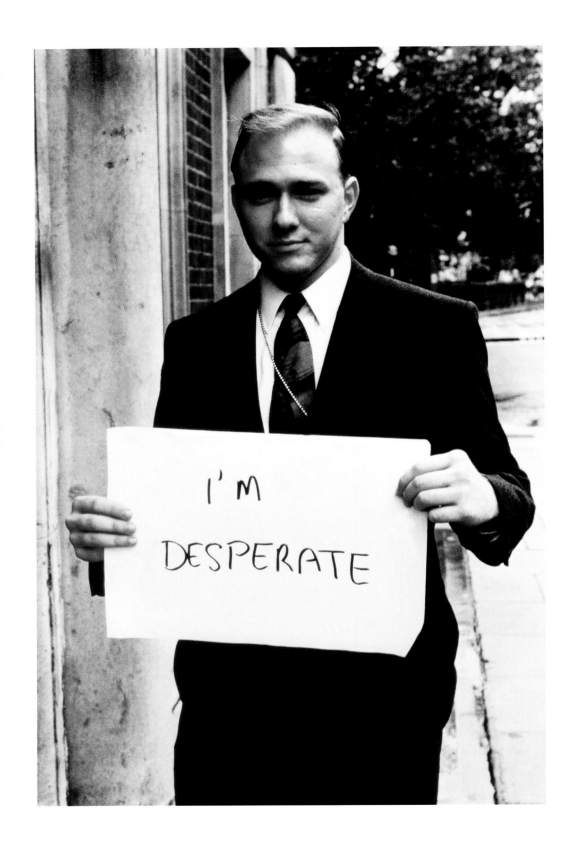

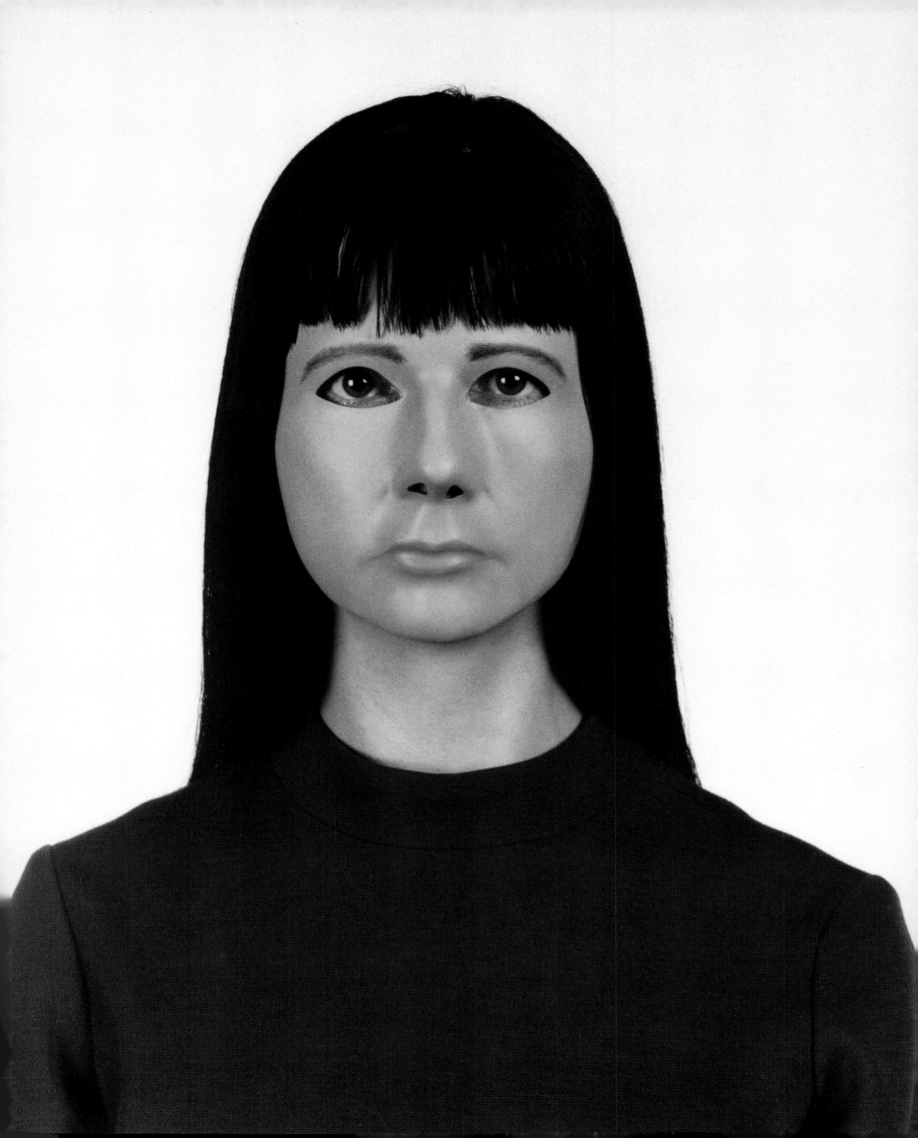

About the
DESTE Foundation for Contemporary Art

The DESTE Foundation for Contemporary Art was established in 1983 by the international art collector Dakis Joannou and is based in Athens, Greece. DESTE is a nonprofit foundation that organizes exhibitions and supports publications that explore the relationship between contemporary art and culture. It aims to broaden the audience for contemporary art, to enhance opportunities for young artists, and to establish a dialogue between generations through an exhibition program that promotes emerging as well as established artists.

From its inception until 1998, when it moved to its permanent quarters, DESTE mounted several shows in Greece and Cyprus and sponsored various cultural events in Athens, Geneva, and Venice. These included *Cultural Geometry, Psychological Abstraction, Artificial Nature,* and *Post Human,* a series of exhibitions curated by Jeffrey Deitch that drew on the holdings of the Dakis Joannou collection. The highlight of the series was *Everything That's Interesting Is New,* which was held in 1996 at The Factory at the National School of Fine Arts, Athens. This major show and its accompanying catalogue featured two hundred works from the Joannou collection by approximately one hundred internationally recognized artists.

Since May 1998, the foundation has hosted more than twenty temporary exhibitions and events in its premises in Athens, presenting contemporary Greek and foreign artists and exploring current tendencies in art. These have included *Global Visions,* a tripart examination of art of the 1990s, a period when the "art world" opened up to include more countries and cultures; Jeff Koons's *A Millennium Celebration,* a solo show that featured all of his pieces from the Dakis Joannou collection; and *Masters of the Universe,* one of the first exhibitions of the work of Tim Noble and Sue Webster outside the United Kingdom.

The DESTE Foundation's exhibition and publishing program has helped assure Athens's inclusion in the global art community. It provides a Greek audience with the opportunity to experience works by major artists from around the world, and introduces contemporary Greek art to an international public. To further support its mission, the foundation inaugurated the DESTE Prize, which is awarded biannually to a Greek artist. DESTE has also established the Contemporary Artists Archive, which serves as a research tool for local and international curators and helps facilitate Greek artists' efforts to participate in exhibitions worldwide.

Exhibitions Organized by the
DESTE Foundation for Contemporary Art

7 Greek Artists—A New Journey

The Gate of Fammagusta, Nicosia, 5–28 December 1983
Curated by Efi Strousa
Exhibition catalogue

Dimitris Alithinos, Bia Davou, Diohandi,
Leda Papaconstantinou, Rena Papaspyrou, Totsikas,
Costas Varotsos

Cultural Geometry

The House of Cyprus, Athens, 18 January–17 April 1988
Curated by Jeffrey Deitch
Exhibition installation by Haim Steinbach
Exhibition catalogue

John Armleder, Richard Artschwager, Ashley Bickerton, Scott Burton, John Dogg, Nancy Dwyer, R. M. Fischer, Katharina Fritsch, Robert Gober, Dan Graham, Peter Halley, Jenny Holzer, Niek Kemps, Harald Klingelholler, Jeff Koons, Annette Lemieux, Sherrie Levine, Simon Linke, Allan McCollum, Gerhard Merz, Matt Mullican, Robert Smithson, Haim Steinbach, Rosemarie Trockel, Meyer Vaisman, Jan Vercruysse, Wallace & Donohue

Sculture da Camera

The House of Cyprus, Athens, 4–30 October 1988
Curated by Galleria Bonomo

Carl Andre, Giovanni Anselmo, John Armleder, Barbro Backstrom, Douglas Beer, Joseph Beuys, Mel Bochner, Alighiero e Boetti, Jonathan Borofsky, André Cadere, Biagio Caldarelli, Bruno Ceccobelli, Stephen Cox, Gino de Dominicis, Chérif et Silvie Defraoui, Tullio de Gennaro, Franco Dellerba, Nicola de Maria, Diohandi, Jiri George Dokoupil, Piero Dorazio, Marcel Duchamp, Fischli & Weiss, Joel Fisher, Lucio Fontana, Richard Francisco, Rebecca Horn, Shirazeh Houshiary, Niek Kemps, Jannis Kounellis, Sol LeWitt, Paolo Lunanova, Ingeborg Lüscher, Piero Manzoni, Fausto Melotti, Mario Merz, Marisa Merz, Afranio Metelli, David McDermott & Peter McGough, Matt Mullican, Richard Nonas, Nunzio, Luigi Ontani, Julian Opie, Meret Oppenheim, Mimmo Paladino, Nakis Panayotidis, Giulio Paolini, Pino Pascali, Vettor Pisani, Julião Sarmento, Mario Schifano, Rob Scholte, George Segal, Joel Shapiro, Pat Steir, Ernesto Tatafiore, Jean Tinguely, David Tremlett, Richard Tuttle, Christos Tzivelos, Jean Luc Vilmouth

Topos-Tomes

The House of Cyprus, Athens, 3–27 April 1989
Curated by Haris Savopoulos
Exhibition catalogue

Nicos Baikas, Yannis Fokas, Apostolos Georgiou, Stelios Koupegos, George Lappas, Eleni Nikodimou, Angelos Scourtis, Thanassis Totsikas, Nicos Tziotis, Christos Tzivelos, Costas Varotsos

Psychological Abstraction

The House of Cyprus, Athens, 18 July–16 September 1989
Curated by Jeffrey Deitch
Exhibition catalogue

John Armleder, Nicos Baikas, Alan Belcher, Gretchen Bender, Mary Carlson, Grenville Davey, Marcel Duchamp, Nancy Dwyer, Fischli & Weiss, Günther Förg, Robert Gober, Joe Goode, Thomas Grunfeld, Peter Halley, Christina Iglesias, Harald Klingelholler, Jeff Koons, George Lappas, Annette Lemieux, Man Ray, Piero Manzoni, Juan Muñoz, Rob Scholte, Thomas Schütte, Mark Stahl, Philip Taaffe, Kathleen Thomas, Ti Shan Hsu, Rosemarie Trockel, Meyer Vaisman, Jan Vercruysse, Wallace & Donohue

Panos Koulermos: Topos, Memory + Form

The House of Cyprus, Athens, 10 February–10 March 1990
Curated by *TEFCHOS Architectural Review*
Exhibition catalogue

Eliminating the Atlantic

Warehouse A, Pier 1, Thessaloniki Harbor, Thessaloniki,
12 May–16 June 1990
Curated by Haris Savopoulos
Exhibition catalogue

Laurie Anderson, John Armleder, Ashley Bickerton, Panayotis Cacoyannis, Nancy Dwyer, R. M. Fischer, Fischli & Weiss, Robert Gober, Fariba Hajamadi, Jenny Holzer, Christina Iglesias, Niek Kemps, Harald Klingelholler, Jeff Koons, Barbara Kruger, George Lappas, Annette Lemieux, Juan Muñoz, Peter Nagy, Thomas Schütte, Haim Steinbach

Artificial Nature

The House of Cyprus, Athens, 20 June–15 September 1990
Curated by Jeffrey Deitch
Exhibition catalogue

Ashley Bickerton, Clegg & Guttmann, Walter de Maria, Laura Grisi, Martin Kippenberger, Jeff Koons, Liz Larner, Tatsuo Miyajima, Peter Nagy, Pino Pascali, Ed Ruscha, Manuel Saiz, Robert Smithson, William Stone, Thanassis Totsikas, Andy Warhol, Meg Webster

Aphrodite: Harmony and Inconceptuality

The Gate of Fammagusta , Nicosia, 10–29 September 1990
Curated by Demosthenes Davvetas

Marina Abramovic, Xavier Bordes, Werner Buttner, Demosthenes Davvetas, Michel Deguy, Manos Eleftheriou, Theodoulos Grigoriou, Hubert Kiecol, George Lappas, Jean Le Gac, Angelos Makrides, Jean-Luc Nancy, Mimmo Paladino, Marie Françoise Poutays, Georges Rousse

Assault on the Senses

The House of Cyprus, Athens, 24 June–24 September 1991
Curated by Catherine Cafopoulos
Exhibition catalogue

Haris Condosfyrris, Dimitris Dokatzis, Yannis Kourakis, Aphrodite Littis, Miltos Manetas, Elias Marmaras, Maria Papadimitriou, Tassos Pavlopoulos

Post Human

The House of Cyprus, Athens,
3 December 1992–14 February 1993
Curated by Jeffrey Deitch
Exhibition catalogue

Dennis Adams, Janine Antoni, John Armleder, Stephan Balkenhol, Matthew Barney, Ashley Bickerton, Taro Chiezo, Clegg & Guttmann, Wim Delvoye, Suzan Etkin, Fischli & Weiss, Sylvie Fleury, Robert Gober, Felix Gonzalez-Torres, Damien Hirst, Martin Honert, Mike Kelley, Karen Kilimnik, Martin Kippenberger, Jeff Koons, George Lappas, Annette Lemieux, Christian Marclay, Paul McCarthy, Yasumasa Morimura, Kodai Nakahara, Cady Noland, Daniel Oates, Pruitt & Early, Charles Ray, Thomas Ruff, Cindy Sherman, Kiki Smith, Pia Stadtbäumer, Meyer Vaisman, Jeff Wall

Spring Collection

The House of Cyprus, Athens, 16 January–2 March 1996
Curated by Helena Papadopoulos
Exhibition catalogue

Katerina Athanassiou, Eleni Christodoulou, Christina Dimitriadis, Alexandros Georgiou, Sophia Kosmaoglou, Nikos Kreonidis, Miltos Manetas, Joanna Mirka, Aliki Palaska, Maria Papadimitriou, Helen Sarris, Sokratis Sokratous, Katerina Würthle

Everything That's Interesting Is New

The Factory, National School of Fine Arts, Athens,
20 January–20 April 1996
Coordinated by Jeffrey Deitch
Exhibition catalogue

Marina Abramovic, Vito Acconci, Dennis Adams, Laurie Anderson, Janine Antoni, Arman, John Armleder, Richard Artschwager, John Baldessari, Matthew Barney, Vanessa Beecroft, Ashley Bickerton, Ross Bleckner, Alighiero e

Boetti, Jonathan Borofsky, Dinos & Jake Chapman, Clegg & Guttmann, Crash (John Matos), Gregory Crewdson, Grenville Davey, Wim Delvoye, Walter de Maria, John Dogg, Cheryl Donegan, Stan Douglas, Marcel Duchamp, R. M. Fischer, Fischli & Weiss, Dan Flavin, Günther Förg, Katharina Fritsch, Gilbert & George, Robert Gober, Jack Goldstein, Dan Graham, Peter Halley, Damien Hirst, Jenny Holzer, Rebecca Horn, Donald Judd, Mike Kelley, Niek Kemps, Jon Kessler, Toba Khedoori, Martin Kippenberger, Jeff Koons, Joseph Kosuth, Jannis Kounellis, Barbara Kruger, George Lappas, Liz Larner, Annette Lemieux, Sherrie Levine, Simon Linke, Man Ray, Piero Manzoni, Christian Marclay, Patty Martori, Paul McCarthy, Allan McCollum, Gerhard Merz, Tatsuo Miyajima, Yasumasa Morimura, Matt Mullican, Juan Muñoz, Peter Nagy, Bruce Nauman, Cady Noland, Gabriel Orozco, Pino Pascali, Francis Picabia, Richard Prince, Charles Ray, David Robbins, James Rosenquist, Ed Ruscha, David Salle, Rob Scholte, Thomas Schütte, Cindy Sherman, Laurie Simmons, Kiki Smith, Robert Smithson, Pia Stadtbäumer, Haim Steinbach, Philip Taaffe, Takis, Wolfgang Tillmans, Rosemarie Trockel, Meyer Vaisman, Jan Vercruysse, Wallace & Donohue, Nari Ward, Andy Warhol, Christopher Wool

Global Vision: New Art from the 90s
(Parts I, II, III)

DESTE Foundation Centre for Contemporary Art, Athens,
7 May–28 June 1998; 7 July–7 November 1998;
24 November 1998–30 January 1999
Curated by Katerina Gregos
Exhibition catalogue

Part I: Nikos Charalambidis, Kcho, Chris Ofili, Yinka Shonibare, Jocelyn Taylor, Kara Walker
Part II: Montien Boonma, Cai Guo-Qiang, Chen Zhen, Johan Grimonprez, Shahzia Sikander, Nari Ward
Part III: Dimitrios Georges Antonitsis, Matthew Barney, Rineke Dijkstra, Anna Gaskell, Mariko Mori, Alexandros Psychoulis, Pipilotti Rist

P+P=D: New (Greek) Art from the
Seventies and Eighties

DESTE Foundation Centre for Contemporary Art, Athens,
31 March–30 May 1999
Curated by Yorgos Tzirtzilakis
Exhibition catalogue

Dimitris Alithinos, Bia Davou, Diohanti, Yiannis Gaitis, Valerios Kaloutsis, Nelly Kanagini, Nikos Kessanlis, Dimitris Kontos, Yiannis Lazongas, Stathis Logothetis, Yiannis Mihas, Rena Papaspyrou, Chryssa Romanou, Angelos Skourtis, Vassilis Skylakos, Thodoros, Thanassis Totsikas, Yiorgos Touyas, Yiannis Touzenis, Costas Tsoklis, Costas Varotsos, and others

Julian Germain: In Soccer Wonderland

DESTE Foundation Centre for Contemporary Art, Athens,
31 March–16 May 1999
In collaboration with The British Council

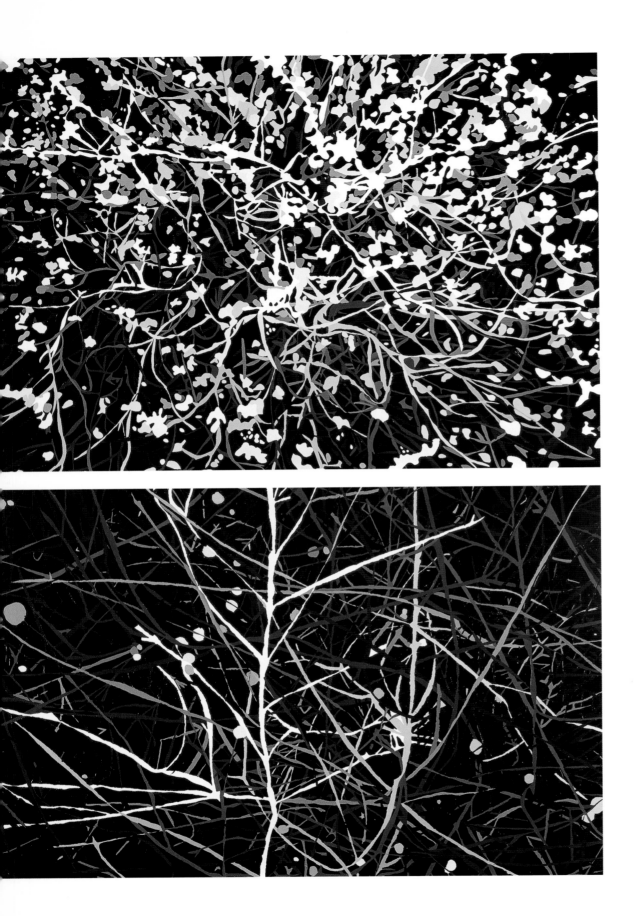

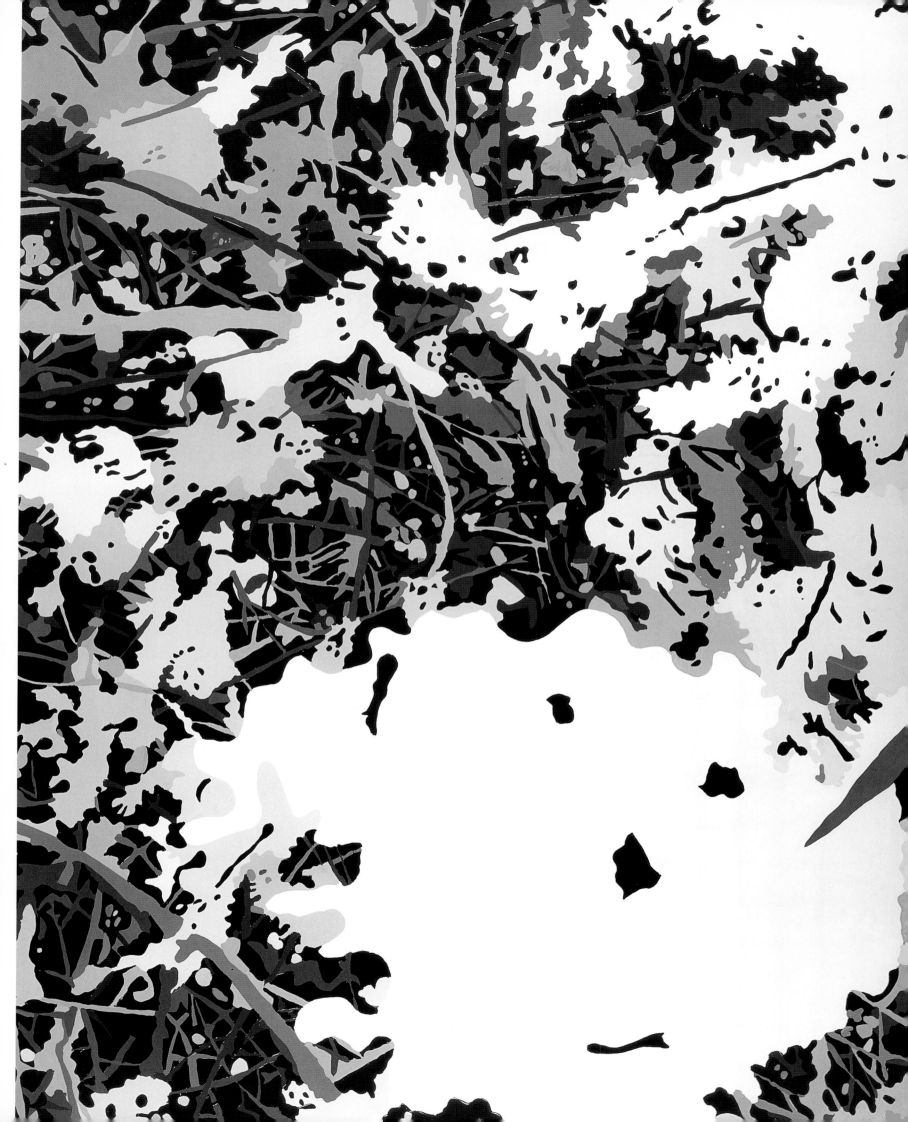

White Nancy. 2003
Enamel on aluminum
261,6 x 198,1 cm/103 x 78 in.

Metro: New Trends in

Contemporary Greek Art 1999

1st DESTE Prize
DESTE Foundation Centre for Contemporary Art, Athens,
24 June–11 October 1999
Curated by Dan Cameron
Exhibition catalogue

Maurice Ganis, Alexandros Georgiou, Kostas Ioannidis,
Despina Isaia, Panos Kokkinias, DeAnna Maganias, Lina
Theodorou, Dimitris Tsoublekas, Panayota Tzamourani

Skin

DESTE Foundation Centre for Contemporary Art, Athens,
19 October–4 December 1999
Curated by Andrea Gilbert
Exhibition catalogue

Ghada Amer, Mary Carlson, Tony Garifalakis, Dennis
Kardon, Maro Michalakakos, Yasumasa Morimura, Shirin
Neshat, Tanja Ostojić, Tony Oursler, Gérard Pascual, Marc
Quinn, Jeanne Silverthorne, Janice Sloane, Kiki Smith

Jeff Koons: A Millennium Celebration—

Works from the Dakis Joannou Collection

1979–1999

DESTE Foundation Centre for Contemporary Art, Athens,
15 December 1999–15 May 2000
Exhibition catalogue

Artifice

DESTE Foundation Centre for Contemporary Art, Athens,
20 June–16 September 2000
Curated by Ann Gallagher
In collaboration with The British Council
Exhibition catalogue

Adam Chodzko, Tacita Dean, Graham Gussin, Siobhán
Hapaska, Stephen Murphy, Simon Starling, Jane &
Louise Wilson

Tim Noble & Sue Webster—

Masters of the Universe

DESTE Foundation Centre for Contemporary Art, Athens,
25 September–11 November 2000
Exhibition catalogue

Tongue in 'Cheek

DESTE Foundation Centre for Contemporary Art, Athens,
25 November 2000–27 January 2001
Curated by Daniel Abadie
Exhibition catalogue

Gilles Barbier, Marie-Ange Guilleminot, Annette Messager,
Erik Nussbicker, Orlan, Jean-Michel Othoniel

New Acquisitions from

the Dakis Joannou Collection

DESTE Foundation Centre for Contemporary Art, Athens,
9 February–27 March 2001

Amy Adler, Monica Baer, Vanessa Beecroft, Michael Bevi-
lacqua, Richard Billingham, Rineke Dijkstra, Olafur Elias-
son, Inka Essenhigh, Anna Gaskell, Kurt Kauper, Kaws,
Gabriel Orozco, Spencer Tunick, Zhang Huan

The DESTE Prize 2001 for

Contemporary Greek Artists

2nd DESTE Prize
DESTE Foundation Centre for Contemporary Art, Athens,
8 June–30 September 2001
Exhibition catalogue

Christos Athanasiadis, Despina Christou, Sia Kyriakakos,
Dimitra Lazaridou, Eleni Lyra, Georgia Sagri,
Andreas Savva

Barry McGee/Margaret Kilgallen—Holdfast

DESTE Foundation Centre for Contemporary Art, Athens,
23 November 2001–28 February 2002

Shortcuts

Nicosia Municipal Arts Centre, Nicosia,
28 November 2001–31 March 2002
In collaboration with The Nicosia Municipal Arts Centre,
The Pierides Museum of Contemporary Art, and
The Laiki Group Cultural Centre
Exhibition catalogue

Janine Antoni, John Armleder, Matthew Barney, Vanessa
Beecroft, Ashley Bickerton, Dinos & Jake Chapman, Clegg
& Guttmann, Cheryl Donegan, Fischli & Weiss, Katharina
Fritsch, Gilbert & George, Robert Gober, Douglas Gordon,
Peter Halley, Mona Hatoum, Damien Hirst, Brad Kahlhamer,
Kaws, Martin Kippenberger, Jeff Koons, Joseph Kosuth,
George Lappas, Christian Marclay, Mariko Mori, Yasu-
masa Morimura, Shirin Neshat, Tim Noble & Sue Webster,
Cady Noland, Albert Oehlen, Chris Ofili, David Salle, Cindy
Sherman, Yinka Shonibare, Kiki Smith, Pia Stadtbäumer,
Haim Steinbach, Philip Taaffe, Rosemarie Trockel, Spencer
Tunick, Meyer Vaisman, Kara Walker, Christopher Wool,
Zhang Huan

Fusion Cuisine

DESTE Foundation Centre for Contemporary Art, Athens,
20 June–30 October 2002
Curated by Katerina Gregos
Exhibition catalogue

Janine Antoni, Cosima von Bonin, Monica Bonvicini, Tania
Bruguera, Lee Bul, Patty Chang, Camilla Dahl, Tracey
Emin, Sylvie Fleury, Jitka Hanzlova, Hilary Harkness, Eliza
Jackson, Liza Lou, Elahe Massumi, Despina Meimaroglou,
Catherine Opie, Maria Papadimitriou, Kiki Seror, Lina
Theodorou, Fatimah Tuggar, Lisa Yuskavage

2·0·0·2

two – zero – zero – two

DESTE Foundation Centre for Contemporary Art, Athens,
20 December 2002–30 April 2003

Kutlug Ataman, Maurizio Cattelan, Rineke Dijkstra, Tom
Sachs, Gregor Schneider

The DESTE Prize 2003 for

Contemporary Greek Artists

3rd DESTE Prize
DESTE Foundation Centre for Contemporary Art, Athens,
28 May–1 November 2003
Exhibition catalogue

Nikos Alexiou, Apostolos Georgiou, Dimitris Kozaris, Nikos
Navridis, Maria Papadimitriou, Nikos Tranos

Yesterday Begins Tomorrow

DESTE Foundation Centre for Contemporary Art, Athens,
2 December 2003–13 March 2004
In collaboration with *Charley* magazine
Curated by Maurizio Cattelan, Massimiliano Gioni, and
Ali Subotnick

Jonathan Borofsky, Clegg & Guttmann, Crash (John Matos),
Grenville Davey, John Dogg, Cheryl Donegan, Nancy Dwyer,
Jon Kessler, Annette Lemieux, Simon Linke, Matt Mullican,
Peter Nagy, Pruitt & Early, David Robbins, Rob Scholte, Pe-
ter Schuyff, Mark Stahl, William Stone, Meyer Vaisman, Jan
Vercruysse, Wallace & Donohue, Meg Webster, Bill Woodrow

Steel Curtain. 1986
Enamel on steel
186,6 × 121,9 cm/73 1/2 × 48 in.

Untitled. 1992
Alkyd and acrylic paint on aluminum
109,2 × 76,2 cm/43 × 30 in.

CHRISTOPHER ▶
WOOL
Born in Chicago, 1955/Lives in New York

WANT
TOBE
YOUR
DOG

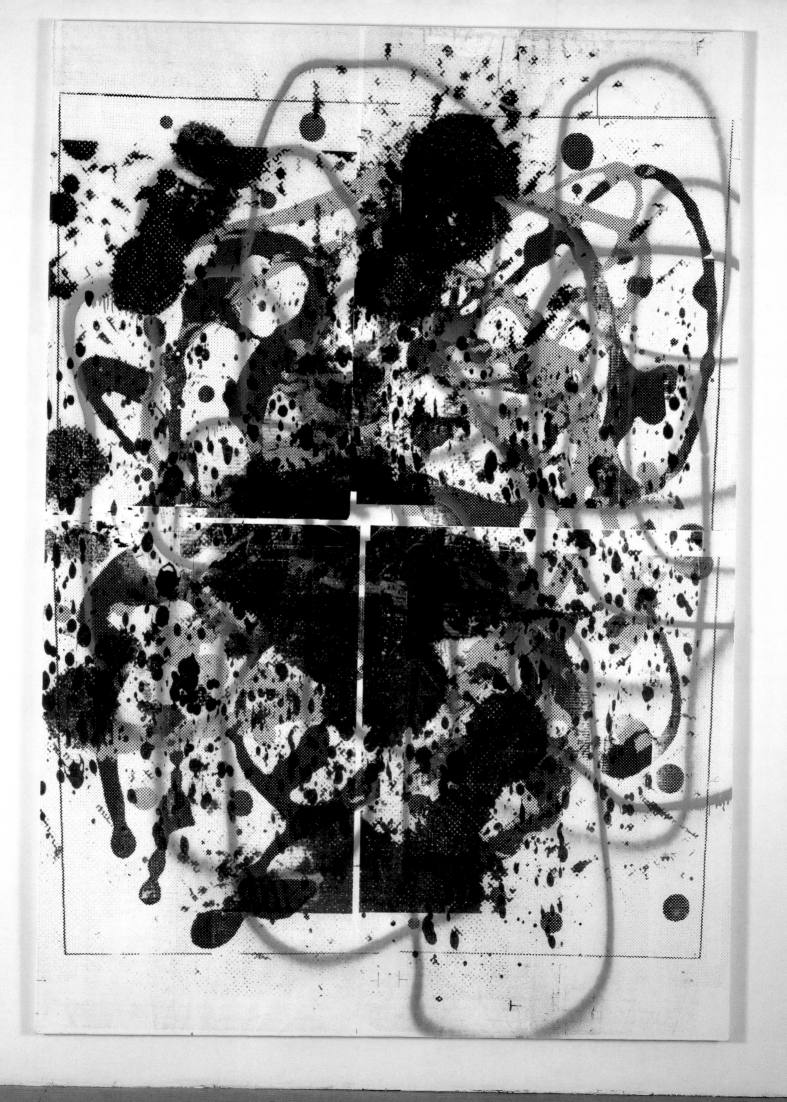

Untitled. 2000
Enamel on linen
274,3 x 182,9 cm/108 x 72 in.

Exhibition staff

George Andreou
Installation manager

Natasha Polymeropoulos
Registrar

Eugenia Stamatopoulou
Conservator

Xenia Kalpaktsoglou
Administration

Daphne Vitali
Assistant project coordinator

Stavroula Tseva
Administrative assistant

Miranda Simou
Intern

Sophia Vassiliou
Intern

Maria Panayides
m.p.artproductions
Media and public relations for Greece

Athanassios St. Bergeles
Packing and shipping of art objects

Katie Alexandridi-Katsargiris
Athenaeum Travel
Travel and hospitality

Maria Skamaga
Translations

Untitled (Comedian). 1989
Alkyd and acrylic paint on aluminum
244 x 163 cm/96 x 64 1/8 in.

CHRISTOPHER ▶
WOOL

Acknowledgments

Dakis Joannou

I would like to express my gratitude to the following individuals who lent their time and support to the completion of this demanding project. Gianna Angelopoulos-Daskalaki, President, ATHENS 2004 Organizing Committee for the Olympic Games, warmly welcomed the idea of the exhibition. Also part of the ATHENS 2004 team, Michalis Zacharatos, General Manager, Communications, Loukia Antoniades, Culture Manager, and Veronica Paikou, Culture Administrator, provided cordial collaboration. Through CEO Minas Tanes and Minas Mavrikakis, Marketing Manager, Heineken/Athenian Brewery supplied generous financial assistance. Our communications sponsor, ERT-SA, guided by John Kalimeris, General Manager, graciously facilitated publicity efforts for the exhibition.

For their contributions to the exhibition as well as the publication, I am extremely grateful to curators Dan Cameron, Jeffrey Deitch, Alison M. Gingeras, Massimiliano Gioni, and Nancy Spector, who have expanded the meaning of my collection in ways that I could not have foreseen. Stefan Sagmeister brought his original vision to the design of the publication, and Diana Murphy provided indispensable editorial guidance. Marina Fokidis offered essential managerial and organizational support, and all of my colleagues at the DESTE Foundation as well as our independent consultants devoted themselves to this project from beginning to end.

Finally, I would like to thank Jeff Koons and Maurizio Cattelan, for their continuous sharing of inspiration.

IF YOU
CANT TAKE
A JOKE YOU
CAN GET
THE FUCK
OUT OF MY
HOUSE

If You. 1992
Enamel on aluminum
274 x 183 cm/107 7/8 x 72 in.

Photograph Credits

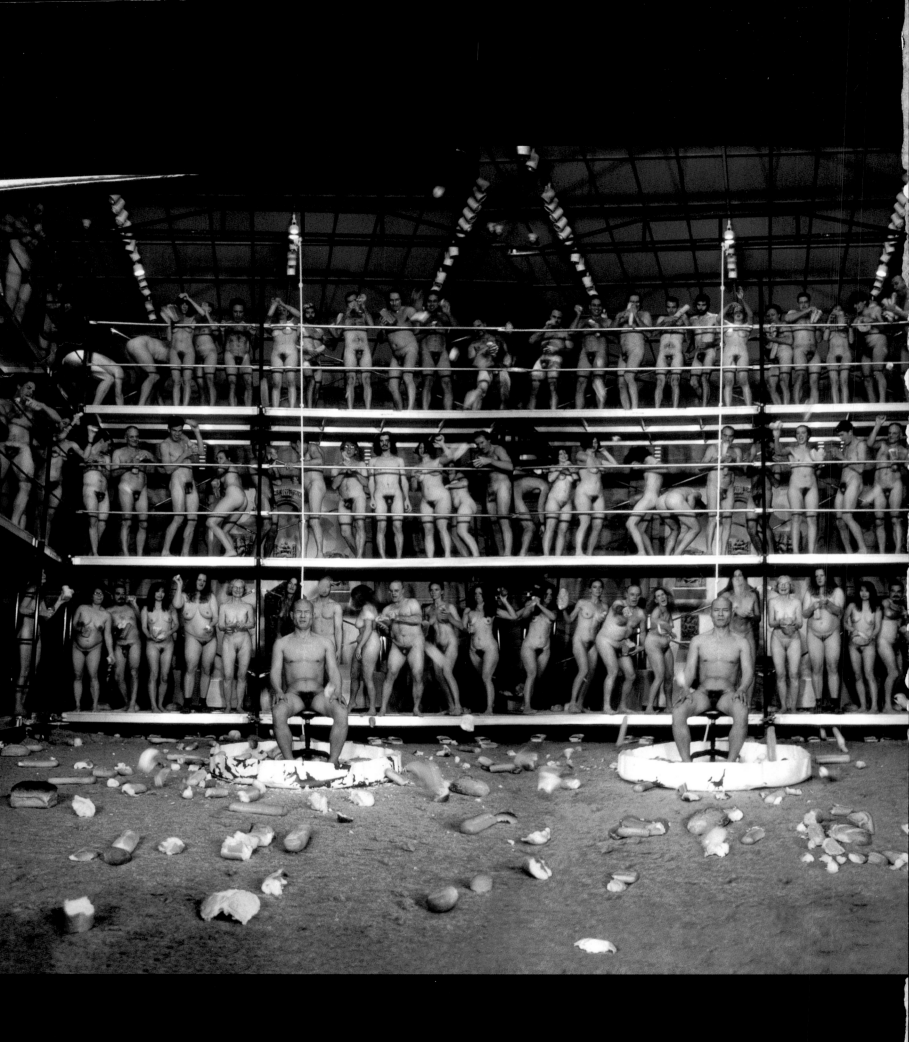

Date Due

12/31/14			